THE HARLEQUIN EATERS

— THE — HARLEQUIN EATERS

FROM FOOD SCRAPS
TO MODERNISM IN
NINETEENTH-CENTURY
FRANCE

JANET BEIZER

UNIVERSITY OF MINNESOTA PRESS
MINNEAPOLIS
LONDON

Portions of the Prologue are adapted from "Colette's Côtelettes, or the Word Made Flesh," *Being Contemporary,* Festschrift for S. R. Suleiman, edited by Lia Brozgal and Sara Kippur (Liverpool: Liverpool University Press, 2016), 305–18. Portions of chapter 1 are adapted from "The Emperor's Plate: Marketing Leftovers in Nineteenth-Century Paris," *Food and Markets: Proceedings of the Oxford Symposium on Food and Cookery 2014,* edited by Mark McWilliams (Prospect Books, 2015), 15–34. Portions of chapter 2 are adapted from "The House of Harlequins: Eugène Sue's *Mystères de Paris,*" *Romanic Review* 112, no. 3 (December 2021), 281–304; reprinted with permission; copyright by the Trustees of Columbia University in the City of New York. Portions of chapter 3 are adapted from "Shooting Them Softly: Photographing Lower-Class Eaters in Belle Époque Paris," *Food and Power: Proceedings of the Oxford Symposium on Food and Cookery 2019,* edited by Mark McWilliams (Prospect Books, 2020), 57–66. Portions of chapter 4 are adapted from "Traveling with a Hairy Heart: Where Annatto Can Take You," *Herbs and Spices: Proceedings of the Oxford Symposium on Food and Cookery 2020,* edited by Mark McWilliams (Prospect Books, 2021), 99–107. Portions of the Epilogue are adapted from "Why the French Hate Doggie Bags," *Beyond Gastronomy,* special issue, *Contemporary French Civilization* 42, no. 3–4 (2017), 373–89.

Excerpts from "Musée des Beaux Arts" from *Collected Poems,* by W. H. Auden, edited by Edward Mendelson, copyright 1940, renewed 1968 by W. H. Auden; reprinted by permission of Random House, an imprint and division of Penguin Random House LLC; all rights reserved; copyright 1939 by W. H. Auden; reprinted by permission of Curtis Brown, Ltd.; all rights reserved.

Published by the University of Minnesota Press
111 Third Avenue South, Suite 290
Minneapolis, MN 55401-2520
http://www.upress.umn.edu

ISBN 978-1-5179-1589-6 (hc)
ISBN 978-1-5179-1590-2 (pb)

A Cataloging-in-Publication record for this book is available from the Library of Congress.

Printed in the United States of America on acid-free paper

The University of Minnesota is an equal-opportunity educator and employer.

32 31 30 29 28 27 26 25 24 10 9 8 7 6 5 4 3 2 1

To my lost ones. For what is left over.
A.P.B., D.D.B., S.C.B.

CONTENTS

LIST OF ILLUSTRATIONS

PROLOGUE

Several years back, I came upon a reference to the marketing of leftover food in nineteenth-century Paris. I was not at the time familiar with the term that caught my eye, "le regrat," nor with the practice to which it referred. The word leapt out of an 1837 novella by Balzac that crosses the culinary arts with the aesthetics of symphonic music through the intersecting stories of a *chef manqué*-turned-leftovers-vendor, Giardino, and a failed composer, the eponymous Gambara, whose remaindered scores are used to wrap rancid butter for resale.[1] Simple curiosity set me to poking around in dictionaries, and then, in a widening circle, sent me to the internet, to novels, through the pages of illustrated period newspapers, through antique postcard collections, and to the historical archives. Gradually, the universe of nineteenth-century leftovers bloomed before my eyes. From the concept of the *regrattier* or *regrattière* who, like Giardino, sold small quantities of secondhand goods like butter or salt—and sometimes restaurant surplus—I arrived at the much more flamboyant practice of the *marchand* or *marchande d'arlequins,* purveyor of mixed plates of leftover food.

The *arlequin* usually consisted of several courses of diverse origin spliced together on a plate into a single recomposed meal, sourced from restaurants, embassies, and wealthy homes through their dishwashers or valets, and sold predominantly to the homeless or the humbly housed. Its socioeconomic history pointed me to an institutionalized and very much for-profit form of food redistribution that had its regimented space in the marketplace (though it also reached

beyond the law and outside the designated arena). Marketplace narratives led me to overlapping cultural histories of Parisian street life that juxtaposed the selling of *arlequins* with other street trades (*petits métiers*) and with other tradespeople such as mustache trimmers, goatmilk vendors, fingernail and toenail cutters, lemon zest collectors, and bouillon oil spitters (whose job was to blow oil onto the surface of thin soup to add an illusion of depth). I found *arlequin* scenes in novels both popular and canonical. Descriptions of this food system took me centuries back to the Commedia dell'Arte in Italy, soon to become the Italian Comedy in France, and to the spangled costume of the infamous Arlecchino (who evolved into Arlequin in France and Harlequin in English-speaking traditions). Arlequin was the character generally assumed to have bequeathed his name to the laden plate that shared his brightly checkered, patchworked appearance, which had originated in the seams of provincial poverty. He, in turn, led me toward two forms of visual ephemera: turn-of-the-century postcard photographs of the *arlequin* trade, and late nineteenth- and early twentieth-century poster art, a movement that peaked in the cult of *affichomanie* under the aegis of Jules Chéret.[2] From postcards I came to understand that the phenomenon of the *arlequin* (which I translate literally in English throughout the book as "the harlequin") was much more comprehensive than its reduction to an assemblage of food clumped on a plate or coalesced into soup in a bowl: it stretched to include the cycling-down process, the merchants, and the eaters as well—raggedy, patched-together Harlequins all, in the eye of the camera and the voice of many writers. On posters I found not only thematic representations of descendants of Commedia Harlequins but also confrontational and controversial emblems of modernism that abstracted both the busy plate and the acrobatic character into dazzling scraps of color and palpitating lines of force.

L'arlequin cuts a broad swathe across disciplines, from cuisine to cultural and socioeconomic history to imperialist race constructions, to theater, to novels, and to a panoply of visual arts, switchbacking through high and low modes as it does so. While Balzac's early staging, in *Gambara,* of a traffic in leftovers in the form of *le regrat* does not enter squarely into the more evocative category of the *arlequin* that is the subject of this book, it usefully announces affinities between the culinary and the aesthetic. Balzac's novella dares to bundle groceries with symphonies, recipes with musical composition, and it boldly suggests that the failure of a cook to make his gastronomic mark might be given the same weight as the fiasco of a musical artist whose compositions are scorned by the public.

Foodstuffs and fine arts were even less comparable in the nineteenth-century high public sphere in France than are the proverbial apples and oranges to fine analysis: they were not meant even to be uttered in the same breath, because the first classification responded to material bodily need while the second answered to the spiritual transcendence of corporeal constraints. In an early short story written over fifteen years before *Gambara,* Balzac had already pointed out wide

gaps in a literary tradition that pretended to represent its era yet omitted any mention of physical nourishment: "Les auteurs s'inquiètent peu de l'estomac de leurs héros. . . . Peignez donc l'époque, et à chaque époque on a dîné" (Authors are little concerned with the stomachs of their heroes. . . . So represent the era, and in each era people dined). And at the same time, Balzac had dismissed the literature of the early part of his century with a single provocative question: "Mange-t-on dans *René*?" (Do people eat in *René*?).[3] In *Gambara,* he then went on to initiate a representational practice that not only violated taboos against describing characters in serious literature in the act of eating or preparing food, but also risked even greater offense by assimilating such material activities to the arts. While the rhetoric of leftovers in Balzac neither reaches the aesthetic amplitude of the *arlequin* trope, nor lends itself to that trope's provocation to rethink eating in relation to class and race, it implicitly opens the way to such work by superimposing kitchen narratives on a story of high (if failed) art that would be received by readers across the social spectrum.

As others who talk about food have remarked, there is often a "mix of veneration and unease" in the discourses it inspires. I borrow these words from Leonard Barkan's book about representations of eating and drinking in Western high culture from antiquity to early modernity, not only for their concise eloquence but for their different chronological and cultural context. Barkan in turn is elaborating on words from Yi-Fu Tuan that refer to Chinese tradition—so along with temporal difference, we find a spatial one as well.[4] But if there is an enduring and universal element underlying the combination of awe and anxiety elicited by food and cooking, there are also vast historical and cultural variations in the particular ethos and in the nature of the phenomena that prompt these reactions, as well as in the forms they take.

This book is about a very specific alimentary practice, *l'arlequin,* the harlequin, that unfolded in a limited cross section of time and space coinciding with "the long nineteenth century" (dating roughly from the French Revolution to World War I) in urban France, with a focus on its most significant city, Paris.[5] And because we can only know the modes of this practice through its representations, *The Harlequin Eaters* necessarily also engages with cultural attitudes—*mentalités*— about the table, the body, and the social body that both shaped and were reinforced by these representations. These include the standards of propriety that strove to relegate material sustenance and eating bodies to the margins of good taste (and to the outskirts of literature and the other arts), and they reach beyond. French cuisine was codified in the nineteenth century, and elevated to the status of an art, but it was understood that criteria for admission into the alimentary canon were class-based: cuisine and its rituals were constituted in terms of socioeconomic and racial distinctions, and inversely, social class and racial difference were consolidated in terms of differential eating. At stake in all these classifications and systemizations, however, are a certain fragility, and a certain

frangibility. The harlequin, in its reliance on a trickle-down process of edible goods and on their cultural arrangement as cuisine, both confirms social systems and threatens them. As an institution, the hierarchic harlequin trade is always subject to significations of democratization and destabilization; as a trope, the harlequin meal is always available to writers and other artists to signal hybridization, opposition, and potential revolt in addition to routine disgust and contempt.

The Harlequin Eaters spins out these explorations in four chapters and an epilogue. Chapter 1, "The Emperor's Plate: The Business of Leftovers in Nineteenth-Century Paris," introduces the broad questions that are essential to the book: it offers an overview of the market operations of the alimentary harlequin through its literary and journalistic representations, and considers the sociocultural presumptions and stakes of these representations in nineteenth-century urban France. *"Arlequinade,"* an interlude that closes the first chapter and prepares those that follow, is modeled on the short Commedia-inspired dialogues or pantomimes of that name, featuring Arlequin, that filled the pause between theater acts in nineteenth-century France. It asks us to think back through the theatrical antecedents of the harlequin in the form of the Commedia dell'Arte's Harlequin and his heirs. Each of the subsequent chapters zooms in to a tighter focus. Chapter 2, "Urban Cannibals: Navigating the Streets with Eugène Sue," is launched by an early harlequin dinner scene in Sue's 1843 blockbuster urban mystery. The first half of the chapter harnesses this scene of food scraps as an opening to an expanding rhetoric of fragmentation, patchwork, collage, and metamorphosis throughout the novel, and as a bridge between aesthetic and sociocultural history. The second half of the chapter grapples with the darker areas of Sue's harlequin practices with recourse to his earlier maritime fiction and considers the author's evocations of cannibalism against his constructions of the colonial and the socioeconomic Other.

I move more squarely to the visual arts in the second half of the volume. Chapter 3, "Postcards from the Edge: Recirculating the People's Food," turns first to photographic postcards of the harlequin, and contemplates the photographic images along with printed labels and messages scrawled on the cards. Close readings of patterns of visual representation of the plated leftovers, the vendors, the consumers, and the presumed external viewer lead, by association, to postcard photographs of other individuals shot in the act of eating or of preparing food—mostly France's imperial subjects put on display in the Colonial Villages of Paris zoos or at the Expositions Universelles. Together these postcarded eaters, representatives of the working classes and the overseas colonized, invite reflections about the spectacle of eating and the subject and object positions enacted in its performance. The final chapter, "From Street Food to Street Art: Taking in Les Halles with Zola," is a diptych that concentrates on the edible and the optical in turn in Zola's marketplace novel. The first part focuses on food in its materiality in *Le Ventre de Paris,* and the second, on less concrete simulations, in writing,

of visual and more broadly sensorial depictions of food. This fourth chapter analyzes the workings of alimentary and painted elements of the harlequinesque in *Le Ventre,* then synthesizes them with Zola's art critical writing and the work of the "new" artists whose paintings he championed. The Epilogue, like the rest of the book, responds to the work of harlequin leftovers in the joined realms of the imaginary and the real. It opens with a consideration of Zola's attention, at the end of his novel, to twinned columns colorfully decked out in posters, which he compares to a pair of Harlequins. Zola presciently introduces a trope that will become a commonplace of fin de siècle poster criticism and a precursor of modernism. I suggest that the passage from Zola's brightly outfitted marketplace pillars to a subsequent era of art-postered walls that turn the streets of Paris into a kaleidoscopic outdoor gallery gives new life and new shape to the concept of the harlequinesque and invites speculation on its continuing evolution in the literary and visual arts of modernism. In its closing section, the Epilogue turns back to the material leftovers with which the book began, looking at how the distribution of dinners in a twenty-first-century urban soup kitchen both harks back to and breaks with a long tradition of recycled food in Paris. The chapters may be read in any order, apart from the first, which supplies necessary contextual background on the harlequin practice. The book proceeds in chronological fashion except for the last two chapters, whose timelines intersect toward the end of the fourth and the beginning of the third. I chose to interrupt a strictly linear order because the postcard explorations of chapter 3 reveal crossings of race and class that help to prepare the reading of Zola in chapter 4, which flows logically into the Epilogue.

Finally, a reflection on the sometimes perplexing relationship of the culinary harlequin and Harlequin (whose identities are multiple and mutable). My linking of the two, contrary to that of other critics who assume a clear and unilateral path from the second to the first based on visual cues, is grounded in a plethora of evidence: behavioral, social, racial, and political as well as chromatic and graphic. I would not want to claim that the harlequin institutionalized as a food distribution mechanism completely replaced Harlequin (who survived in somewhat attenuated form throughout this period in a variety of theaters and in diverse art modes, and who outlived the alimentary phenomenon in these different and metamorphic shapes). Instead, I suggest that this harlequin, in the guise of unpredictable masses of jumbled edible matter crowded promiscuously on a plate or enfolded in newsprint wrappings, best embodied the often clashing stories that the nineteenth century was telling about itself. It provides us still with a way to integrate sociocultural history with the history of aesthetics, and to rethink the imbricated place of class, race, and food in the longer history of modernism.

THE EMPEROR'S PLATE

THE BUSINESS OF LEFTOVERS IN NINETEENTH-CENTURY PARIS

The stuff of imperial banquets and the fare of the lower classes are extreme concepts not usually considered together. And yet they come together in a practice through which food circulated wildly across socioeconomic, cultural, and imaginary borders over the course of the long nineteenth century.[1] It was not impossible during this period for beggars to eat like the emperor—or the king or the president of the Republic or the Rothschilds, depending on the year and the milieu—because they might be consuming the very scraps cleared from such privileged tables.[2]

The practice of clearing leftovers from the grand tables of palaces, ministries, embassies, *hôtels particuliers* (mansions), and fine restaurants and reselling them to the less privileged at market stalls, in taverns, and in humble restaurants was common throughout the nineteenth century. The cycled-down scraps were formally known under the heading of *regrat* or *rogatons*. The popular term *arlequins* took over by midcentury, and the seller, usually a woman, was known as *la marchande d'arlequins*; another (originally ironic) slang expression, *bijoux* (jewels), was sometimes used as well, and its seller was called *une bijoutière* (a jeweler).[3] *L'arlequin* quickly became the alimentary idiom in French for a patchwork of reassembled table scraps generally assumed to be visually reminiscent of the costume of its namesake, the buffoon figure in the Commedia dell'Arte; on the gustatory, olfactory, and tactile levels as well, such motley food remains would have been analogous to the garishly mismatched costume fabric of the

Commedia character. But the analogy, as I argue in this chapter, was overdetermined on both sides; it was motivated by a spate of characteristics identified with Harlequin, but not reducible to the bright, diamond-patterned material he wore, and it extended to more referents than the mixed plates of leftovers. To retain the theatrical and aesthetic resonances of the term in English, along with its later literary and painterly connotations, I hold to a literal translation of both Arlequin and *l'arlequin,* which I will respectively render as "Harlequin" for the character and "the harlequin" for its alimentary applications, with variations such as "harlequin eating," "the harlequin plate," "the harlequin meal." Yet as we shall see, there are moments when we are hard put to tell the harlequin from Harlequin.

L'arlequin had a special place—a quite literal space—in the market cellar. It was there that the remnants of opulent dinners arrived in the wee hours of the morning, crammed helter-skelter in large vats. These table scraps were transported to Les Halles in vented carriages driven by middlemen (sometimes the husbands of the *marchandes*) who contracted with the kitchen staff of restaurants and the household staff of *hôtels particuliers* to purchase their meal remains.[4]

In the renovated space of the Baltard-redesigned Halles in central Paris, the triage and recomposition of the leftovers took place behind the scenes, underground (Figure 1).[5] In subterranean passages removed from the light of day, the remains could be prepared for marketing to the public in a painstakingly refurbished state: the almost intact morsels salvaged for resale at premium secondhand prices, the gristly half-devoured bits replated and artfully sauced, garnished, recomposed in more or less attractive collages, and priced accordingly (Figure 2). From here they would be sent up to the ground-level pavilion stalls devoted to this specific kind of commerce.[6]

—— THE TWO DISCOURSES

In the pages that follow I look beyond the already richly preserved corpus of gastronomy as it was codified in nineteenth-century Paris, to the other extreme, the commerce in leftovers, and more specifically, the plate, bowl, or newsprint-wrapped bundle of recomposed table scraps. I include in my purview "street soup" (my moniker for the runny meal made from the dissolving dregs of kitchen scrapings and often sold alongside more solid *arlequins*) as a related and indeed derivative product: it was the residue of remains, and so in a sense the quintessential form of leftovers.

My aim is to survey not only the practice and the operation of the harlequin industry, but also—and especially—its representations. To this end, I focus on the dominant discourse of its contemporary historians, journalists, and novelists, which has been passed down to, and has most often been adopted by, our own contemporaries as well. I call this discourse *degradational* for the emphasis of its oratory both on the ignoble and disgusting nature of the secondhand food it presents as already deteriorating and heading toward decomposition, and on

Halles centrales de Paris. — Coupe d'un pavillon depuis le faîte jusqu'au sous-sol. — Dessin de Lancelot.

FIGURE 1 A cross section of a Baltard pavilion at Les Halles reveals its strata, from the cellar, where the most disreputable activities were situated, to its ground-level vending areas, to its lofty iron and glass upper levels. Dieudonné Auguste Lancelot, *Halles Centrales de Paris, Coupe d'un pavillon depuis le faîte jusqu'au sous-sol,* 1862. Engraving. Bibliothèque nationale de France.

the parallel Parisian business of selling it down the socioeconomic chain in increasingly dissolute form to a progressively impoverished and contemptible clientele. A host of sanctimonious bourgeois commentators ranging from the late eighteenth century to the present display expansive sympathy and pity as they complacently deride the dregs of fine repasts passed down to the dross of the social order. This discourse typically takes the unmistakable high voice of overflowing outrage and disgust; however, it is a little more reticent about the question of whether the intended object of disgrace is the food to be swallowed, the swallower—as victim or as culprit—or the sociopolitical system responsible for the inequities of food distribution. Alexandre Privat d'Anglemont's tour guide–like spiel to an audience presumed not to know about the harlequin trade, that is, an audience of his well-to-do peers, is an archetype of the genre:

> "Si vous avez des nausées, ne vous en prenez qu'à votre curiosité . . . vous n'avez pas besoin de rien exagérer pour apitoyer utilement sur le sort de ces malheureux. . . . Tous les morceaux que la pratique laisse dans ses assiettes se vendent par sceaux. C'est avec cela que [la marchande] compose ses *arlequins* . . . elle les assemble, elle les assortit, elle les approprie et les vend aux gens aisés pour les animaux domestiques, et aux pauvres pour leur nourriture."

Manipulation du beurre.

Parure de légumes.

Gaveuses de pigeons.

Trieur d'os.

Plumeurs de volailles.

Descente de la viande.

Compteur d'œufs.

LES CAVES DES HALLES CENTRALES

FIGURE 2 In the underground spaces where leftovers for harlequin plates were sorted, other suspicious alimentary preparations also took place, including the butchering of animal carcasses, the force-feeding of pigeons, and the adulteration of butter. Auguste-André Lançon, *Les Caves des Halles Centrales,* 1869. Wood engraving. Musée Carnavalet, Histoire de Paris.

"C'est triste."

"Je n'en disconviens pas."[7]

["If you become nauseous, you have only your own curiosity to blame . . . you have no need to exaggerate anything to take pity on the fate of these unhappy souls. . . . All the scraps that clients leave on their plates are sold by bucketfuls. With these, the seller composes her harlequins . . . she assembles them, sorts them, arranges them, and sells them to the well-to-do for their pets, and to the poor for their own sustenance."

"That's sad."

"I don't disagree."]

Such a display of schadenfreude-laden benevolence shadowed by notes of marveling disgust is characteristic of harlequin narratives.

While I, in turn, look at the harlequin trade through this screening rhetoric of intermingled pity, contempt, and revulsion that is our prime means of access to it, I seek a way to speak differently about the business, the mode of eating, and the practitioners. The knee-jerk reaction of recoil that the greater part of harlequin descriptions provoke may be an inevitable first line of approach, but I believe it is necessary to find a path through and beyond this response in order to understand just what it is about secondhand food (which Jean-Paul Aron more precisely refers to as "[l]es consommations . . . *de deuxième bouche*" [*second-mouth* food]) that elicits such a generalized gut-heaving reception from observers.[8] Admittedly, it is sometimes difficult even as a second-degree commentator to find the right tone with which to talk about the contagious disgust of others and the objects that incite it: one risks either sharing their patronizing voices, or taking too great a distance from them and so slipping into another sort of condescension.

Toward the end of this chapter, I suggest an alternative perspective, one not meant to deny the controlling bias of degradation, nor to replace it, but rather, to supplement and ramify it. Although this second angle is perhaps less readily evident, it can be reconstructed from traces present in period narratives as well as latter-day accounts; it often exists in a minor key even in the texts whose major key is degradational. I call this other discourse *aspirational*; it tends to espouse or at least broach a subjectivity other than the author's own, and it approaches the practice of eating other people's discarded food as an act that may be metaphysically as well as physically motivated. To use or to listen to such a discourse is to be at least implicitly attentive to hunger in its affective and imaginary regimes rather than only in a somatic register. Broadening the concepts of hunger and of taste allows us also to thicken our understanding of food across an array of categories and functions, cultural as well as natural, adulterated as well as pure, and to think about leftovers not only in connection to need but also in relation to choice. The harlequin, like any other alimentary matter, involves process as

much as product, agency as well as reception, and invites a consideration of eating (and of cooking, though that is less my focus here) as acts of potential acquiescence or revolt that are alternately capable of affirming or putting into question accepted social, political, and aesthetic definitions of taste and disgust.

—— TROP ET TROP PEU

There is a fair amount of both documentation and mythology pertaining to the rise of haute cuisine in postrevolutionary France, but the poor left few recipes. The gastro-history of the underfed is only belatedly being resurrected, piece-meal, thanks to a handful of contemporary historians who are ferreting out sources in chronicles and novels of the period, many of which are little read or even forgotten (and generally out of print) today.[9] If the diet of the lower so-cioeconomic echelons was not contributive to the culinary record of their era, neither was it completely unknown to mainstream social commentators, nor was it without interest to them. Indeed, working-class fare did attract some lim-ited attention from period chroniclers of gastronomy and fine restauration—but primarily as a means to disparage and dismiss its consumers by way of conflat-ing them rhetorically with the scum they presumably ingested.[10] The gap—of knowledge, of discourse, of empathy, and, most concretely, of resources and of substance—that separated high tables from low (or no) tables also, paradoxically, was responsible for connecting them and for putting into socioeconomic circula-tion a vast array of objects of consumption.

By way of prelude to the intricacies of the commerce in harlequins and the complexities of its reception by those who put it into discursive circulation, I want to emphasize how radical were the dichotomies that enabled it. To evoke the profound disproportions of the Paris food scene, let us consider both sides of a small but representative series of polarities usually not addressed head-on by written and visual representations of the era. An exception to the general rule of nonconfrontation of alimentary disparity is the lithograph by Henri Monnier titled *Trop et Trop Peu* (Too Much and Too Little) that gives me my subheading (Figure 3). It juxtaposes two dramatically opposed scenes of dining and with them, two contrasting socioeconomic clusters whose visual positioning corre-sponds to class situation: the privileged diners are on a restaurant balcony above, and the humble eaters, below, outside on literal ground level. As if to cinch the implications of the two spatial tiers, a figure on the upper left who visibly rep-resents the "too much" contingent leans over his loge to release the excess of his self-indulgence in a stream of vomit that appears aimed at the "too little" crowd below. Echoes of this explicit presentation of the social disparities that grounded the institution of the *arlequin* can be more painstakingly teased out of various remnants of visual and written food history.

In the first of three examples, I offer, on the one hand, Alexandre Balthasar Laurent Grimod de la Reynière's *Almanach des gourmands* with its recherché

FIGURE 3 This is a rare illustration—and acknowledgment—of the radical class disparities that regulated alimentary access. Henri Monnier, *Trop et Trop Peu,* 1831. Hand-colored lithograph, Plate 9 from series *Pasquinades.* Copyright The Trustees of the British Museum.

counsel—expanded and reinvented with the successive publication of each of eight volumes of the almanac—about where the most discriminating palates might find the highest quality of everything gourmand, from extravagant ingredients, to exquisite restaurant meals, to fine crystal, porcelain, and linens; on the other, Pierre Hamp's account of the protest of one outraged beggar, who meets a restaurant kitchen handout of ham fat wanly couched between two rags of gnawed bread ("du gras de jambon [qui] pâlissait entre deux torchons de pain mordu") with the cry: "Voilà ce qu'on me donne. Vous ne pouvez pas m'avoir quelque chose de mieux? Vous avez de la chance, vous, vous choisissez votre nourriture. Moi je dois avaler tout ce que je trouve, ou crever" ("This is what I'm given. You can't get me anything better? You are lucky, you get to choose your food. I have to swallow whatever I find, or die").[11] If our sources are to be believed, such a complaint would have been extremely rare—or in any case, the reporting of it would have been exceptional. Far more common are patronizing accounts of the gratitude of the poor for anything at all, along with comments on their lack of discrimination. Jean Barbaret, for example, speaks in this way of occasional charitable handouts from harlequin sellers to the truly destitute

and starving: "Ce ramassis n'était pas paré, mais ceux à qui on l'offrait n'y regardait pas de si près. Il y avait toute une élégie dans le remerciement muet qu'ils adressaient aux donateurs. Le don n'était peut-être pas très vendable; quoi qu'il en soit . . . la faim rend l'odorat insensible" (This heap was hardly presentable, but those to whom it was offered didn't look too closely. The silent thanks they addressed to the donors was like an elegy. It is true that the gift may not have been very marketable, but in any case, hunger dulls the sense of smell).[12]

Another example: let us juxtapose the recipe for "Le Potage Camerani" with the protocol for a rather different preparation of soup (Figure 4). The Camerani version (as described by Eugène Chavette and illustrated by Cham [the pseudonym of Charles Amédée de Noé]) was invented on the occasion of an early nineteenth-century dinner for ten eminent gourmets at the elegant Café Anglais; the recipe stipulates that its chicken liver base be derived from forty fattened chickens killed by electrocution rather than bleeding or strangulation.[13] The second brew, common to multiple soup vendors catering to the indigent, begins with a stock sourced from the greasy residue of dishes skimmed from the dishwater by the kitchen staff when they were done with their day's work. Its preparation is here summarized by Barbaret: "Les cuisiniers laissent refroidir et reposer l'eau chaude qui a servi à laver la vaisselle. Au bout de quelques heures, la graisse remonte à la surface et forme une couche plus ou moins épaisse selon la quantité de sauce laissée au fond des assiettes. Cette graisse est écumée et mise de côté pour le bijoutier, qui en fera le lendemain la base de ses potages" (The cooks let the hot water used to wash the dishes cool down and settle. After a few hours, the grease comes to the surface and forms a layer that might be thinner or thicker depending on how much sauce is left on the plates. This grease is skimmed off and put aside for the harlequin seller, who will use it as soup base the next day).[14]

Finally, a third apposition: the harmonies of a sumptuous repast prepared with lavish, calculated attention, such as Marcel Rouff evokes it: "Étalez . . . tous les produits animaux et végétaux de la terre, du ciel et de l'onde, et songez à l'effort intellectuel, à la géniale intuition qui les harmoniseront" (Display all the animal and vegetal products of the earth, the skies, and the waves, and imagine the intellectual effort, the inspired intuition that will harmonize them)—or alternatively, the gentle accords of a well-conducted menu such as Auguste Escoffier conceives it: "Il . . . s'agit . . . de choisir ces mets avec discernement, de les grouper harmoniquement et de réaliser, avec ces notes éparses, une sorte d'orchestration savoureuse" (One must choose these dishes with discernment, group them harmoniously and achieve, with these scattered notes, a kind of delectable orchestration). Such harmonies may be contrasted with what Madeleine Ferrières names "une cacaphonie de couleurs et d'arômes" (a cacaphony of colors and aromas)—or instead, the dissonances of potluck delivered, in Jacques Castelnau's description, by a merciless ladle emerging like a lottery draw ("c'est le hasard, la loterie") from a pot of melded remains; its arbitrary haul might dispense

LES GRANDES CUISINES.

FIGURE 4 Cham's illustration of a gastronomic recipe (so fastidious as to require that its component chicken livers be sourced from chickens killed by electrocution) evokes electrical currents coursing through the vapors rising from the soup. *Le Potage Camerani,* drawing by Cham (Charles Amédée de Noé), from Eugène Chavette, *Restaurateurs et restaurés,* Dessins par Cham (Paris: A. Le Chevalier, 1867). Bibliothèque nationale de France.

anything ranging from "une cuisse de poulet à moitié rongée" to "de modestes lentilles" (a half-eaten chicken thigh or some modest lentils).[15] This last example precisely encapsulates the dynamic of the passage from wealth to poverty, privilege to indigence, choice to imposition, and aesthetic intention to random consumption that characterizes the institution at the center of this book.

—— TRICKLE-DOWN EATING

The phenomenon of selling used food preexisted the alimentary application of the term *arlequin.* In his late eighteenth-century *Tableau de Paris,* under the entry "Mets hideux," Louis Sébastien Mercier describes the antecedent to what would become a somewhat better-regulated trade in recycled food at Les Halles in the mid-nineteenth century:

> Au détour de cette rue, dans cette étroit échoppe, qu'aperçois-je sur ces assiettes mutilées? Quels sont ces restes où la moisissure a déjà déposé sa première empreinte? Ces restes, rebut des valets, après avoir touché la bouche d'un évêque qui s'est arrêté par réflexion pour donner la préférence à un autre morceau, ont été dédaignés des marmitons [. . . qui] les ont ramassés pêle-mêle et les ont vendus à des

regrattiers qui les exposent à l'air. . . . Sur le soir, un indigent enveloppé d'une redin-
gote, descend de son grenier et vient acheter ces restes dégoûtants, sur lesquels la
valetaille a bavé ; il les cache et les emporte.[16]

[At the bend of the road, in that narrow stall, what do I spot on those mutilated
plates? What are those leftovers already marked by mold? Those leftovers, rejected
by the valets after having touched the mouth of a bishop who paused in the act out
of deliberate preference for another morsel, were disdained by the scullions who
gathered them pell-mell and sold them to secondhand dealers who let them sit out-
side. . . . When evening comes, a pauper wrapped in a frock coat comes down from
his attic and buys these disgusting leftovers that the valets have drooled over; he
hides them and carries them off.]

Though Mercier's early version of the trade in dinner remains describes the shad-
iest of food recyclings, concealed in dark alleyways, marginalized in space and
time, the cycle announces the very same trickle-down pattern that would re-
main in place throughout the new century. And as we shall see, the practices he
describes, though they become illegal, do not completely vanish during the nine-
teenth century.

In the memoir of his early days as pastry chef and then apprentice restau-
rant cook in the late 1880s and early 1890s, Pierre Hamp recounts the triage that
took place in the kitchens after the diners left, and which resulted in a full cycle
of recycling:

Les maîtres d'hôtel triaient pour le marchand d'arlequins ce qui dans la desserte
conservait un peu d'envergure, gardait dimension de tranche ou de morceau. . . .
Ce qui restait coulant, juteux, faisait le régal des miteux honorifiques . . . le pourri
[tombait] dans les tonneaux [vendus] aux nourrisseurs de porcs. . . . Le cycle de la
nourriture, qui commençait au maraîcher et au troupeau, finissait au fumier et à
la porcherie.[17]

[The butlers sorted for the harlequin dealer whatever table remains retained a bit
of heft, or kept the semblance of a slice or a chunk. . . . Whatever was still runny and
juicy became an honorific feast for the filthiest and most bedraggled; what was de-
cayed fell into barrels that were sold to pig farmers. . . . The food cycle, which began
with the market garden and the flocks, ended at the dung pit and the pigsty.]

Hamp's accounts of the downward spiraling of food are especially useful because
they are among the few that emanate from a witness who was on the receiving
rather than the bystanding end of such practices; he describes them with the
intimacy of an insider rather than from a gawker's perspective, although aging
and evolving circumstances distance the writer at the time of writing from the

experiences he relates. Other commentators recount similar kitchen operations that, alternatively, culminate in the sale of just such grease and slops and debris to soup vendors and harlequin sellers rather than pig farmers. For some, animals are not mere beneficiaries of paupers' discards, but their rightful match in the struggle to eat. Castelnau calls the harlequin seller "le concurrent le plus redoutable des chiens, des chats, et des porcs" (the most formidable competition for dogs, cats, and pigs) and adds: "il retire véritablement le pain de la gueule" (he takes bread from their very mouths).[18]

The cycling down that I, with my sources, refer to is multidimensional; it has most obviously to do with the descent of comestible matter from the wealthy to the poor, and then, too, with the crumbling, dissolving, degenerative state of this material as it follows its plunging course—a path we will later pick up again as well. But it is also related, as the preceding excerpts suggest, with the passage of food down the evolutionary order, so that edibles, with animals, devolve commensurably. What is not clearly articulated—though it is repeatedly implied in so many of the descriptions that detail the passage of upper-crust meals to the working classes and to beasts—is that those humans who are lower on the socioeconomic scale are, like the four-footed creatures who sometimes share their diet, similarly assigned to the lower echelons of the evolutionary scale.[19]

—— OF BEASTS AND MEN

The visual and literary iconography of harlequins in the nineteenth century in fact consistently has consumers vying with beasts for their sustenance.[20] Tales are legion of dishwashers and other kitchen staff turning a profit by selling off (fairly interchangeably) to pig farmers or to harlequin merchants, on the sly, the dinner vestiges meant for charitable handouts. According to Ali Coffignon, the harlequin stands were first providers for "des bonnes âmes qui gâtent les petits chiens" (the good souls who spoil little dogs), but human consumers are listed as the secondary clientele: "bien des gens viennent chercher dans les assiettes d'arlequins un repas à bon marché" (many people come to harlequin plates seeking an inexpensive meal).[21] Maxime Du Camp specifies that after the choice scraps are snapped up by humans, "il reste encore bien des détritus qu'il est difficile de classer. Ceci est gardé pour les chiens de luxe" (there remains debris that is difficult to categorize. It is kept for high-class dogs). He lingers on the itineraries of the well-to-do women who cross Paris to buy succulent, low-cost mash ("une pâtée succulente et peu coûteuse") for their coddled dogs from the harlequin stalls at Les Halles.[22]

Paintings and photographs of harlequin merchants and harlequin restaurants typically feature a dog crouching beneath or beside the display or dining table, at once a naturalist detail and an ideological commentary (Figure 5). Written accounts frequently expose a thin conceit on the part of buyer and seller alike that the food is being purchased for a pet at home, as in the following exchange

reported by Pierre-Léonce Imbert, in which a customer requests a dish for his dog, and the merchant adds the cunning comment that the ostensible dog food would be good enough for human consumption:

> "Je voudrais un ragoût pour mon chien."
>
> "J'ai justement ce qu'il vous faut; un plat délicieux, sorti des cuisines de M le comte de Flûte-en-Bois. J'en ai déjeuné ce matin et je m'en lèche encore le bout des ongles . . . C'est exquis . . . il est dommage qu'un chien l'avale . . . c'est de la nourriture de chrétien."[23]

> ["I would like a stew for my dog."
>
> "I have exactly the right thing for you; a delicious dish, prepared in the kitchens of M. the Count of the Sylvain Flute. I had some for breakfast this morning and I'm still licking my fingers. . . . It is exquisite . . . what a shame that a dog is to eat it . . . it is food fit for a Christian."]

For the author, the biggest joke may be on the seller, who condescends to her low-life buyer's feigned distinction between himself and his dog, while her own finger-licking behavior shows her to be no better than either one of them. It is, of course, relevant here, as in so many juxtapositions of dogs and harlequin consumers, that the popular term for the low-born, the riffraff—*la canaille*—comes from the Latin word for "dog."

Chronicles of the harlequin participate in a familiar naturalizing discourse that assimilates the poor to the savage, the uncivilized, the creaturely: in sum, to the "natural," an anxious concept that can never be sufficiently unpacked. We recall Edmond de Goncourt's glossing of naturalism in much the same terms: "Nous avons commencé par la canaille, parce que la femme et l'homme du peuple [sont] plus rapprochés de la nature et de la sauvagerie" (We began with *la canaille,* because the people are closer to nature and savagery).[24] A rhetoric of mixing operates across the board, exposing as corollary to the mixing of foods and tableware the fearsome collapse of species, classes, and other categories that should all remain separate. Pierre-Léonce Imbert among others explicates the fortuitous and heterogeneous nature of the harlequin and indeed of the entire phenomenon, from consumer to consumed to surface of consumption: "Sur des assiettes de toutes formes et de toutes dimensions sont exposés des aliments destinés aux consommateurs de toute classe et même de tout espèce, hommes, chiens, ou chats . . . on y voit des objets dont il est difficile de déterminer la nature . . . des poissons mêlés à des fragments de rosbif et de salade. Tout y est, même—trop souvent, hélas! pour les nécéssiteux—ce qui ne devrait pas y être!" (On plates of every shape and dimension we find foods bound for consumers of every class and even every species, men, dogs, or cats . . . we see objects whose nature is difficult to determine . . . fish mixed with fragments of roast beef and salad. Everything is there,

PARIS DISPARU : LE RESTAURANT DES PIEDS HUMIDES, AU MARCHÉ DES INNOCENTS. — Dessin de GODEFROY DURAND.

FIGURE 5 One of many illustrations of a harlequin restaurant for the poor where people sit at long communal tables outdoors, at ground level, with omnipresent dogs waiting for spills and connoting fungibility with human feeders. The accompanying article announces the demise of this restaurant, one of the casualties of Baron Haussmann's Paris renovations. Godefroy Durand, *Paris disparu: Le Restaurant des Pieds Humides, au marché des Innocents.* Cover illustration from *Le Nouvel Illustré,* August 26, 1866. Engraving. Author's collection.

even—too often, alas! for the needy—what should not be there!).[25] The menace of hybridity that is condensed in the melded scrapings on the harlequin plate, as we shall see, reaches beyond it, has diffuse roots and implications.

—— THE AFTERLIFE OF THE HARLEQUIN

The harlequin is a stage or phase ("un prologue," Jean-Paul Aron calls it) in a slowly spooling cycle of recycling.[26] Though most goods left the harlequin counters before day's end to be eaten on the spot or carried home, some had an extended history of displacement and alteration during which they slowly transitioned "du vestige au déchet, du déchet à la dénaturation" (from vestiges to waste products to denatured substances), in Aron's words.[27] While the practice was somewhat better regulated and policed in the marketplace by the Second Empire, there were multiple opportunities, once provisions were removed from the market stalls and their vicinity, for eluding the law and raising the practice to greater heights of insalubrity (as there were numerous branching channels for leftovers prior to their arrival at the market or on the sidelines). We can get a good sense of the range of harlequin afterlives from a few of the episodes that have been handed down by period chroniclers.

Chavette recounts the epilogue to a story of foods condemned by the authorities at Les Halles that nonetheless continued to circulate:

> [Aux] Halles centrales . . . ces détritus sont au moins sous l'oeil de l'autorité, qui les fait retirer de la vente avant qu'ils soient entièrement corrompus. Mais ne craignez rien, ces restes condamnés par l'inspecteur ne sont pas encore perdus. Ils disparaissent pour aller dans les faubourgs, loin de la surveillance de l'autorité, approvisionner la cuisine de bouges épouvantables où se repaît la misère.[28]

> [At the central Halles . . . this detritus is at least under the watch of a surveilling authority who has it withdrawn from sale before it is entirely spoiled. But fear not, these leftovers condemned by the inspector are not yet entirely lost. They disappear only to go to the city outskirts, far from the surveillance of any authority, where they provision the kitchens of appalling hovels where misery feeds.]

Alternatively, there are the *houillers,* who were traffickers in spoiled goods (poultry, game, etc.): food so far gone as to have been rejected by the lowliest of market dives, and so normally destined for the refuse dump. Instead, it is purchased for next to nothing by a *houiller,* who takes it to the outskirts of Paris. There, he poses as a peasant "qui vous aborde dans la rue et sous les portes, pour vous proposer, avec des airs mystérieux, du gibier à bon marché" (who confronts you in the street and in doorways with mysterious proposals to sell you cheap game). His merchandise is carefully wrapped " 'pour ne pas attirer l'attention de la police,' vous dit le prétendu braconnier. Le bas prix vous décide, il vous passe le

paquet . . . et vous rapportez la peste au logis" ("so as not to attract the attention of the police," says the so-called poacher. The low price is decisive, he gives you the package . . . and you carry the plague back to your lodging).[29] There is a third scenario offered by Chavette in this survey of deteriorating remains, this one aquatic: "Il y a quelques années, le service de salubrité des Halles faisait enlever le poisson gâté dans des voitures qu'on allait vider aux *dépotoirs* de la Villette. Un beau jour on arrêta des gens qui, depuis des années, venaient, après le départ des voitures, repêcher le poisson dans cet étrange liquide et le revendaient aux barrières. Rien à ajouter après ce détail" (Several years ago, the health services at Les Halles regularly removed spoiled fish in carriages that were sent to be unloaded into the *dumps* of La Villette. One fine day came the arrest of those who, for years, had arrived after the departure of the carriages to recatch the fish restocked in this strange liquid and resell it at the Paris limits. There is nothing to add to this detail).[30]

This author may have nothing to add, but others take up the slack. Coffignon leaves page upon page that elaborate on the specialized work of oyster resellers, vendors of oysters gone bad and palmed off cheaply by sellers unwilling or unable to sell them to their more demanding clients. The resellers, known as "undertakers" (*des croque-morts*), stock thousands of spoiled oysters in large wooden tubs in large open sheds commonly referred to as *infirmeries.* Here they are set to soak in saltwater sometimes dosed with algae to approximate seawater. The oyster, dying but not yet dead, has sufficient reflexes remaining to open upon contact with the saltwater, to "drink," and when replete, to close—and so to give the illusion of vitality and edibility. "[L'huître] meurt aussitôt d'indigestion, mais elle est fraîche à l'oeil, elle sonne le plein et elle a du poids" (The oyster dies quickly from indigestion, but appears fresh to the eye, it sounds full and bears weight).[31] It is no wonder, then, that the consumption of oysters in the nineteenth century begins to be more common, becomes "democratized," to use Coffignon's term. "L'huitre se démocratise . . . elle est rentrée dans la consommation courante" (The oyster is becoming democratized . . . it is once again commonly consumed), he reports.[32]

Hamp's memoirs of his restaurant apprenticeship include several accounts of the eating habits of those living below even the level of most harlequin patrons. The shabby (literally, "moth-eaten") beggars he refers to as *les miteux* come by for the handout of leftovers the kitchen staff prepares for distribution to the toothless at appointed hours: "Les maîtres d'hôtel devaient nettoyer de près les desseres, les rognures de gras et les bavures de sauce pour rendre succulentes les croûtes destinées aux dents des crève-la-faim. Ces damnés attendaient le matin leur dégoûtante pitance, à l'heure où les garçons de salle changeaient les nappes blanches des tables et y disposaient le cristal et l'argenterie" (The butlers needed to carefully clear the table remains, the greasy bits and the smudges of sauce to soften the crusts headed for the teeth of the starving. These damned

souls waited for their disgusting pittance each morning, at the very hour that the waiters changed the white tablecloths and laid out the crystal and the silver).[33] Hamp is both well placed and well disposed to observe the ironic extremes of alimentary provisioning, and he testifies frequently to these. He further describes a food cycle linking the pinnacle of haute cuisine inexorably to the dung heap, each stage of which is socioeconomically determined and strictly hierarchized accordingly: "La nourriture du grand restaurant passait des convives riches aux clients des échoppes de rognures, aux miséreux des rues, aux pauvres des hospices, aux cochons à l'engrais. Chacun cherchait son profit dans ce trafic où la moindre miette de pain et la plus dégoûtante bave de sauce avaient une valeur commerciale" (The cuisine of fine restaurants passed from wealthy guests to the clients of scrap stands, to the street poor, to indigent asylum inhabitants, to fattening pigs. Everyone sought profit in this trafficking where the smallest crumb of bread and the most disgusting drool of sauce had commercial value).[34] Nature may be but thinly veiled by culture, but culture exerts its socioeconomic and political forces to regulate how what is deemed "natural" is both determined and determinative.

—— NOTHING IS LOST

If the harlequin finds its place in an institutionalized (re)cycling of food whose drip-down path mimics the social ladder, it also is informed by a broad economic mandate of thrift and reuse. Time and again we are reminded by various dictums and declarations in the accounts of food circulation that nothing is to be wasted. As corollary, everything must be done to assure that nothing is discarded, including reconditioning, savvy marketing, fraud, and cosmetic enhancement (which we will explore later in more detail). Though insalubrity and dishonesty were easier to implement away from the surveillance of authorities in the marketplace, commerce at Les Halles was no exception to the rule of salvage and recirculation, and one has the sense that many vendors indulged in whatever operations might bring a profit and escape detection. "Rien ne se perd à Paris," Coffignon reminds us, "aux Halles moins que partout ailleurs" (Nothing is lost in Paris, at Les Halles less than anywhere else).[35] Aron says of the harlequin: "L'industrie de la pourriture a pour maxime que rien ne se perd" (The industry of rot takes as its maxim that nothing is lost).[36] Butter that fell on the floor would be used for frying. Cooking utensils and grills were fashioned from old umbrella ribs by a small tradesman on the edge of Les Halles.[37] Discarded butt ends of smoked cigars were gathered for recycling by another specialized tradesman (*le ramasseur de bouts de cigares*).[38]

Du Camp offers the summary judgment that "on utilise tout dans cet immense Paris, et il n'est objet si détérioré, si dédaigné, si minime, dont quelque homme intelligent ne parvienne à tirer parti" (everything is put to use in this wide Paris expanse, and there is no object so deteriorated, so disdained, so trivial, that some

intelligent man doesn't manage to take advantage of it).[39] As illustration, he goes on to narrate the cycle of bread, starting with the used bread sellers (literally, "crumb and crust sellers" [*les marchands de mie et de croûte*]) at Les Halles. But the narrative flashes back, for the source of the recycled bread can be traced to school canteens where the boarded children freely waste their bread, throwing it, kicking it "[comme] si c'était des cailloux ou des mottes de terre" (as if it were pebbles or lumps of earth). These clods of bread, "couverts de poussière, tachés d'encre, qui ont trempé dans les ruisseaux, qui ont durci oubliés derrière un tas d'ordure" (dust-covered, ink-splattered, damp from the gutters, hardened into oblivion behind rubbish heaps), are gathered and sold to used bread dealers, who sort through the haul. The fragments that are "encore présentables" are dried in the oven and grated, to be used for making croutons or thickening soup. The crusts and crumbs deemed "trop défectueuses" are pulverized in a mortar and used for breading chops. The "débris infimes" (minute particles of debris) are blackened over a fire, ground into a dark powder, mixed with honey and sprayed with a few drops of spirits of mint, and sold as toothpaste.[40] Castelnau gives a similar account of the bread recycling industry, adding that the used bread sellers' employees charged with triage work in teams morning to night in vast sheds; faced with "des montagnes de pain qui grossissent à vue d'oeil" (mountains of bread that grow larger before one's eye), they struggle to sort the scraps between those still fit for humans and those to be consigned to rabbit feed.[41]

Zola (following Du Camp) describes the handling of butter (among other unsightly alimentary activities better practiced underground) in the cellars of Les Halles. Like cheap wine, butter for the poor was composed of an amalgam of sources, some in the process of turning, and some already rancid. Once it was kneaded into a single mass by bare arms buried up to the elbows, the blend would be visually enhanced by the addition of a colorant derived from the annatto tree. Or, more economically, carrots or marigolds would do the trick.[42]

The line separating thrift and enterprise from unsanitary practices and fraud is sinuous, whether within or without the zone of surveillance. Hamp recounts, from his days as a pastry apprentice in the upscale Pâtisserie Laborde, that the owner "nous dressait à éviter le gaspillage même d'une miette. On utilisait tout au dernier suc" (trained us to avoid wasting even a crumb. We used everything down to the pith). So it may not be a great surprise that the syrup used for glazing babas au rhum was drawn from "les écumes: . . . résidus sucrés, raclures de fondants, fonds des bassins de meringues [. . . et quand] ces ordures succulentes débordaient par la fermentation, on vidait ce déguelis dans un bassin de cuivre et on cuisait jusqu'à la clarification" (the scum: . . . the sugary residue, icing scrapings, and meringue clinging to the bottom of bowls . . . and as this succulent muck fermented, the nauseating overflow spewed into a copper pan and was cooked until it clarified). Hamp goes on to relate the proprietor's purchase of some surprisingly well-priced vanilla beans from a passing sailor ostensibly returning from

the Antilles. Upon use, however, it became clear that the vanilla was second-hand and had been doctored with oil and chemicals: "on s'aperçut qu'elle avait déjà servi; vieilles gousses trempées dans l'huile pour les regonfler, leur donner du luisant, et reparfumées à l'essence chimique" (we noticed that it had previously been used; old vanilla pods [that had been] soaked in oil to plump them up again and make them glossy, and artificially flavored with chemicals).[43] The self-proclaimed mariner of the seven seas had in fact sourced his exotic vanilla pods in the Paris refuse.

Castelnau gives as an example of the increasingly prevalent "art d'accommoder les restes" (art of using leftovers)—an art that was gradually becoming a bourgeois value, and not just a popular necessity—a portrait of *la zesteuse,* the "zester woman":

> Dès qu'elle aperçoit une écorce d'orange ou de citron, elle s'en empare avidement. Pendant la saison des huîtres, on la rencontre rôdant autour des restaurants et des bars en vogue. Sa prunelle s'allume dès qu'elle distingue un panier de coquillages. A la longue, le garçon la reconnaît et, si elle est avenante, lui garde les précieuses épluchures. Rentrée chez elle, elle les râpe ou, pour employer le mot technique, les "zeste." Son commerce prenant de l'extension, elle s'adjoint des aides. . . . Les expéditions se font d'abord dans Paris, puis en France, enfin à l'étranger, et la fine poudre, tantôt jaune comme l'or, tantôt rouge comme le cuivre, se transforme en essence de citron, en sirop d'oranges et en curaçao de Hollande.[44]

> [As soon as she notices an orange or lemon rind, she bears it off greedily. During the oyster season, she can be found prowling around trendy restaurants and bars. Her eyes brighten as soon as she spots a basket of shellfish. With time, the waiter recognizes her, and if she is attractive, he keeps the precious peels for her. When she returns home, she grates them, or, to use the technical term, "zests" them. If her business grows, she takes on assistants. . . . Such expeditions take place first in Paris, then in France, and later abroad, and the fine powder, sometimes golden yellow, sometimes copper red, is transformed into lemon extract, orange syrup, and Dutch curaçao.]

Echoing his fellow chroniclers, Castelnau repeats the refrain: "on ne perd rien," manifestly using the present example to speak not only to the mantra of avoiding loss, but also, to the potential gains of economy, frugality, and entrepreneurial skills—prime among them, the cosmetic.[45]

—— THE SELLER AS ARTIST

Zola describes the hybrid composition of a lower-end plate: "Dès neuf heures, les assiettes s'étalent, parées, à trois sous et à cinq sous, morceaux de viande, filets de gibier, têtes ou queues de poissons, légumes, charcuterie, jusqu'à du

dessert, des gâteaux à peine entamés et des bonbons presque entiers" (By nine in the morning, the plates are displayed, fully arranged, priced at three or five sous, pieces of meat, game filets, fish heads or tails, vegetables, charcuterie, even dessert, cakes barely tasted and bonbons almost intact).[46] His insertion of the adjective *parées* (adorned, decked out, or arranged)—given emphasis by its framing commas—signals the artisanal element of the harlequin merchant's work (which requires not merely dishing out but dressing, decorating, embellishing), and announces a common motif.

Like Zola and so many others, Suzanne comments on the artistry necessary to a harlequin seller intent on making her composite wares appetizing to the eyes of those customers who choose to eat the remnants of other people's fancy (if used) food instead of buying less extravagant raw ingredients, for much the same price, to be freshly prepared. After the early morning collection by intermediaries (or by harlequin merchants themselves) who contract with various ministries, embassies, fine restaurants, and *hôtels particuliers* to pick up pails of leftovers from their kitchens, after the delivery of these dinner remains to the underground sorting areas of Les Halles, where they are poured and scraped into large vats, the work—but also the craft—of the harlequin sellers begins. The labor of sorting through the vats (*les mannes*) filled with the mixed ruins of miscellaneous dinners is only the start. She or he must also, most crucially, "garnir ses assiettes avec tact et discernement" (garnish her plates with tact and discernment). Suzanne emphasizes the element of craft required to market harlequins: "Ce n'est pas une petite affaire pour le *bijoutier* que de parer et d'apprêter sa marchandise, puis de la répartir sur les nombreuses assiettes qui figurent à son étalage, en l'arrangeant de manière à tenter les regards et la convoitise des amateurs" (It is no small task for the "jeweler" to arrange and ready her [or his] merchandise, and then to divide it among the numerous plates at the stand, laying it out so as to tempt the eye and the desire of clients).[47] Coffignon confirms the efforts of the harlequin merchant not only to select but also to stage the stuff of each plate: "le bijoutier [avait besoin] de parer sa marchandise, de lui donner un air appétissant, après l'avoir répartie entre de nombreuses assiettes" (the "jeweler" needed to arrange her merchandise, to give it an appetizing appearance after distributing it among many plates).[48]

The harlequin seller is an artisan as well as a merchant. Commentators consistently use not only *parer* but also a host of other verbs such as *habiller* (to dress), *rhabiller* (to rehabilitate or dress up), and *maquiller* (to make up, to apply cosmetics) to describe the work of *bricolage* (cobbling or tinkering) that is the essence of the trade. As Ferrières has suggested, to sell used food is to engage not only in commerce but also in transformative work; it is to refurbish, to renew, to beautify, to stimulate appetite, to make new things out of old things: "regratter, c'est aussi rendre plus beau, plus appétissant, faire du neuf avec du vieux" (*regratter* is also to make something more beautiful, more appetizing, to make new things

from old things).[49] Rhetoric writes the harlequin seller as a tailor, a shoemaker, a dresser, a wardrobe mistress, a makeup artist, and at times a brothel madam who trades in recomposed bodies of food that must be overdressed because they are already overcirculated: overaged, overcombined, overmixed, they are promiscuous objects of desire proffered for public consumption.

Other writers furnish details on the practice of "making up" fish (*maquiller le poisson*). The usual method involved an infusion of blood into the gills of fish that are no longer fresh. Lobster, crayfish, and other mollusks that deteriorate quickly in warm weather were not subject to the same kind of "freshening up"; instead, the spoiled parts would be simply detached. Any gaps or irregular shapes occasioned by the amputations would be stuffed with chervil, parsley, or aromatic herbs to mask the ammonia smell given off.[50]

Butter was not the only food artificially colored. Various kinds of fowl and sundry cuts of pork were cosmetically refreshed and retouched. There was a specialized tradesman called *le peintre de pieds de dindons* whose job was to apply a glaze on turkey feet so that they would appear to have "le teint frais et la mine vermeille" (a fresh and ruddy appearance), and would retain this aspect "bien des jours après leur trépas" (for many days after death).[51] Other sorts of fowl were prepared for sale by a variety of enhancing techniques. Pigeons were force-fed by workers blowing grain, mouth-to-mouth, then infused with saltwater and killed in their digestive afterglow to present a white and delicate flesh to the consumer.[52] Ducks and chickens were artificially plumped for market by blocking their cloaca with paper and then forcing air into their trachea.[53]

The marketability of soup as well as of solid-state harlequins was correlated with the relative successes of preparatory operations that ranged from beautification and ornamentation to disguise. Du Camp and others report on the very specialized tradesman called *l'employé aux yeux de bouillon,* the bouillon beadmaker (literally, "the worker who makes eyes in bouillon"). His task was to create the illusion of depth and richness of texture in a very thin broth made from such vestigial materials as we have seen, or, to quote Du Camp, from an even more watery base: "[une] soupe qu'ils puisent à la fontaine et colorent avec un peu d'oignon brûlé" (a soup they drew from the fountain and colored with a little burnt onion).[54] Castelnau elucidates the inimitable work of this specialized laborer who must simulate the unctuous depths of a complex bouillon on the dull surface of singed onion water by spraying oil through his mouth: "Ce précieux auxiliaire . . . prend dans sa bouche une cuillerée . . . d'huile de poisson . . . et souffle avec force en serrant les lèvres. Il se répand alors une espèce de brouillard dans la marmite. Sous l'action de cette rosée bienfaisante les yeux se forment et font de la nappe brunâtre une radieuse constellation" (This precious helper . . . puts a spoonful of fish oil in his mouth and blows forcefully while compressing his lips. This spreads a kind of mist over the pot. This bountiful dew causes beads ["eyes"] to form and turns the brownish surface into a radiant constellation).[55] Not the

least sordid element of this description is its rhetorical turn, which snidely transforms the human saliva spat out onto on a brownish surface of slops into a radiant constellation of dewdrops.

—— *L'AMBIGU*: MAKING FOOD MAKE SENSE

If fraud, profiteering, and economizing were rampant characteristics of the food distribution system in an era whose ethos relied on not letting anything, even if spoiled, go to waste, it was above all the harlequin trade that elicited the targeted condescension, disparagement, disgust, and fascination that we have begun to tease out. The harlequin finds its place within a general climate of detritus, re-circulation, and thrift, but also stands out against it as distinctive. The marketing of other leftovers that ranged from single-composition servings (a dish of cold fried fish or a portion of almost intact saucisson, for example) to upper-end combinations dominated by a chunk of meat or other such solid, identifiable (and sometimes even posh) components rather than mashes or liquids did not receive quite the same attention. Let us speculate about why this particular form of leftovers earned its scandalous reputation.

Almost all commentators emphasize the collective, agglomerative nature of the harlequin as they draw awareness to its revolting nature. Chavette underscores the category of the disparate in "L'Arlequin," the penultimate of ten chapters that descend the rungs from "Les Grandes Cuisines" to "Dernier Échelon," or charity handouts, in his book on restauration. He introduces the harlequin by its peculiarly mixed appearance—"Ces plats étranges, mystérieux amalgames de morceaux si divers qu'on leur a donné le nom d'*arlequins*" (these strange dishes, mysterious mixes of pieces so diverse that they have received the name of *harlequins*)—and goes on to detail its random composition: "Vous rappelez-vous ces *restes* . . . qu'on triait avec soin pour en tirer les meilleurs morceaux? . . . L'arlequin est composé du reste de ces restes! Têtes de poissons, os de côtelettes, bouts de gigots, fragments de pâtisseries, tout cela est pêle-mêle, imprégnee de vingt sauces différentes, déjà vieux de quatre ou cinq jours et attendant la pratique à certain coin des Halles centrales" (Do you remember those *leftovers* . . . that were sorted so carefully to pick out the choicest morsels? . . . The harlequin is composed of the leftovers of those leftovers! Fish heads, chop bones, leg of lamb ends, pastry bits, all that is permeated pell-mell with twenty different sauces, four or five days old, and lies waiting for the customer in some corner of the central Halles).[56]

Suzanne attempts to impose some order onto what he, like other commentators, represents as an inherently anarchic phenomenon. To this end, he distinguishes between varying grades of harlequins destined for correspondingly different classes of eaters (there are "choice" harlequins and "cheap" harlequins), doing the work of classification and categorization. The inexpensive plates start at twenty centimes and are largely a medley of vegetables; meat, in

this lowest of classes, is scarce. The most expensive portions are also at once the most richly assorted—*richement assorties*—and, it goes without saying, the most strictly sorted—so that the nature of the individual elements is more elegant (*recherchée*). Suzanne offers three meticulous examples of the finest concoctions, going for ten to twelve sous: "[1] une cuisse de volaille, une patte de homard, un filet de sole, une croûte de pâté et de la crême aux pistaches; [2] un demi-pied truffé, une tranche de galantine, une côtelette panée, une tête de poisson et un éclair au chocolat; [3] de la choucroute, des écrevisses bordelaises, du lapin sauté, de la tête de veau, un filet de chevreuil et de la charlotte de pommes" ([1] a poultry thigh, a lobster claw, a filet of sole, a crust of pâté and some pistachio pudding; [2] half a truffled trotter, a slice of galantine, a breaded cutlet, a fish head and a chocolate éclair; [3] some choucroute, a few crayfish à la Bordelaise, some rabbit sauté, some calf's head, a venison filet and an apple charlotte).[57] Nonetheless, his prose is almost audibly sniggering in its qualifying terms (the odd bit of pâté is dried up, the truffled trotter is sundered, the fish, decapitated, has lost its body), so that mayhem is reintroduced into his organizing gesture.

Coffignon in turn lists possible components of an arranged plate as "croûtes de pâté, restants de légumes, os de gigots à moitié rongés, carcasses de poulets, poissons" (crusts of pâté, vegetable remnants, half-eaten lamb leg bones, chicken carcasses, fish)—an enumeration whose essential point, though already implicitly clear, is not left to the reader's powers of deduction. He finishes with an explicit flourish: "Il y a de tout" (Everything is there).[58] Coffignon's is the summary judgment of all the enumerations, narrations, and examples put forth by the various commentators. It is as if they were rivaling for the most absurdly combinatory descriptions possible. The unforgivable feature of the harlequin is its foundational and defining one: the relentless recombining and blending of ingredients, the mingling of separate parts that, in coming together, fuse, shed their identity, or threaten to do so.

Negative connotations of the composite can be traced back as far as the Bible, reports Michel Pastoureau: Leviticus prohibits practices of mixing, and modern occidental culture is still tacitly permeated by the outrage of variegation, by a belief that the solid and the monochromatic are godly while the mottled is diabolical.[59] The harlequin is monstrous in its confusion of too many incongruent parts. It is shameful in its flaunting of overmixing, which is one particular kind of promiscuity (and it is no coincidence that, as we noted earlier, the *marchande d'arlequins* is sometimes compared to a brothel keeper striving to seduce her customers with embellishing flourishes).

We cannot forget that French cuisine was codified in the nineteenth century, and that the harlequin broke all its rules. This was an age whose culinary style was revolutionized and then came to be characterized by the great chef Antonin Carême's emphasis on *separating* and *simplifying* rather than *piling up* flavors and ingredients. Jean-François Revel describes the premises of his art:

L'art carémien . . . n'a pas pour but de superposer les saveurs mais bien au contraire de les isoler et de les mettre en relief. La grande cuisine, avec lui, n'est pas comme on le croit trop souvent . . . l'accumulation barbare de produits hétéroclites et non dosés, mais la dominante préservée dans la préparation finale.[60]

[The aim of Carême's art is not to superimpose flavors but on the contrary, to isolate them and contrast them. Fine cuisine, for him, is not, as is too often believed . . . the barbaric accumulation of disproportionate and heteroclitic products, but the preservation of the dominant note in the final preparation.]

At roughly the same time Carême was refining and purifying the gastronomic arts in France, Grimod de la Reynière, ultimate gastronomer and food snob of the postrevolutionary era, deprecated a culinary trend called *l'ambigu.* From the seventeenth century onward, *un ambigu* was a meal that combined entrée and dessert in one service, taking the diner and the semiotics of dining in two contrary directions at once. In 1808 Grimod decried the *ambigu,* declaring it a practice that was acceptable, if barely, only at lunchtime, because lunch was already meaningless: "un repas sans conséquence." Only lunch could tolerate an indiscriminate juxtaposition of foods that everywhere else would be insulting to good taste and proper values, a juxtaposition "[qui] répugne à la délicatesse d'un convive, ami de l'ordre et de la propreté" (that is repugnant to a guest's refined nature, which prefers order, neatness, and appropriateness).[61] The contradiction of courses offered by an *ambigu,* in other words, made the meal improper, unclean, polluting—and perhaps unmeaning—in that it transformed cuisine into what Mary Douglas might qualify as "matter out of place."[62]

Grimod's intolerance of the concept of conjoined courses hints at more, however. The offense of *l'ambigu,* compounded in the case of *l'arlequin,* was that it put matter *out of time* in addition to out of place. I suggest that the scandal of the harlequin has to do with how it decomposes elements and structures in time as well as in space. Pâté, fish heads, meat bones, pastry crumbs, and salad leaves (for example) heaped together on a plate speak not only to the eradication of individual constituents, but also to the erasure of course sequencing. Du Camp is clear about the violation of temporal structure in his depiction of collected pre-triaged harlequin matter as "cet amas sans nom, où les hors-d'oeuvres sont mêlés aux rôtis et les légumes aux entremets" (this nameless heap, where hors d'oeuvres are mixed with roasts, and vegetables, with pre-dessert dishes).[63] The fact is that descriptions of post-triaged, plated harlequins display the same impermissible synchrony as the "unnameable," unsortable mass Du Camp portrays here. In collapsing properly successive dinner courses into one, the harlequin violates the rituals of dining that are so heavily dependent on order and sequencing, performing what Madeleine Ferrières has called "un exercice de gastro-anomie."[64]

There is a logic underlying the received structures of meal preparation and service, as Jean-Louis Flandrin has demonstrated in his aptly titled *L'Ordre des mets* (*Arranging the Meal,* in its English translation); it is a logic that is both culturally determined and determinative.[65] The term *mets,* from the verb *mettre,* has to do with place, and putting things in their proper place—whether in space or in time.[66] If meals, like plots, are arrangements that correspond to cultural structures, then whatever or whoever violates the rules risks falling out of culture into nature, and correlatively, sliding onto the far side of meaning.[67] How much more ambiguous than the dish named *l'ambigu,* how much more likely to muddle and disrupt signifying processes, was the harlequin! In crowding the properly sequential fragments of an entire meal onto the surface of a single plate, it managed to transgress social, cultural, aesthetic, and semiotic categories.

—— SOUP

From the vantage point of the well-heeled and well-fed of the period, harlequins constituted the antithesis of "grande cuisine"; Ferrières calls them "le degré zéro de l'alimentation."[68] How then—for even harlequins are hierarchized—shall we plumb the depths of their lowest incarnation, harlequin soup? Where on the scale of ignominy shall we place the epitome of harlequin indiscrimination, this product of ingredients scraped from the top of the sink and the bottom of the barrel, blended into what is often a rendering into oblivion of the constituent parts? Alimentary matter, like any substance, is graded, and runs from solid and firm to chunky and mushy, to viscous and runny. Lowest in the lowly trio that also contains stews and ragouts, soup constitutes the nadir of the harlequin, and logically merits the classification of *subzero* on the gastro-culinary continuum.

To be clear, it is less the numerical ranking of the harlequin and its derivatives that preoccupies me than its topographical semantics. Narrators of the harlequin represent it consistently from above. The commentator is looking down, way down to the last step of whatever socioeconomic or aesthetic ladder is in use. We have watched the scene of sale being plotted in dark corners, murky alleyways, marginalized urban outskirts; down a sloping street, round the bend of a sinister twisted lane glimpsed from an overlooking window. The base matter, gathered from the kitchens of the upper crust under cover of night and shadow, in pails and vats and troughs, is delivered for triage, disguising, and presentation to the subterranean depths of Les Halles: *les caves.* Du Camp comments on the cellared sequestration of the work of the *marchande d'arlequin*: "On se cache pour accomplir ce travail d'épuration, et le client n'y assiste pas, en vertu de cet axiome, encore plus vrai là qu'ailleurs, qu'il ne faut jamais voir faire la cuisine" (She hides herself to perform the task of refining the food, and the client is not present, by virtue of the axiom that is truer there than elsewhere, that one must never watch the process of cooking).[69]

Chroniclers of the leftovers trade inevitably describe soup sold either by harlequin merchants or by specialized soup sellers as stagnant, the bottommost slough in a degenerative passage from solid to liquid that corresponds to a dive down the social hierarchy. Hamp's triage of the social classes follows a diet that is progressively revised as he descends the ranks, and whose lowest form is liquescence; that is, soup, sauce, or worse: "les cadavres de sauce, les rinçures, le vomi des clients ivres, le brûlé et le pourri" (the cadaverous sauces, the slops, the vomit of drunken diners, the burnt and the rotten).[70] This mush is often skimmed off in its trajectory toward the pigs by the hungry poor whom Hamp calls "les damnés," and whom Aron in turn refers to as "de pauvres diables" (poor devils).[71] Everywhere it is described by a vocabulary of variegation that we have seen coded as ungodly and diabolical: hybrid, putrid, dirty, muddled. Barbaret's description of the soup made by harlequin dealers with the vestiges scavenged from the assembling of harlequin plates is representative: "La graisse grossièrement écumée est versée dans des vases en fer blanc. Avec la graisse et de l'eau, ils font chauffer du bouillon auquel ils ajoutent des restes de purée de pommes de terre, des haricots, d'autres légumes et des croûtes de pain ramassées" (The coarsely skimmed grease is poured into white iron vessels. They heat this grease and water into a bouillon to which they add leftover mashed potatoes, beans and other vegetables, and crusts of bread they have gathered up).[72] Typical as well is his disparaging remark about the tasteless consumers to whom this liquid diet devolves: "Au surplus, les consommateurs de ces mets ne sont pas difficiles. . . . Ce sont généralement des vagabonds, dont le palais est insensibilisé par l'alcool" (Besides, the consumers of these dishes are not difficult. . . . They tend to be vagrants, whose palates are desensitized by alcohol).[73] These undiscerning itinerant eaters whose desensitized palates place them so far from the *fins becs* at whose tables and sinks their soup might have originated seem somehow to deserve the murky pulp they are served (Figure 6).

It is here, in representations of soup and its consumers, that the discourse of the harlequin begins most visibly to converge with representations of the Paris urban poor, colloquially referred to as *les bas-fonds,* literally the shallows, figuratively, the dregs of society, an underworld brilliantly explored by Dominique Kalifa over a century later.[74] Kalifa locates the archetypal scene of indigence, tightly bundled with vice and crime in the nineteenth-century imaginary, in the pre-Haussmannian Paris street, "surpeuplé[e] et surchauffé[e], sale, suintant[e] et labyrinthique . . . noire, obscure, crottée" (overcrowded and overheated, dirty, oozing, and labyrinthine).[75] What is at stake in this infernal topographical imagery is not only the habitat of the lowlifes but the downward slope leading there, a slippage that Kalifa describes as "un monde qui est entraîné vers le bas, dans un mouvement toujours descendant" (a world that is being dragged downward, in an ever-descending movement).[76] This is remarkably congruent with the

LE MONDE ILLUSTRÉ

JOURNAL HEBDOMADAIRE

ABONNEMENTS POUR PARIS ET LES DÉPARTEMENTS
Un an, 24 fr.; — Six mois, 13 fr.; — Trois mois, 7 fr.; — Un numero, 50 c.
Le volume semestriel, 12 fr. broché. — 17 fr., relié et doré sur tranche.
LA COLLECTION DES 24 ANNÉES FORME 48 VOLUMES.
Directeur, M. PAUL DALLOZ.

BUREAUX
13, QUAI VOLTAIRE
5ᵉ Année. Nᵒ 1288 — 3 Déc. 1881

DIRECTION ET ADMINISTRATION, 13, QUAI VOLTAIRE
Toute demande d'abonnement non accompagnée d'un bon sur Paris ou aura
poste, toute demande de numero à laquelle ne s'ra pas joint le montant en
timbres-poste, seront considérées comme non avenues. — On ne répond pas
des manuscrits envoyés.
Secrétaire, M. ÉDOUARD HUBERT.

SCÈNES PARISIENNES. — *LA MARCHANDE DE SOUPE LE MATIN A LA HALLE.* — Tableau de M. Gilbert.

(Gravure de M. Fleuret.)

FIGURE 6 Scenes of street soup consumers and vendors, usually satirical, were popular in visual and written media throughout the nineteenth century. Victor Gabriel Gilbert, *Scènes parisiennes. La Marchande de soupe le matin à la Halle,* 1881. Cover illustration from *Le Monde Illustré,* December 3, 1881. Engraving by M. Fleuret from a painting by Victor Gabriel Gilbert. Author's collection.

imaginary of the harlequin in its various plummeting phases, encapsulated by Aron in these words that describe its slippery slope: "[des] produits du système hiérarchisé dont nous dévalons la pente de plus en plus hallucinée . . . du vestige au déchet du déchet à la dénaturation, les transitions sont insensibles" (products of the hierarchic system whose increasingly deluded slope takes us downward . . . from vestiges to waste products and from waste products to denaturation, the transitions are imperceptible).[77] Kalifa might as well be offering us a sampling of harlequin soup when he summarizes period representations of the lowest human social order as infernal swamplands:

> Tout en bas, on retrouve l'eau, l'eau stagnante puante, putride, le cloaque qui renvoie . . . aux représentations classiques des Enfers, bordés par le Styx, le fleuve des morts. Tout le lexique ici est liquide. On parle de fosses, d'égouts, d'abîmes, d'abysses. . . . La pauvreté est une mare stagnante, une mer de misère humaine, les pauvres sont de la boue.[78]

> [At the very bottom there is water, stagnant, stinking, putrid water, a cesspool that goes back to . . . classic representations of Hell, bordered by the Styx, the river of the dead. The entire lexicon here is liquid. It speaks of pits, sewers, chasms, abysses. . . . Poverty is a stagnant swamp, a sea of human misery; the poor are enmired.]

—— THE HUMAN STEW

The language of nature and its cognates, the natural, the denatured, denaturation (and of course the aesthetic movement, naturalism, made in this name) is unstable, particularly as it is applied to "the people" and their correlative objects of consumption. Assumed to be close to nature because perceived as inherently primitive, impure, and low, harlequins and their consumers slide quickly into the (only apparently opposite) category of the denatured or unnatural; and a vocabulary that calls upon certain deselected aspects of nature is invoked, as in Aron's harlequin description and Kalifa's summary of the bas-fonds: we see mud, sewers, swamps, debris, filth, stagnant mire, miasmas. David Gissen has added yet another cognate to the degenerative expanse of natural vocabulary, coining the term "subnature" to address what he calls an "other, stranger form of nature"—raw, marginalized, undesirable elements—that has been underdiscussed in architecture.[79] While I am not sure that his categories (including dankness, smoke, gas, dust, puddles, mud, debris, pigeons, and crowds) have been as neglected in discussions of the nineteenth-century lower socioeconomic echelons as they may have been in architecture, his insights into what has been excluded from the built environment are helpful for thinking about the similar constituents of urban nature that have been maligned if not barred from the textual environment and then exoticized as a kind of antinature. And Gissen's perceptions about the uses of subnature as "a form of agitation or intellectual

provocation"—a way to think about power inequities reproduced by recourse to a conventional, comfortable idea of nature—are especially helpful for thinking about the volatile mutations of "nature" and the "natural" into the "denatured" and the "unnatural" when what is at stake are the humans assigned as closest to nature (as the Goncourt duo and other naturalists wrote them), and melded with their equally denatured diets.[80]

When we read harlequin narratives, we, like their authors, are onlookers, outsiders situated elsewhere, as if on highlands marked off safely above the Stygian depths, peering down into the morass. The object of the gaze directed down upon the crowded plates of kitchen scrapings or on the slops in the cauldron below is only secondarily the "denatured" food; it is first and foremost, if not always explicitly, the disparate horde of human castoffs mirroring the alimentary debris. Here is Castelnau's description of customers thronging for the "unimaginable" harlequin ragout that he has just luridly detailed, and which, more concisely, consists of buckets of food pulp and discarded sauces dumped into a pot and heated up together:

> Le tout est déversé dans un vaste récipient et réchauffé; les sauces se mélangent pour donner un invraisemblable ragoût. Le festin ainsi préparé, le défilé des hôtes commence. Il y a là tout ce que la comédie humaine compte de plus pitoyable: visages hâves, émaciés, teints cireux, dos voûtés, membres fragiles recouverts de loques, prunelles allumées par la révolte ou éteinte par la résignation.[81]

> [It is all poured into a huge receptacle and heated up; the sauces combine to make for an unimaginable stew. Once the banquet is prepared, the parade of guests begins. It includes all the most pitiful elements of the human comedy: haggard, emaciated faces, waxen complexions, stooped backs, fragile limbs covered with rags, eyes lit by revolt or extinguished by resignation.]

The garbage stew and the human stew are parallel constructs, analogous scenes of mixing, each deserving and determinative of the other.

Broadening the focus beyond Castelnau's slow gaze at soup stands and stew-pots, Suzanne observes leftovers counters and their customers, and comes to similar conclusions about their confluence. He comments on the motley horde queuing up for the harlequins: "C'est un spectacle curieux et intéressant que celui de tous ces misérables se pressant autour des étals, inspectant minutieusement les trois ou quatre rangées d'assiettes alignées, et faisant leur choix parmi cet assortiment innommable de débris de victuailles" (What a curious and interesting sight is presented by all these paupers crowded around the stalls, minutely inspecting the three or four rows of plates lined up there, and making their choices from this unnamable assortment of food waste). He presents parallel harlequin alignments in duplicate, as mirror images of each other: the plates

of assorted debris that are the object of the customers' gaze, and the customers themselves, who are society's sundry castoffs. Together they present a conjoined comical spectacle offered up to the gaze of author and reader (Figure 7).[82]

—— THE HARLEQUIN EATERS

Although nineteenth-century commentators and their echoing successors tend to assume a direct analogy between the stock figure of the Commedia dell'Arte identified by his garishly stitched-together aspect, and the similarly composed plate of leftovers that came to borrow his name, both the naming and the analogy beg to be further considered in terms of their connotations as much as their denotations. Let us first pull out the conspicuous common thread that runs through the commentaries. Du Camp expounds on the theatrical Harlequin and his avatars: "Cela s'appelle aujourd'hui des *arlequins*. De même que l'habit du Bergamasque est fait de pièces et de morceaux, leur marchandise est composée de toutes sortes de denrées. Ces gens-là recueillent les dessertes des tables riches" (Today these are called *harlequins*. Just as the Bergamasque's costume is made of bits and pieces, this merchandise is composed of all kinds of foodstuffs. These people collect the food cleared from wealthy tables).[83] More succinctly, Chavette explains that the fragments are "[de] mystérieux amalgames de morceaux si divers qu'on leur a donné le nom d'*arlequins*" (mysterious mixes of fragments so diverse that they have been named *harlequins*).[84] Castelnau disparagingly depicts the harlequin seller as "ce sous-gargotier [qui] réunit en un seul plat les mets les plus divers; sa cuisine ressemble au manteau du légendaire bouffon, d'où le nom du personnage" (this lowliest of cooks who combines in a single dish the most diverse courses; his cooking looks like the legendary clown's coat, which explains the character's name).[85] Philippe Mellot offers a similar explanation, proposing that "[les] restes de viandes, de poissons ou même de pâtisseries provenant de la desserte des tables des grandes maisons, ces *arlequins* tenaient sans doute leur nom d'Arlequin, ce personnage comique dont l'habit bigarré était fait de pièces de rapport vertes, jaunes, rouges et bleues" (since the remnants of meat, fish, or even pastries came from the cleared tables of fine homes, those *harlequins* took the name of Harlequin, the comic character whose multicolored clothing was made of green, yellow, red, and blue patchwork).[86]

While the oft-repeated alimentary-vestimentary analogy is pertinent, it is most often, as I hinted earlier, a little too simplistically sustained in the commentaries. If the scrappy culinary wares resemble the pieced-together costume of the legendary character, so too do the clothes of the individual consumers, so too does the physical appearance of each one; and the collective physiognomy of the attendant queue follows suit. Here is one harlequin client described by Imbert:

Son linge [est] effrangé, froissé, fripé . . . les boutons [sont] enlevés à des endroits où ils sont essentiels [. . . laissant] des hiatus injustifiables. Au-dessus d'un col de

«LES ARLEQUINS». GRAVURE DE CASTELLI
(PREMIÈRE ÉDITION ILLUSTRÉE).

FIGURE 7 An engraving captures the assimilation of harlequin plates to consumers. Horace Castelli, *Les Arlequins,* circa 1879. Engraving. From Émile Zola, first illustrated edition of *Le Ventre de Paris* with engravings by André Gill, Georges Bellenger, Horace Castelli, etc. (Paris: C. Marpon and E. Flammarion, 1879). Image reproduction made from a copy of the original engraving in Émile Zola, *Oeuvres complètes,* ed. Henri Mitterand (Paris: Cercle du livre précieux/Fasquelle, 1966–), *Le Ventre de Paris* (vol. 2). Author's collection.

chemise qui, d'un côté, disparaît sous la cravate et de l'autre retombe mollement en pointe comme un chiffon mouillé, s'épanouit un visage rond, imberbe, fleuri, auquel les yeux, qui regardent en sens contraire,—celui de droite en bas, celui de gauche en haut,—prêtent une expression des plus étranges. Mal peignée, sa maigre chevelure s'échappe au hasard d'un feutre mou. Quelques mèches très-longues destinées à dissimuler une calvitie précoce, flottent d'une façon plaisante dans le dos. La jaquette est poudrée de pellicules aux épaules et de duvet ailleurs. Le pantalon n'est pas plus propre: plantés dans l'étoffe, des poils de chien indiquent un intime compagnon d'existence.[87]

[His clothing is frayed, crumpled, wrinkled . . . the buttons are missing in the places where they are most essential, leaving unjustifiable gaps. Above a shirt collar which on one side disappears under a cravat and on the other furls loosely like a wet rag, a round, florid, beardless face emerges, which takes on the strangest expression because the eyes look in opposite directions—the right one, below, and the left, above. Uncombed, his thin hair escapes haphazardly from a shapeless felt hat. A few long strands meant to hide his premature baldness float comically down his back. His jacket is powdered with dandruff around the shoulders and with down in other places. His trousers are no cleaner: the dog hairs implanted in the fabric indicate that he has an intimate life partner.]

Imbert sketches the portrait of another client, whom he calls "le père Muflard," playing on the resonances of the name with its root in *le mufle,* a word that means "muzzle" or "snout," but is figuratively used to evoke a boor or an oaf. Old Muflard's loutishness is evident in his rude behavior: he makes the rounds of the harlequin stalls, sampling everything but buying nothing. Imbert shows him dressed for the part, that of an old, ragtag skinflint: "un vieux grigou qui marche dans des souliers éculés, avachis, informes, et dont le vêtement tout rapiécé rappelle celui de Trichka, personnage du célèbre fabuliste russe Jean Krylof. Trichka rognait les parements de ses manches pour boucher les trous de ses coudes, puis ses basques pour rallonger ses manches" (an old miser who walks in worn-down, misshapen shoes, and whose patched clothing recalls that of Trichka, the character created by the famous Russian fabulist Ivan Krylov. Trichka trimmed his sleeve cuffs to patch the holes on his elbows, and then his coat tail to lengthen his sleeves).[88] In the fable Imbert is referring to, "Trishka's Coat," Krylov presents a country bumpkin's actions as a cautionary lesson about acting rashly in the moment and not thinking through long-term consequences: Trishka represents a kind of false thrift.

Imbert in turn borrows "Trishka's Coat" as a means to mock the harlequin consumer. In good physiognomist fashion, the author closes his tale on a chortling note by marveling at the gullibility of the *marchandes d'arlequins,* who, unlike him, do not seem to be good semioticians: "Comment toutes les marchandes

ne comprennent-elles au costume, à la mine et à la manière de déjeuner de cet homme, qu'il se connaît en arlequins!" (How can all these vendors not understand by the dress, the appearance, and the eating habits of this man, that he knows his harlequins all too well!).[89] Muflard's cunning, however, seems to have outwitted the vendors (and perhaps Imbert as well) in the continuation of the anecdote, where this harlequin eater gets what he wants without spending a sou. In both of Imbert's examples, harlequin habits of eating are mediated by harlequin modes of dress, which in turn convey a generalized character disorder: a foolishness or petty madness.[90]

We begin to see a pattern of determinism characterizing the linked representations of harlequin foods and their consumers. If Brillat-Savarin's axiom was "you are what you eat," the anecdotes at hand seem rather to indicate that you eat what you are.[91] Following a fearful symmetry, the wretched of the earth are fed the wretched remains of the table. As if they were accomplishing a destiny, *les miteux,* the shabbily clad, "the moth-eaten," tautologically eat pre-nibbled shreds. The rhetoric and tone of such commentaries make clear that the rags and tatters that cover the harlequin eaters, like the variegated scraps they put in their mouths, are never merely fabric and foodstuff, but are always also implicit bearers of greater meaning. Jeremy MacClancy and Helen Macbeth's claims for the double nature of food, "both 'nature' and 'culture' . . . substance and symbol" could easily be extended, mutatis mutandis, to clothing.[92] Similarly, the link between rags and table scraps is not merely circumstantial, not only economically driven, but also, fundamentally, motivated by contempt.[93] In the guise of compassion and commiseration we find sanctimony and a presumption of due justice: you eat what you deserve, and you deserve what you eat. In a deterministic universe, people who wear mismatched, handed-down clothes swallow oddly combined, mouthed-down foods. This, I suggest, is because there is something disconcerting, something potentially disruptive, about those who present a composite exterior, just as there is about those who take in a mottled meal. If to bourgeois eyes, as Ferrières has observed, "l'arlequin étale un désordre esthétique" (the harlequin spreads aesthetic disorder), the disarray migrates outward from the food: the consumer cannot be told from the consumed.[94] The harlequin plate may evoke Harlequin garb, but the connection is mediated by the uncultivated tattered pauper who resembles and reassembles both, in his or her essentially unbalanced and unbalancing personage.

Patched trousers, asymmetrical collars, clashing colors, specks of dandruff, dog hairs, lint, physical impairments, and motley crowds: all are comical, in the commentary of our narrators; they are also unsettling in that what is torn, gnawed, ripped, spotted, patched, sprinkled, and stained threatens to destabilize and transgress order and harmony. Throughout the Middle Ages and beyond, we recall from Pastoureau, the variegated was suspect: the prostitute, the buffoon, the criminal, the disorderly, and the mad were consigned to clothes that

were striped, streaked, patchworked, gaudily colored, spotted, or otherwise var-
iegated to signal "la même idée de trouble, de désordre, de bruit et d'impureté"
(the same idea of trouble, disorder, noise, and impurity). Such fabrics might be
visually different, but they are semiotically akin: "rayé, tacheté, varié, bariolé dif-
fèrent peut-être visuellement . . . mais pas conceptuellement ni socialement. Ils
traduisent seulement les divers degrés d'un même état: celui de la transgression"
(the striped, the mottled, the variegated, the multicolored are perhaps different
visually . . . but not conceptually or socially. They all translate the diverse degrees
of the same state: that of transgression).[95]

In these narratives of Parisian street life, then, the harlequin eaters become
Harlequins as well, metonymically assimilated to the food they consume, and
metaphorically identified with the lineage of Harlequin, the jester, the *jongleur,*
the buffoon, the clown, the servant fool. Each individual case arguably presents
itself, too, as a microcosm of the crowd, sundry, derisible, socially marginalized,
yet foundational in the structure of social hierarchy, unstable and potentially
destabilizing, and therefore menacing. The harlequin eaters provoke a range of
reactions including benevolence, pity, sanctimony, ridicule, self-righteousness,
defensiveness, schadenfreude, and fear. Rarely are they appraised with em-
pathy or generosity. In both the anecdotes and the rhetoric adopted by most of
their chroniclers, as we have noted, these consumers are depicted as hungry,
desperate, gullible, stupid, and enmired in bodily need. They are repeatedly rep-
resented as bottom feeders and are cynically described by one author as "ceux
dont la profession est de mourir de faim" (those whose profession is to starve to
death).[96] Aspiration, inspiration, longing, and admiration are far less common
among the characteristics attributed to the patrons of harlequin stands and har-
lequin restaurants. But they do exist, and it is time to attend to them.

—— SAVOR THE HARLEQUINS

Coffignon closes his review of a predictably revolting spread of harlequin
plates with the comment that, nevertheless, "il ne manque pas d'yeux avides
pour passer en revue l'étalage" (there is no lack of covetous glances taking in
the display).[97] The observation of desire in the eyes of customers is admittedly
ambiguous; one might assume the draw of the harlequin to be either one of econ-
omy instead of enjoyment, or of brute hunger rather than allure. But there are a
number of other accounts that more expansively explain why consumers might
be tempted to dine on harlequins even if not reduced to doing so by their means.

Du Camp makes clear that there are harlequin consumers who are not simply
social victims; some have other alternatives, and patronize the harlequin sellers
by election:

> Beaucoup de malheureux, d'ouvriers employés aux Halles préfèrent ce singu-
> lier genre d'alimentation à la nourriture plus substantielle, mais trop chère, qu'ils

trouvent dans les cabarets et les gargotes. Pour deux ou trois sous, ils ont de quoi manger. Chose étrange, les marchands ont une clientèle attitrée, et ils l'attribuent uniquement aux cuisines savantes d'où ils tirent ces débris de nourriture. Bien des gens riches, mais avares, sans oser l'avouer jamais, viennent faire là secrètement leurs provisions.[98]

[Many poor people, workers employed at Les Halles, prefer this unusual style of eating to meals that are more substantial, but too expensive, which are found in cabarets and cheap restaurants. For two or three sous, they have enough to eat. What is strange is that these vendors have a regular clientele, which they attribute solely to the distinguished kitchens where they source these food scraps. Many who are rich, but miserly, come secretly to buy their food here, though they don't ever admit it.]

His point here is that the appeal of this peculiar mode of eating ("ce singulier genre d'alimentation") is not only the low price of the food, but, too, the high profile of the originating kitchens. As tangent to his explanation of the steady clientele of the harlequin seller, Du Camp also suggests a curious postscript to the abiding message we have been reading across our texts to the effect that harlequin eaters are in violation of the codes of the French table. While these shunned eaters may indeed transgress the laws of gastronomic punctuation by partaking of a range of passed-down dishes at once and on one plate, the very fact that they are sampling even the skeletal remains of recipes prepared in Parisian "cuisines savantes" means that the new culinary protocols are being filtered across a wide spectrum. In retrospect, the democratization of the French palate had diverging consequences: it may well have provided a fearsome specter for those seated at high tables whose diet was no longer exclusive, but it may also have accelerated the codification of what was becoming "French cuisine."

The stakes were high for those who could manage to at least taste the drippings of tables to which they could not accede.[99] Coffignon ramifies the motivation of the harlequin clientele. Portraying a woman who patronizes the harlequin stalls, he specifies that her work provides her with an income that is amply sufficient to dine as she likes; she is not financially bound to have recourse to leftovers. He concludes: "Ce n'est donc pas par besoin qu'elle va rendre visite aux bijoutiers des Halles; c'est par goût" (So it is not by need that she visits the leftovers sellers at Les Halles: it is by taste).[100] And Imbert offers a more general analysis of why some people choose to eat harlequins: "La clientèle de la marchande d'arlequins est considérable, car nombre de pauvres sont heureux de se repaître à très bas prix *des mêmes morceaux que les riches*" (The harlequin seller's clientele is considerable, because a good number of paupers are happy to feed on *the same morsels as the rich* at a very low price).[101] Such evocations of taste, curiosity, and envy direct us toward appetites of the mind and the spirit.

There is another side to the overtold story of institutionalized putrefaction and adulteration that calls out to be heard. It is true that hunger, penury, and their exploitation played a fair part in the buying and reselling of prepared food. Who would not, after all, have preferred to be part of the first seating, welcomed among the fortunate diners who had the right of first refusal of the sumptuous excesses of the high tables? But it is also precisely hunger—though understood now in a metaphysical sense—that begins to explain that there were reasons for eating the remains of other people's meals that accompanied and sometimes even transcended economic deprivation and brute need.

The allure of socioeconomically exotic cuisine in the nineteenth-century imagination responded not only to bodily famishment but also to a hunger for the storied possibilities classier nourishment opened: its mystique depended upon what Rebecca Spang, in her discussion of restaurants, has called "the suspicion that somebody else was having a better dinner, a more titillating dalliance, a more exotic bottle of wine."[102] Taking *suspicion* here not in its most common understanding, as an emotion or a cognition having to do with a "conjecture of evil," but in a secondary sense related to the "imagination of something (not necessarily evil) as possible or likely," I use the term with the implications of its etymological derivation from the Latin *suspicere*: "looking up from below" or "looking upward," that is, looking on, with connotations of admiration and esteem and awe. Just this kind of suspicion abetted not only the establishment of restaurants in the nineteenth century, as Spang argues, but also the derivative institution of selling food down the socioeconomic chain in increasingly deteriorating form.

We might then modify our attention to the prevailing degradational discourse we have been following to consider as well a different reading of harlequin ways of eating: one that is open to imagination and dreaming. This other way of reading, which my citations above begin to introduce, teases out elements of the aspirational discourse I referred to earlier; it borrows what we might call an upwardly suspicious voice, along with an upwardly mobile eye. This aspirational mode is operative in both Sue's *Mystères de Paris,* in the early harlequin scene that opens my next chapter, and again in Zola's *Ventre de Paris,* toward the end of that novel. I will not here rehearse the details of these scenes, to which I give abundant attention in the respective chapters in which they appear; a few summary remarks, however, will at least begin to register the possible enticements of the harlequin in order to offset its more infamous forces of repulsion. The appeal of such used goods for consumers caters to a brand of suspicion that has ties both to desire and to naïveté: a suspicion that is, in fact, a kind of pauper's *bovarysme,* to use the word coined by Jules de Gaultier; it opens the space of dreaming to those who live in ungenerous streets beneath low and heavy skies.[103]

As Gaultier must have realized when shifting emphasis from psychology to philosophy in his second essay on *le bovarysme,* written ten years after the first,

the condition to which Emma unwittingly lent her name is less personal and pathological than perceptual; it is arguably metaphysical, and even hermeneutic.[104] So, too, is the upward eating that we hear of in passing in anecdotal accounts, or in more extended form in novels. Even as harlequin narrators who are intent on denouncing rehashed dinners and outcast diners write of both with downcast eyes, they pitch the gaze of the captivated consumer—our suspicious eater—above and beyond. Not always, but often enough to make us take notice. This upward glance becomes the subdued emblem of a broader ascending perspective. Reactions of the various characters and types to their respectively proffered harlequins—Coffignon's "yeux avides," Imbert's "pauvres . . . heureux," Sue's Chourineur's cry of glee—all signal this attitude. So, too, does Zola's "petite vieille" (little old woman), Mlle Saget, as she opens her gable window, leans out, looks up at the sky and then onward, across the distance, toward Les Halles, the site of her harlequin sprees.[105]

Mlle Saget, habitually wary and calculating, is usually quick to disbelieve the words of others as she leaps to unmask the evil she senses hiding everywhere. Yet this skeptical woman moves into an entirely different interpretive realm when she approaches her preferred *marchande d'arlequins,* who claims to sell leftovers sourced exclusively at the Tuileries. So taken is Mlle Saget with the myth of the emperor's old food that she shops for her dinners at this vendor's stall confidently, exchanging doubt for gullibility as she prepares to receive in her mouth what is tantamount to the imperial body and blood. In so doing, she moves from her usual mode of apprehending the world—one that is anchored in skepticism and mistrust and approaches the most common meaning of suspicion—to a mode that is based on the rarer meaning of this word, that approximates credulity and awe.[106] The suspicious eater, emblematized by Mlle Saget, is also the personification of a certain hermeneutics—open, accepting, mobile, capricious—that is usually kept tethered, if not repressed, in narratives of the harlequin. But occasionally it breaks out.

As if from the vapors of harlequin pots and the stains of harlequin plates a voice sounds, sometimes a silhouette forms, like that of a perverse genie rising to personify the scum, but also, evanescently, to transvalue it, challenging and densifying the dominant denigrations.[107] It is not always clear who is speaking in such instances, as voices fade and narrative positions blur, and it is not always easy to take the full measure of a voice that is thickened by an undertone, a description that is fissured by an incongruity, or an assertion that turns upon itself like a Möbius strip. The speaker might sound like Sue's ex-con Chourineur, whose words cross the narrator's and flick our uneasy ears; it could look like a stingy old woman like Zola's Mlle Saget, whose gaze appears momentarily to take off from her narrator's prose and to soar briefly on its own. Or perhaps it appears as Imbert's urban oaf who wins a match he did not even know he was fighting with his author, who appears equally disengaged. Alternatively, it resounds in Coffignon's fleeting

attribution, breaking through his own generally harsher voice, of taste and volition to those souls in the harlequin horde that he has deprecated at length. This voice, this figure or apparition might evoke, might join with, might become the disorderly and disordering Harlequin, and might introduce a fracturing play of light and color within otherwise somber, subterranean scenarios of fixed meanings, ideologies, and didactic readings. It echoes faintly in what would have been the unsettling insinuation, in an 1833 treatise on gastronomy, that the indigent could be thought together with the forces of seduction and the temptations of luxury: "L'Arlequin n'est pas d'un aspect séduisant, mais il est encore apprécié par certains palais; quelquefois même une bribe de turbot, de dinde truffée, venant à s'y rencontrer, initie l'indigent aux sensualités de l'opulence" (The harlequin may not have a seductive appearance, but it is nonetheless enjoyed by some palates; sometimes even, a bit of turbot and a speck of truffled turkey, happening to coincide, might initiate a pauper into the sensuality of opulence).[108]

By the early twentieth century, the harlequin (whose avatar had of course been hugely popular in seventeenth- and eighteenth-century France as a lowly trickster and clown) was no longer a mere emblem of mockery and disgust, but also a figure of agitation and revolt. This figure was increasingly appropriated by writers as rebel and hero, and had a similar trajectory in painting. It served authors and artists who identified with it and harnessed it iconoclastically as a force of provocation and contestation. However, as we have seen, even the lowest of harlequins had already begun to provoke ambivalent responses in some of the most virulent of nineteenth-century diatribes against popular ways of eating.

Here it becomes evident that I am deliberately fusing and confusing different H/harlequin representations: there is the trickster clown harking back to the Commedia; the plate of mixed leftovers and the industry that grew up around it; the harlequin eater who tended to be conflated with both his food and its roots in the tattered Commedia character. And in the wings waiting to come on stage, Jules Chéret's explosive Arlequin queues up with Picasso's sad clown and Vladimir Nabokov's kaleidoscopic trope. We advance in a spiraling path that at times feels closer to a referential vortex, swirling together and eddying apart representations of beggars and fools, workers, stage buffoons, costumes, colors, dinner vestiges, and volatile abstractions. This is H/harlequin unbound: the shape-shifting harlequin trope that in the nineteenth century takes a predominantly alimentary form without ever relinquishing the traits of its theatrical predecessor, all the while slowly metamorphosing into modernist conformations. It is time to zero in on this figure.

—— INTERLUDE: *ARLEQUINADE*

As I have begun to suggest, the assumption that the alimentary harlequin takes its name from the theatrical Harlequin on the basis of a shared piecemeal appearance, while not false, is reductive. It turns out that the affinities between the two

are dizzyingly overdetermined. The history of the Italian-born Arlecchino as he evolves into Arlequin in France and then continues to shift under that name reveals the complex dynamic nature of the character both in and of himself and on a changing theatrical scene, as well as the longevity of French spectators' attachments to his moving selves. A sweep through the reincarnations of Harlequin on the many stages upon which he played in France illuminates the food stories told in the same name. The enormous vitality and rebounding energy of the Harlequin figure stand in dramatic contrast to the fits and starts and then the dull, slow agony of the Commedia dell'Arte in which he rose to fame.[109] Harlequin seems to transcend the death knoll of each theatrical subtradition in which he moved to emerge triumphant, alternately outlandish and beloved, from each successive ebbing wave that carried him from the Commedia in Italy to the Italian Comedy in France, and onward to the Théâtre de la Foire, L'Opéra-comique, the Théâtre du Boulevard, the Opéra-Bouffe, a variety of vaudeville venues, and short *arlequinade* interludes that were performed between theater acts. Harlequin endured in the nostalgic nineteenth-century French revival of the Commedia, championed by George Sand, who had her *arlequinades* performed by family and friends either acting live or performing with the marionettes she created with her son, Maurice (between 1854 and 1872).[110] And Harlequin survives in the twenty-first century appropriation of his name for such diverse appellations as sports teams, restaurants, movie theaters, candy brands, and wine labels.

REPUTATION

Commentators consistently acclaim this character as the long-beating heart and enduring soul of the Italian comedy and its posterity.[111] Lucette Desvignes states the case made by many: "Aucun autre personage des divers repertoires de l'Ancien Régime n'aura pareil impact, ni pareille longévité. . . . Arlequin, lui, a presque dès le début dépassé le statut de personage pour acquérir la pérennité du mythe" (No other character among the various repertoires of the ancien régime would have a similar impact, or a similar longevity).[112] Numerous critics address the paradoxical disequilibruium between Harlequin's official status of second zanni and subordinate valet, on the one hand, and on the other, the proliferation of his name in play titles, echoed by the public's infatuation with his character. Silvia Leoni attributes the power of Harlequin's name to his overwhelming popular reception: "La sur-représentation d'Arlequin dans les titres des comedies pourrait donc être le signe d'un pouvoir d'attraction de ce personnage qui, bien que second zanni, second valet, semble avoir occupé une place plus importante dans l'esprit de ses contemporains que dans les pieces où il apparaissait" (The overrepresentation of Harlequin in comedy titles might then signal the powers of attraction of this character who, although only the second zanni, the second valet, seems to have occupied a more important place in the mind of his contemporaries than in the plays in which he appeared).[113]

ORIGINS

Harlequin hails from the countryside of Bergamo, in northern Italy, and speaks the Bergamasque dialect. His poor peasant background and an oafishness visible in his clothing, his accent, bearing, lack of education, and his naïveté make of him an outsider in Venice, where he goes to find work—which, traditionally, consists of domestic servitude, the backbreaking job of a porter, or other forms of manual labor. His marginal, immigrant status often makes him a derisory figure, but also can be exploited—and often was—to constitute him as a mouthpiece of outsider social critique.

The derivation of the Harlequin name and character is subject to speculation and disagreement. Many critics, turning in part to etymology, track him back to the term for the demon "Hellequin," and the phenomenon of *la maisnée Hellequin,* a troupe of medieval diabolical forebears who roamed the countryside and were represented theatrically in passion plays.[114] There are also arguments, again etymologically reinforced, for finding Harlequin's roots in Dante's *Inferno,* where Alichino is one of a host of devils who escort Dante and Virgil.[115] Some scholars, including Luigi Riccoboni, trace his ancestry back to ancient performances of jesters in Roman mime and Atellan farce (both of which go back to Greek models) beginning in the third and second centuries BCE and continuing as late as the seventh century CE.[116] Charles Mazouer places Harlequin in the larger tradition of "le personnage du naïf" in his book of that name, mapping his antecedents back to the Middle Ages.[117]

Where and when one finds a character's origins or demise is partly dependent on how narrowly or broadly that character's identity is conceived. At least a few commentators find the latter-day avatars of Harlequin in the late eighteenth-century French theater of Marivaux to be so changed, so modified to correspond to an evolving French theatrical aesthetic antithetical to that of the original Arlecchino type who entered France, that the character can no longer be considered the same. David Trott connects the abandonment of the mask and costume (both conventions of the Italian theater relinquished with the move toward greater realism) with a radical departure from the old Commedia code.[118] He argues that the Harlequin of eighteenth-century France has traveled a path taking him from a stylized type to a character who has become humanized: "[un] cheminement vers une humanisation du type et une déstylisation d'Arlequin."[119] Given that Arlequin is gradually suppressed in French theater, either literally, as when he fused with the figure of Pasquin, who was played unmasked in the 1791 reprise of Pierre de Marivaux's *Les Jeux de l'amour et du hasard,* or figuratively, by a slow "destylization" or breaking with codes, a question might be raised as to the limits of identity or identifiability.

Is there a point at which Harlequin (like any other character) has evolved so far beyond the familiar contours of his character, surviving himself, one might say, that it no longer makes sense to think of him as continuous? Or even as

Harlequin? The question is real, but for my purposes, remains rhetorical; what is critical to my thinking about Harlequin, especially in relation to the alimentary harlequin, is precisely that he morphs when he is appropriated by different users for varying ends, while retaining sufficient traits to be recognizable— even as his ongoing evolution at any moment risks fracturing the last image we thought we held. This mutability is Harlequin's consistency; it fashions him as "a continuously moving kaleidoscope," in Michele Bottini's happy phrasing, or in Riccoboni's much earlier evaluation, "un caméléon qui prend toutes les couleurs" (a chameleon that takes on all colors).[120]

THE PHYSIOGNOMICAL HARLEQUIN

The most prominent of Harlequin's facial characteristics is, in fact, the shrouding of these, effected by a mask (Figure 8): a black leather mask that covers half to three-quarters of his visage, deferring facial expressivity to necessarily extravagant gesture, exaggerated verbal mimicry, and overblown body articulations. This body/head opposition is reflected but reversed in Carlo Goldoni's removal of masks in his eighteenth-century reform of Commedia theater, in order to privilege facial expressivity.[121]

The black mask, historians suggest, is a reference to affinities with the devil, and by extension and in line with traditional stereotypes, also contains a reference to human skin darkness, seen in racial and social class terms: black pigmentation attaching to the African slave/savage, and peasant swarthiness acquired from long hours working in the fields under the sun.[122] A progenitor of American blackface, the black Harlequin mask is similarly a by-product of imperialism, of the encounter with and exploitation of African Others. Michael Rogin details this aspect of the imperialist experience as "the material and psychological investment in the peoples being incorporated into the capitalist world system of the sixteenth and seventeenth centuries."[123] In France, I will argue, the investment in the dark Other (with accompanying components of curiosity, anxiety, and fear) played out in scenarios that juxtaposed and confused the African and the peasant: the racial Other and the socioeconomic Other who were experienced, ironically, as invading the European material and psychological landscape. We shall feel tremors of this unease barely surfacing in, but unsettling, Sue's and Zola's novels.

Harlequin typically has a very large (sometimes red) wart on his (masked) forehead, which commentators suggest is an atrophied horn reminiscent of his diabolical ancestry; we might read, too, here an allusion to his virility. He often has a bristly beard, or coarse, sparse hairs that give the appearance of—and perhaps are made of—horsehair and are affixed to the mask, signaling animality.[124] Maurice Sand reports that the mask is based on one that Michelangelo modeled on an antique satyr's mask.[125] There are small piercings, sometimes round, sometimes teardrop-shaped, in the mask in the place of eyes, which give him,

alternately, an air of savagery and a sense of perpetual wonderment often seen as childishness; his cheeks are sometimes stylized as hollow cavities, inverted pouches that Bottini compares to "a frame of hungry sacks as if eternally empty and ready in any moment to eat, like a rodent, all the food in the world!"[126]

So we see in Harlequin an incarnation of appetite: sexual, visceral—often bestial—coupled with an insinuation of color (blackness, the swarthiness of the sun—reflected and refracted by his multihued clothing). Hungry, lascivious, bestial, and darkened, he is the perfect (and tired) receptacle for the projection of Otherness in nineteenth-century Western Europe. Here is the dark African and/or the peasant laborer, either and both represented as puerile, uncivilized, oversexualized, growling ravenously at the door.

THE PHYSICAL HARLEQUIN

Harlequin is often referred to as a small man. While his actual stage size would necessarily vary depending on the physique of the player in the role, what is abiding is that he is imagined and represented as fragile, childlike, vulnerable, and inferior, so that the moral and social correlatives of a diminutive stature were implied even when the actor was tall.[127] Harlequin is routinely agile and supple, moves with the nervous grace of an animal—a cat or a goat—or alternatively, the rapid, fiercely instinctual mobility of a child. Some actors accord to him the dexterous movements of an acrobat, and the moral attributes to match: quickfire changes of mood, sartorial and behavioral disguise, emotional volatility, capriciousness, faithlessness.

HARLEQUIN'S PROPS

In addition to his mask, the traditional Harlequin is never without his *batte,* his slapstick (a reminder to us of the derivation of slapstick comedy), which was made from supple leather or thin wood, with a center slat that hit against the two outer flaps and made a sharp noise when slapped against another actor or the air. Some historians argue that the slapstick is an avatar of the stick the provincial Harlequin would have used in his old rustic life to herd cows.[128]

HARLEQUIN CLOTHES

The iconic Harlequin figure leaps to mind in his multicolored diamond or triangle-studded coat and pants. But it is crucial to remember that the patchwork-patterned outfit is a refined stylization of the original rags and tatters that were all the poor peasant boy that he was had to wear. Like a model for the pauper mother-to-be, Mont-Saint-Jean, whom we shall meet in Sue's *Mystères de Paris,* Harlequin's mother collected assorted scraps of cloth begged wherever they were to be found ("[d]es bouts de tissu mendiés chez les uns et les autres," says Desvignes), and stitched them together so that her child could be clothed.[129] These are the origins of the harlequin costume: patched-together random bits of color

FIGURE 8 Harlequin mask, France or Italy, eighteenth century. Leather. Metropolitan Museum of Art, New York. Gift of Irwin Untermyer, 1970.

covering the nakedness of poverty. What we think of as the aesthetic of patchwork originated in the work of piecing clothing tatters into a shelter from the elements. A ragwork covering of fabric remains (the leftovers of more fortunate people's clothing), and random spots of color only later become standardized as the ritual color-blocked costuming material for the Harlequin of the Commedia and its afterlife (Plates 22, 23, and 24).[130]

On his head, Harlequin wore an evolving variety of slouchy, well-worn hats, the form depending on the actor or artist and the period. In the beginning there

was a rabbit tail or feather adornment hanging off the hat, usually assumed to allude to cowardice, fearfulness, and flight. The ornament is sometimes taken in a more realist interpretive mode as simply a representation of the headgear of Bergamasque peasants.[131] In all cases it adds a note of ridicule to the character.

HARLEQUIN MANNERS

If Harlequin is a domestic laborer, a servant, or a beast of burden, he is not servile, except where it behooves him to act that part. He is insolent, disrespectful, saucy, brash, uneducated, uncouth, deceitful, bawdy on the verge of the obscene, opportunistic—or alternatively, endearingly rough at the edges, candid, clownish, timid, and charmingly naive. He is resourceful, *débrouillard,* as the French would say, able to find his way out of difficult situations, capable of inverting social positions and economic conditions to emerge on top. This skill is one that is refined over the course of the character's theatrical life, largely through the investment of various actors—prime among them, the early French Arlequin, Domenico Biancolelli, known as *Dominique.* Maurice Sand summarizes Harlequin's gradual metamorphosis: "C'est au dix-septième siècle que se transforma complètement le rôle d'Arlequin. Il devint spirituel, rusé, grand diseur de bons mots, et tant soit peu philosophe" (In the seventeenth century the role of Harlequin was completely transformed. He became droll, crafty, a master of witticisms, and even a trifle philosophical).[132] If Harlequin was traditionally the second zanni, playing the fool to the first zanni's more wily trickster, he comes to change place, taking on the characteristics and the standing of the primary zanni (at least until the nineteenth century, when he came under the shadow of Pierrot during the reign of the mime Debureau at the Funambules).[133]

HUNGER

The soul of Harlequin is his insatiable sensuality: his taste for women, wine, and food. He is above all a glutton, constantly eating or plotting the next meal, snack, or sexual escapade, always distracted by the possibility of a drink or a bite. Sausages are particularly common stage accessories and are exploited for their double signifying value.

But the more common name for gluttony is hunger. One way to read Harlequin and to understand the source of his caricatural actions that take the manifest forms of greed, avarice, and gourmandise is to adopt a perspective we could anachronistically call sociological. Harlequin's appetite is comical; but we laugh for many reasons. Desvignes reminds us that the traditional gag that has Harlequin on stage popping flies into his mouth has its origin in the cruel fact that he has nothing else to eat; she further observes that the grotesque twists and turns that contort his body when the flies he has gobbled ostensibly tickle his insides are a displaced sign of the disabled functioning of his long-empty stomach.[134] His iconic voracity, viewed as an insistent manifestation of his hunger, is

the equivalent of his colorful patchworked outfit: it is the hyperbolic statement of his poverty. Threadbare clothing and gnawing bellyaches alternatively indicate his material misery, and a constant concern for money joins them as the third exhibit in this trinity of need. Harlequin, "[ce] fils de la plèbe qui a toujours manqué de tout" (this son of the people who has always lacked everything), is a stand-in for the starving people, acts as a single link representing the chain of human suffering.[135]

REVOLT

When we perceive Harlequin as the iconic *misérable,* a personification of the famishment and penury of the masses, we might then heed him as a mouthpiece for the people, a rebel soul who speaks truth to power—though sometimes in disguised form. The message of this social critic skirts censorship because of his covering candor or foolishness. In the struggle to survive, Harlequin refines his arsenal of resources, cunningly retaining his unwitting air because it serves him well to get the better of his masters: he illustrates the right of the socially lowest to become the highest. Bottini reenvisions what appear to be diabolical Harlequin figures in social realist terms as having "dark and deformed faces like those who have worked in the fields under the sun, who suffer defeat and are always humiliated and beaten down by the 'winning side,' " and notes that "the winning side look[s] more like the well-kept angel-like ruling class." He further suggests that spectators would have understood the dramatized confrontation of Good and Evil as "an eternal battle between servants and masters."[136] Like Bottini, Desvignes is an ardent proponent of Harlequin as rebel: although he is a servant, he is defined politically or sociologically as proletarian, unlike the traditional comic valet. Desvignes's Harlequin is an anarchist folk hero scornful of private property, a political outsider, a self-willed marginal man comparable to modern equivalents outside the power structure: "Il serait de nos jours Arlequin émigrant, Arlequin vagabond" (In our day he would be Harlequin the emigrant, Harlequin the vagrant).[137] Jeffrey Ravel makes a similar if more moderate claim, suggesting that at the moment Louis XIV expelled the Italian Comedians from the Hôtel de Bourgogne in 1697, he marked them as antiestablishment; henceforth they belonged to the streets and claimed the whole city as their stage.[138]

Harlequin is multiple; he is many things in quick succession and even at once. In his consistent (if oxymoronic) presence as phoenix-like, protean, mercurial, kaleidoscopic, and chameleonesque—all recurrent metaphors I borrow from his commentators—he offers himself as eminently available, appropriable, and recyclable. This is not to say that he can be or do anything at all, fulfill any purpose for whoever wishes to appropriate him, but rather, that his bag of tricks is full and that each one is metamorphic. It would not be overstating the case to say that his ruses are also everywhere subversive: while for Bottini and Desvignes, "Arlecchino is revolution," in less absolute terms one might say that he consistently

destabilizes his world, pierces the social fabric, rips it to shreds and turns it inside out, exposing its unsavory underbelly to all eyes.[139] Unruly Harlequin, patched in the frayed rags of others, noisy eater of all scavenged things, unbridled seducer—carnality incarnate—Harlequin *is* the underbelly of society.

—— PUTTING TWO THINGS TOGETHER

When a poor worker chose a harlequin from a market stand display, when a famished couple emptied their purses to indulge in a harlequin meal at a dark tavern table, when a laundress who had not eaten for days found a few coins to buy whatever might be left at a harlequin vendor's stall, did they think about Harlequin leaping from one identity to another in multilayered masks on a Commedia stage, or dangling his colorfully spangled legs in the air and gesticulating wildly with a sausage in hand at the Foire Saint-Germain, or miming a desperate search for victuals in a performance at the Funambules? As the harlequin eaters chewed gristle and swallowed thin bones, did the scratching in their belly remind them of Harlequin in his well-known routine of twitches and contortions after devouring flies? Did the harlequin eaters take on, or take in, the body of Harlequin with the ingesting of the meal that took up his name?

Nabokov elliptically sketched a kind of harlequin mathematics according to which harlequinesque objects, images, and situations combine, recombine, and metamorphose: "Put two things together—jokes, images—and you get a triple harlequin."[140] Obeying a similar calculus, harlequin eaters present a double harlequin, and maybe more: the plate of food under the aegis of the eponymous Harlequin, and the eaters themselves, who take on the identity of the scrappy meal, and with it, that of the ghost of Harlequin himself: Harlequin, the master eater, the harlequin eater well before the lexical fact, that is, the magpie consumer of bits and pieces gleaned wherever found. Together doubled—or, by a mere stretch of comprehension, tripled—the H/harlequins blend into a scene of eating, a performance. "How do you know the dancer from the dance?" asked the poet; and we might follow that question with another: "How do you know the feeder from the food?"[141]

Harlequin food is a crystallization of Harlequin as he had evolved on his whirl through time into the nineteenth century. Crystal: a strange metaphor, perhaps, to conceptualize a plate of coalescing food that conjures up images of murkiness and mire rather than transparency, but one that seizes the idea of materialization and combines it with reflection. The edible harlequin crystallizes the microdynamics of Harlequin's enactments into the most material of forms: matter to be digested that is already vestigial, well on its way to being broken down. Mixed matter that is all the more hybrid when it passes through the class stream, opening to the lower classes a heady taste of richness and a dream of elevation, opening to the upper classes a nightmare of degradation: the fearsome specter of the poor sinking their teeth into flesh they are not entitled to eat. This plate

serves up a materialization of class difference, of the conflict of master and slave, the relativity of taste, the unremitting call of the senses, the potential fluidity of power, the suppressed but ultimately irrepressible force of the body, the possibility of subversion, and sometimes, even the dazzle of fantasy, the transformational magic of dross taking on the power of exotic philters and potions unknown. To each taster, each spectator, each writer or artist who takes on the h/ Harlequin, the plate offers a dappled array of possibilities or a sinister jumble of perils, *au choix*. But here begins the rest of the book.

URBAN CANNIBALS

NAVIGATING THE STREETS WITH EUGÈNE SUE

ARLEQUIN (ar-le-kin) s.m. 1. Personnage de la comédie italienne, dont le costume est fait de pièces de toutes couleurs. Par extension, un habit d'arlequin, un tout formé de parties disparates. 2. Populairement, débris de repas, et surtout débris de viandes, ainsi dit parce que ce plat, que l'on vend pour la nourriture des animaux domestiques et que les pauvres ne dédaignent pas, est composé de morceaux assemblés au hasard. 3. Familièrement, c'est un arlequin, se dit d'un homme qui n'a pas de principes arrêtés, qui change d'opinion à tout moment. J.J. ROUSS., *Ém. II:* Nos arlequins de toute espèce imitent le beau pour le dégrader.[1]

—excerpted from Littré, *Dictionnaire de la langue française,* 1872–77

When Eugène Sue set his opening cast of characters before a feast of leftover dinner scraps in the second chapter of *Les Mystères de Paris,* he was obliged to explain to his reader what exactly he meant by the slang term *l'arlequin.*[2] This moment in June 1842 is a watershed, because never again in nineteenth-century Paris would an author need to explain the idiom, which was henceforth popularized by the novel's monumental success across all social classes.[3] Sue's mainstreaming of the alimentary harlequin is all the more thought-provoking as a discursive event because his novel firmly attaches it, from the moment of its introduction, to a host of other metaphorical uses of the term. From the beginning

of its entry into common parlance, then, the harlequin is not just a term having to do with certain aspects of that most basic of human material needs—eating— but also a figurative concept that binds eating to dressing, to decorating, and to ways of thinking of and talking about the world economically, philosophically, aesthetically.

In Part I of this chapter, I look closely at the harlequin dinner scene that all but opens *Les Mystères,* anchoring the sociocultural reality of this nineteenth-century alimentary institution in Sue's literary representations. This focus opens a window on perceptions of knowledge, privilege, and power trickling down across class lines, along with foodstuffs. It also invites a reevaluation of the narrative, philosophical, and ethical stakes of its author. I move on in Part II of the chapter to juxtapose *Les Mystères* with one of Sue's maritime novels, *Atar-Gull,* in order to delve into the darker regions opened by Sue's harlequin practices; there I consider Sue's constructions of cannibalism in terms of both the colonial and the socioeconomic Other.

PART I. THE HOUSE OF HARLEQUINS: *LES MYSTÈRES DE PARIS*

The harlequin practice as it evolves in Sue's novel is a bridge between sociocultural and aesthetic history, fabricated in tandem with an expanding rhetoric of fragmentation, patchwork, collage, bricolage, and metamorphosis throughout *Les Mystères.* In a spirit of veritable contagion, the pattern of remnants and scraps that introduces the harlequin dinner scene spreads to descriptions of bodies and body parts, clothing, decor, modes of attention and belief, narrative form and style. It leads on to a contemplation of Sue's attempt to forge a writing identity in a similar light, which is to say, in the context of his own stylistic, political, and moral harlequinism.

—— THE HARLEQUIN FEAST

When Rodolphe, le Chourineur, and Fleur-de-Marie sit down to reconcile their near-fatal differences in the Cabaret du Lapin-Blanc, no one of them is any more aware of the identities of the others than is the reader (and only Rodolphe knows his own origins). So the motley threesome—one a grand duke in disguise, one a semi-reformed ex-con, and the third, a prostituted princess wearing rented clothes—begin to spit out their sordid stories as they take in a meal (orally or visually) as mixed as their assembled company, and no less recycled. The central element of the table, *l'arlequin,* ordered from the tavern keeper by the lowlife le Chourineur (whose name means "slasher" or "butcher") is described twice—once by the narrator and once by le Chourineur; the space between the two versions is at least as important as the information provided by either one of them. Here is le Chourineur exulting before the mixed plate:

> "Quel plat! Dieu de Dieu! . . . quel plat ! C'est comme un omnibus ! Il y en a pour tous les goûts, pour ceux qui font gras et pour ceux qui font maigre, pour ceux qui aiment

le sucre et ceux qui aiment le poivre . . . Des pilons de volaille, des queues de pois-
son, des os de côtelette, des croûtes de pâté, de la friture, du fromage, des légumes,
des têtes de bécasse, du biscuit et de la salade. Mais mange donc, la Goualeuse . . .
c'est du soigné."[4]

["What a dish! God almighty! . . . what a dish! It's like an omnibus! There's something
for all tastes, for those who eat meat and those who don't, for those who like sugar
and those who like pepper . . . Poultry drumsticks, fish tails, chop bones, pâté crusts,
fried food, cheese, vegetables, woodcock heads, biscuits, and salad. But eat up, la
Goualeuse . . . this is refined food."]

What constitutes "refined food" is, of course, a matter of perspective. For le
Chourineur, brought up in the gutter and used to scrounging food when and how
and if he can, the assorted odd bits of other people's dinners that recombine
separate dishes and sequential courses in a replated synchronous moment are
a veritable banquet. For the narrator glossing the term *arlequin* in a footnote,
however, the affect is not the same: "Un arlequin est un ramassis de viande, de
poisson et de toutes sortes de restes provenant de la desserte de la table des do-
mestiques des grandes maisons. *Nous sommes honteux de ces détails,* mais ils
concourent à l'ensemble de ces menus" (48 note 2; my emphasis) (A harlequin is
a collection of meat, fish, and all kinds of leftovers cleared by servants from the
tables of fancy houses. *We are ashamed of these details,* but they contribute to an
understanding of such menus). Exultation turns to repulsion, and relish to dis-
gust. Quantity, abundance, and variety are represented more succinctly by the
single pejorative term *ramassis*: collected jumble, hodgepodge, mess. Because
the brief footnote appears in the text just before the harlequin plate is served and
then described by le Chourineur, it introduces it and has the privilege of spin.[5]

—— SHAME

The apology concluding the footnote ushers in le Chourineur's harlequin plate
under the sign of shame. It is not entirely clear whether the narrator's avowed
mortification is to be attributed to the plight of his fellow humans at the bottom
of the social hierarchy who are condemned to consume the relics of the higher
orders, or (more likely) to a potential offense his details might deliver to the taste
and sensibilities of his bourgeois readers, but the carefully crafted ambiguity of
his phrasing begins to suggest the hypocrisy of his discourse. The tone of com-
mingled pity, contempt, and disgust preseasons our reception of le Chourineur's
feasting. This diner takes palpable pleasure (and his vigorous exclamations of
gustatory delight are themselves offered as clear markers of his crude taste) in
the quantity and variety of his comprehensive plate, thereby enacting his lower-
class status: he is an indiscriminate eater.

Le Chourineur's recognition that the food he is devouring is not only abun-
dant but also, rather differently, that it originated under the aura of an Other,

FIGURE 9 This image from the first illustrated edition of Eugène Sue's *Les Mystères de Paris* represents the tavern where le Chourineur eats his harlequin while Rodolphe and Fleur-de-Marie (and the narrator) look on in horror. The illustrator dares go so far as to depict the riffraff clientele but—unlike the author—not the ragtag food. Louis Joseph Trimolet, *Le Tapis-franc*, in *Édition illustrée des Mystères de Paris*, 4 vols. (Paris: Charles Gosselin, 1843–44), vol. 1. Wood engraving. Typ 815.43.8120 (v. 1), Houghton Library, Harvard University.

higher world is both recorded and narratologically mocked in his comment that the mess of food on his plate, the disordered and desequenced result of its social slide, is *soigné*. The implicit wink to the reader contained in his quoted labeling of the harlequin as "refined food" is in fact a narrative nod of complicity to bourgeois tastes and habits; it provides a clear demonstration of how social classes are constituted and (at least theoretically) maintained as separate by means of eating practices, preferences, and aversions.[6] For the aestheticization of eating is a privilege of leisure and luxury not available to a déclassé like le Chourineur, who can only mime the words like a monkey but have them mean something demeaning to him. So Rodolphe buys dinner for this man-who-eats-like-an-animal, and the act of eating the dinner becomes a show for Sue's readers: le Chourineur obligingly "sings" for his supper (Figure 9).[7]

—— THE OMNIBUS

Immediately after the rhapsodic exclamations of the hungry man comes "his" comparison of the harlequin plate to an omnibus, a designation whose source, inasmuch as it is double voiced (le Chourineur's relish channeled by the narrator's disgust), opens a similarly double semantic space. The omnibus, a form of

transport *for all,* alludes etymologically and metaphorically to the cornucopian inclusiveness of the meal. The omnibus plate takes as its vehicle the more literal public transport system that had been introduced in Paris fourteen years earlier, and that was still the object of scandal and disgust for bourgeois citizens and commentators. As Masha Belenky's work has documented, the omnibus appeared to many contemporary observers as "a ravenous monster whose enormous size and indiscriminate palate fostered chaos and disorder, both in the streets of Paris and within the established social order."[8] Encouraging promiscuity—an overmixing of the sexes and the classes—this democratizing vehicle cut an inexorable path through socioeconomic *quartiers,* across cultural mores, and through alimentary stratifications that ostensibly maintained the classed boundaries of French bodies. The harlequin plate, standing in for the trickle-down institution that conflated upper-crust diners with the lowest of bottom feeders through the unrestrained circulation of food across class lines, also indiscriminately mixed distinct dishes and courses.[9]

Standard bourgeois commentary on harlequin meals routinely collapses plebeian eater and eaten and conflates the appearance of lower-class consumers with the shabby, ragtag aspect of their food.[10] Here too, the food plate is disfigured as voracious palate, and tainted with projections of its brutish, devouring consumer. Sue's omnibus meal, like its vehicular twin, carves a passage through Paris that makes socioeconomically segregated neighborhoods interpermeable as it opens the gullets and gorges and maws of all its citizens to all others. The scandal of the omnibus harlequin is rendered in the image of the people as a deep throat ingesting the remains of the gentry, cannibalizing its parts.

—— THE HARLEQUIN FAST

But not all the diners choose to consume the feast. While le Chourineur devours, his host, disguised as an artisan eking out an honest living, passively attends. Rodolphe makes clear when asked for *his* order that *he* won't be eating: "Demandez au Chourineur, la mère; il régale, moi, je paye" (48) ("Ask le Chourineur, my good woman; he's feasting, I'm paying"). And Fleur-de-Marie, who hasn't eaten all day, is hungry, but not enough to let physical need overcome her distaste for the people's plate. She refuses even a single bite of the harlequin array she is offered, professing a loss of appetite that cannot be attributed to satiety, given her pointed remark that she has only consumed her habitual morning ration of a sou's worth of milk and of bread. The girl's fasting is doubly determined by the narrative. Initially, she recoils from her dinner companions' recent street fight: "'Oh! J'avais bien faim,' répondit-elle; 'mais de voir des batteries, ça m'écoeure, je n'ai plus d'appétit'" (42) ("Oh! I was really hungry," she answered; "but after watching you beat each other up, I feel nauseated, I haven't an appetite anymore"). Shortly thereafter, she is revolted by the tavern fare. Although she has joined the reconciled men upon assurances that eating will restore her appetite, she retreats

from the prospect of eating, now at the sight of the harlequin spread: "Oh! non, ma faim a passé" (49) ("Oh! no, I'm not hungry anymore"). We should bear in mind, however, that this sixteen-year-old has been living a starved and sometimes homeless life among the riffraff since early childhood, reduced to gleaning scraps in the fields and sneaking licks of the barley pops she is supposed to sell to others. Her discriminating taste in food can only be a sign of her distinguished (if still hidden) bloodline, which naturalizes good taste as class distinction.[11]

Bearing witness to harlequin eating and to beating have the same appetite-suppressing effect on Fleur-de-Marie. The combination of the street brawl and the leftovers plate quashes her appetite; on the contrary, it boosts le Chourineur's. He sits down to his meal with his spirits and his hunger roused by the thrashing he has received, in much the same way that enslaved Africans, according to popular wisdom, were "fed by beatings."[12] (And tellingly, le Chourineur has just recognized Rodolphe's boxing mastery in an ambiguous phrase that inaugurates a master–slave relationship: "Tu es mon maître, je le reconnais" [42] ["I've met my master, I admit it"].) The conjunction of beating and eating at the doorway to the tavern ushers us into the novel as well, forming what will become a persistent pattern as the novel gains heft and speed.

—— EATING AS REVOLT

One eats, the others do not. Fleur-de-Marie and Rodolphe decline the harlequin which le Chourineur demolishes with delight, one vociferously and the other by implication. It becomes clear that Sue organizes eating along class lines, though these lines are not immediately divulged. Fleur-de-Marie, the divinely beautiful young woman nicknamed la Goualeuse (Songbird) opens her mouth to emit angelic notes of song and closes it to gutter scraps. As Fleur-de-Marie, the prostitute with the Virgin's name, "Mary's flower," she plays the unlikely role of Virgin Prostitute to Mary's Virgin Mother, street child with a heart of white, purified by her yet-unrevealed lineage, ascetic consumer of milk and bread. Lost daughter of Rodolphe, Grand Duke of Gerolstein, she is, as it were, "naturally" repulsed by the surfeit her lowlife companion greets as plenty, and feels violated by the dissonance he broadly welcomes as variety. Fleur-de-Marie and her father, Rodolphe—acting out the narrator's disgust at the shards devolving to the people's plate, and his shame for the gusto that falls to its palate—rise above their circumstantial alimentary situation at the threshold of the novel. What then shall we say of le Chourineur's embarrassing appetite for the discordant colors and shapes on his plate? Can he wrest agency for his act of eating from the narrator's parodic mastery? Can he transport his jubilation at the panoply of textures and tastes away from its patronizing screen? We might just as well ask, "Can the subaltern eat?" And can eating be an act of revolt?

While the answers to these questions might be a resounding no, the very act of posing them may be a useful rhetorical act. For when we reread the doubly

articulated detailing of the harlequin plate as a narrative projection, we recover an impossible piling up of generic categories that couldn't possibly fit on a single plate (once again: "le sucre . . . le poivre . . . des pilons de volaille, des queues de poisson, des os de côtelette, des croûtes de pâté, de la friture, du fromage, des legumes, des têtes de bécasse, du biscuit et de la salade"). The list constitutes, for the most part, less a specific description than a process of signifying excess, dissonance, disorder, and bad taste. Let us remember that Sue was writing—and dining—in the wake of the first celebrity chef, Marie-Antoine Carême, who revolutionized high culinary style in France, emphasizing the separation and simplification of flavors and ingredients rather than their accretion. Carême's aesthetic, as we have seen Jean-François Revel describe it, was antithetical to the presentation of le Chourineur's plate, for it emphasized the distinction and contrasting of flavors as opposed to the "barbaric" piling up of heteroclitic ingredients.[13]

Meals, Bourdieu reminds us, are cultural arrangements whose content and form are class-dependent; and it is quite plausible that what constitutes "bad taste" or evokes disgust on the part of a diner like Eugène Sue or his proxy narrator would cause a diner like le Chourineur to salivate.[14] The harlequin plate implicitly complicates both food hierarchies and class hierarchies, since it (re) serves to the less fortunate, albeit in rearranged form, the "grande cuisine" of the well-to-do. So it is not entirely clear which way the double-edged discourse cuts, and which class is more compromised by the passing down of dinner remains (which is simultaneously an eating up of the poor).

One reference, "des têtes de bécasse" (woodcock heads) stands out from the jumble on the harlequin plate, marks a specificity among the pileup of categories, and—along with le Chourineur's imputed glee and relish—acts as a kind of bait and switch for our brains, advertising one voice and delivering another. This single referential detail among the amassed culinary taxonomies (there are vestiges of poultry, fish, cutlets, fried food, salad, and more) suggests an observation on the part of the active eater. It is whisked into the assemblage of degraded food groupings with which the narrative arms itself for attack. The trick here is the use of indirect discourse; there is a "fading" of voices that, in context, might better be called a "bleeding" of voices to take account of an aggressivity along with a blurring.[15] Each voice is almost indistinguishable from the other. Le Chourineur explicitly speaks—"il s'écria"—but he is ventriloquized by other voices coming from another class (what we might call the "narrating class"). There is, on the one hand, an assault, a projected wounding, an envisaged vulnerability on the part of the narrator and the (bourgeois reading) consumer sensitive to the sharp edges of the harsh things so precipitously swallowed (drumsticks, fishtails, bones, crusts). But there is also, on the other hand, beyond the expanding allusions to the violence of eating, an unexpected potential consanguinity of voices, of sensibilities, of bodies, of beings, of classes: a bleeding together of readers and eaters,

a mixing of blood. I mean this not as a claim for an effective democratization of reading (or of eating), but rather, as an indication of the fear of class mixing on the part of the bourgeoisie, figured here by the horror of passed-down food.[16]

—— A TISSUE OF HARLEQUINS

Were Sue Balzac, he might have articulated the fact that the patchwork harlequin meal with which he indulges his readers summarizes the tavern and its owner and its clients just as they, in turn, summarize the plate of food. The tavern as public site of consumption is a place where the sharing of food and drink brings clients to mingle and, with its added shield of anonymity, it potentially puts classes into contact, making it at the very least a place of symbolic fusion.[17] The possibility of social assimilation that eating establishments generically imply finds its hyperbolic expression here where Grand Duke Rodolphe rubs shoulders with ex-cons and other lowlifes (not to mention the young woman later discovered to be his own prostituted daughter, who, as such, is the embodiment of social hybridity).[18] The motley clientele of the *tapis-franc* where they sit, the appearance of Fleur-de-Marie in her patched-together, rented ensemble of other people's clothes, Rodolphe in his pose as painter of fans doing piecework, all are crowned by a preview of the worst thug of all, the prison escapee called "le Maître d'école," who has altered his face to hide his identity, hacking off the end of his nose and "washing his face" with vitriol so that it is "as stitched together as a ragpicker's jacket" (69) (aussi couturé que la veste d'un chiffonnier).[19] All announce and are announced by the harlequin supper so differently relished by le Chourineur and his narrator.

If this initial tableau of dinner fragments summarizes and completes the scene in which it is embedded, it also synecdochically announces the more than one thousand pages to follow. The dinner scraps prefigure a comprehensive operation of collage as motif and process: the early scene of eating is a model for the piecemeal structuring of other material objects and nonmaterial processes in the novel having to do not only with food but also lodging, clothing, and language. Sue's shifting incarnations of the harlequin will eventually take us toward the harlequin disincarnate as form, style, and ideology.

The table scraps lead out to some analogous materializations from a recurrent point of departure: the textually central lodging house on the rue du Temple, a relay site for the many interrupted plots and recurrent characters in the novel. Sue's house has not only many windows, like Henry James's (not yet constructed) allegorical house of fiction, but also a range of other visual apertures and auditory openings: peepholes cut in room partitions, sound-permeable doors, paper-thin walls, stairways and corridors whose labyrinthine twists invite hide and seeking.[20] I would be remiss in my tour of the premises if I neglected to point out the attic storeroom cum "theater loge" where M. Pipelet, concierge by circumstance, shoemaker by trade, and voyeur by predilection, keeps his leather

materials and spies on the intimate dramas of his very poorest tenants who live piled up in the adjoining garret room: "Le digne portier appelait ce réduit 'sa loge de mélodrame,' parce qu'au moyen d'un trou pratiqué à la cloison, entre deux lattes, il allait quelquefois assister aux tristes scènes qui se passaient chez les Morel" (419) (The worthy porter called his attic storeroom "his theater loge," because a hole he had made in the partition between two slats let him watch the sad scenes that took place in the Morels' garret). Here are so many mechanisms for spying and eavesdropping, so many opportunities for juxtaposing people's lives.

The rooming house, pointedly located in a neighborhood of small shopkeepers and other working-class people, will play a pivotal role as meeting ground, crossroad, and stage for the spectacularly overlapping plot fragments and intersecting characters; its concierges, M. and Mme Pipelet, will be active agents in the circulation of gossip, the facilitation of espionage, and the manipulation of the private lives and plots of their lodgers, visitors, and passersby.[21] As we shall see, the house on the rue du Temple is inhabited by harlequin people decked out in harlequin clothing, studded with harlequin accessories and décor. And it is also the place where the novel's fractured and fractious pieces (its part plots, class strata, life fragments, and bit players) most often encounter each other and activate the mechanisms by which the reader is relayed, retracked, switched among interrupted plots and episodic lives.[22] Not only does Sue not try to hide the mosaic effect; he brings it to our attention by metadiegetic commentary. When, for example, the narrator abruptly abandons Fleur-de-Marie to the clutches of kidnappers at the end of one chapter, in order to pick up different characters and another plotline at the start of a new chapter back at the lodging house, he underscores the narrative disconnect:

Le lecteur nous excusera d'abandonner une de nos héroïnes dans une situation si critique, situation dont nous dirons plus tard le dénouement. Les exigences de ce récit multiple, malheureusement trop varié dans son unité, nous forcent de passer incessamment d'un personnage à un autre, afin de faire, autant qu'il est en nous, marcher et progresser l'intérêt général de l'œuvre. (362–63)

[The reader will forgive us for abandoning one of our heroines in such a critical situation, a situation whose outcome we will relate later. The exigencies of this complicated narrative, whose unity is unfortunately split, force us to move constantly from one character to another, in order to maintain and advance the book's general interest to the best of our abilities.]

Sue's novel with its central harlequin house is also Sue's house of harlequins, his house of fiction fragments.[23] When we encounter the harlequin here, it is both formally and grammatically different from its tavern debut: its form is not alimentary, and it reappears—persistently—now in a modifying rather than

substantive position. When Rodolphe enters the modest five-story building to rent a worker's room (the better to navigate the network of plots crisscrossing this house, and to further his social engineering), he notices in the porter's lodge "un lit recouvert d'une courtepointe arlequin, formée d'une multitude de morceaux d'étoffes de toute espèce et de toute couleur" (200) (a bed covered with a harlequin counterpane, made of a riot of fabric scraps of all sorts and colors).[24] This will not be the last time we find such words used to describe fabrics, clothing, accessories, and even human hair and flesh. The common denominator is the people: the patchy elements—assorted articles of clothing, accessories, or body parts—consistently belong to members of the working class.

As Michel Pastoureau has so elegantly shown, a long tradition—dominant in the Middle Ages but stretching back to Leviticus—forbids vestimentary or textile mixing, by association of the variegated with the scandalous. By convention, the solid and the monochromatic are taken to be godly, while the mottled is diabolical. Pastoureau, we recall, groups the striped, the stippled, the variegated, and the multicolored under one conceptual standard: "celui de la transgression" (that of transgression).[25] He mentions in passing that the alternation of different bright colors ("des couleurs vives") has traditionally presented a heightened offense to the notion of social order.[26] The idea of clashing, of brash colors—and of color itself—has a long association in the West with marginality. In fact as we shall explore later in more detail, color itself has been marginalized, "purged," in David Batchelor's words, "made out to be the property of some 'foreign' body—usually the feminine, the oriental, the primitive, the infantile, the vulgar, the queer or the pathological."[27] Banished from high culture, good taste, and civilized values, color has been relegated to the province of the poor, the tasteless, the uncivilized.

It is consistent with this tradition that Sue amplifies the bad taste of the tenement decor (and of course, implicitly, the foul company associated with it) through details including two sconces fitted with sequined oranges standing in for tapers, and a pair of mismatched boxes—one shell-incrusted and one made of multicolored straw—which, the narrator observes, can only be the products of the kind of busy work that is imposed on prison or asylum inmates (200–201). By way of the garish patchwork counterpane, the jarring boxes, and the glittery oranges (not to mention Rodolphe's efforts to "pass" in the worker milieu by donning a clownish ensemble consisting of a dirty overcoat, a misshapen hat, grotesque overshoes, and a red tie), we come to the description of Mme Pipelet-as-concierge, so compliant with the stereotype of a concierge that it can be abbreviated, says the narrator with a collusive wink of an eye, to a reference to Henri Monnier's caricaturing of that iconic figure.[28] Except for a single component so heteroclitic that no summary is possible:

> Le seul trait que nous nous permettrons d'ajouter . . . sera une bizarre coiffure composée d'une perruque à la Titus; perruque originairement blonde, mais nuancée

par le temps d'une foule de tons roux et jaunâtres, bruns et fauves, qui émaillaient pour ainsi dire une confusion inextricable de mèches dures, roides, hérissées, emmêlées. (201)

[The only feature we will add . . . is a bizarre coiffure consisting of a Titus-style wig; a wig that was originally blond, but which time has nuanced to include a swarm of red and yellow, brown, and tawny tones flecking an inextricable tangle of rough, stiff, bristling, matted locks.]

Mme Pipelet's wig, a fantastical massing of nonmatching colors staining rebel strands of bristling hair, makes an unmistakable allusion to the people and its revolutionary specter through its description of "a mob of hues milling madly," and its classification as "Titus-style"—which for Sue's contemporaries would have been a clear allusion to the Jacobins, who had revived the ancient Roman mode.[29]

M. Pipelet is similarly patchworked, sporting "un tablier de cuir [qui] dessinait son triangle fauve sur un long gilet diapré d'autant de couleurs que la courte-pointe arlequin de Mme Pipelet" (216) (a leather apron that hung like a tawny triangle over a long waistcoat patched with as many colors as Mme Pipelet's harlequin counterpane). So, too, is the misshapen street urchin Tortillard who is outfitted like a jester-harlequin-troubadour figure, "habillé comme qui dirait en troubadour, avec une toque noire, une collerette et une jaquette abricot; il bat du tambour . . . pour attirer les pratiques, sans compter que le petit soigne le cheval tigré du dentiste" (214) (dressed up like a troubadour, one might say, with a black cap, a ruff, and an apricot-colored morning coat; he beats a drum . . . to attract customers, not to mention that this child also takes care of the dentist's speckled ["tigered"] horse).[30]

At the rue du Temple bazaar, we find a clothing market that replicates once again, in its essential principle of reusing old, deteriorated things—the scrappier the better—the early alimentary harlequin scene: "Dans ce bazar, toute marchandise neuve est généralement prohibée; mais la plus infime rognure d'étoffe quelconque, mais le plus mince débris de fer, de cuivre, de fonte ou d'acier y trouve son vendeur et son acheteur" (450) (At this bazaar, new merchandise is generally forbidden, but the minutest scrap of fabric, the scantiest particle of iron, copper, lead, or steel finds a seller and a buyer). The rag sellers are remarkably like the harlequin vendors Sue and his contemporaries describe, hard at work sorting scraps that do not look much different than the garishly colored rags they wear: "Il y a là des négociants en bribes de drap de toutes couleurs, de toutes nuances, de toutes qualités, de tout âge, destinées à assortir les pièces que l'on met aux habits troués ou déchirés" (450) (There are cloth merchants who trade in scraps of all colors, all nuances, all qualities, of all times, scraps meant to match the patches that are sewn on torn or worn-out clothing). Mountains of filthy, mutilated, and rotting shoes, "véritables squelettes de chaussures [où]

tout . . . est moisi, racorni, troué, corrodé" (450) (the skeletal remains of shoes now mildewed, shriveled, full of holes, and corroded) recall decomposing heaps of dinner remains. And in fact Sue turns to cheap food as his operative comparand when he wants to mock the piles of disintegrating, discolored women's hats that arrive at the market in secondhand dealers' bags. The hats, folded in two, are so flattened, crowded, and crushed that "sauf la saumure, c'est absolument le même procédé que pour la conservation des harengs" (450) (except for the brine, it's exactly the same process as is used to preserve herrings).

Now, herrings in nineteenth-century Europe were considered to belong to the category of food known as offal, a term derived from what is "fallen off, refuse, remnants, leftovers," or, in other words, "what is unfit for food, unfit to feed those who can do better."[31] Among other examples of offal, the *Oxford English Dictionary* gives "low-priced, inferior fish; small fish caught in nets unintentionally along with larger or more valued fish." Herring was a fish at once so small and so plentiful—so *common* in nineteenth-century France—that its consumption was considered in medical manuals to be evidence of pica, the pathological desire to ingest substances deemed inedible.[32] The notions of social hierarchy, taste, and pathology that stigmatize food not sanctioned by the upper classes operate analogously to deprecate the teeming sacks of secondhand hats sold in the marketplace.

As Rodolphe's outsider view guides us through the rue du Temple market, it directs our attention to theatricality, performance, and display: "ces exhibitions de vieilles chaussures, de vieux chapeaux et de vieux habits ridicules, sont le côté grotesque de ce bazar" (451) (these displays of old shoes, of old hats and of ridiculous old outfits are the grotesque side of this bazaar). Through the eyes of Rodolphe as a duke in disguise feigning artisan status but in fact "slumming it," Sue's rhetorical gawking emphasizes the spectacular aspect of this market, which he freely associates with its vulgar, lower-class patrons. He concedes that "ce vaste établissement est d'une haute utilité pour les classes pauvres ou peu aisées" (this vast establishment is hugely useful to the poor or less comfortable classes), snidely adding that the poor can buy here, at enormous discount, things almost new, that is, "dont la dépréciation est pour ainsi dire imaginaire" (451–52) (whose depreciation is hardly evident). In short, the choice of each element in the portrayal of the rue du Temple market contributes precisely to the received idea of the street market as *bazaar*: its displays of "des myriades de vêtements de couleurs, de formes et de tournures encore plus exorbitantes" (451) (myriad clothes of exorbitant colors, shapes, and contours) are given in evidence of the eccentric, the loud, the vulgar, the multicolored, the scrappy, the heteroclitic: which is to say, the popular.

If all that comes in intimate contact with the lower classes—notably, what they put in or on their bodies—shares these brash, patchworked features, it makes sense that their bodies also comply. The seamed face of le Maître d'école that we

glimpsed earlier returns two more times, and in color, as "[un] visage couturé, que le froid marbrait de cicatrices violâtres et livides" (281) (a sewn together face, marbled with livid violet-hued scars by the cold) and then again as "[un] visage couturé [qui] devint pâle sous ses cicatrices" (1121) (a stitched-up face that paled under its scars). Stitched together, seamed, and scarred, this "hideous" visage, this "monstrous" face, this "abomination," this "frightful mask" (1121) evokes the pieced-together body of Frankenstein's creature. And the clear allusion to Mary Shelley's monster, which had appeared in French twenty years earlier, introduces a motif that just won't be dismissed.

In a charity hospital in the countryside of Asnières, the suffering population of indigent women all fear death, less for its blanket fatality than for that particular misfortune of being offered to the claws of the well-named Dr. Griffon, who exercises there "toutes les capricieuses tentatives, toutes les savantes fantaisies d'un esprit inventeur" (1052) (all the capricious efforts and all the prodigious fantasies of an inventive spirit); that is, he experiments on the bodies of the poor for the benefit of treating the better-off.[33] His patients fear above all what will almost inevitably befall the lonely pauper's corpse they may become. A tubercular patient called "la Lorraine" relates her own terror through the dying fears of mutilation shared by a newly deceased fellow patient: "Cela lui faisait mal de penser qu'elle serait disséquée . . . coupée en morceaux" (1059) (It pained her to think that she might be dissected . . . cut in pieces). And the scene closes with a handing down of this hitherto anonymous woman's body, become mere remains. Dr. Griffon offers the cadaver with instructions for its appropriation to his student, François Dunoyer: "'Marquez le sujet, prenez possession' . . . L'élève, à l'aide d'un scalpel, incisa très délicatement un F et un D . . . sur le bras de [la] défunte, pour prendre possession, comme disait le docteur" (1066) ("Mark the subject, take possession of it" . . . The student, with the help of a scalpel, incised a very delicate F and a D . . . on the arm of the dead woman, to possess her, as the doctor put it).[34]

—— HARLEQUIN FAMILY

Such fantasmatic images of dissected bodies evacuated of identity and humanity—the People's limbs amputated in experiments designed to heal the upper classes—and vitriol-altered faces sutured back together, begin to prepare us (to the extent one can ever really be prepared for Sue's next coup) for the episode of the monster-woman, Mont-Saint-Jean, interned at the woman's prison of Saint-Lazare. Described with a smattering of adjectives ranging from "ridicule" to "grotesque," "abominable," and "hideuse," her ugliness is further detailed as asymmetrical and deformed: she is "un être informe . . . courte, ramassée, contrefaite, ayant le cou enfoncé entre des épaules inégales" (578) (a misshapen being . . . squat, stocky, deformed, with a neck sunk between uneven shoulders); and she is also a kind of compendium of various racial stereotypes, "allongée au museau . . . tannée, sordide, d'une couleur terreuse, percée de deux narines et

de deux petits yeux rouges bridés et éraillés" (578) (with a long face . . . that was swarthy, dirty, pierced by two nostrils and two small, slanted, bloodshot eyes). In her own words, she is simply "laide, un vrai monstre" (579) (ugly, a real monster). Scapegoated by the other prisoners for the bald reason that they are suffering and she is an easy target, she is mocked, too, for her displaced name. She is called "Mont-Saint-Jean," a place rather than a personal name, after her lover, who took that name from his wounding at the battle of Mont-Saint-Jean. Sue's contemporaries would have known that this was the name Napoleon preferred to give to his Waterloo, a village on the other side of the escarpment where the fatal battle was fought. The prisoner Mont-Saint-Jean walks, then, in the name of loss: her own status as "créature perdue" (577) (lost creature) is compounded by the doubly distanced proper name, the lost lover (dead or vanished, we do not know), the lover's wound, the lost battle, the lost emperor. She is further taunted with cruel suppositions about her lover's appearance:

> "Ça devait être un invalide . . ."
> "Un restant d'homme . . ."
> "Combien avait-il d'oeils de verre? . . ."
> "Et de nez de fer-blanc? . . . ,"
> "Il fallait qu'il eût les deux jambes et les deux bras de moins, avec ça sourd et aveugle . . . pour vouloir de toi." (579)

> ["He must have been a cripple . . ."
> "The vestiges of a man . . ."
> "How many glass eyes did he have? . . ."
> "And how many tin noses? . . . ,"
> "He must have been missing his legs and arms, and on top of that, been deaf and blind . . . to want you"].

Imagining him as an invalid with glass eyes and a tin nose, deaf, blind, and quadruply amputated—in short, a pile of human remains, or in other words, a lover made in her own image—the women reconstruct, in duplicate, Frankenstein's monster, a man made for the woman who loves him, a hideous harlequin couple cobbled together with epithets and jeers. But there is more, because Mont-Saint-Jean is pregnant, presumably with this lover's child.

Sue takes up where Mary Shelley left off, conjuring a spin-off of the unfulfilled story she had Victor Frankenstein's Creature dream for himself and demand of his Maker: "I am alone and miserable . . . but one as deformed and horrible as myself would not deny herself to me . . . This being you must create." Though Victor ultimately chose to abort his labor for fear that "a race of devils would be propagated upon the earth," Frankenstein's monster has his bride at last in Mont-Saint-Jean, and she, her groom.[35] Together they procreate what can only

be a monstrous baby, a composite being that will be so grotesquely malformed, suggest her fellow prisoners, that its clothes must be fitted on the warden's pet dog (579).

—— CLOTHES FOR A BABY HARLEQUIN

When the pregnant Mont-Saint-Jean makes her first appearance in the novel, spilling into the courtyard of the women's prison together with all the other "lost creatures" (577) released there for their hour of recreation, she is immediately set upon by the horde of inmates who rip off her head covering to bare her raggedy, unkempt hair, and try next to pry out of her clutch a small package wrapped in a grungy, tattered old handkerchief.

Visually unclassifiable, the content of the handkerchief is identifiable only by the bereft victim of the attack: "Eh bien! C'est un commencement de layette pour mon enfant . . . je fais ça avec les vieux morceaux de linge dont personne ne veut et que je ramasse" (579) ("Well, it's the start of my child's baby clothes . . . I'm making them from old scraps of cloth no one wants, that I collect"). Setting upon the wad of cloth like a throng of maenads, the gang of inmates tears it from her grasp, ripping the already torn covering so that it releases its barely wrapped scraps and shreds:

> Le mouchoir presque en lambeaux se déchira, bon nombre de rognures d'étoffes de toutes couleurs et de vieux morceaux de linge à demi façonnés voltigèrent dans la cour et furent foulés aux pieds par les prisonnières, qui redoublèrent de huées et d'éclats de rire.
>
> "Que ça de guenilles!"
> "On dirait le fond de la hotte d'un chiffonnier!"
> "En voilà des échantillons de vieilles loques!"
> "Et pour coudre tout ça . . ."
> "Il y aura plus de fil que d'étoffe . . ."
> "Tiens, rattrape-les maintenant tes haillons." (579–80)

[The handkerchief, already almost in shreds, ripped open, and a number of tattered fabrics of many colors, and old scraps of half-sewn clothes flew around the courtyard and were stomped underfoot by the prisoners' feet, which only increased their hilarity and their jeers.

"What a bunch of rags!"
"Looks like the bottom of a ragpicker's basket!"
"Well, there you have a nice bunch of old clothing scraps!"
"And as for sewing all that together . . ."
"There'll be more thread than fabric . . ."
"Here, go ahead now and catch your shreds of cloth."]

If for the assembled inmates Mont-Saint-Jean is no better than a ragpicker meriting ridicule for hoarding worthless threads and fabric ends and holes, one observer is able to see beyond what looks like humiliating trash collecting. This is Fleur-de-Marie, who, as chance has it, is also at this time interned briefly (and unjustly) at Saint-Lazare. Transfiguring ridicule as pity, and humiliation as generosity, she gradually convinces the women to gather up the scattered scraps and return them to the expectant mother, for whom they are not rubbish but fragments of a mosaic of promise, threadbare leftovers to be recomposed as nothing less than a harlequin cloth. Though not immediately labeled as such, the harlequin is evoked by a near-verbatim repetition: a description of the ragged bits of baby clothes as "bon nombre de rognures d'étoffes de toutes couleurs et de vieux morceaux de linge à demi façonnés" (579–80) echoes the words earlier used to describe Mme Pipelet's harlequin counterpane: "une multitude de morceaux d'étoffes de toute espèce et de toute couleur" (200) (a riot of fabric scraps of all sorts and colors). Among the trampled rag ends loosed from the bundle is a tiny, almost intact baby's cap tugged between two inmates; its safe return is begged for by the mother-to-be and her ally:

> "Rendez-lui ce petit bonnet..."
> "Ah bien oui!... c'est donc pour un arlequin au maillot, ce bonnet ! Il est fait d'un morceau d'étoffe grise, avec des pointes en futaine vertes et noires, et une doublure de toile à matelas."
> Ceci était exact.
> Cette description du bonnet fut accueillie avec des huées et des rires sans fin...
> "A moi le bonnet d'arlequin!" dit la Louve, qui s'en empara et l'agita en l'air comme un trophée. (581)

> ["Give back her little bonnet..."
> "Well indeed! It must be for an infant Harlequin, this bonnet! It's made of a bit of gray fabric, with tips of green and black fustian, and a lining of mattress ticking."
> This was exactly right.
> The description of the bonnet was greeted with jeers and hilarity...
> "Give me the harlequin bonnet!" said la Louve, who grabbed it and waved it in the air like a trophy.]

So the harlequin aesthetic diffused in the air with the clothing scraps takes shape and substance here in the tiny hat, itself miraculously whole, but made of many different parts. It is a composite of different colors (green, black, and gray) and textures (mattress ticking, generic cloth, fustian—itself already a composite of linen and cotton). The mixed fabric of this little cap also invokes the classic example of the aesthetic by explicit reference to the material costume of Harlequin. But while Mont-Saint-Jean's baby hat repeats Harlequin's patchwork motif,

the description given of the baby "bonnet d'arlequin" corresponds neither to period-style Harlequin hats nor baby caps: Sue's "bonnet . . . pour un arlequin au maillot," made of piebald fabrics with two drooping points, is sui generis. The description is not referential but semiotic, designed to deride the harlequin baby-to-be by association with Harlequin as jester and as mongrel. The strange little hat, so patched together, so odd, can only be for a Harlequin in swaddling clothes, conclude the inmates, which is to say, for an infant as hybridized as its parents.[36]

When Fleur-de-Marie has finally worked her magic, turning the prisoners' harsh laughter into tears of commiseration and shame, and their cruelty into kindness and generosity (583), the Harlequin cap is transfigured as well. Turned on its head, so to speak, inverted, the head covering becomes a container: "une sorte de bourse," an empty purse that she circulates to collect money for fabric from which all the women will help to sew a set of baby clothes to replace the rags and tatters of Mont-Saint-Jean's layette (584). One might reflect on the number of circulating elements in these pages: the cap, the purse, the money, Mont-Saint-Jean's name, the prostituted bodies of the women passed around among men and recycled to the prison house; Fleur-de-Marie herself cycling through the social order as a high-born child become street urchin, become prostitute, become angel of paradise (and eventually, on the rise, princess and nun).[37]

—— THE ANGEL OF PARADISE AND THE CONGENITALLY DEPRAVED

For the grateful Mont-Saint-Jean, Fleur-de-Marie is supreme benefactress, guardian angel, "bon petit ange du paradis" (768, 585). Though she is jailed as an equal in the company of prostitutes, and dressed like them in the prison uniform of black cornette and blue smock, her loveliness cannot be eclipsed: "sous ce grossier costume, elle était encore charmante" (580) (despite this coarse outfit, she remained lovely). Deprived like the others of food and comforts, Fleur-de-Marie stands out nonetheless as a different manner of creature, transcending both the coarseness of the prison milieu and her not dissimilar childhood milieu; she retains her white hands, seraphic voice, and queenly beauty, and is marked as elevated from the miserable horde in some mysterious way. But perhaps not entirely mysterious: for isn't this the way of bloodlines, "la voix du sang," as the narrator puts it in another context (768)?[38]

Fleur-de-Marie's distinction (and Sue's exceptionalism) can better be comprehended in juxtaposition with her author's representation of her fellow prostitutes, who understand that they should not position themselves too close to her: she walks in a sacred space. As Mont-Saint-Jean explains to Fleur-de-Marie, her refusal to sit next to her savior is a question of hierarchic deference: "Respect à la discipline . . . ; soldats ensemble, officiers ensemble, chacun avec ses pareils" (770) (Discipline must be respected . . . ; soldiers together, officers together, each belongs with equals). Yet we need to remember that at this time and place in the narrative, Fleur-de-Marie's royal origins are not yet known. She should be for all

intents and purposes a *fille* like any other to the collective of imprisoned prostitutes. So the difference Sue makes between her and those others must be sought outside the confines of the plot and the motivations of the characters.

In the process of rendering as "nondescript" ("au premier abord, leur aspect n'avait rien de particulier" [577]) the two hundred women assembled in the prison yard, a veritable city of prostitutes, the narrator nonetheless notices something about them that is rather remarkable indeed: "Mais, en les observant plus attentivement, on reconnaissait sur presque toutes ces physionomies les stigmates presque ineffaçables du vice et surtout de l'abrutissement qu'engendrent l'ignorance et la misère" (577) (But upon looking at their facial traits more attentively, one became aware that almost all were marked by the indelible stigmata of vice and, especially, degeneration that were engendered by ignorance and poverty). "The indelible stigmata of vice and degeneration" is a curious (if not impossible) metaphor that bears pondering: what would such marks look like?—le Maître d'école's vitriol-eaten flesh, Frankenstein's monster's sutures, or Christ's wounds? While it is clear that the Lavater-inspired traits serve Sue in order to sign these faces as inherently vicious and degenerate, Sue seems in the same breath to attribute them to circumstance and environment rather than nature ("qu'engendrent l'ignorance et la misère").[39] The next breath, however, brings another revision:

> À l'aspect de ces rassemblements de créatures perdues, on ne peut s'empêcher de songer avec tristesse que beaucoup d'entre elles ont été pures et honnêtes au moins pendant quelque temps. Nous faisons cette restriction, parce qu'un grand nombre ont été viciées, corrompues, dépravées, non pas seulement dès leur jeunesse, mais dès leur plus tendre enfance ... mais dès leur naissance, si cela se peut dire. ... Car les classes pauvres payent seules à la civilisation cet impôt de l'âme et du corps. (577)

> [At the sight of these gatherings of lost creatures, one cannot help thinking with sadness that many among them were pure and honest for at least a while. We make this distinction because a lot of them were contaminated, corrupted, depraved, not only since childhood, but since earliest infancy ... even since birth, if that is possible to imagine. ... For this tax to civilization is imposed on the body and soul of the lower classes alone.]

Now tracing depravity and vice back to the cradle, and indeed to birth, Sue replaces the assertion of milieu-inflicted corruption by that of inherited defects, "*a tax that the indigent classes pay to civilization*" (my emphasis). Blood and class here dissolve in an implicit idea of race (almost in the sense Taine would later come to use this term, and quite in the way the Goncourt brothers would speak of innate traits of the people).[40] In just such a way, Fleur-de-Marie, though raised and then prostituted by street thugs, can be the "belle reine" (beautiful queen)

of the prison yard, with magical fairylike white hands and angelic manners. She can somehow be a child of the streets *and* a beautiful damsel whose voice and speech together improbably elevate her well above her prison or peasant garb: "Quoiqu'elle soit mise en paysanne, il n'y a pas une bourgeoise, pas une grande dame pour parler aussi bien qu'elle, avec sa petite voix douce comme de la musique" (809) (Although she is dressed like a peasant, there is no bourgeois woman, nor any lady, who speaks as well as she does, with her gentle voice as sweet as music).

Fleur-de-Marie's representation can embrace these extreme contradictions—by which I mean at once her contradictory social roles and Sue's inconsistent ideological positions—because somewhere, not so very deeply ensconced in his newly socialist being, Sue continues to believe in the determinism of birth and blood. It can be only on the basis of these beliefs that he is able to have the savior angel Fleur-de-Marie embrace Mont-Saint-Jean as equal—"Il n'y a aucune différence entre nous deux" (770) ("there is no difference between the two of us")—and almost simultaneously suggest that she turn her messianically awaited baby over to virtuous people in the countryside who will benevolently "raise a good farmgirl or a good farmer" (772–73). Here is a rumbling of scientific racism at work before it was formally theorized and lexicalized as eugenics (though it is strangely encapsulated in the name of the author, *Eugène,* who was himself certainly "better born"). Sue's is a peculiar, difficult-to-classify brand of eugenics, because it confuses nature and nurture, race and milieu, implying at once that Mont-Saint-Jean's baby needs to be removed from its mother because of her congenitally monstrous nature, *and* that a removal from an urban lower class environment might be sufficient to right the wrongs nature inflicts.[41] It is one strand of a rather noxious discourse about the people that laces this novel, operating as a sort of glass ceiling for the populace he ostensibly wants to raise up from the streets.

—— LES MYSTÈRES D'EUGÈNE

Les Mystères de Paris pretends, on the one hand, to promulgate social justice and the rehabilitation of the unfortunate multitudes; on the other, it repeatedly implodes into scenes of the people as savage horde.[42] It is a novel that reproaches the state for its role in creating the downtrodden and hence the criminal masses, and goes on to suggest that it is society's responsibility to take remedial action in the form of utopian social justice projects. (These range in scope and intent from an agricultural rehabilitation project, to a similarly conceived prison farm, to a workers' bank, to punishment reform that includes a plan to surgically blind criminals as an alternative to expending prison resources.) The novel professes faith in the salvageability of (some of) the people. But plot developments and vivid tableaux that figure popular violence in the most brutish and inflammatory terms destabilize the lofty rhetoric of redemption.[43]

The novel's many contradictions, paradoxes, and inconsistencies do not lend themselves to reconciliation or resolution, though attempts at explanation are not lacking. Sue's biographer, Jean-Louis Bory, pleads a case for his subject's evolution: a young man born to privilege matures and develops a social conscience belatedly. Sue then (in sum) undergoes a veritable conversion experience at the time he is writing *Les Mystères de Paris* that leads to his becoming a socialist, a champion of the people, and an elected deputy for the people.[44] After reading along Bory's biographical line for a moment, though against the grain of his voice, I will propose a more cynical evaluation of his work that subordinates his life to his words.

For Bory, Sue was a typical offspring of privilege, the prototypical "spoiled rich kid." Born to a lineage of medical men, he showed no bent for such studies (or any others). His father, in desperation at his unrepentantly flighty, dissolute progeny, sent him off to sea as a corrective, as well-to-do despairing fathers in his era were wont to do (as Baudelaire's stepfather would do, and as did the father of the less privileged but equally irresponsible and headstrong Mathieu in Sue's short story "Le Parisien en mer").[45] When Eugène returned, he came into his inheritance and was able to resume a profligate, worldly life, styling himself as a dandy who loved pleasure and play and was unable to devote himself for any extended period to any one person, pursuit, or idea. He turned to literature, initially as a pastime and then, when he had exhausted his money, as a livelihood, writing first maritime novels and later social novels. His dispersed and often discontinuous style was perhaps the result, Bory suggests, of his early marine adventures, punctuated by short stints in different ports of call, so many distractions in his trajectory. Sue himself had already self-consciously and a tad anxiously discoursed on the subject of narrative disunity and disjointedness in the introduction to his 1831 novel, *Atar-Gull*.[46]

Something admittedly changes in Sue's focus and responsiveness as he writes his way into *Les Mystères,* a shift that Bory describes as a transfiguration: a turn from self-indulgent dilettantism and decadent self-absorption toward a certain attentiveness to others. In the midst of an existential crisis, approaching forty, developing a paunch, and at a loss for what to write next, Sue is introduced by his friend and colleague Félix Pyat to a worker-activist and his family; somehow in the space of this brief encounter, he sees the light. Sue, the dissolute son, the dandy, the flâneur, the spendthrift always in need of more cash, a new idea, an exotic port or plot, finds a calling as the people's advocate, writer and spokesman for the downtrodden.

There may well be some retrospective teleological truth to the train of this narrative; at any rate, Sue's philanthropic position begins to take form in his text.[47] Yet there is also a consistent inconsistency in Sue's writing, whether we are talking about expositional or ideological delivery: Sue seems always to do what he does, say what he says, in his books, letters, politics, by whim rather than

conviction. In *Les Mystères de Paris* we perceive this lack of conviction as an internally contradictory rhetoric, a rhetoric so overcharged that it corrodes narrative authenticity.[48] This is what makes it possible to stud the novel with theories of social progress and idylls of individual redemption, and yet to cast individual characters categorically in physiognomical types that build to a crescendo with a caricature of the people devolved to a raucous mob of bloodthirsty cannibals.[49]

—— CANNIBAL ZONES

These cannibals that close the body of *Les Mystères de Paris* are not to be taken lightly, even if they appear to be dressed up in metaphor as well as carnival costume, and even if they usher off the royals to an otherworldly epilogue removed to a Neverland called Gerolstein. They join with savages and primitives in a larger rhetoric that solders urban poverty to ethnic alterity, a nexus Kalifa suggests in his study of the nineteenth-century imaginary construction of the urban underworld, *les bas-fonds.*[50] The rhetoric of barbarism in itself is fraught and can never be sufficiently unpacked. But Sue's Parisian cannibals are also woven, throughout *Les Mystères,* into a tissue of orally linked violence, a violence centered on eating that extends to biting people as well as more ordinary foodstuffs, and also to force-feeding, to withholding food, to poisoning, to extracting teeth, and to speaking (to name just a few variants). They spill out of Paris to France's new Algerian colony, as they flow into Paris from West Africa in a veritable (distorted) replay of the French Atlantic triangle, via Floridian plantations with their enslaved Africans. The cannibals of *Les Mystères* are arguably avatars of the more routine exotic variety of overseas flesh-eater that we encounter, literalized, in Sue's earlier seafaring fiction, most significantly, in *Atar-Gull.* In other words, the black African cannibals of *Atar-Gull* turn that novel into a palimpsest by means of which we can better read the cannibal rhetoric and subplots of *Les Mystères de Paris.* All of these versions of cannibalism, ranging from the figurative to the literal, and from the urban to the foreign (or, we might say, from the endo- to the exo-colonial) beg to be considered together as overlapping manifestations and complications of harlequin eating, that is, as kaleidoscoping instances of eating the remains of the Other, and further, as variations on Sue's own Harlequin stance that lets him have his Others and eat them too.

PART II. AT SEA IN THE CITY: REREADING *LES MYSTÈRES DE PARIS* WITH *ATAR-GULL*

In turning to concentrate on scenes of eating that cross over oceans from Paris and back again, to situate Sue's lowly Paris eaters against overseas cannibals, I recall the origin of the term *bas-fonds* that became the common appellation for the dregs of society: those who were socioeconomically or ethnically Other, who inhabited what was taken to be the very lowest social and moral ground. The sociomoral category was derived from a maritime term referring to the dangers

Bal à la Barrière du Maine.

FIGURE 10 Echoing Sue's prose, his illustrator reveals the people in their barbaric colors and lewd, body-contorting dances at a tavern on the outskirts of Paris on a night when a public execution coinciding with Carnival excites the mob to a pitch. Charles Michel Geoffroy, *Bal à la barrière du Maine,* in *Édition illustrée des Mystères de Paris,* 4 vols. (Paris: Charles Gosselin, 1843–44), vol. 4. Wood engraving. Typ 815.43.8120 (v. 4), Houghton Library, Harvard University.

of the ocean floor, in English "the shoals," or "the deep bottom."[51] My return to *Les Mystères* through Sue's maritime fiction is, then, deeply overdetermined. It is compelled first by the textual resonances of the two novels, and then again by their eerie echoing in the double implications of the term *bas-fonds* that links Sue's social melodrama to his maritime fiction and traces the author's trajectory from sea to urban swamp.

—— *MENACES DE CANNIBALES*

The novel's end returns us to the beginning in a perfect circle of fabricated horror: a horror fanned by disgust, revulsion, and fear worked deep into the fabric of the closing narrative frame then acts as magnifying mirror for the opening frame (Figure 10).[52] Fleur-de-Marie's last encounter with *l'ogresse* mimics the opening one in that both take place in rowdy taverns in close proximity to each other. The symmetrical setting of the *tapis-franc* with its presiding *ogresse* and vicious mob situates the cannibal question as both final and primal, which is to say, structurally central.

When the term *cannibale* finally is articulated at the end of the novel, it is over-determined both by context and by narrative history. Most simply, *menaces de cannibales* refers to verbal threats made to Rodolphe's entourage by the raucous mid-Lent mob. As the royal party leaves Paris for the duchy of Gerolstein at day-break, they are set upon by the people roused to an untrammeled fury stoked by a night of carnivalesque drinking and reveling. The orgiastic celebration has been further fanned by the lure of official violence: the anticipated spectacle of a dou-ble execution to follow later in the day. The "cannibalistic threats" correspond also to the vaguer risks perceived by Rodolphe and his party (and projected onto the lower classes by Sue's narrator, who emphasizes in this closing moment the urgent need to show readers a graphic example of "le péril qui menace incessam-ment la société" [1149] [the peril that constantly menaces society]). Here once again this narrator is double-tongued: he couches his venomous depiction of the dangerous classes in the shape of social reformism. He protests "le vice des lois répressives . . . l'absence des mesures préventives, d'une législation prévoy-ante, de larges institutions préservatrices" (1149) (the vice of repressive laws . . . the absence of preventive measures, of precautionary legislation, of overarch-ing protective institutions). Yet the disgust that permeates his rhetoric is hard to ignore: "Qu'on s'imagine tout ce qu'il y a de plus bas, de plus honteux, de plus monstrueux dans cette crapule oisive, audacieuse, rapace, sanguinaire, athée, qui se montre de plus en plus hostile à l'ordre social" (1149) (Try to imagine all that is lowest, most shameful, most monstrous in this idle, brazen, predatory, bloodthirsty, godless and degenerative mob that shows itself to be increasingly hostile to the social order). While he seeks legislation to transform the muddy en-vironment in which "the disinherited" (*ces êtres déshérités*) wallow, he also seems to see this mire deterministically as their birthright, for he calls them "cette race de voleurs et de meurtriers [qui] . . . se gangrènent ainsi incurablement . . . dans la fange de misère, d'ignorance et d'abrutissement où ils se traînent en naissant" (1149) (this race of thieves and murderers who . . . fester incurably . . . in the mire of poverty, ignorance, and debasement they sink into at birth).

Still there is at least a small leap from the idea of a murderous, cutthroat, bloodthirsty crowd to that of a cannibal people, and it is here that we need to consider why we should understand the rhetoric of cannibalism to be conveying something more or rather, *other* than hyperbolic violence: something rather par-ticular that has to do with identifying the people as devouring, rapacious human flesh eaters. It is time to consider more closely the back story of anthropophagy in *Les Mystères* and other fictions by Sue, and a trifle less sensationally (perhaps), that of eating and speech.

—— **MOUTHINGS**

It is both unsettling and revealing to see the people relegated to gutter status, devolved to the *cannibale* and the *canaille* (words that for a long time were presumed to share the same etymology).[53] After all the rehabilitative measures, all the social engineering projects, all the socialist sentiments that Sue and Rodolphe have put in place, it is even more surprising, given the inexorable ideology of the entire novel, that it has taken so many pages for the term to be explicitly introduced. For the concept of the cannibalistic, as we noted in passing, was already introduced by implication in the initial harlequin scene, in the interstices between the reverential relish of le Chourineur savoring his plate and the disdainful shame (and shaming) of the narrator commenting upon it.[54]

The mouth then becomes the multivalent site of class demarcation: a passageway for food and words between the body and the external world, but one that is always socially mediated and complicated. As Maggie Kilgour has noted, "If cultures are defined by what they eat, they are also stereotyped by how they speak, as 'barbarian' referred originally to those who could not speak Greek."[55] In the case of le Chourineur, who puts into this orifice messy matter, and excretes from it coarse language, it is first a hole for vile substances to traverse in both directions. He is a master of prison slang, the subject of which opens the very first sentence of the novel, associating it with theft and murder: "Un tapis-franc, en argot de vol de meurtre, signifie un estaminet ou un cabaret de plus bas étage" (35) (A *tapis-franc* [dive bar], in the slang of thieves and murderers, designates the lowest kind of bar or cabaret). That this language, described as murderous, bloody, filthy, foul ("immonde" [35]), and completely marginal ("ces hommes ont . . . un langage à eux" [37] [these people have their own language]), receives so much fascinated attention from the very first disparaging sentence suggests how closely linked repulsion and seduction are, and what a game of cat and mouse the narrator is playing with his readers (not to mention himself). He apologizes profusely for his linguistic sins (in much the way he does for speaking of that other shameful oral abuse, the harlequin), while promising a moderation that never comes: "Nous n'abuserons pas longtemps de cet affreux langage d'argot, nous en donnerons seulement quelques spécimens caractéristiques" (38 note 3) (We will not indulge in this hideous slang for long, we will only offer a few characteristic examples).[56]

In fact, Sue's contemporary readers were both deeply shocked and utterly charmed by his gutter slang; Judith Lyon-Caen summarizes critical reaction to "l'irruption de l'argot" (the eruption of slang) in the respectable *Journal des débats,* where the novel was serialized as "le point de départ d'un immense scandale littéraire" (the starting point for a full-blown literary scandal), yet a contemporary article in *La Caricature* relates that slumming, linguistic and otherwise, had become quite trendy during the first six months of the novel's serialized publication: "Au lieu de prendre un professeur d'anglais ou d'italien, on suit un cours d'argot" (Instead of hiring an English or an Italian tutor, people take a slang class).[57] Both

accounts are true, both are representative, and both attitudes are already com-mingled in the author's presentation of the dirty words and smutty sounds he puts in his characters' mouths. Nowhere is bourgeois slumming more invasive, if often invisible, than in Sue's practice of observing and representing lower-class speech. When Sue's narrator apologizes profusely for the reproduction of "hor-rid" popular slang in his narrative, which nonetheless continues to absorb this language throughout, he is simultaneously appropriating it, incorporating it, absorbing it into his narrative system, within which an originary "higher" dis-course can no longer clearly be perceived, let alone extricated intact. Sue's novel effectively cannibalizes urban lowlife speech, taking leftover crumbs from the people's mouths, consuming them bit by bit, scrap by scrap. Eating the people's words, Sue's narrative performs linguistically the projected devouring processes played out in reverse class order by the harlequin feeding habits of the poor.

In the case of Rodolphe and Fleur-de-Marie, however, the mouth, as we have begun to see, is only semipermeable, or more precisely, selectively permeable. Rodolphe, though a discriminating eater, is a master of all trades, including the most marginal ones; he has somehow acquired fluent prison slang, and can speak it with the worst of them. That Rodolphe is adept at the foul language of ex-convicts and gutter trash is testimony only to his extreme flexibility and intel-ligence: here we have a linguistic disguise to complement his panoply of sartorial masquerades. Rodolphe can fake it like no other. That Fleur-de-Marie, who has lived among criminals for almost her whole life, does not speak their language, and in fact implausibly speaks Academy French, is perplexing on a logical level but clear on an ideological level; her natural purity must be maintained, her (yet undiscovered) position as royal daughter legitimated, to the extent that when Rodolphe first encounters the young woman in the streets, he is arrested by her voice, whose pure, clean tones, we recall, have earned her the nickname of la Goualeuse (Songbird): "Jamais timbre plus doux, plus frais, plus argentin, ne s'était fait entendre à son oreille" (41) (Never had such sweet, fresh, silvery tones reached his ear).[58]

But although eating and speaking are ostensibly class determinants (and are themselves determined by social mores), and though such determinations appear to be rigidly upheld, the boundaries are eminently breachable. The narra-tor's mockery of le Chourineur's lusty appetite for used food gives the impression of confirming staunch social hierarchies, but such contempt conceals fears of social leakage materialized by the descending passage of food. The downward directionality of such a passage is already a rhetorical cover for the circulation and interpenetrability of social classes: while expressing a slide down the socio-economic ladder and a corresponding plunge of aesthetic and sensorial taste, it masks anxieties about an upward movement of the lower classes, a potential uprising materialized by the appropriation of higher-class food, a phantasmatic upward passage of hungry mouths. The rhetoric of disgust surrounding the

harlequin is so thickly and ubiquitously applied that it seems counterintuitive to insist on a change in directionality—that is, to maintain that the harlequin poses at least as great a threat to the upper classes as it does to the underclasses who are taking the food from their mouths—but let us pursue that possibility.

—— THE DEVOURING CLASSES

The very idea of eating the remains of other people's meals, especially when they have lost their form and integrity, implies partaking of the body of those others by synecdoche: swallowing a bite, or sip, or breath, or taste of that other. Even without being digested, food that has touched the mouth, palate, tongue, teeth, saliva, breath of a being is irrevocably altered: diminished, supplemented, refigured.[59] We like to know what is being eaten, down to each trace of every discrete ingredient, so that we do not need to wonder who is being eaten. The horror of the harlequin lies in its indistinguishable ingredients, the unknowability of its unidentifiable sources. As William Ian Miller has argued, anything chewed is transformed, irremediably changed so that it evokes not mere death but the unbounded flux between life and death, a kind of "life soup."[60] I construe this "life soup" broadly, as representative of the erodibility of all boundaries, and the threat of residual flow.

More concretely, however, anything bitten or mashed evokes chewing, as Margaret Visser has noted—and anything chewed suggests violence.[61] The crude figure of the voracious Chourineur gulping down his *ramassis de restes,* his muddled mash of remains, is just an opening act. The late crowd scene joins the early harlequin scene to enclose the body of the novel in the bracketing images of the cannibalizing collectivity hurling imprecations, and the crowded harlequin plate harboring bones. Together they consolidate a hideous mosaic image of the people's palate, the people as palate, the cannibal palate as the working jaws of the people.

—— EATING OTHERS

Eating has multiple networks of meaning in *Les Mystères,* and all are integrally related to violence. At the novel's opening the most critical senses of the verb *manger* each make their appearance. Le Chourineur makes literal use of the verb in his urging that Fleur-de-Marie share his harlequin feast: "Mais mange donc, la Goualeuse . . ." (49) ("But eat up, la Goualeuse . . ."). Chronologically speaking, however, the very first instance of the frequently used verb occurs earlier, just a few pages into the novel, when le Chourineur, wrestling Rodolphe, threatens: "Si tu ne lâches pas ma cravate, je te mange le nez" (40) ("If you don't let go of my cravat, I'll eat [bite off] your nose"). This initial combination of eating and aggression slips into the extreme form of the metaphor, killing, when, a few chapters later, la Chouette stalls her companion, le Maître d'école, as he is drawing his dagger, stopping him from killing Fleur-de-Marie and Rodolphe on the spot:

"Minute . . . minute, *fourline* . . . tu mangeras ces deux mufles tout à l'heure, ils ne t'échapperont pas" (74) ("Hold on . . . hold on, you villain . . . you will get to eat [kill] those two fools soon enough, they won't escape you").

Manger also has to do with verbal assault, starting with the response of the *ogresse,* who refuses to snitch when queried about one of her clients: "Est-ce que tu crois que je vas *manger* mes pratiques?" (47; [*sic*]) ("Do you think I am going to *eat* [snitch on] my clients?") In this sense of spoken destructiveness too—informing on or turning in—*manger* pervades *Les Mystères.* The literal meaning of the verb is so routinely stretched to cover activities ranging from consuming food, to squealing on companions, to biting them, to destroying them, that each use bears shades of all the others, all becoming aggressively charged; and eating one's plate of food is consequently tinged with suggestions of devouring one's Others.

—— LE CHOURINEUR'S DREAM

Sue, then, immediately establishes eating, and more broadly, orality, within a semantic network of violence. Le Chourineur's story, recounted during the tavern dinner from which Fleur-de-Marie abstains, intensifies the connections. As he tells it, an early job as a slaughterhouse assistant plays a major role in his descent into criminality, catalyzing the chaotic inner turmoil of this child of the streets, furnishing an object for his aggressions. At age ten or twelve, though at first put off by the task of massacring horses, he comes to take pleasure in his savagery, especially when he is rewarded with a cut of the haunches of a diseased horse to eat either grilled or raw, as fortune allows. After puberty, however, his evolving reactions of distaste, then interest, and then pleasure turn to a frenzied rage, a hunger that can be sated only by bloodshed:

> "D'abord ça avait commencé par m'écoeurer d'égorger ces pauvres vieilles bêtes . . . après, ça m'avait amusé; mais quand j'ai eu dans les environs de seize ans et que ma voix a mué, est-ce que ça n'est pas devenu pour moi une rage, une passion que de chouriner! J'en perdais le boire et le manger." (67)

> ["At first it disgusted me to butcher those poor old beasts . . . later, it amused me, but then when I was about sixteen and my voice changed, well, somehow the slaughter became my passion and my obsession! It took over, was more important than eating and drinking."]

He describes how he would stand naked and feverish with a sharpened butcher knife raised in the midst of the horses he was to kill, striking wildly with uncontrollable lust:

> "Quand je me mettais à les égorger, je ne sais pas ce qui me prenait . . . c'était comme une furie; les oreilles me bourdonnaient! Je voyais rouge, tout rouge, et je

chourinais . . . et je chourinais . . . et je chourinais jusqu'à ce que le couteau me fût tombé des mains! Tonnerre! C'était une jouissance!" (67)

["When I began to kill them, I don't know what came over me . . . it was like a furor; my ears began to ring, I saw red, red everywhere, and I slashed . . . I slashed . . . and I slashed until my knife fell out of my hands! Damn, what a turn-on!"]

The excessive reiteration of the verb *chouriner,* another slang usage that ostensibly lashes bourgeois ears and sensibilities, ensures that the physical act of unrelenting slashing (reverberating constantly in le Chourineur's moniker as well) is performed, too, as a linguistic attack.

Before continuing, I want to emphasize that le Chourineur's narrative repeatedly loops back to connect equine slaughter and eating, both in the logical chain of events by which killing horses yields horsemeat, and in the figurative substitution of chevaline bloodlust for more quotidian forms of bodily hunger. Food and carnage, eating and killing, hunger and murderous desire, the violence of doing and the violence of speaking, all come to fulfill parallel needs for le Chourineur, and all are sexually charged.

In her exploration of the changing fortunes of hippophagy in nineteenth-century France, Kari Weil implies a connection between the human consumption of horsemeat and of human meat in the nineteenth century—when the horse was at the pinnacle of popularity and near domestication—as if hippophagy were a substitute for anthropophagy, a way to eat an Other who is almost Self to avoid eating the Self.[62] The continuation of le Chourineur's narration suggests a similar hypothesis, and then goes on to frame it in even bolder terms by means of the workings of dream logic.

Here is the next sequence of his story. After being fired because his frenzied slashing surpasses even the tolerance of the slaughterhouse, le Chourineur seeks work as a butcher. But when he is rejected from this ostensibly related work by the butcher shops because of his vulgar occupational background (slaughterhouses and butchers having been rigorously separated and hierarchized by the early nineteenth century), le Chourineur joins the military. Offended one day by his sergeant, he loses control and falls into a state resembling his old slaughterhouse ragings; obedient only to blind fury, he kills the sergeant and wounds two soldiers. Fifteen years later, after he has manifested signs of rehabilitation (he has risked his life to save numerous comrades), his death sentence is commuted. Released from prison, he is nonetheless condemned to a recurring nightmare that combines the barracks murder and the slaughterhouse massacre, replayed in a scene of horrific genocide:

"Il ne se passait presque pas de nuit où je ne visse, en manière de cauchemar, le sergent et les soldats que j'ai chourinés, c'est-à-dire ils n'étaient pas seuls, ajouta

le brigand avec une sorte de terreur; ils étaient des dizaines, des centaines, des milliers à attendre leur tour dans une espèce d'abattoir, comme les chevaux que j'égorgeais . . . Alors je voyais rouge, et je commençais à chouriner . . . à chouriner sur ces hommes, comme autrefois sur les chevaux. Mais, plus je chourinais de soldats, plus il en revenait . . . Ce n'était pas tout . . . je n'ai jamais eu de frère, et il se faisait que tous ces gens que j'égorgeais étaient mes frères . . . A la fin, quand je n'en pouvais plus, je m'éveillais tout trempé d'une sueur aussi froide que de la neige fondue." (68)

["There was scarcely a night that passed when the sergeant and the soldiers that I'd slaughtered didn't appear to me in a nightmare, and in fact they weren't alone," added the felon with a kind of terror; "there were dozens, hundreds, thousands of them waiting their turn in a kind of slaughterhouse, like the horses I'd killed . . . Then I saw red, and I began to slash out at these men, like I had in the past at the horses. But the more soldiers I cut down, the more returned . . . And that's not all . . . I never had a brother, and yet it happened that all the men I killed were my brothers . . . At last, when I couldn't bear it any longer, I would wake up in a sweat that soaked through me like cold melted snow."]

In this anticipatory Baudelairean dreamscape, carnage lushly flowers: life blooms from death as le Chourineur's grim reaping of soldiers sows multiple new lives. As is often the case for dreamers, le Chourineur awakens from his nightmare before the worst part—the merely implied part—of his phantasm is played out. If his dream replays the trauma of long-term work in the abattoir and grafts it onto the murder of his sergeant as a scene of mass human rather than equine slaying, it elides the logical next step. The slaughterhouse boy who retrieved an alimentary compensation from his horsekill is played in the dream by a grown man who slays men in a military slaughterhouse, with the unspoken alimentary corollary being human meat. In the elided sequence, the dream-Chourineur would become the most extreme kind of cannibal: since the genocide of his nightmare is marked as a symbolic fratricide ("tous ces gens que j'égorgeais étaient mes frères") in which he would be eating his brothers. The frenzied dream rhythm suggests he will stop at no one—consuming his brothers, consuming himself. This would be anthropophagy joined with incest and coupled with autophagy in the most restrictive sense of eating one's own.

—— B/EATING

Les Mystères de Paris begins with a beating: a child, Fleur-de-Marie, is being beaten. She is rescued by a passing stranger (Rodolphe) who begins to beat the unknown beater (later revealed to be le Chourineur). From here, we slide right to the feast scene passively observed by the child. The novel ends well over a thousand pages—but just a few years—later, with this same child being "eaten."

75

Fleur-de-Marie or la Goualeuse, renamed "Amélie" in an attempt to wipe clean her history, ends her life fasting, devoured by a past that will not be erased. The passage from being beaten to being eaten, and from beating to eating, punctuates the novel, forming both the overarching trajectory for Fleur-de-Marie's short life and the microrhythm of its many long subplots.

Sue's novel also plays out an assortment of fantasies revolving around beating and eating and their fused performances, exemplified by the bits of le Chourineur's and Fleur-de-Marie's featured stories that we sampled and that are dispersed throughout the text. The reader is spectator to scenes best described by a few serial examples:

1 A caretaker (la Chouette) bites chunks of flesh out of a child's face (Tortillard's) in sadistic parodies of kissing.[63]

2 An unjustly imprisoned young man (Germain), accused of being *un mangeur* (a mole), is in turn "mangé," denounced and marked for assassination by a hardened killer (Gros-Boiteux), facially well suited to his task of *mangeur*: "Sa physionomie bestiale . . . se rapprochait beaucoup du type du bouledogue . . . [sa] lourde mâchoire . . . inférieure, très saillante, était armée de longues dents, ou plutôt de crocs ébréchés qui çà et là débordaient les lèvres" (950) (His bestial physiognomy . . . was similar to a bull-dog's features . . . his heavy lower jaw, which was very prominent, was armed with long teeth, or rather, jagged fangs that stuck out over his lips in places).

3 A rodent-infested cellar serves as a makeshift prison and torture chamber, where the god-fearing (Rodolphe) and the evil (le Maître d'école and la Chouette) are equally likely to be fed to the rats and to each other. Rodolphe, of course, endures, but the pair of erstwhile lovers emerge battered, bitten, and half-dead—that is, he survives, disfigured by her teeth; she dies, grotesquely mauled at his hand and mouth.

The reciprocal phonetic echo that English gives to the verbs *beat* and *eat* is expressed otherwise, but just as sharply, by the semantic overdetermination in French of the verb *manger* that Sue, we see, knows how to exploit. Beating and eating walk hand in hand, subsist fist on fist. To beat is to dominate, to harm, to do violence, to consume or destroy. Eating is a specific kind of beating: it is to strike with the teeth and absorb into the body. Similarly, effecting the eating of an Other, or feeding an Other (*faire manger* in French) also involves penetration of the body. Isidoro Berenstein's description of what constitutes beating holds true for eating and feeding as well: "the act of entering the body of the other through an orifice, which may take two forms . . . The first is through a natural orifice . . . The other form, connected with violence, is penetration through a non-natural orifice, and here there are two subforms: predestined orifices that, however, constitute closed doors that are violated by the act of penetration, or surfaces in

which an orifice is opened up, as in wounding . . . equivalent to making a orifice where none exists . . . and it is the . . . skin that bears the marks."[64] Both verbs imply transgressing bodily boundaries. Rodolphe beats—dominates—le Chourineur in their match. He could have b/eaten him in all senses of the verb *manger*; he could have finished him. Instead, he feeds him (moving from *manger* to *faire manger* [to eat/to feed]). This is another way to dominate. Rodolphe then has le Chourineur eating out of his hand, so to speak; and this is the very metaphor le Chourineur uses to describe his attachment to Rodolphe: "les chiens . . . sont bêtes, ce qui ne les empêche pas d'être attachés et de se souvenir au moins autant des bons morceaux que des coups de bâton qu'on leur donne; et M. Rodolphe m'avait donné mieux que des bons morceaux, pour moi M. Rodolphe c'est tout . . . je suis à M. Rodolphe comme un chien est à son maître" (994–95) ("dogs . . . are animals, which doesn't prevent them from forming attachments and remembering the treats at least as much as the blows they are given. For me M. Rodolphe is everything . . . I belong to him like a dog to his master"). At the end, retaining the "attachement aveugle, obstiné du chien pour son maître" (1142) (blind and stubborn attachment of a dog to his master), like a loyal dog, "brave et dévoué," in Rodolphe's words (1155), he saves his master's life.[65] But at the beginning, Rodolphe feeds him a harlequin plate of food that could in theory have begun as a dinner at his table served to his worldly Paris friends, taming him as one would any animal.

—— A TOOTH FOR A TOOTH

But back to Fleur-de-Marie. Her story is no gentler than le Chourineur's, as both observe when they compare notes. It also follows a path from beating to eating, with the difference that she is the receiver rather than the giver of blows, or analogously, the dinner rather than the diner. Her earliest memories of an enslaved childhood include performing forced labor in the service of feeding others (digging worms to sell to fishermen, selling barley sugar on Paris bridges), and receiving harsh beatings meted out in the place of food: "Quand je n'apportais pas au moins dix sous en rentrant, la Chouette me battait au lieu de me donner à souper" (53) ("When I didn't bring home at least ten sous, la Chouette beat me instead of giving me supper"). Locked in a vicious cycle of beating and eating, the starving girl is all the more battered and trampled underfoot when she cries out in hunger. Finally, one day the famished child can no longer resist the temptation of her wares and dares to sample some unsold barley candies. Caught in the act by her vigilant keeper, she is duly punished in the way of talion law: la Chouette puts the child's head in the vice-like grip of her knees, and, working methodically with pliers and cruel fingers, she succeeds at last in extracting a tooth. Her subsequent warning to Fleur-de-Marie plays oddly on binaries of eater and eaten: "Maintenant, je t'en arracherai une comme ça tous les jours . . . et, quand tu n'auras plus de dents, je te ficherai à l'eau: tu seras mangée par les poissons;

y se revengeront sur toi de ce que tu as été chercher des vers pour les prendre" (57–58 [*sic*]) ("From now on, I will pull out one of your teeth like that every day . . . and when you don't have any teeth left, I'll throw you in the water: you'll be eaten by the fish; they will get even with you for all the worms you dug to catch them"). In this world of Sue's, one must devour or be devoured. Already hungry, now deprived of a tooth, she will be rendered incrementally toothless, which is to say, edible: meat for other teeth.

It is at this point that the terrified girl makes her break for the streets. Even if she escapes with most of her teeth, the extraction emblematizes a symbolic toothlessness. That is, from feeder, she has been reduced to food: "La faim me dévorait," she recounts (58) ("I was devoured by hunger").[66] And indeed, over the many ensuing pages, Fleur-de-Marie will be devoured in serial morsels, consumed bite by bite. She will be starved into prostitution, rescued, and sent to a fresh-air cure, abducted and thrown back to the gutters, unjustly incarcerated; she will narrowly escape death at the hands of gutter "cannibals"—which is to say, *la canaille*—in the penultimate urban street scene that returns her (and her reader) to the opening harlequin scene.

The narrative loop is closed here and Fleur-de-Marie's lifeline cut. Though we see Rodolphe and his newly recognized daughter escaping from Paris (their flight is merely postponed by the predatory mob seeking blood), ostensibly for an idyllic new life back in the duchy of Gerolstein, the cannibalizing interruption augurs her end. For if in the closing frame Fleur-de-Marie recognizes as horrific portent the face of the monstrous tavern keeper of the opening frame, *l'ogresse*— one of many cannibals in the fearsome mob—it is because she emblematizes the jaws to which the girl is being returned at the very moment of her apparent liberation. These are memory's jaws reopening in the guise of premonition; the cavernous mouth of her past among the people is a trap that will never let her free, never spit her out whole to reclaim her noble birth, never release her unscathed to a noble future. This is the virtual scene of her end; the actual death is only deferred.

In an epilogue that liberates Fleur-de-Marie into a fairy-tale extraurban life complete with castles and jewels, ladies-in-waiting, extravagant bouquets, a handsome, well-born suitor, and a new identity, she will actively choose the fate she managed (if barely) to elude during all of the preceding pages: she fasts her nineteen-year-old self to death in a cloister cell, allowing her relentless history to swallow her at last. Rodolphe's daughter languishes under the blight of her tainted past as "Princesse" and then "Soeur" Amélie (though the narrator maintains the right to the end to call her "Fleur-de-Marie").[67] In contrast—and in penance, one supposes, for her moral stains—she becomes whiter and whiter as she appears to move forward into her royal station in Gerolstein, and then into her religious life, and into death:

Fleur-de-Marie se leva droite, pâle, et belle de la majesté d'un malheur incurable. (1197)
[Fleur-de-Marie drew herself up majestically, rendered pale and lovely by her incurable suffering.]

Ses traits amaigris . . . ont la froide blancheur du marbre. (1199)
[Her gaunt features . . . have the cold whiteness of marble.]

Je fus effrayé . . . de sa pâleur et de la profonde altération de ses traits. (1205)
[I was frightened . . . by her pallor and her profoundly altered features.]

Fleur-de-Marie . . . devint encore plus pâle. (1207)
[Fleur-de-Marie . . . paled even more.]

Whiteness—what David Batchelor elaborates, in his study of fear of color in the Occident, as "the virtuous whiteness of the West"—is incarnated in "the great Western ideal of the classical body," a body that, diametrically opposed to the open, visceral medieval body Mikhail Bakhtin ascribed to grotesque realism, is pure white, finished, and self-contained: "All orifices of the body are closed."[68] Although Fleur-de-Marie has always been represented as angelic, pale, white-handed, originally pure, and only accidently marked, and though it is clear that she has been tainted by force and not by choice, somehow neither she nor the plot that drives her can ever cleanse her enough—though it is not, as we can see, for lack of trying (Figure 11).[69]

—— THEORIES OF COLOR

There is as much ambivalence about color among different color theorists—and also, at times, even *within* the musings of individual theorists—as in Sue's declarations about the people. In fact, color theory appears to be a kind of harlequin, inconstant and chameleonlike. A certain strain of thought endures over the centuries, however. It is epitomized by Goethe (writing two decades before Sue), who wants to purge color from high culture, sequestering it in a realm of Otherness projected onto animals, children, savages, workers, the ill, and often, women. According to Goethe, "It is . . . worthy of remark, that savage nations, uneducated people, and children have a great predilection for vivid colours; that animals are excited to rage by certain colours; that people of refinement avoid vivid colours in their dress and the objects that are about them, and seem inclined to banish them altogether from their presence."[70] Academy art historian Charles Blanc (so well named) maintains Goethe's premises, emphasizing color's pernicious feminine nature. He couches his thoughts in the long-standing debate about color and design when he writes, two decades after Sue's *Mystères,* "Colour . . . is the

FIGURE 11 Sue's illustrator reemphasizes Fleur-de-Marie's purity by the dove on her shoulder, reinforcing the white coiffe and apron she wears at her haven in the countryside. Gustave Staal, *Fleur-de-Marie à la ferme de Bouqueval*, in *Édition illustrée des Mystères de Paris,* 4 vols. (Paris: Charles Gosselin, 1843–44), vol. 2. Wood engraving. Typ 815.43.8120 (v. 2), Houghton Library, Harvard University.

peculiar characteristic of the lower forms of nature, while drawing becomes the medium of expression, more and more dominant, the higher we rise in the scale of being. The union of design and colour is necessary to beget painting just as is the union of man and woman to beget mankind, but design must maintain its preponderance over colour. Otherwise painting speeds to its ruin: it will fall through colour just as mankind fell through Eve."[71]

Writing ostensibly about lexical roots in his encyclopedic *Etymologies* well over a millennium earlier, scholar and archbishop Isidore of Seville had already suggested the elemental reason for which color was demonized and feared in his time, and was, still, when Sue was writing, and well beyond: "Colors are named

colores because they are brought out by the heat, *calor,* or fire or sun."[72] Whether his etymology is false or not, it is revelatory of long-lasting associations of color with the sun and its complex range of derivatives: heat, light, fire, passion, instability, danger, and excitement. Isidore's evocation of sunlight and fire is suggestive but restrained in its exposition; jumping forward to twenty-first-century anthropologist and color theorist Michael Taussig, we find a more expansive musing that both echoes the archbishop's multivalent tracing of *colores* to *calor* and reflects the long history of ambivalent reactions to visual vibrancy: "Distaste for vivid color is actually an unstable mix of attraction and repulsion. . . . [Color is] a splurging thing, an unmanageable thing like a prancing horse . . . this formless thing that we need to fence in with lines and marks, the boundary-riders of thought. . . . Color amounts to crime."[73]

Taussig's articulation of the seductiveness of color was anticipated by Le Corbusier's elegiac ode to its powers: "To thrust your hands into the deepest part of your pockets and, with eyes half closed, to give way to the slow intoxication of the fantastic glazes, the bursts of yellows, the velvet tones of the blues . . ."[74] The architect's infatuation with pigment does not prevent him from conventionally assigning it to the realm of the Other, however, as in his terse but crystalline declaration that "[color is] suited to simple races, peasants and savages."[75]

Twenty-first-century theorists Batchelor and Taussig each understand responses to color, whether they tend toward rejection or embrace, as emotions inspired by the unknown or the unfamiliar. Batchelor comments that the marginalization of color in the Occident, since antiquity, is a prejudice that, like any other, "masks . . . a fear of contamination and corruption by something that is unknown or appears unknowable."[76] Taussig reaffirms associations of the colorful with defamiliarization, and revalorizes them positively, while linking the lackluster to the familiar, in his observation that "to sail from home is to exchange a colorless world for a colorful one."[77]

The diachronic record shows the unequal binary of design and color to be of remarkable longevity across the centuries in Western culture, with color's riotous chaos and sometimes acknowledged lure regularly assigned to design's discipline.[78] Despite the continuity, it may be useful to briefly situate the nineteenth-century stage upon which the battle of line and color played out. The Renaissance articulation of the Florence–Venice-based debate about *disegno* versus *colore* was continued in seventeenth-century France with Nicolas Poussin and Peter Paul Rubens charged with picking up the gauntlet for line and color, respectively. In the early nineteenth century, the two camps were represented by Jean-Auguste-Dominique Ingres and Eugène Delacroix, with the first artist associated with neoclassical linear purity, and the second, with romanticism's splashy, dramatic use of color. The confrontation would come to a head several years after *Les Mystères* (beginning roughly midcentury) with the rise of the group of artists who would become known a few decades later as the Impressionists,

who made their presence known (and contested) through their spectacular use of vivid color. Though in one sense this was nothing new, the expansiveness and intensity of this aesthetic phenomenon (whose proto-emergence historians date to the 1850s but would have been building at the time Sue was writing his own colorful novel) peaked around midcentury, at a moment very close to that at which Sue's *Mystères* burst out upon the scene.[79]

—— THE COLOR OF THE PEOPLE

Small wonder that Sue needs to blanch Fleur-de-Marie within and against her early popular milieu of rampant, unruly colors. Sue's lower classes are not white. Their hearts are dark, their skin is swarthy ("hâves et tannées" [942]), their hair multicolored, and their clothes, a cacophonic pandemonium of hues. Le Maître d'école has "un visage olive" (69); "marbr[é] de cicatrices violâtres"; and "[des] paupières rouges" (281) (an olive complexion; marbled with purplish scars; reddened eyelids). We have noted the rush of colors tinting Mme Pipelet's wig red, yellow, brown, and tawny, with a few remaining strands of blond (201). The animal tamer Coupe-en-Deux in the convict Pique-Vinaigre's story is a veritable rainbow: "il avait le teint couleur de revers de botte, les cheveux rouges comme les poils de son singe, les yeux verts, et . . . la langue noire" (971) (his complexion was the color of the underside of boot leather, his hair, as red as his monkey's fur, his eyes, green, and his tongue black). When le Chourineur is in his heat of slaughter, all, we recall, is red: "Je voyais rouge, tout rouge, et je chourinais" (68). Such portraits of lower-class individuals who feel no shame in showing their true colors are partial echoes of the harlequin counterpanes, decors, and outfits we have seen, and foretell the appearance of the cannibal horde in the final carnival scene.

Those revelers who do not have the means to buy masquerade costumes, animal heads, masks, or other such disguises wear color instead. And even those who can afford costumes augment them with garish patches of color: "des guenilles de couleurs tranchantes" (1147) (rags of garish colors).[80] Examples abound: there is the woman coiffed in torn ribbons and "une sorte de justaucorps de drap rouge . . . [et] une jupe verte" (1148) (a tight-fitting jacket of red cloth . . . and a green skirt), or the man who has blackened his face and dressed in "une haute cravate faite d'un vieux châle rouge . . . un habit vert en lambeaux et . . . un pantalon garance rapiécé en mille endroits" (1148) (a high cravat made of an old red shawl . . . a green frock in tatters, and . . . red trousers patched in a thousand places), or his dance partner wearing "une veste et un pantalon de velours vert éraillé assujetti à la taille par une écharpe orange aux longs bouts flottants" (1148) (a jacket and frayed green velvet pants fastened at the waist by an orange sash with long flowing ends), or the child dressed like a little devil, additionally sporting "un caleçon rouge et . . . un masque vert horrible et grimaçant" (1149) (short red pants and a horrible, grimacing green mask). The high color of the lowlife is to be contrasted with the colorlessness of Rodolphe and his daughter, "vêtu[s] de

grand deuil" (dressed in high mourning); Fleur-de-Marie in particular is by contrast all toned down in black and white. "[Sa figure] s'encadrait dans une petite capote de crêpe noir qui faisait ressortir encore la blancheur éblouissante de son teint" (1151) (Her face was framed by a little bonnet of black crepe that made the dazzling whiteness of her complexion stand out all the more).

Although the people's colors break out in force with the carnival mania at the end, this is only the crescendo toward which the gaudy bursts of their everyday overcolorful life have been tending, and which contrast with the more muted colors that characterize the likes of Rodolphe and Fleur-de-Marie.[81] The assigning of color to the people, to the (savage) horde, is a way of cordoning it off, marking it as an uncivilized and marginal characteristic (by way of an equation of the lower classes with primitive people—about which I will have more to say later). To color the people is to erase color from society "proper." But it is also a way to preserve color and the chaotic forces with which it is associated, situating them on a kind of reservation land that is outside conventional social territory but nevertheless open for tourism.

— CANNIBALS AT SEA: WHITE MEAT FOR BLACK SAVAGES

A dozen years before applying the epithet "cannibales" to the carnivalized people of Paris in his *Mystères,* Sue wrote a more "conventional" Middle Passage cannibal story into his 1831 maritime novel, *Atar-Gull.* Here we have the banal stuff of nineteenth-century exoticizing: two warring African tribes, *les grands Namaquas* and *les petits Namaquas,* respectively, take prisoners and make meals of each other.

But here is the longer version. A French slave ship off the African coast is pirated by another of its kind and divested of its human cargo—referred to by the then-common derogatory term *bois d'ébène* (ebony wood)—along with its white crew and captain, Benoît.[82] (To underscore what will already be obvious to readers used to Sue's cynicism, the reason for the seizure of the enslaved Africans is economic rather than humanitarian: they have value as movable property for the pirate captain, who never entertains a thought of liberating them.) Before re-embarking for Jamaica, where he will sell his stolen cargo to the colonists, Brulart, the Machiavellian captain of the pirate slaver, exploits his knowledge (and doubtless, reader expectations) of African cannibal practices and tribal rivalries to purge his white captives at the mouths of the *petits Namaquas.* Brulart's emissary delivers Benoît and his men to the *petit Namaquas* village along with a revelation of Captain Brulart's role in trafficking their compatriots. Brulart's urging to deal the white men the fate normally reserved to their *grands Namaquas* enemies is enhanced by the promise of uncharted gastronomic pleasure: "Si vous destinez vous ennemis à être dévorés, tâtez du Blanc, et vous verrez que c'est un manger fort délicat" (197) ("If you assign your enemies to be devoured, try a White, you will see that it is a very delicate meat"). The tribesmen take the proffered bait: the last we see of Benoît and his crew, they are tied up on the ground

while the entire community of *petits Namaquas*—children, women, men, and the aged—give themselves over to a delirious transport. Pointing at the bound white prisoners, they rub their bellies in anticipatory glee and chant an ode to gastric interment: "Nous les ensevelirons là, noble tombeau, noble tombeau pour les hommes pâles" (199) ("We will bury them here in this noble tomb, such a noble tomb for white men").

So a circle of human trafficking and cannibalism is closed, leaving open, however, questions of agency, responsibility, and even definition. If at first glance it seems obvious who the cannibals are, and what cannibalism is, a second look displaces facile conclusions. As Benoît begins to grasp his impending doom in the pots of the people whose families he has plundered, he uses the label "cannibale"—but not to designate a prospective *petit Namaquas* feeder; he is referring instead to Brulart as the agent of the machination that delivers him and his truth to the people who will consume his body ("Mais tu es donc un monstre . . . un cannibale . . . criait sourdement Benoît" [198]) ("But then you are a monster, a cannibal," Benoît protested dully). But if Brulart is a cannibal (or even a cannibal in scare quotes) because he brings about the consumption of humans by other humans, what are we to think about his crew, not explicitly labeled "cannibal," but "demon," and described as "noirs de poudre et de fange, basanés, cuivrés, bronzés, cicatrisés . . . les yeux farouches . . . les ongles crochus" (180) (black with gunpowder and muck, swarthy, copper-colored, sunburnt, scarred . . . with savage eyes . . . and claw-like nails), and introduced on a deck "couvert . . . de larges taches d'un rouge noir . . . mêlées de certains débris membraneux séchés et racornis au soleil, que Benoît reconnut en frissonannant pour être des restes de lambeaux de chair humaine!" (181) (covered . . . with large, dark red patches mixed with dried membranous debris shriveled up by the sun, that Benoît recognized with a shudder as the tattered remains of human flesh!). And what should we say about Benoît, whose commerce in lives has caused the destruction of so many, both those he cavalierly relegates to the category of "le déchet," the collateral waste of the shipboard passage (the dead and infirm), and those captives delivered alive to the colonies but whose lives and limbs are radically altered under the regime of slavery? What of "le père" Van-Hop, the white dealer who procures *petits Namaquas* prisoners from the *grands Namaquas* for the slave traders, and then boasts of having elevated the *grands Namaquas* from cannibalism by providing them with this alternative means of population control?[83] What of the slave Atar-Gull, the eponymous protagonist (to whom we shall return), who bites open his veins, only to be "saved" from devouring his own life by the financially motivated ministrations of Brulart, who gives orders to one of his seamen to stanch the captive's wounds with wads of chewed tobacco? Nor should we forget the rattling chests and buccal contortions of the shackled Africans who seek death in the ship's hold by straining to swallow their tongues.[84]

Here, then, are multiple variants on cannibalism, ranging from eating the Other, to eating the self, to having the other eaten by another Other, to "consuming" the other by nonoral means (slavery prime among them).[85] This latter broad category of consumption coincides with one of the frequent metaphorical uses of *manger* to connote violence of many sorts in *Les Mystères de Paris*. In *Atar-Gull* the brutalities of enslavement and cannibalism come to cross on more than one occasion, well emblematized by the enigmatic description I cited earlier of the ship's deck on Captain Brulart's aptly named *Hyène*. The exact source of the dark red stains mixed with "certain dried membranous debris" recognizable as shreds of human flesh is never explained; in immediate shipboard context the reader might most directly make a connection to the so-called *déchets* (waste products) of the slave trade, the Africans presumably beaten to a pulp there, yet given the wider novelistic frame it is impossible that such human scraps not also evoke a dinner of harlequin remains, the parodic harlequin plate of cannibalism, the other system for disposing of reviled bodies that traverses *Atar-Gull*.[86]

Sue's reiterated pairing of slave trading and cannibalism—respectively, the business of humans *beating*—in the most extreme sense—other humans, and the business of humans *eating* other humans—cries out for commentary. What is at stake in the recurrent analogizing of slave traders to cannibals? Certainly we can pick up, in Sue's repeated suggestions that the barbarism of the "primitive" cannibals who consume their enemies is met and matched by the brutality of "civilized" men (the "civilized" Europeans and "semicivilized" Africans who trade in human lives), an echo of Michel de Montaigne's model in "Des Cannibales."[87] Sue's frequent narrative ironizing of the superficially "honest" and "fatherly" slave trader Benoît expresses a certain condemnation of the hypocritical paternalism of his métier, and ostensibly exposes the evil of subordinating black to white humans under the guise of sound commerce.[88] So, for example, Captain Benoît "fai[t] la traite avec autant de conscience et de probité qu'il est possible d'en mettre dans les affaires, et ne croyant pas agir plus mal que s'il eût vendu des bestiaux ou des denrées coloniales" (158) (engages in the slave trade with as much conscience and probity as is possible to invest in a business, and does not believe he is acting any worse than if he had sold cattle, or produce from the colonies). Similarly, "l'honnête Benoît . . . après tout, faisait, si vous voulez, un petit trafic que quelques personnes réprouvent, mais au moins le faisait-il honnête-ment, en conscience, et, après tout, comme il le disait avec beaucoup de justesse d'esprit: 'Pour soutenir les colonies; car, sans colonies, adieu sucre, adieu café, adieu indigo . . .'" (181) (the upright Benoît, after all, engaged in some commerce that some, if you like, condemn, but at least he worked honestly, conscientiously, and after all, as he would say with great clarity of mind: "It is to support the colonies, for without the colonies, it's goodbye to sugar, goodbye to coffee, goodbye to indigo"). Sue's narrative ironizing of the posture of racial superiority that he

reveals in his slave traders ostensibly holds him apart from it. But it is uncertain if his irony clears him of the act of othering or wraps him in a veil of complicity with it.

Outside the protective cover of ironic discourse, unsettling phrases emerge. There is a reference to "la stupide ignorance des sauvages" (203) (the stupid ignorance of savages). Descriptions of the *petit Namaquas* slave Atar-Gull routinely focus on his sharp white teeth, as in "son eternel sourire qui laissait voir ses dents blanches et aigues" (245) (his eternal smile that showed his sharp white teeth). The slave is regularly bestialized by the narrative, rendered as predatory: "s'élançant comme un tigre" (244) (bounding like a tiger); "en rugissant comme un lion, et mord[ant] la terre avec rage" (244) (roaring like a lion, and biting the dust with rage). So there is a kind of counterdiscourse that threatens to undo the work of irony, reducing the African to tired stereotypes of the savage and the cannibal. While Sue periodically winks at the reader, he continues to reproduce these stereotypes.

—— M. TARGU THE HARLEQUIN MAN

Atar-Gull undergoes a slow, secret, and apparently radical transformation over the course of the novel. Captured from his *petit Namaquas* tribe by the *grands Namaquas,* sold to Captain Benoît as merchandise—*bois d'ébène*—and then pirated off as the same by Captain Brulart, resold to the British planter Tom Wil in Jamaica, relocated to England and finally to France as a freed man still serving as Wil's personal slave, Atar-Gull's life story circumscribes the full Middle Passage, but departs from any stereotypical trajectory.

It is true that his body is heavily scarred from repeated beatings and that he has witnessed horrific crimes, from the maiming of his lover to the lynching of his father (whose productivity had declined with age), and in that, his personal history of enslavement does not look unusual. However, Atar-Gull's line of action is ultimately not flat and compliant. He has plotted a slow course of revenge relying on his painstakingly measured fanning of smoldering rage, his cunning, and his calculated planning. Over long years and with recourse to *marron* sorcerers in the Jamaican hills, he has stealthily engineered the ravaging and financial ruin of the plantation and the poisoning of the livestock; he has arranged the death of Wil's daughter and wife—events whose somatized climax is the master's muteness, technically attributed to paralysis of the tongue.

Superficially attentive and faithful to the end, Atar-Gull (Frenchified, in France, as "M. Targu"—and I will use the two names interchangeably) ends up in a garret room in central Paris with Wil, who has become completely dependent on his former slave for his every need: physical, psychological, and financial. While all onlookers, from the doctor to the concierge to the neighbors, marvel at the apparent devotion of the now-freed "slave" selflessly nursing a bedridden, indigent, and senile "master" who is increasingly incapacitated (and whose

muteness conveniently prevents his correction of their misperceptions), Atar-Gull takes his revenge, revealing to Wil his step-by-step role in preparing the planter's familial and professional debacle. He tortures him by persistently rehearsing, *en huis clos,* every detail of the death and destruction he cunningly prepared. Finally acceding to the role of power he schemed over protracted time, Atar-Gull has reversed positions. Inverting years of submissive silence, he speaks truth to a silenced master. He ekes out payment for Wil's expenses by performing odd jobs; the sheer will of the former slave is responsible for any food or medication that passes the lips of Tom Wil. Atar-Gull has become master to the former planter, who dies way too soon for his attendant servant to inflict sufficient suffering on his former torturer. M. Targu cries genuine tears of rage at the too-rapid expiration of his revenge—tears misinterpreted by observers as signs of the grief of a sorrowful servant—and is duly awarded the Montyon Virtue Prize for his long-standing loyal care of the expired colonist (Figure 12).[89]

Atar-Gull, a.k.a. M. Targu, is the modern Harlequin, crisscrossed with scars and masked by shadow. The night, we are told, is "l'unique instant où [Atar-Gull] pouvait quitter son masque d'humble et basse soumission" (243) (the only moment when Atar-Gull could take off his humble and groveling mask). He is regularly shown hidden behind curtains or lurking under cover, even after his "master's" death, when he can be found "au fond d'une obscure travée, masqué par un rideau rouge . . . un personnage sombre et silencieux avait prêté une oreille attentive . . . c'était Atar-Gull" (295) (shrouded in a hidden wing of the theater, masked by a red curtain . . . a mute and shadowy character had been listening attentively . . . it was Atar-Gull).

M. Targu's physical being is a grotesque parody of the figure of the Harlequin. Risen from the lowest sort of "valet" status to a position of master of his master, he is a caricature of the traditional naive Arlecchino, who schools himself in guile and outwits his social betters. Of course, as Maurice Sand notes in his historical account of the character's evolution, the Arlequin of the late eighteenth and early nineteenth century was no longer quite as simple and innocent as his original Commedia forebear: the ignorant, foolish bumpkin of the early Commedia had evolved into a being who was, once again, "spirituel, rusé . . . et tant soit peu philosophe" (droll, crafty . . . and even a trifle philosophical).[90] In this, Sue's character not only is unexpectedly consistent with the Italian Comedy character (by Sue's time chased away from legitimate theaters to performances at the *foires*) but also is a derivative spirit incarnate of the trickster characteristics known in ancient Greece as *mētis,* the ruse and guile deployed by the underdog: "une forme d'intelligence et de pensée, un mode du connaître . . . un ensemble complexe, mais très cohérent, d'attitudes mentales, de comportements intellectuels qui combinent le flair, la sagacité, la prévision, la souplesse d'esprit, la feinte, la débrouillardise, l'attention vigilante, le sens de l'opportunité" (a form of intelligence and a way of thinking, a mode of knowing . . . a complex but very coherent

La veille des noces.

Le prix de vertu.

FIGURE 12 A pair of illustrations reflect Sue's vigilant effort to represent Atar-Gull, throughout his text, as ever-watchful, biding his time in hiding and in shadow. J. A. Beaucé, *La Veille des noces,* and *Le Prix de vertu,* from *Oeuvres illustrées d'Eugène Sue par J.-A. Beaucé* (Paris: Marescq, 1850). Engraving. Bibliothèque nationale de France.

set of cognitive attitudes, intellectual behaviors that combine flair, sagacity, anticipation, mental flexibility, deception, resourcefulness, vigilance, readiness to act).[91] Like Arlequin, like the Greek subject endowed with the cunning intelligence called *mētis,* Atar-Gull, given in advance as beaten, is not broken but ends up triumphant, the emblem of a reversal of fortune brought about by his wiles, his "adresse prodigieuse" (280), which he has meticulously shaped into "son système" (267)—a system to which he is unwaveringly faithful.

Let us replay this turnabout with an emphasis on its alimentary-oral terms. The former slave M. Targu, silenced and subjugated for long years, bides his time, during which he cunningly retaliates with barnyard poisonings, devastation of the fields, venomous murder by arranged snakebite, and other deftly arranged plots; he ends as the beneficiary of a prize of virtue accompanied by a hefty financial award and a logorrheic speech. The plantation owner Tom Wil ends up dependent, destitute, mute, eaten away, malnourished ("réduit à un état de maigreur et de marasme effrayant") (288). That the master, fed by the hand of his slave, ends up wasting away, dying of malnutrition, is not without significance: his feed or (passive) feeding (*son manger*) is his death; the slave's (active) feeding, *son faire manger,* is his consummate act of murder. Atar-Gull kills Wil by controlling his food; this is a symbolic form of cannibalism, an eating away of the master by the slave.[92]

Atar-Gull is Sue's cannibal from the first. He is, after all, a *petit Namaquas,* member of the tribe that keeps no prisoners because it eats them instead. Portrayed consistently as tall, regal, proud, and watchful, he is described with recurrent emphasis on his mouth, sharp white teeth, agile, bounding, pouncing form. Like a wild beast (alternately lion, tiger, jackal, serpent)—like Marcel Detienne and Jean-Pierre Vernant's *homme à la mètis,* he is—borrowing their words—"sans cesse prêt à bondir" (constantly ready to pounce).[93] Wil's submissive slave during the day, Atar-Gull transforms at night: "Il fallait alors le voir bondir, haletant, crispé, furieux, se rouler en rugissant comme un lion, et mordre la terre avec rage . . . Alors ses yeux étincelaient dans l'ombre, ses dents s'entre-choquaient" (244) (You should have seen him pounce then, panting, coiled for action, enraged, tensed up and roaring like a lion, biting the dust with fury. . . . Then his eyes gleamed in the dark, his teeth rattled). His servile daytime smile nevertheless presages a bite, with its omnipresent glimpse of sharp white teeth (245).

Small wonder that Tom Wil's slow death is marked by oral deficiencies—juxtaposed muteness and malnutrition—while his attentive slave is increasingly defined by his verbal aggression and his overpowering mouth: "un affreux sourire sur ses lèvres contractées qui laissaient entendre le sourd claquement de ses dents qui s'entre-choquaient comme celles d'un tigre qui mâche à vide" (283) (a ghastly smile on his contracted lips that revealed the muffled chattering of his teeth that rattled against each other like those of a tiger chomping air). The slave's vigilant watch over his diminishing master is noted by the porter in similarly oral metaphors: "On dirait que son nègre a peur *qu'on ne lui mange son maître*; personne ne peut l'approcher" (278; my emphasis) ("It looks like his slave is afraid *that someone might eat his master out from under him*; no one can approach"). Tom Wil must be cannibalized, but only by the right cannibal and in the right way: a diet of meager material sustenance and masterful psychic corrosion. When the dying Wil refuses to eat, Atar-Gull forces a few spoonfuls of bouillon down his throat to prolong the agony of his hostage while he roars out the tale of his slave's revenge: "hurlait le nègre en rugissant come un tigre, et bondissant dans cette chambre en poussant des cris qui n'avaient rien d'humain" (285) (howled the black man as he roared like a tiger, leaping around the room and uttering inhuman cries).

Here again we find ourselves (mirroring Sue) in that gray zone of discourse emanating from an uncertain voice whose source is blurred by irony and free indirection. We witness the triumph of M. Targu over Tom Wil—and Atar-Gull as well—but it is hard to say if we are being directed to applaud the victory of an African reclaiming his rights and his humanity, or the uncommon performance of a being who, having outwitted all the forces combined against him to rise beyond all expectation, remains still for Sue essentially a black man, *un nègre,* and as such, a brute creature grudgingly admitted his extraordinary story as an exception. For, to return to the problem of the ambiguously voiced stereotypes

I introduced earlier, we pass from recurrent images of sharp white teeth to descriptions of ominous white eyes shining in the dark: "On ne voyait de ce colosse noir que deux yeux blancs fixes et arrêtés, et au milieu de ce blanc un point lumineux qui brillait comme du phosphore dans l'ombre" (283) (Of this black colossus, only the fixed whites of his eyes could be seen, and in the middle of the whites a glaring dot that shone like phosphorus in the dark). The narrator does not stop at clichéd physical descriptions; he alternates these with received ideas of essentialized "African" character traits: "Ces paroles . . . empreint[e]s de toute *l'exaltation fougueuse d'un Africain,* retentiront, j'espère, dans le coeur des gens qui . . . s'obstinent à regarder les Noirs comme une classe à part" (293; my emphasis) (These words . . . stamped with all the *hot-blooded exaltation of an African* will echo, I hope, in the heart of those who . . . persist in viewing Blacks as a separate class); "Atar-Gull avait reconnu celui qui partageait avec le colon toute sa *haine africaine*" (267; my emphasis) (Atar-Gull had recognized this man as one who shared with the colonist all *his hatred of Africans*). And he tosses the reader anecdotes that comply with the most hackneyed cultural representations, crowned by the infantilizing description of Atar-Gull, still a plantation slave in Jamaica, who, catching a trinket tossed by his master as a "prize" for good behavior, "se livrait à une joie d'enfant en approchant la montre de son oreille pour écouter le bruit du movement" (239) (surrendered to childish joy as he put the watch up to his ear to listen to the sound of its movement).

Does it matter that such tired accounts are occasionally interspersed with self-conscious recognitions of the cultural work of stereotypes? As for instance, to cite one of the most flagrant examples, when the slave Atar-Gull is at work in the plantation house and "sa bouche conservait toujours ce sourire stéréotypé que vous connaissez" (248) (his mouth still held the stereotyped smile that you well know). At what point does the narrative discourse become ethically responsible for the actions and reactions ascribed to the protagonist? And at what point is it accountable for the style and tone of its free indirect reports?

—— METEORIC AESTHETICS

The preface to *Atar-Gull* takes the form of a letter to James Fenimore Cooper, Sue's model writer of adventure tales, especially of the maritime variety. This public letter in professed response to Cooper's "flattering" personal communication about his earlier maritime novel *Kernok* affords Sue the occasion to bask in Cooper's light while he writes the apology for his self-avowedly disconnected novel. Recognizing that his novels might suffer from too many characters, lack of unity of place, of time, and of action—a problem he blames on the nature and pressures of the sea voyage—he suggests as a possible transcendent remedy the recourse to powerful ideas or superhuman characters that might, even if ephemeral, provide unity by the extraordinary lingering force of their memory, since they are "toujours frappants, saillants, d'une espèce à part, [et] traversent notre

existence, rapides et éphémères, comme ces météores que nous ne voyons qu'un moment, et qui s'éteignent pour toujours" (1318) (always striking, prominent, of an extraordinary nature, and they cross our lives rapidly and fleetingly, like meteors we see for only a moment, before they are extinguished forever). With the disclaimer that his intent is not theoretical but rather, vindicatory, intended to head off potential accusations of dispersed focus, he proceeds to justify what he suggests is a style of diffusion—but one that we might also call a theory of aesthetic and moral dispersion (1318–19).

Sue argues (a bit defensively) that the maritime novel poses an inherent series of challenges to the author due to an inevitable influence of its thematic matter on its form: that is, the fact that a ship visits different ports of call imposes a certain punctuation of stops and starts and revisions on the novel that would represent its voyages. The episodic nature of shipboard life therefore works to disrupt any attempt to endow a maritime novel with unity of interest.[94] The author must therefore seek other means of focus, such as the forces of excess embodied by certain individuals (1318).[95] These meteoric beings, bearers of almost supernatural powers (they are, he insists, "d'une espèce à part"), are like "ces apparitions soudaines qui brillent un instant et s'effacent pour ne plus reparaître" (1318) (the sudden apparitions that gleam for a moment and then fade, never to reappear again).

Was melodrama Sue's meteor, the sought-after solution to this problem, with its avalanche of fleeting Manichaean sinners and saints? If such cosmic events provide a way out of incoherence and disunity, though, I suggest it is rather by way of distracting than by imposing continuity, much like a kaleidoscope constantly shifts the viewer's attention as it breaks up each almost-image. Or, to change the metaphor but keep the thought, like spasms or paroxysms that contract and contort and interrupt the reading process, as Poe might have been suggesting when he classed *Les Mystères* among "the 'convulsive' fictions."[96]

To recapitulate Sue's argument succinctly: the theme and content of a maritime novel dictate its form and style; thematic displacement translates as formal disruption. Sue's biographer, Jean-Louis Bory, reads the letter to Cooper as "[la] proposition d'une nouvelle esthétique du roman maritime, délaissant unités d'intérêt et de lieu pour tenter la représentation d'une réalité dispersée, déchirée, fragmentaire—par 'épisodes' qui n'auraient pas forcément de lien entre eux: bref, proposition d'un roman qu'on serait tenté d'appeler *centrifuge*" (a proposal for a new aesthetic of the maritime novel, one that would abandon unity of action and of place to attempt to represent a dispersed, torn, and fragmentary reality, by "episodes" that would not necessarily be linked: in short, a proposal for a novel that one might call *centrifugal*).[97] The only problem with Sue's argument, and Bory's neat rephrasing of it, is that the "episodic" solution he proposes to correspond to maritime reality is not confined to the maritime novels; it describes very well the fragmented "harlequin" style we charted in *Les Mystères de*

Paris, a novel set far from the high seas.[98] The notion of "episodic," fragmented, or disrupted form is a characteristic of all of Sue's writing, and so I want to hold on to these terms, and especially, to Sue's notion of the "meteoric," while divorcing them from maritime causality. In fact, I suggest that we expand the notion of "meteoric" character (a metaphor Sue borrows from the transient flash or glow or fiery streak accompanying a falling mass) beyond the formal realm of his writing to qualify the aesthetic and moral as well. In the flickering firestorm of interrupted events, fragmented episodes, recirculating characters, contradictory pronouncements, and crossing voices whose phantasmagoric flares and glints make us uncertain of origination and perspective, and unable to decipher a recommended itinerary, we are left in a glaring darkness to ponder Sue's irony.[99]

——— REDEEMED INTO AFRICA

Back in Paris, far from African cannibals and slave brokers who sell exogamous tribespeople to colonial masters, the mysteries of the urban underworld are plumbed and managed by the ubiquitous traveling monarch Rodolphe, who metes out justice and chastises criminals, rewarding virtue and rehabilitating the happy few he deems worthy. While Africa enters into the goings-on of Rodolphe's domain, it does so only peripherally: most notably, in the form of his personal physician, David, and David's estranged wife, the Creole temptress Cecily, who are both former slaves liberated by Rodolphe from a Florida plantation.[100] But the European–African traffic is not unidirectional: Rodolphe, it turns out, plays an active role in North African colonization.

It seems that the individuals he separates from the downtrodden masses as feasible projects for redemption must be taken out of Paris and transported to a safe remove. As part of his plan for social action, Rodolphe establishes a model farm in the Val d'Oise regulated by what he calls "l'aumône du travail" (322) (the alms of work): admitted on the basis of their promise and their honesty, the poor but worthy laborers move through a two-year rotation on an agricultural public works project through which they prove themselves and earn permanent employment. The essential element of rehabilitation here is agrarian: the distance of the farm from the city, proximity to the animals, the soil, and the fresh air removed from the noxious vapors of Paris. Even the incorruptible Rigolette is spirited off at the end of the novel to this same farm in Bouqueval in the countryside north of Paris (the very same to which Rodolphe took Fleur-de-Marie to escape urban dangers and be cleansed of insalubrious urban experience).[101]

As for the rougher elements whose inherent goodness the perceptive Rodolphe recognizes under their cover of Paris fierceness and dirt, they must be moved a good bit farther away: all the way to Algeria, in fact. Le Chourineur, la Louve, and Martial are all determined, by Rodolphe's piercing moral vision, to be at core good souls besmirched by a foul social environment; nevertheless, an implacable narrative logic operating in Rodolphe's name rules that they must be

sent to the Algerian frontier in order to be fully reformed. A farm in the Paris suburbs may be a good enough rehabilitation site for those who have slipped or been pushed off the path of virtue, or those who risk corruption by their fellows, but for an ex-con like le Chourineur, a strayed woman like la Louve, or a poacher like Martial—a poacher born into a family of murderers—the place and means of reform must evidently meet different criteria.

Rodolphe proposes to le Chourineur the management of a farm he has purchased for this express purpose. Located at the outer bounds of the Atlas Mountains in Algeria, at the edge of French colonization of the region, it is "exposé[e] à de fréquentes attaques des Arabes" (exposed to frequent Arab attacks) and will therefore require of le Chourineur that he be "autant soldat que cultivateur" (176) (a soldier as much as a farmer). Practicing agrarian and military arts together, serving the French colonists, le Chourineur will be constantly exposed to danger and as a result, explains Rodolphe, "[sa] réhabilitation sera plus noble, plus entière, plus héroïque, si elle s'achève au milieu des périls d'un pays indompté qu'au milieu des paisibles habitudes d'une petite ville" (177) ("his rehabilitation will be more noble, more complete, more heroic, if it is completed amidst the perils of an untamed country rather than among the peaceful customs of a small city").[102] Rodolphe makes a similar proposition to la Louve and Martial, for comparable reasons:

> Se souvenant de ce que Fleur-de-Marie lui avait dit des goûts un peu sauvages de la Louve et de son mari, il proposa . . . des terres en plein rapport, dépendantes d'une ferme voisine de celle qu'il avait fait acheter pour le Chourineur, et qui était aussi à vendre . . . le prince avait encore songé que Martial et le Chourineur, tous deux rudes, énergiques . . . doués de bons et valeureux instincts, sympathiseraient d'autant mieux qu'ils avaient aussi tous deux des raisons de rechercher la solitude, l'un à cause de son passé, l'autre à cause des crimes de sa famille . . . Bientôt une amitié sincère unit les futurs colons. (1142)

> [Remembering what Fleur-de-Marie had told him about the somewhat savage tastes of la Louve and her husband, he proposed . . . some land with good yields, dependencies of a farm neighboring the one he had arranged to buy for le Chourineur, which was also for sale . . . the prince had also imagined that Martial and le Chourineur, both unpolished, energetic . . . endowed with good, brave instincts, would get along all the better because both had reasons to seek solitude, one because of his past, the other because of a family history of crime. . . . Soon a sincere friendship united these future colonists.]

On the French frontier in Algeria, the rough-and-ready trio will apply their better instincts to keeping a people rougher still in check. As Martial and le Chourineur wax poetic about the brotherly life they will share in the new land working the

earth and knocking off indigenous Bedouins, we arc led to believe that Rodolphe in his infinite wisdom has chosen well for his protégés. Rodolphe has doubtless chosen strategically for his French colonist friends as well, for newspaper reports filtered into the last pages of the novel let us know that Martial and la Louve, these "colon[s] d'Algérie" (Algerian colonists) have together shown great intrepidity and prodigious rifle skills "en repoussant, à la tête de[s] métayers, une attaque d'Arabes pillards" (1185) (by repelling an attack of Arab looters, leading a group of sharecroppers).

Le Chourineur is not named in the newspaper article, for the good reason that he turned back from Algiers at the last minute. Ostensibly this is because he is constitutionally unable to leave his "master" Rodolphe behind in Europe (though one wonders if his failed transit to Africa has also to do with the possibility that the "Slasher" become soldier once again might realize his dream by not only slaughtering his [br]others, but eating them too). Separated from his savior, le Chourineur is, to borrow his own words, "comme un chien qui aurait perdu son maître" ("like a dog that has lost its master") from which he concludes that he may as well "faire le chien pour lui et defendre [s]on maître" (995) ("act like a dog for him and defend his master")—particularly because Rodolphe (as le Chourineur continues in the same metaphorical register) "se mêle à de si grandes canailles (j'en sais quelque chose)" (994) ("mixes with such animals [and I know a thing or two about this]"). He will end taking the knife meant for Rodolphe, dying like a dog at the hand of this very "canaille," the savage pack from which he was extricated and domesticated by Rodolphe.

So Africa, land of man-eaters and savages for at least one voice of *Atar-Gull,* is, for at least one voice of *Les Mystères de Paris,* a reserve for the refuse of Europe (to be sure, the salvageable elements that can be repurposed in the interest of exporting white European civilization and facilitating commercial expansion and political dominion). The lesser devils of the Parisian netherworld—the flower of the *canaille*—are purged to the continent of "untamed" Arabs and tribal cannibals. Sue's urban cannibals—his flamboyant she-wolf, his sharpshooter poacher, and his voracious slasher—sent to suffuse the North African frontier with the color of the Parisian people, and to symbolically drain it from Paris as well, transpose ideologies of class hierarchy on those of race, naturalizing both. While Rodolphe and his daughter leave Paris "pour jamais" for the fantasy kingdom of Gerolstein, and the three prospective colonists finalize plans to leave for Algiers, the novel proper closes on the scene of the riotous people of Paris taking over the streets, drunk, roaring, shaking their gaudily-clad hips, and thirsting for blood: "Ce fut alors une mêlée épouvantable; on entendit des rugissements, des imprécations, des éclats de rire qui n'avaient plus rien d'humain" (1150) (Then transpired a dreadful fray; one could hear bellowing, swearing, bloodcurdling bursts of laughter that were beyond the human). Meanwhile, far off in another novel, but on a not-so-distant Parisian street, an African slave roars his similarly voiced rage: "'C'est moi . . .

hurlait le nègre' . . . en poussant des cris qui n'avaient rien d'humain" (*Atar-Gull* 285) ("It's me" . . . howled the black man . . . whose shrieks bore no trace of the human), while the author of both novels continues to profess a staunch belief in the socioeconomically determined depravity of the disinherited classes and the colonized races, along with a scattered utopian vision of change.[103]

—— A CHILD IS BEING EATEN

Manger: to eat, to beat, to bite, to destroy physically or verbally; in sum, to do violence to the body. The many variants of urban and maritime cannibalism we have sampled caution against sweeping statements about its agents, objects, and processes. Yet one thing is clear: cannibalism, like eating, like beating (which I will collapse now into a single category for the reasons I have earlier exposed) is everywhere vociferously attributed to a sociopolitical Other. Usually a subaltern, this Other can also be a self or a hegemonic Other: there are scenes of breathtaking cruelty attributed to the godly Rodolphe, who, for example, metes out his own brand of justice by ordering his personal physician to put out the eyes of the thug le Maître d'école, or by setting up the lawyer Jacques Ferrand to be devoured by unrequited lust. In Sue, as more generally, few punishments do not involve violations of bodily integrity.[104]

If *manger* is usually used transitively by Sue in the sense of *manger l'autre* (to borrow Jacques Derrida's seminar title), this sense is also extended—as in the harlequin scene at the very beginning of *Les Mystères de Paris*—to signify *manger les restes de l'autre* (to eat the remains of the Other), with an obvious double meaning. When le Chourineur sits in a tavern with Rodolphe and Fleur-de-Marie and eats his harlequin plate, he is, by implication, consuming the remains of a dinner Rodolphe or one of his peers initially consumed, but he is also symbolically eating the bodily remains of Rodolphe and his peers: gnawing away at the integrity of their stature, their stance, their class, their bodily well-being.[105] Paradoxically, however, *manger un arlequin* literally means "to eat a valet," "to eat an underling," which makes us rethink facile suppositions about the dynamics of eating others: it is now the upper classes cannibalizing the people. The easy flipping of conceptual hierarchies suggests that social categories are not fixed, that anxieties about class contact and potential mixing are not stable. Fears about encroaching bodies and enveloping jaws have no secure sender and no permanent address; the origins and ends of such fears are often misidentified or confused, and can seamlessly be shifted or rerouted. Fantasies of being eaten, fantasies of eating, fantasies of watching others eating or being eaten are fluid and metamorphic; agent and object are subject to kaleidoscopic permutations, with the same basic action recurring in an infinite series of modifications, and the roles played by a host of transforming players.

If we were to begin to decline the verb *manger* as it is performed in Sue's narrative, it might look something like this: *manger, être mangé, voir manger quelqu'un,*

faire manger quelqu'un . . . (to eat, to be eaten, to see someone eat, to make some-one eat, or to feed someone). And this would be just the start of an endless series of structural variations, which in fact we earlier explored more concretely by focusing on the representative histories of Fleur-de-Marie, le Chourineur, and Atar-Gull, whose protagonists are alternately eaters and eaten in dizzying succession and recombination. These stories both horrify and discomfort us, but they also amuse us, and perhaps even seduce us. How can we be so engrossed, so diverted, so enthralled by a narrative that, as we have seen, swings madly between benevolent belief in the inherent goodness of marginalized peoples and races, and self-righteous condemnation of their violent "inborn" depravities? How do we comprehend its ideological and discursive inconsistencies?

Sigmund Freud's 1919 paper, "A Child Is Being Beaten," invites oblique dialogue with these questions. The essay, known to be among the most puzzling and complex of Freud's works, explores the three evolving transformational stages of a childhood beating fantasy, replete with a shifting cast of characters and a gender differential.[106] Commentators traditionally discuss the piece as a theoretical reflection on fantasies of masochism and sadism, and on perversion, and it later became a useful tool for feminists and other gender theorists, especially for reflecting on cinema and its gendered spectators.[107] My own turn to this paper departs from both previous lines of commentary and is rather particularly oriented: I am interested in how it helps us think about the general structure of fantasy in Sue's narrative, and especially about fantasies of violence as they relate to agency and responsibility.

The English translation of Freud's title highlights something that might go unremarked in the original German. "Ein Kind wird geschlagen" is the simple present in the passive voice. It might be translated "A Child Is Beaten." By introducing the word "being," the translation retains the passive voice, but shifts to the present continuous tense and emphasizes the repetitive or ongoing nature of the beating. The beating seems to be anonymously delivered and received, and to go on in infinite time without beginning and end. The title's double lack of specificity corresponds, on one hand, to the circulating agents and objects of beating (the agent is the father, in the first two phases, though only gradually and vaguely identified as such in the first phase, and in the third phase, a fluctuating father surrogate; the object of beating changes, and coincides with the fantasizing subject only in the second—unconscious—phase, and never in the first and third conscious phases); on the other hand, the title's imprecision responds to the repetitive nature of the fantasy, which plays out in an unpunctuated duration—as if the translation were striving to account grammatically for a more significant ethical aberration that has been linked not only to beating fantasies but, more broadly, to fantasies of violence.

I will not enter into the many details of the beating fantasy that are of little relevance to Sue's eating narratives. Rather, I want to home in on the question

of the shifting agents, objects, and spectators of beating. It bears repeating that only in Freud's second (unconscious) phase is the fantasizer a participant; in the first and third (conscious) phases, the fantasizing subject is a non-participant observer. The third phase interests me most for its loss of focus: the identity of the object is erased or shattered into a multiplicity; the father is displaced to a paternal variable, and the fantasizing subject, reduced to a specular function. For Jacques Lacan rereading Freud's paper, the erstwhile subject is now radically de-subjectified: "Le sujet n'est plus là que réduit à l'état de spectateur, ou simplement d'oeil" (The subject is no longer there except reduced to the state of a spectator, or simply, an eye).[108]

Psychoanalyst Marcelo Viñar, building on Lacan's commentary, also uses visual metaphors to characterize the third phase as a "dilution and blurring of the characters on the stage." The consequences are significant: the flickering of the various players and, particularly, the fading of the fantasizing subject from a position of "participation in and responsibility for the violence suffered and inflicted" mark the foundational structure of perversion. The role of the fantasy with its fluctuating cast of characters and disappearing fantasizer is to allow this fantasizer "to disclaim responsibility for [any] place in the scene even to the point of denying its authorship."[109]

Viñar suggests that Freud's work on the beating fantasy has bearing not only on the genesis of perversion, but also on broader attitudes toward violence in society, which he takes to be universal and timeless. Without wanting to make quite that vast a claim for continuity in space and time, I suggest that we might think with Freud, Lacan, and Viñar about Sue's eating fantasies, with their own fluctuating players, oscillating patterns of agents, objects, perspectives, lambent narrative tongue, and alternating states of narrative consciousness.[110] Sue's eating scenarios facilitate an analogous evasion of positionality and, therefore, of responsibility.

Writing well before Freud, Lacan, and Viñar had developed a psychoanalytic vocabulary and theoretical infrastructure with which to frame questions of violence, responsibility, and ideology, Karl Marx framed Sue's ideology as similarly evasive, decentered, disembodied, and voyeuristic. In *The Holy Family,* the 1845 pamphlet he wrote with Friedrich Engels, Marx strove—with impressive vigor and passion—to dismantle Sue's socialist manifestations in *Les Mystères de Paris,* and to uncover their hypocritical core.[111] The philosopher's disdain for Sue's exploitative gaze is adroitly condensed by Umberto Eco in his paraphrase of Marx's critique: "Politically speaking [Sue] is a social democrat; from a literary point of view, he is a sensation-monger who speculates on human misery." More specifically, Marx accuses Sue of writing with a reformer's rather than a revolutionary's spirit, that is, of having his characters perform the kind of token philanthropic gestures that ensure that deep social structures never change. For example, Sue has the wealthy Clémence d'Harville make self-distracting charitable gestures

that temporarily relieve the poor while not effecting real social change. He has Rodolphe save Fleur-de-Marie for her innate goodness, only to sacrifice her as scapegoat for society's stains. He redeems le Chourineur but delivers him to such a paternalistic regime that he is no longer capable of living for himself.[112]

Deconstructing Sue's socialism turns out to be a tricky undertaking, however, when the vehicle used is his *Mystères de Paris*. It may well be impossible to separate theory from fiction, or critic from novel reader. Certainly Marx shows himself to be a rather clumsy critical reader, mixing narrative and story, confusing diegetic with referential universes. He chides Rodolphe for his ignorance of European law.[113] He mocks the economic logic of the model farm at Bouqueval for its faulty mathematical calculations; and he confesses to a secret "malicious pleasure" when the virtue of society ladies is unveiled as infidelity.[114]

Watching over Marx's shoulder as he reads Sue, Alice de Charentenay and Anaïs Goudmand note the critic's surprisingly intense readerly engagement with Sue's multifarious plots and subplots and characters—in short, with Sue's fictions—entwined with a scathing critique of his socialist program.[115] They observe Marx's emotional investment in the storytelling and his attachment to the characters. Reminding us that "la frontière entre fiction et philosophie est poreuse" (22) (the frontier between fiction and philosophy is porous), they suggest that Marx is responding metaleptically to the story wrapped with the social philosophy. The two may not in fact be extricable. To put it simply: Marx gets so embroiled in his historical critique because he cares so much about the story.

The exposition of Marx's vulnerability to Sue's fiction even as he is lancing the bombast of the novelist's social theory may give us pause to consider our own tangled experiences of reading Sue as critics and, simultaneously, as more gullible armchair readers. I wonder if we are like Marx when we read Sue indignantly, tempering our readerly pleasure with our critical angst? Are we like Marx—who in turn may be more like Sue than he would care to admit—when we wander like tourists in the dirty alleyways of la Cité, peeping through chinks into fifth-floor garrets at the poorest of the poor, and morphing into feverish page turners unable to avert our eyes from the morbid excesses of suffering and sin and folly? Are we—like Marx—like Sue when we blur our more conscious ethical identities and critical attitudes with blatant spectatorship? Do we, too, become all eyes?

The ideological questions are both troubling and intriguing, and all the more perplexing given the monumental effects of *Les Mystères de Paris* across the lines of Paris populations. If many of Sue's peers found the novelist to be a hypocrite, his novel, an exploitation of the lower classes, and his socialism, a sham, at least some of the urban downtrodden were thrilled to find their woes staged and their brethren represented. Like Marx, they did not always distinguish clearly between narrative and extranarrative levels, and some wrote impassioned letters

to Rodolphe, in care of Sue, hoping to be among the redeemed. We might find this simplicity foolish or embarrassing or charming, and Sue's showy socialist cant all the more hypocritical, but the fact remains that the serialization of his novel led to a column in the same conservative paper, *Le Journal des débats,* which became a forum for voices across classes to speak to the problems of economic inequality and social injustice; and the likelihood remains that the Revolution of 1848 responded in part to the publicizing of these same problems by *Les Mystères de Paris.*[116]

I can go no further than Sue's best critics, many of whom end up explicitly renouncing the effort to determine his ethical and political position—though not without strenuous initial attempts. Bory finds Sue split: "dandy mais socialiste," in double but equal terms. *For* the workers, but *for* his own luxurious quotidian ways as well: stables of horses and showers of courtesans, rampant displays of exotic flowers, Jockey Club sorties and glittery dinners at ruinous expense. Eco similarly posits that Sue's socialism was "merely a new and exciting way of displaying his eccentric dandyism." Lyon-Caen acknowledges the many-layered nest Sue weaves in a language that reflects the foliated texture of his prose, and flatly refuses to engage with the question of political consistency: "Mieux vaut écarter la question des convictions" (better to set aside the question of convictions).[117]

It would be disingenuous to ignore a certain readerly complicity with Sue evinced by our riveted attention to the comings and goings of his characters through the maze of crossed plots, and to disregard how such a collaboration necessarily complicates our critique. Sue's stance sets him sputtering among discordant pronouncements, and oscillating between rhetorical contradictions, clothed, as it were, in "pièces de toutes couleurs" (patches of all colors), much like the epigraphic figure that opens this chapter, demonstrating by example one more variation on harlequin modes of being. Yet as critics who are ultimately always primarily readers, we inevitably follow in his peripatetic steps and virtuoso leaps, spellbound by his acrobatics, unable to parse the choreography of his ideological improvisations.

POSTCARDS FROM THE EDGE

RECIRCULATING THE PEOPLE'S FOOD

Somewhere betwixt and between the researching and the writing of this chapter lies a more evasive prehistory: that of the sinuous turns of its material sources. A tangled path of crisscrossed comings and goings, switchbacks, spirals, and circles describes my quest for the recycled postcards of recovered food that are the centerpiece of the chapter. These cards, originally sourced in occasional book reproductions, quickly took on independent lives and clamored to be held, turned over, and viewed in all their splotched splendor of inked addresses, messages with crossed-out words, canceled stamps, time-stained images, and weathered edges. Inevitably, this impelled ownership, or at least firsthand contact, which in turn involved travel (both virtual and real), encounters of varied sorts, and unpredicted adventures.

A thicket of itineraries took me to a series of Paris library archives whose reading rooms included both historically majestic, muraled halls and stuffy consultation cells improvised for use during building renovations. The holdings of more local research libraries drew me from the Rare Book collection at Yale's Beinecke Library to the Getty Research Library's collection on the other coast. I attended postcard fairs that offered hundreds of vendor-operated booths (most notably the mammoth biannual Salon de la Carte Postale on the outer edges of Paris). I chatted with postcard dealers at fixed addresses ranging from the expensive and exclusive Passage des Panoramas (with carefully catalogued albums and prices correlated with the real estate rates) to the stalls along the Seine where

bouquinistes sell books, calendars, and cut-rate postcards whose jumbled masses make any find miraculous. I visited flea market vendors selling antique postcards along with pornography, limbless dolls, and old newspapers, and spent hours perusing online marketplaces specializing in *cartes postales anciennes,* coins, and stamps, notably Delcampe, on whose massive site I won several prized postcards and lost a few as well to other bidders in virtual auctions. I went on foot down a twisting, sleazy alley behind the buzzing street life of Montparnasse to pick up a card I had purchased online from a dealer who was reluctant to post it in an envelope; his tiny corridor of a store, hidden by a sex shop, sold stamps, postcards, and *fèves* to bake in king cakes. The shop was rank with layered odors of sweat, cigarette smoke, and the dust of ages. Upon entering I fought back an almost irrepressible desire to beat a hasty retreat, with or without the card I had come to retrieve. Hanging fire, I stood back from the counter while the one-armed merchant nudged the card methodically into a plastic sleeve with his elbow stump and rasped on about his cardiology appointment earlier in the day. I thought of Balzac's cast of old men—antiquarians, blind clarinetists, and castrati leading the list.

Early on in my quest I accepted, with a twinge of trepidation, an invitation to view in real time and space the web-marketed collection of a Provençal postcard vendor who was displaced to Lexington, Massachusetts. Throwing caution to the winds, I drove to the Boston suburbs to find an entire room of floor-to-ceiling, shoebox-sized cartons of postcards, and discovered an unexpected colleague and a generous fount of knowledge in this current-day merchant of leftovers. On another occasion that, on the contrary, had roused no foreshadow of alarm, I was physically attacked at the reception desk of the Bibliothèque nationale Richelieu by an overwrought librarian visibly on the edge of a breakdown. (She was, I noticed, once I had extricated myself from her steely grip, uncannily clad in a harlequin-inspired dress: blue background with superimposed patches of red, yellow, and green.) Following the incident, and as if in compensation for it, I was treated with such solicitude and sympathy by the other librarians who had either observed or got wind of the assault that I gained access to sources I might otherwise not have found.

Along the way, I witnessed bits of other people's lives that had influenced the circulation or interrupted the flow of postcards, or intersected with their trade. I listened with rapt attention to a young dealer's cross-Atlantic love story that so perfectly mirrored that of a deceased collector that it garnered him the acquisition of a monumental corpus, which then began to recirculate. Conversely, I was captivated by another tale of a comprehensive work on postcards whose posthumous publication was aborted by the jealous lover who inherited the manuscript, fearing that the story of his clandestine relationship with the author would circulate in tandem with the postcard history. Not all postcard narratives are love stories, however. In one shop located at a posh address, as I paged through

volumes of postcard albums, a loquacious third-generation postcard professional fed me insider stories about long-dead collectors from his father's and grandfather's eras. His handed-down recollections of the machinations of dealers past, punctuated by references to the "Jewish collectors" among them, left me tasked with the impossibility of separating the seed of his narrative from its anti-Semitic chaff.

Such anecdotes may seem peripheral to a chapter about photographic postcards that recirculate scenes of used food, recycled eating, and throwaway eaters. Please bear with me. I begin from the edge—of the story and of the postcard—less to be edgy than to center a chapter that is about edges of many sorts, among them, socioeconomic margins, national frontiers, imperialistic abuses, and body boundaries. Reviewing postcards means not only viewing their photographs many times and from many angles, but also attending to their backstories, which are touched by the ancestors of what today are called hate crimes and hate discourses and are motivated by racial, sexual, religious, national, ethnic, and class differences. Looking back at these cards entails taking stock of the sharp edge dividing message and image sides of the card. And it involves considering the line, less patent but foundational, between archival and commercial resources.

It is significant that the better part of my postcard base is trade rather than library sourced, though not for lack of frequenting the archives. Commercial postcard collections, both online and in shops, tend to be more plentiful and much better curated than library holdings in this sphere, and their dealers, in the best cases, are more knowledgeable about postcard history and its representations of *les petits métiers* (small trades) than are librarians. There is a certain justice—whether commercial or poetic—to be found in this practice of modern-day recirculation by small tradespeople of the so-called ephemeral images of small trades and tradespeople that were so widely circulated in another century, as there is a certain aesthetic symmetry to be perceived in my own perambulations in their tracks. The fortuitous finds and misses of my travels echo the similarly aleatory dissemination of postcards and their histories, both of which are also subject to chance encounters, risks taken or refused, pathologies, seductions, asynchronies, and fortuitous timings. These pathways echo Jacques Derrida's musings in *La Carte postale* on a stream of associations conjoining postcard collections, circulations, repetitions, correspondences, reproductions, fragments, crossed love stories, and intersecting lives.[1]

—— POSTCARD 1

If I were to lay all my cards on the table, they would form a mosaic rather than a sequence. There would be reverberations and repetitions, yet each would contribute elements to the narrative as it gradually emerged from their juxtaposition and accumulation. Because writing tends more toward linearity than does visual representation, I will respect the composite operation of the cards by situating

them in dialogue, allowing each to interpose its evidence so as to build gradually and cumulatively toward an analytic framework.

My first postcard, dating roughly from 1911, bears the photograph of a harlequin stall where leftover food was marketed at Les Halles (Plate 1).[2] This particular specimen has not circulated by post: it bears no message, address, stamp, or postmark. But its edges are burnished and lightly frayed; it has at the very least traveled in time. There is printed text superimposed on the photograph in the form of a serial number, a series title, a legend, and the initials of the photo editor: "18.—Une visite aux Halles Centrales. Les Arlequins. Les restes des restaurants sont vendus, chaque plat séparément, 1 à 2 paniers par jour. J.H."[3] (18.—A visit to the Central Halles. Harlequins. Restaurant leftovers are sold, each dish separately, one to two baskets per day. J.H.). The printed matter appears to function straightforwardly and indexically on this card that is unblemished by a handwritten message; it seems to retransmit, in words, what is shown in the photographed scene, and perhaps to orient the eye of the receiver. Postcard inscriptions (whether printed by the editor or handwritten by the sender) can work either to echo and naturalize the presentation of an image, as we see here, or—as is often the case with senders' texts—to defamiliarize it, through a manifest disconnect between photo and message.

Compositionally, the photograph on postcard 1, itself horizontally formatted, presents a series of predominantly horizontal rectangular shapes intersected by some less regular and less angular (and mostly human) vertical forms. The long, white-papered rectangular tabletop slices diagonally but incompletely into the photo, catching the light and disrupting the pictured space. It is cluttered with a jumble of plates, which are in turn littered with hard-to-discern clumps of food. Beneath the disarray of plates is a similarly scruffy table support, which looks to be formed of two worn oblong crates whose wood surface is rough-hewn and uneven: its pocked texture is grimy and splintered. The length of this table is echoed by an expanse of pavilion wall whose multitoned rectangular bricks are arranged in configurations of diamonds (which might be described as distorted rectangles) to the right. Though patchworked like the plates of food, the mosaic wall resists a similar appearance of random patchiness by means of its regular diamond patterning. On a smaller scale, a sheaf of newspapers hanging behind the table (and echoed by the smaller rectangular document or flyer suspended above it) replicates the shape of the diamonds. The newspapers function materially to cover and so to hide the food scraps purchased for home consumption (as opposed to those consumed on the spot), but in paradoxical fashion, they serve semiotically as well to highlight the principle of circulation that is as inherent to the practice of recycling leftover food as it is to disseminating the news. The food wrapping is, then, a cover but also an announcement: it materializes the concept of recirculation that might seem superficially to be concealed by the newsprint used to shroud the takeaway leftovers from curious eyes.

On the ground in front of the table to the right is a cloth sack of the sort used by many small tradespeople; the *chiffonnier* springs first to mind. It might hold more newspapers, utensils, or reserved bits of ragtag food waiting to cycle up to the counter to be plated; or perhaps it hides the unsold remnants of remnants, spoiled spoils to be finally withdrawn from circulation.[4] By means of a slight and almost unthinking visual adjustment, we assimilate this sack to the plethora of rectangular shapes that structure the image, yet we also cannot help but notice that this particular rectangle is distended, swollen like the vendor's belly. It both mirrors and refigures the pile of newspapers hung on the other side of the table, acting as a transition between all the right angles and the less regular human forms.

Against the backdrop of straight lines and elongated surfaces are poised a barely visible *marchande d'arlequins* who faces out from behind the table, and a group of nine male harlequin diners who are dispersed around it. We see two of them in profile, surveying the options, two partially cut off, and four full face (though one of these faces is partially eclipsed), returning our gaze. One of these men catches our eye not only because of his impeccable attire (black top hat and elegant overcoat) but also because the photographer seems to have used him as a focus; he is immobile and therefore unblurred, while many of the others are in part shrouded by fuzziness. Was this man a photographer's assistant? If so, why was he not dressed to blend in? Could he have been an actor planted in the scene for sartorial contrast? The ninth male figure, who is visually central, is shot from behind. He stands out not only because of his compositional centrality, which is reinforced by his contrasting lighter-colored clothing, but also because of his vulnerability. He is bent over the harlequin plates he is scrutinizing, as the viewer scrutinizes him in a parallel act of consumption. His slouched posture is not entirely explained by the act of leaning in toward the foodstuff; it signals also his infirmity. Frail, white-haired, and aged, this hunched figure dressed in rumpled clothes that are a little threadbare at the elbow and the hips draws to him the attention and the energy of the tableau.[5] The white blur of his hair and beard are echoed by the white patches of the other men's faces, and the hillocks of food on round white plates. The *marchande* standing opposite him across the table facing the camera is visible only by the top of a skirt swathing a well-fed belly, and the barely glimpsed lower blur of an amply swelled blouse. Because her upper body is obscured by shadow, our attention is distracted slightly left to the wad of newspapers that catches the light and hangs at the level where we would expect to see her head. Anonymous and faceless, she is reduced to her function of agent of (re) circulation who mediates between social classes.[6]

This effect of obfuscation may to some extent be an attribute of my copy of this card, of the vagaries of its past life in attic or basement storage, its contact with greasy fingers, or its exposure to sunlight or flooding. Although photographic postcards are mass produced, each bears the imprint of its individual circulation. I consider these acquired markings to be part and parcel of the card, like the

scars and wrinkles that sign human bodies. Therefore, although we can, to a certain extent, talk about the components of an image on a photographic postcard much as we would discuss the same image were it reproduced in a book or hung on a wall, there is always, in the case of a postcard, the (at least) virtual additional weight of a chance marring, a scribbled message, a stamp, or a printed caption to be considered.

The small oblong textbox in the lower right corner of the card, which encloses the caption I mentioned earlier, might be said to summarize the predominance of rectangular forms, whose regularity nonetheless is interrupted by the sloppy human faces and figures and the jumbled slops-filled plates they hold. This caption, reminiscent of the labels affixed to photographs used in medical, criminal, and anthropological records in the second half of the nineteenth century, locates the ungainly, excessive, messy practice of the *arlequin* within the regime of knowledge and power that took the form of classifications, taxonomies, and expositions: a "self-monitoring system of looks" that Tony Bennett has named "the exhibitionary complex." This regime crested in *le bertillonage,* the anthropometric system of identification invented by French criminologist Alphonse Bertillon in the wake of the phrenologic and physiognomic wave of the nineteenth century.[7]

The label here acts as a miniaturized inset of the postcard itself. Mise en abyme, it suggests that this card, and perhaps the viewcard as genre, participates in a similar venture of carving up and offering for public consumption, in discrete morsels, an entire culture on display. So, for example (depending on what postcard series we are viewing), we might see, under the rubric "Une Visite aux Halles Centrales," in addition to the *marchande d'arlequins* selling meals to the poor, collections of other cards, each bearing an image: butchers with animal carcasses, fishmongers and their wares, greengrocers' displays, a spread of dairy products, and so on. Or alternatively, in the series called *Les Petits Métiers,* or another called *Paris vécu* (Paris experiences), we could find cards depicting not only what the leftovers seller looks like, but also: the flower vendor, the toenail trimmer, the dog groomer, the cigar butt collector, the citrus-zest gatherer, the birdseed seller, the tooth extractor—and so forth, following a series of grids in a vast system of classification.[8] The imposition of rectilinear forms, labels, and edges (including the very borders of the card) onto the lumpishness of harlequin modes of eating, modes of dressing, and modes of being frames and reforms (we might say *disciplines*) the unruly ways of the lower classes.[9]

—— FRAGMENT: POSTCARD DOCUMENTARY

The labels on postcards that represent harlequin scenes sometimes classify the card by the food that is being vended (*La Soupe, Les Arlequins*), but more often they assign it to the category of the pictured vendor (*La Marchande d'arlequins, La Marchande de soupe,* etc.)—the latter, somewhat paradoxically, since the semiotic

focus of these images is generally on the food and the customers that are served up together to viewers. In each case, however, the photo is conditioned by a cultural discourse, whether such a discourse is textually cited, gestured toward in passing, or even unstated. What I am here calling the label or, alternatively, the caption can stretch from the explicit to the virtual, spanning a continuum from materialized text to ideological scaffolding. It is available to the viewer only by way of immersion in a cultural context (whether by experience or through research). So a postcard photograph, which arguably, like other photos, is technically "mute," in Susan Sontag's terms, nonetheless "talks through the mouth of the text written beneath it."[10] I want to interpret this captional text broadly, qualifying it as sometimes quite talkative, but potentially taciturn: implicit or palimpsestic—which is to say, quietly ideological.

On the card at hand, the editor has expansively labeled the photo with components that I earlier grouped under the classificatory terms of serial number, series title, and legend. I reproduce this text once again in order to reformulate its elements functionally as title, subtitle, and nominal explanation: "18.—Une Visite aux Halles Centrales. Les Arlequins. Les restes des restaurants sont vendus, chaque plat séparément, 1 à 2 paniers par jour. J.H." The first part of the label (following its number) functions as the postcard's title. "Une Visite aux Halles Centrales" insinuates the idea of tourism, as in "une visite aux catacombes," or a "visite guidée" of a museum. The designation that would usually constitute the card's sole textual classification is here positioned as a subtitle, "Les Arlequins," and the explanatory sentence that follows is a micronarrative: it succinctly details the harlequin operation for those to whom it is presumably unfamiliar. The implied tourism together with the description of the practice of selling leftovers delivers the postcard in the manner of an ethnography that is designed to present the eating habits of a foreign people. As we shall later see, the conjunction of the urban masses Othered by class and overseas populaces Othered by race is a recurrent trope and warrants further scrutiny.

Like other postcard photos, like photographs more generally, my harlequin viewcards belong to a double signifying universe: on the one hand, they have an evidentiary value that for some reaches mythic proportions; on the other, they participate in the same ideological systems that ground other forms of representation of the working classes in the long nineteenth century, including paintings, engravings, drawings, and narrative media ranging from novels to newspapers to physiologies to treatises.[11] I want neither to contest the essential reality principle of photography nor to mask my own susceptibility to it. (I still recall the shiver of combined recognition and wonder I felt upon my first discovery of a postcarded harlequin photograph: after long months of reading broadly around the phenomenon, *here it was* for the first time materialized before me.) But I do want to qualify my credulity about the evidentiary value of these photos by thinking about *how they represent* the harlequin institution, within the larger context of photography's

ambiguous position between evidence and evaluation. The question is not only whether that which a photograph transmits was real, but rather, what part of the real it transmits, from what angle, and by whom; in other words, how its epistemological authority has been technically framed and ideologically prepared.[12]

The availability of a photograph for both documentary and ideological uses is further complicated when the photo is two-faced: that is, when it appears on a photographic postcard whose edge divides two surfaces.[13] Harlequin seller photos that used to be widely circulated on cards sometimes appear as historical book illustrations today in a different format, routinely abstracted from their material postcardness, whose identifying marks are either airbrushed or ignored.[14] When any such image is shaved off its supporting structure (including such elements as cardboard, editorial signage, stamp, postmark, address, message, smudges and stains), it is necessarily disfigured, deprived of its integral working context in which photography's sanctioned triad of photographer, object, and spectator is routinely broken and re-formed to include also the hypothetical sender(s) and receiver(s) as secondary spectators. The meaning conveyed by a postcard photo is vehiculated not simply by its (already never simple) image but also by its potential communicatory and postal accoutrements, however inconsequential or tangential these may appear to be.

—— FRAGMENT: POSTCARD SPECTRALITY

A slight deflection of our angle of approach to that icon of photography's evidentiary value, Roland Barthes's *ça-a-été,* displaces the emphasis from its reassuring *realness* (which I think of also, in more spatial terms, as a *thereness*) to its disconcerting *passedness.*[15] The photo indexes that which *was* and no longer is. Even if a photographed person, place, or thing still exists, it will never again have the form it took as the shutter clicked. The quality of passedness is one element of photography's particular relationship to time and death and to what Barthes calls *resurrection,* a term we might, in more pagan terms, replace by *haunting.*[16] For Barthes, in the moment the photograph transforms the subject into an object, it also imposes on this passing subject a microexperience of death, which he assimilates to spectrality.[17]

I rehearse these excerpts from Barthes's well-known musings on photography and mortality for their contribution to focusing my own viewing of photographic postcards. In an era when time was perceived as speeding up dramatically and sweeping away the vestiges of daily life as it was known, much of the avowed motivation for producing and collecting the cards that circulated images of *les petits métiers* had to do with a sense of the ephemerality of such trades. Even as harlequin sellers and their fellows continued to purvey their wares against the mosaic backdrop of Les Halles, there was a widespread sense, which has been chronicled textually as well as photographically, that these practices and the backdrop against which they were exercised were in the process of vanishing. In this vein,

an eyewitness in 1904 comments: "De nos jours, les villes et les villages se transforment sans cesse. . . . Nous croyons donc que les cartes-vues doivent fixer dans les albums des collectionneurs un souvenir de ces choses qui n'existeront plus dans vingt ans"[18] (These days, cities and villages are constantly being transformed. . . . We therefore believe that view cards should preserve in collectors' albums a memory of the things that will no longer exist in twenty years). Almost a half century earlier, at the height of Haussmannization, journalist and building inspector Charles Yriarte prefaced his collection of portraits of Paris street personalities with these discerning words: "Demain il serait trop tard pour écrire un pareil livre: les ingénieurs sont venus. . . . Adieu la gaïeté de nos places, adieu les vêtements bariolés, les chansons étranges, les dentistes en plain air. . . . Je vous jure, messieurs les édiles, que Paris s'ennuie: il a la nostalgie du pittoresque" (Tomorrow will be too late to write such a book: the engineers have arrived. . . . Goodbye to the liveliness of our streets, goodbye to color-splashed clothes, to odd songs, to open-air dentists. . . . I swear to you, venerable aediles, that Paris is bored, it is nostalgic for the picturesque).[19] If wistfulness can be in place before its object is lost, this was surely the case for those who had a foreboding that the fixtures of everyday life were rapidly becoming folkloric, quaint before their expiration. As we read through the lens of commentators who were lamenting the evanescence of such scenes even as they were witnessing their performance, we might imagine nostalgia to be already inhabiting the margin of time and space that the shutter took to fall into place or the ink to spill into words on the page. I contend that this margin—this edge at which subject passes into object—partakes of the spectral, and that it ghosts the photographic document itself.

When I look, with a century's distance, at postcarded sellers and consumers of recycling foods, I, too, feel a whisper of wings, a passing shiver of mortality. For me, however, this sense of spectrality is evoked differently than it was for those who wrote nostalgically of the soon-to-be-vanished breed of small tradesmen, or for those among their contemporaries who may have photographed these tradesmen in a similar spirit. To my eyes, the eaters and vendors photographed on cards form assemblages of phantom presences. They are stripped of sovereignty and soul and materialized on cardstock in a command performance of comestible and sartorial dishevelment that is condemned to a Sisyphean circulation that can never be laid to rest. The blur that at times marks a subject's movement in fact signals the camera's eternal arrest of his or her mobility; it heightens the sense that these people are reduced to apparitions.

Although Western stereotypes assume that those who react to the camera with fear or hostility are in the camp of Luddites, primitives, or followers of premodern religions, theorists across two centuries have read its artifacts as at once indexical documents and ghost stories, and have invoked the eeriness of photography as process and of the photographic image as product.[20] Associations between photography and specters are complex, and they return in unexpected

guises. This chapter is similarly subject to such erratic hauntings; I sketch, in this brief interlude, an opening onto a phantom that will intermittently reimpose itself, in the pages that follow, in variable apparitions conjointly partaking of the real and the ghostly.

—— POSTCARD 2

The next card (Plate 2), postmarked August 25, 1908, shows a leftovers vending scene similar to that on the first card, but the photo is better crafted: it is perfectly centered against a similar diamond-patterned mosaic backdrop (a wall of the pavilion that housed the *marchandes d'arlequins* at Les Halles), with the *marchande* at the center and two men triangulating the image, framing the posing vendor at an equal distance from her and from the card's edges. This scene is crowd-free, heightening the suggestion that it may have been posed. The two men epitomize very different clients—if they are indeed both consumers. One, a butcher or charcutier, is holding a tool of his trade, maybe the crank of a meat grinder; his apron and the ground in front of him are soiled, perhaps bloodied. The other figure, dapper, well groomed, and smartly suited, seems as alien to the *arlequin* experience as the debonair gentleman of postcard 1 as he imperiously surveys the displayed plates. Perhaps he is simply a flâneur, taking in the sights, or a gentleman seeking food for his pets. He is viewed in classic profile, reminiscent of the early conventions of photographic portraiture to which I return below.

The emblematic pile of newspapers lies neatly stacked behind the table to the left, while tacked to the wall behind the *marchande* are some newssheets accessible for wrapping, along with some *petites affiches* (posted notices and ads). Two moments of circulation are juxtaposed: the currently circulating and the precirculated, recycling as leftover news ready for leftover food. The relative tidiness of the piled newspapers and arrayed plates of heaped food above or on the table seems parodied by all that lies under this surface. Wrapping debris litters the right foreground beside used plates holding leftover leftovers. Large bulging bags and woven baskets, stock items of harlequin photos, lie under and to the right of the table. The scraps, the trash, the spills, the rumpled sacks, and a threadbare curtain dangling above the table contrast with the elegant lace of the Baltard ironwork visible only by its arabesque shadow cast across the empty street below. The legend, "381—Paris—Les Halles—La Marchande d'arlequins," is designed in small scarlet letters poised artfully at the edge of the curb, and the editor's logo, "Royer/ Nancy," is displayed to the left in a stylized vertical form suggesting the chop signing a Japanese or Chinese scroll. The symmetry of the card's stylish design is at odds with the strewn papers, ungainly sacks, and clumped food plates it is representing.

On the back, the sender, signing "Marguerite," addresses to a certain "Jeanne" or "Melle Cordes" in Belle Isle, Morbihan, ten lines expressing birthday wishes along with condolences, and announcing an imminent departure with "Maman"

for a St. Germain *villégiature* (country vacation). There is no reference to the photo, nor any discernible connection between it and the message. The photograph on the other side seems to have been invisible to the author of the message.

—— FRAGMENT: FACE TAKES

The *marchande* offered here is captured full face, as are most postcarded soup and leftovers sellers, exemplars of the lower classes working in the *petits métiers*. Her butcher client is taken in three-quarter view, his eyes meeting the camera's eye, while the well-dressed onlooker looks away from the camera, perfectly silhouetted against the rough burlap bags and discoloring brick wall. I note these perspectives because although the camera angles may be random, they bring up larger questions of the socially codified stereotypes of early photographic portraiture.[21] These codes are broad generalizations—clichés to which there are many exceptions—but they typify still-common associations of photography with surveillance and power, connotations that leave their trace in the crime report mug shot.

A pair of 1853 engravings by Honoré Daumier, *Pose de l'homme de la nature* and *Pose de l'homme civilisé* (Pose of the Natural Man and Pose of the Civilized Man) satirize some of the class-based conventions of early photographic portraiture (Figure 13). In Daumier's reading, poses coded as aristocratic (and which would have been assumed as well by the bourgeoisie in the course of the nineteenth century) tended to be in profile or three-quarter view. Their angled gazes did not directly confront the camera, whereas what John Tagg has called "the burden of frontality" slid down the social hierarchy to those considered to be social inferiors.[22]

If we think about head-on photographs as full frontal "takes"—and I use the anachronistic cinematic term advisedly to allude to a kind of face grab, a violation of identity—we come back to the ostensibly primitive beliefs conventionally attributed to camera-shy religions and ethnicities. But in fact the fear of image theft was shared by none other than the novelist canonized as the founder of realism. There is only one known photograph of Balzac: the daguerreotype taken by Nadar, who attributed Balzac's unease about being photographed to the writer's theory that each body is composed of matter arrayed in an infinite series of specters superimposed in finely leaved layers; since nothing is created from nothing, each photograph is a theft that necessarily lifts and makes off with a ghostly layer. And Balzac, according to Nadar, was not alone among the literati in his dread of the camera: his writer friends Gérard de Nerval and Théophile de Gautier quickly fell in step with Balzac's ghost stories: tales of vulnerability, apparition, invasion, desecration, and body snatching carried out in protracted slow motion.[23]

We have come today to associate the head-on shot, the "mug shot," with police lineups and prison records. In the late nineteenth and early twentieth centuries it was linked to these and other scientific or pseudoscientific enterprises. The list includes asylum and hospital files, anthropometric research and colonial

FIGURE 13 Honoré Daumier, *Pose de l'homme de la nature / Pose de l'homme civilisé,* from *Le Charivari,* 1853. Lithograph. Courtesy of the Daumier Register. Copyright www.daumier.org.

exhibitions, the related daily work of scientists in the emergent fields of sociology and anthropology, and European and American bourgeois tourism, which used photographic postcards in the service of catching Others in the throes of their projected difference.[24] What is elided, however, in this summary is agency. I am referring first to the work of the photographer who aims the camera and who operates under the dictates of cultural expectations, who chooses the frontal shot (which, Catherine Lutz and Jane Collins argue, is the angle that renders facial scrutiny most accessible to the European gaze)—or not—and subordinates the photographed Other to this gaze—or not.[25] Also, quite differently but no less critically, I am thinking about the at least partial reactive agency of those subjects who manage to look back in defiance, anger, discomfort—or to look away—and of those subjects whose relative position and power allow them to assume an allure and a gaze that situates them above the other pictured subjects. This is the case of many of the *marchandes,* in relation to their clients, and of the incongruously well-dressed men on postcards 1 and 2.[26]

Socioeconomic and demographic factors are especially revealing about the conditions of mobility and access related to photography. As Naomi Schor and

others have observed, throughout the nineteenth century, and increasingly in post-Haussmannian Paris, "the ability to move from *quartier* to *quartier,* hence, to adopt the all-seeing perspective of the taxonomist, was . . . a privilege of class and gender."[27] The bourgeois male had access to the progressively segregated high and low areas of Paris, *beaux quartiers* and ghettos alike, but a widening socioeconomic gulf constrained the worker's mobility. While the existence of the flâneuse has been both well established and complicated, we know that she was a rarer phenomenon precisely because bourgeois women could not easily circulate without recourse to disguise or its diametrical opposite, flamboyance.[28] Not surprisingly, then, the photographers who mapped Paris onto postcards—recapitulating the administrative gridwork of arrondissements now chiseled in a no less gridlike network of photographic images—seem to have been largely bourgeois men, flâneurs with cameras.[29] Schor states that within the prominent LL photographic service that is her prime focal point around 1900, she "would be most surprised to discover that any member of the . . . team was a woman or a worker."[30]

Elizabeth Anne McCauley, focusing on carte de visite precursors to viewcards, finds that in that industry in 1860, there were more than five times the number of men to women (461 men to 92 women [and 13 children]). We should note, however, that McCauley offers no statistics about the internal gender breakdown among photographers, retouchers, and other technical atelier employees; it seems reasonable to surmise that the number of women photographers, particularly street photographers, was quite small. We do know that across the board in the industry, the socioeconomic level was reasonably high: among male employees, approximately five out of six lived in privately owned homes; among women, the ratio was better than eight out of nine. All of the men were able to read and write, as were all but five of the women.[31] The statistical evidence supports a viewing economy structured by a privileged gaze dominating a largely working-class public exposed to the camera. The trope of the photographer as sanctioned bourgeois male spectator looking down on his lower-class subjects is formally realized by the angle of the camera, which is poised in most of these photos above ground level so that the viewer looks down (spatially as well as attitudinally) upon the scenes of popular eating.

—— POSTCARD 3 (POSTCARD 4)

We move on to a *gros plan* with a haloed legend printed in the lower right: "905. Paris—Halles Centrales—La Marchande d'Arlequins—E.L.D." (Plate 3).[32] This *marchande d'arlequins* is again remarkably well fortified in comparison to her clientele. She bears her weight assertively, shoulders thrust back as she appraises her domain and the camera that is simultaneously taking it all in. Her *embonpoint,* a fitting advertisement for the bounty she dispenses (or at least for the good living she reaps from it), appears in marked contrast to the leanness of her

customers, which is ironically echoed on this particular copy of the postcard by the figure of Marianne *la semeuse* on the ten-centime stamp in the lower left. Still wearing her Phrygian cap, Marianne sows her seed with an expansive gesture from a cloth sack that evokes the ragpicker-like bags that are iconic elements of the *arlequin* postcards; with her seeds, she disseminates the signs of agricultural prosperity and plenty smack in the face of the urban indigence depicted in the photo.[33] That *this* photo on *this* card bears *this* stamp while others may not is not a deterrent for the story I am trying to tell, any more than is my taking into account a host of other contingencies such as postcard editors' captions or logos super-imposed on photos, and various individual messages on cards; it will become evident that my attention is driven not to the photographs in isolation, but to the composite effects they elicit from today's viewer-reader, even when contingent, and even though they may be different from the range of reactions they might have provoked in earlier confrontations.[34]

The vendor poses for the photographer as do her dozen pictured custom-ers, most of whom focus on the camera rather than on the plated food they are thronging to buy. Their gazes mix curiosity, hostility, suspicion, irritation, defiance, and a strained forbearance in varying measure. These clients look resistant, less ready to accept an identity capture passively; in particular, the woman in the right background who shields her eyes from the light in order to maintain her gaze implies a reluctance to become a mere object of photo-graphic scrutiny. A single figure, the worker at the front of the food queue on the left, appears almost to be playing a consumer's role in the face of surveillance, transacting a purchase rather than an exchange of stares; he performs the role so completely that he already holds a morsel of food in the fingers of his dra-matically outstretched hand. Reminding us of the overzealous café waiter in Jean-Paul Sartre's famous analysis of bad faith, he exaggerates the actions of an actor playing a customer intent on his purchase, becoming like a caricature of such a customer, indicating in this way that he is perhaps even more alienated from his role-playing than the visibly recalcitrant patrons around him.[35]

Beneath the table, mirroring the profile of the harlequin consumer, sprawls a large shaggy dog whose matted fur forms tufts that caricature the folds of the worker's shirt and echo the ridged basket weave. Whether pictured like this, under the table, as was most common, or shown surveying the scene from the side, dogs had an iconic presence in images of *marchandes d'arlequins* and their consumers. On postcard 4 (Plate 4), a dog eyes the harlequin scene from a litter-strewn street, at just a small remove from the men queuing up. Such canine iconography serves as a reminder that these scraps of other people's meals were more appropri-ately consigned to pet food.[36] The image insinuates that those humans to whom devolved such remains were themselves no better than dogs, derived, like the de-rogatory term for the working classes—*la canaille*—from the same root as *le chien*. The message is tautological: dog food for the dogs, or trash for the trashy.

But the connotations of these images would have been overdetermined at the turn of the century, only three decades after severe food deficits during the siege of Paris and the Commune led merchants to stock their butcher shops and charcuteries with less than prime cuts. Food scarcity forced shopkeepers to source meat in the stables, gutters, zoos, and boudoirs of Paris, if we are to believe the anecdotes and illustrations that have been passed down, and yielded variety meats ranging from horses, to rats, to elephants, to cats and dogs.[37] So the sight of dogs in proximity to harlequin tables might also have raised the specter of a hunger so extreme that it could drive humans to eat their pets and their companions, or could, at the very least, spur their provisioners to market animal flesh of ambiguous identity.[38] A cartoon from 1872 (Plate 5), immediately following the Prussian occupation of Paris and the ensuant Commune, further points to the network of associations that connect the rigors of food paucity (whether the cause is poverty or war) to animals usually considered to be part of the family. Henri Meyer's *La Marchande d'arlequins* is a caricature of a harlequin seller and her wares—some of which are porcine products prepared and plated on the counter, and some, a variety of canine flesh still alive under the counter, awaiting processing. The insinuations of this image are as multilayered as the *marchande's* display case, which shows the dogs snarling at each other in a "dog eat dog" attitude as they eat ill-descript matter from a communal dish on the lower level. The receptacle is the replica of those that hold the foods displayed for human consumers above them.[39] What are these animals eating, and to whom will *they* in turn be fed?

Postcard 3, which launched this section (Plate 3), is postmarked January 4, 1906. On the back, a man who signs himself "petit Pierre" sends to his addressee, Madame Suzanne Champadour of Nevers, a laconic kiss ("un baiser") utterly dissociated from the imaged scene, leaving the belated viewer caught in limbo between two pages, as it were.

—— FRAGMENT: WORKING DOGS

Dog-drawn wagons, carriages, and delivery vehicles were outlawed by the Paris police in 1824, less for reasons of cruelty to animals than because of the perceived menace of biting, speeding, and traffic accidents. If the Paris ban on working dogs of 1824 was reenacted in 1911, implying a certain urban vigilance along with a likelihood that the initial prohibition was not completely effective, the story in the provinces was different. In his well-illustrated *Chiens au travail dans la carte postale ancienne,* Yves Bizet reports that canines were widely used to transport people, merchandise (especially of an alimentary nature), and building materials.[40] They were harnessed to milk carts and butcher's wagons, used to convey bread, meat, fish, fruits and vegetables, charcuterie. They worked for newspaper vendors, ragpickers, farmers, loggers, mail carriers, knife grinders, tinsmiths, carpenters; they performed in circuses and fairs and were the literal

motor force for certain small tradesmen and (proto) taxi drivers. Canine physical labor was in fact so common and so onerous that the dog was referred to as "le cheval du pauvre" (the pauper's horse).[41] More widespread measures were taken not to ban but to regulate the labor of dogs throughout France, with efforts beginning in 1894 and then rearticulated by the minister of the interior in 1936. But exceptions were frequently made: work authorizations were broadly granted on a case-by-case basis for a wide variety of reasons, including infirmity, age, poverty, family needs, and professional necessity.

As Bizet's postcard collection confirms, the toil and industry of dogs were well illustrated, and its postcard record widely disseminated in France. In the light of these photographs of canine hard labor (Figures 14, 15), contemporaneous photographs of dogs lolling about at Les Halles, surveying the scene of hungry people, lazing beneath tables laden with food ready to drop in their mouths—a picture of canine indolence—show city dogs to be slothful and unproductive. Perhaps they are ready for slaughter? The attendant harlequin eaters, already assimilated to these dogs because of their eating habits and lowly trades (they, too, beasts of burden), are by inference another shiftless pack of idle creatures.

—— POSTCARD 5 (POSTCARDS 6, 7, 8)

Harlequin vendors and soup sellers serviced a similar clientele, often sold their wares side by side, and were sometimes photographed together in a kind of diptych image, as in postcard 4. As I show in greater detail in chapter 1, the two categories overlapped; the *marchande de soupe* used ingredients comparable to those of the *marchande d'arlequins,* albeit deteriorated one step further, and so suited for the more intensive mixing, mashing, and dissolution characteristic of soup. In harlequin narratives and images, soup then becomes the degree zero of the leftovers trade, lowest of the low.

Postcard 5 (Plate 6), dating from 1905, features dedicated soup sellers specifically labeled *marchandes de soupe*. This card, numbered 688 in the celebrated editors Neurdein series *Marchés de Paris,* is further tagged "Halles Centrales, une Marchande de Soupe."[42] We notice here as in other soup-seller photos that the assembled patrons tend to look, as an ensemble, far more threadbare and disheveled than the average harlequin patrons; probably not coincidentally, the photographers tend to shoot them unmercifully, exposing them in their infirmity, eccentricity, and indigence. In the left foreground an amputee balances himself on his crutches and peg leg along with a bowl of soup in one hand and a spoon in the other. In the midground a haggard woman with deep circles under her eyes, wearing a torn and wrinkled skirt, dips a spoon into her bowl while on the right a male client is caught in the act of eating. Meanwhile the *marchande,* seated behind her soup pots, hands over a bowl to a fourth client shot with outstretched hand. Behind and all around her, people swarm. A comparison of *marchande d'arlequins* and *marchande de soupe* cards suggests a socioeconomic

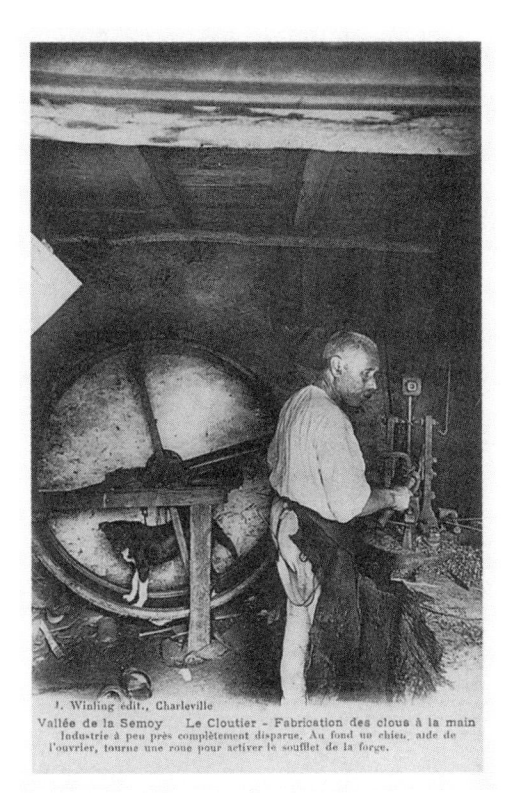

and gastronomic descent from harlequin to soup stands and a plunge into more popular and populous scenes. The photographer striving to seize a moment that might hold together all the moving parts in his shifting scene would have needed to work quickly, and indeed we see traces of the shifting crowd in the blurring around the soup seller's extended hand as well as around the amputee's spoon rising from bowl to mouth.

From amid a plastering of posters on a building wall in the upper left corner, one in particular leaps out (Plate 7, which is a detail of Plate 6). It bears the full-length image of a fashionably dressed, elegantly bonneted and booted young woman proffering what appears to be a *pièce montée* (an elaborate confectionary centerpiece) in the direction of the words announcing the twenty-second Exposition Culinaire to take place at the Tuileries Garden. Like the Expositions Universelles where they were born (and from which they branched out to became independent dedicated culinary events beginning in 1883), French Culinary Exhibitions were ideologically entwined with nationalism, imperialism, and the production of elite culture. The stakes here for culinary professionals were correspondingly high. To assure the admission of gastronomy into the pantheon of the *beaux arts* rather than the *arts décoratifs,* and to usher chefs into the ranks of artists rather than workers or tradesmen, chefs needed to distinguish their art from the vulgar purposes and practices of domestic cooking. This entailed a radical discursive revolution: "Transforme[r] la représentation de l'acte de se nourrir: ce n'est plus chose ignoble mais . . . affaire de goût et de raffinement" (To transform the representation of the act of eating: this is no longer a base undertaking, but a matter of taste and refinement), in the words of Denis Saillard.[43] Much like the harlequin and soup stalls at Les Halles, the Culinary Expositions used long tables to display their culinary wares, but unlike the seamy table surfaces common in the market stalls, these tables were set as visual spectacles adorned with floral displays, fine linens, crystal, edible sculptural and architectural pedestals. Striving toward artistry, the expositions were modeled on Salons d'Art and were designed to illustrate the latest—signed—works of the great chefs and to celebrate their fine Frenchness.

Such references to the high cultural reformation of cooking are packed wordlessly into the advertisement for the twenty-second Culinary Exposition suspended above the soup eaters. It stamps the scene of hungry people like an ironic mise en abyme, a trace of elite banquets whose substance might conceivably have trickled down into the workers' bowls, now retransformed into the ignoble stuff of mere bodily nourishment.[44] What more efficient—and charged—way could we imagine to distinguish between social and cultural groups than to juxtapose and contrast what they put in their bodies? From anthropologist Claude Lévi-Strauss to philosopher Pierre Bourdieu to restaurateur and television chef David Chang, we hear reverberations of the same lesson, which is that food is used to construct racial, ethnic, and religious determinations and hierarchies,

or, in Jean-Pierre Poulain's summary words, "l'aliment insère le mangeur dans un système d'alimentation" (food inserts the eater into an alimentary system).[45]

There is a second poster, mostly hidden behind the Culinary Exhibition advertising that papers it over, on which we make out "Bataclan," the name of a site that has been branded onto twenty-first-century history by the terrorist attacks of November 13, 2015.[46] Before its late twentieth-century reincarnation as a site for music performances, the theater was a venue for popular theater. Constructed in 1864 by the architect Charles Duval, the Bataclan stood out, then as now, for its exotic pagoda-like architecture, one of many stylized artifacts through which the French reinterpreted Far Eastern style. It took its name from Jacques Offenbach's 1854 opera bouffe, *Ba-ta-clan,* which also dealt in *chinoiseries,* French stereotypings and re-imaginings of Chinese and broadly pan-Asian cultures. Next to this partially visible poster is a political placard that is duplicated slightly to its right, on the other side of the furled curtain, upon which we read the heading "Le Repos hebdomadaire." These posted bills call out, in unison, for a weekly day of rest for workers. The demand for regulated time off would only be satisfied by law the following year, in the summer of 1906, though it had been in slow process since 1900 and was the last in a series of labor reforms begun in 1890. France was the penultimate Western country to enact legislation for a day of rest. It has been argued that among the deciding factors for passing this law were sociopolitical and hygienist concerns, post defeat by the Prussians, about the degeneration of virility and the falling birth rate in France—despite opposing arguments that a day off would encourage workers to congregate in cabarets where they might drink and agitate.[47]

As if in response to the clashing elitist and populist posters backgrounding the scene of worn and hungry workers, a postage stamp affixed to the lower right corner of the card seems literally to weigh in the balance. The stamp, which incongruously echoes the culinary poster both in its rectangular shape and its imprint of a feminine figure, bears the image of a very different woman, this one the allegorical personification of justice. Each of the two feminine figures appears with a symmetrically outstretched hand, one the embodiment of gastronomy, holding a cake, and the other, the incarnation of fairness and impartiality, armed with a set of scales. Ensconced in opposite corners of the card in apposing three-quarter view, mirroring each other, the paired women seem ready to engage in a face-off. The play of rectangles does not stop there, however. The superimposed posters on the upper left back wall—the upscale culinary, the lowbrow theatrical, and the working-class socialist—form a composite rectangle that is also in play with the philatelic rectangle on the bottom right. From this perspective, its figure of justice seems poised to adjudicate the complex messages crossing the card.

The photograph dates from 1905; the card was posted in 1907. The canceled stamp tells us it has circulated—but other details indicate that its tour was

eccentric; indeed, it is inscrutable. For there is not only no handwritten message but also no address. The single postmark of origin indicates a missing destination, an undeliverable communication, a message undelivered—or better said, misdelivered, leaving this reader and her postcard seller and no doubt at least a handful of others caught in the act of reading (and perhaps overreading) other people's reticent mail.

Other postcard photographs of soup stalls follow suit in their unflinching visitation of working-class eating scenes (Plates 8, 10, and 11). There is a violence in the exposure of so many hovering spoons, opening mouths, avid downturned glances at the bowl, teeth gnawing at tightly clutched scraps of bread. Intimate space is invaded as the private becomes spectacle. These scenes show hunger: we are shown public feeding, not refined dining; brute animal need rather than civilized good taste (recalling the distinction Bourdieu makes between "the taste of need and the taste of luxury").[48] Both food and human beings are reduced to their lowest common denominator as they converge in a base bodily function. The camera lens trained on ascending and descending spoons and devouring mouths reveals the nakedness of poverty and the projection of human corporeality and mortality onto it. We might paraphrase Auguste Villiers de l'Isle-Adam's *Axël* here: "Manger? Les serviteurs feront cela pour nous" ("Eat? The servants will do that for us").[49] To photograph staunch bourgeois citizens standing outside swallowing soup or chomping hunks of bread would, of course, be unimaginable. If the modern viewer feels compelled to look away from some of these images it is to break a complicit triplication of our gaze with the eye of the photographer and the lens of the camera, which presume the availability of these Othered bodies, offered like pimped prostitutes or pinned moths or animals at feeding time in the zoo.

Speaking generically about the act of taking a picture, Susan Sontag called it "predatory," explaining that "to photograph people is [to see] them as they never see themselves, [to have] knowledge of them they can never have; it turns people into objects that can be symbolically possessed."[50] Like most forms of predation, photography, we might add, has a pecking order, tending first to devour its least defended, its most visible and accessible, its most abject objects. Like most metaphors, predation brings together two word-stories in the union of vehicle and tenor; but in the particular case of soup-eater photography, both stories are about consumption: together they tell a convergent, double-layered story about voracity. Camera predation, like consumption, has to do with crossing a series of edges separating categories, bodies, subject and object, outside and inside. One of the cruelest breaches attributable to the photographic predation of soup stalls may be that of intimacy, which Western thought as well as grammar locates in the deep reaches of human space.[51] If it is true, as Barthes reminds us, that the coming of age of photography coincides with a new social phenomenon, the making public of the private, whereby "le privé est *consommé* comme tel, publiquement"

(the private is *consumed* as such, publicly), it is essential to add that what he calls "l'irruption du privé dans le public" (the eruption of the private in the public sphere) is much more than an abstraction: it takes (and is photographed in) the conspicuous human shape of those who already inhabit or pass time in this sphere: the denizens of the streets and its public feeding grounds.[52]

To think further about this assault on privacy, we might look at the soup vendor in postcard 8 (Plate 11), "Paris Vécu—La Soupe aux Halles," who seems to take her head out of the picture as she bends over and reaches down, blanking out her identity as she gives the camera a function—an expanse of white apron—instead of a face. We might speculate on the photographer's design, wondering why he chose this particular moment of facial erasure to click the shutter, or if this exposure was merely an accident of time; we might then further reflect on the intent of the photographer and the editor in selecting this particular shot to be postcarded. We can imagine different narratives, but none adequately accounts for the central placement in the photo of an effectively decapitated *marchande* with her shroud-like apron catching the light. All that remains visible of the *marchande*'s head is her hair pulled up in a bun, ironically suggesting the knot of a brioche hovering tantalizingly over a scene of food scarcity.

The soup seller's white pinafore visually separates the standing men into two murky, nonparallel columns on either side of her. One column of three faces the soup seller, eating; the other, also composed of three figures (one of whom is almost obscured by another), stands behind her. This second group is on another plane facing out toward the camera, and only one man is pictured with soup. The two figures on the far right are further distinguished from the already divided cluster—and even separated from the third man who is spatially proximate—by their demeanor and dress. The only two men without a a soup bowl, they stand apart and are engaged in looking back in the direction of the camera rather than eating. While it is possible that they are waiting to be served, their position behind the vendor belies this. Perhaps they have wandered over to observe the tableau of eating, or the scene of shooting this tableau. Tall and darkly bearded, they are dressed in dark clothes, unlike the others. One is covered by a long outer garment, while the other wears a different kind of head covering than any of the others, one that approximates a skullcap of the sort that was worn by Muslims or Jews—though the former were rare in Paris at the time. Everything suggests that they are not local figures, or at least not typical ones; yet I can do no more than hazard guesses about their identity.

The sender of this card, G. Aressy, leaves no commentary about the image that she sends to Monsieur Dieudonné in Laon; she gives as sole message an address, presumably her own—or perhaps that of an assignation--across the bottom of the image, scrawled under the photo caption: "10, Passage Dulac (XV$_e$)." This concision (fewer than five words) allows her legally to affix a five- rather than a ten-centime stamp to the card, mailed in December 1904.[53]

——— FRAGMENT: COLONIAL ZOOS

For at least as long as Malek Alloula's *Harem Colonial* has been circulating, and probably longer (it was published in French in 1981 and translated into English five years later), scholars have been speaking critically about the exhibition and circulation of the colonizer's gaze upon the colonized, the projection of imperialist phantasms upon subjugated people, and the use of constructed images and the discourses they support to justify the so-called civilizing processes and the violations of colonialism.[54] That such challenges to and deconstructions of exoticizing projects have most often been addressed to exocolonialist iconography and rhetoric (in the French context, picture postcards of West Africa, North Africa, Indochina, New Caledonia, sometimes the Antilles, and so-called French Polynesia and French Guiana) should not deter us from thinking in much the same way about similar processes used in "endocolonialism": collective phantasms projected upon subordinated human groups within the hexagon displayed on the basis of socioeconomic rather than racial difference (or for that matter, on the basis of any other form of "deviance" from normative categories). As Anne Maxwell contends in *Colonial Photography and Exhibitions,* the live displays of ostensibly primitive peoples performed at the Expositions Universelles and other fairs and circuses and the well-circulated photographic images of these colonized peoples were parallel representations of European hegemony.[55] Serving a variety of purposes ranging from the promotion of nationalism and imperialism to the (not unrelated) advancement of scientific theories about race, live or "anthropological" exhibiting and photographic recording of colonized Others worked hand in glove to gird European expansion and tourism both direct and vicarious.

In Paris displays of primitive peoples were located alongside the animals as early as 1872 at the Jardin d'Acclimatation in the Bois de Boulogne. In the 1880s the Jardin, Maxwell notes, "began to resemble a zoo: human specimens were placed behind fences and railings, and spectators began to throw them coins."[56] Here a pattern began to be set; in 1889, when ethnographic displays at the Exposition Universelle abounded, the "native villages" were installed behind tall fences that caged in the "natives." In Germany as well, the ethnographic exhibition was set up as a human zoo. The showman Carl Hagenbeck, "impresario of the exotic," was initially an animal dealer. He first started importing non-Western people as an extension of his menagerie in Hamburg. Inventing the word *Völkershau* for the human exhibit, he set up a live exhibit of Mongolians in 1883 at the Berlin Zoological Garden.[57]

The 1900 Exposition Universelle in Paris featured a Senegalese village fenced off from the crowds, the scene "evoking a zoo," recounts Catherine Hodeir.[58] A few decades later, Kanak and African "native villages" at the Colonial Exhibition of 1931 put their respective "primitives" behind bars. Didier Daeninckx's novelized account of the New Caledonian village at this exposition represents

onlookers throwing peanuts and bananas at the caged Kanaks while they follow orders to bare their teeth and growl.[59] The newspaper *Paris Soir,* in its daily coverage of the Colonial Exhibition of 1931, ran a photo representing "an African 'native' alongside zebras and monkeys from the Vincennes zoo," invoking the obvious social Darwinian trope.[60] Crowds swarmed to gawk at the spectacle. The record shows rare traces of an occasional voice registering disapproval, such as Sudanese militant Tiemoko Garan Kouyaté's denunciation of the exhibition as a "commercial and epicurean zoo of caged African lackeys."[61]

The move to connect the exhibition of exotic outsiders, or racial savages, to that of exotic insiders, or socioeconomic primitives, is more of a glide than a leap, enacted rhetorically as well as conceptually. There is a long history of assimilating the poor to the "primitive," the "savage," and the "uncivilized" races; it is archived in the turn-of-the-century borrowing of the French term *apache* from the American Indigenous tribal name, to refer to gangs of young urban criminals viewed by the bourgeoisie as "the new barbarians."[62] But in 1842, well before the Belle Époque extension of what Michel-Rolph Trouillot calls "the savage slot" from the Indigenous to the indigent, Eugène Sue, as we earlier observed, had appropriated James Fenimore Cooper's *Last of the Mohicans* to paint the "dangerous classes" of Paris as "les barbares . . . au milieu de nous" (the barbarians . . . among us).[63] Notions of race, not unproblematic today, were extremely fluid throughout the nineteenth century.[64] As Françoise Mélonio contends, old fears of the "savage" peasant yielded quickly as the century progressed to "la crainte . . . de l'ouvrier, barbare ou apache. . . . Des ruraux comme des ouvriers, on dit volontiers qu'ils sont 'd'une autre race' que les bourgeois citadins" (a fear of the worker, barbarian or hooligan. Speaking of country folk as well as of urban workers, it is said that they are "of another race" than bourgeois city dwellers).[65] The nineteenth-century poor, notes Judith Walkowitz, were constituted by the rhetoric of urban imperialism as "a race apart."[66]

Exhibitions of racial others and displays of socioeconomic others, whether live or photographed, can be traced back to "freak shows" at carnivals, fairs, circuses, and street shows that staged humans as oddities, based on perceived physical differences such as size, missing limbs, excessive hair, and gender crossing; ethnicity later joined such characteristics. But as Burton Benedict comments, "Behavioral 'freaks' can be created from one's own culture, especially if eating is involved."[67] What I am suggesting is that postcard exhibiting of the laboring classes serving or slurping soup, or lined up as if to mirror the displayed food debris they were waiting to consume, constituted anthropological displays or human zoos not unlike those of racially exotic postcards and live colonial expositions: such cards circulate traces of the feeding behaviors of Others publicly performing creaturely needs on behalf of those who could afford to do so in private.[68]

—— FRAGMENT: ON FRAGMENTS

Again, picture postcards did not have a monopoly on humiliating displays of lower-class feeding: the other visual arts, and a multitude of narrative descriptions going back to the late eighteenth-century work of Louis Sébastien Mercier collaborated to provide a fairly congruent representation of the practice as it evolved over time, meaning not a representation that is "true" or smooth, but one that is ideologically inflected in consistent terms. The reason for putting postcards on the witness stand, so to speak—specifically granting them an independent chapter—has as much to do with their wide distribution and the way such distribution re-enacts the trajectory of leftovers as it does with any evidentiary function of the photographs they bear.

I give postcards an edge because of their compelling relationship to the traffic in food scraps: one that is not only metonymic but metaphoric as well. That is, the photographic viewcard is materially attached to the photo it bears of the *arlequin,* but it is also itself, by analogy, *un arlequin,* a scrap, a replica, whose path goes wide and far. "C'est fait pour circuler," says Derrida of the postcard (it's made to circulate).[69] The principle of circulation and recirculation is a defining one for postcards and table scraps in the long nineteenth century, as is the notion of repetition, as is the regime of fragmentation. The postcard, like the *arlequin,* is an entity always broken away from a whole, a thing whose essence is always to be already *en morceaux* (in morsels or scraps).[70] The edge I grant postcards is precisely their physical edge, or edges, *les bords*: a material limit that reproduces a broken condition, a falling away from an earlier feast, the bits and bites of a banquet.

—— FRAGMENT: THE FIFTH EDGE

If a postcard has four obvious edges that cut it off from the "live" surrounding world, there is also a fifth edge that divides the photograph and the message, and in so doing, separates the sender/message writer and the image. In the case of the "modern" postcard, formatted as we know it still since its late 1903 inauguration, with a divided back for address and message, the edge is literal: the card must be turned from front to back, recto–verso, to read the message, or inversely, verso–recto, to view the image.[71] For postcards printed and circulated before the format change, however, when message writing on the then-undivided address side of the card was not allowed and senders instead wrote their messages around, above, below, or across the image, what I'm calling the "fifth edge" was virtual. This edge, analogous to the "fourth wall" in theater and in cinema (which separates the actors from the audience or the camera and constitutes them as oblivious to the public), can similarly be broken, but rather oddly, usually remains intact, even when image and message are juxtaposed or superimposed on the same side of the card. As preparation for examining in more detail the radical disjunction between message and image that I call the fifth edge, I want to look at a few exceptions that work to confirm the rule: rare examples of messages, on either side of the card, that mention, explicitly or by allusion, the accompanying photograph.

—— POSTCARD 8 (*BIS*)

On a card that I earlier identified and discussed as postcard 8 (Plate 11), and which was labeled by the editor, LJ & Cie, "Paris Vécu.—La Soupe aux Halles," we may recall finding, under the feet of five hungry male soup eaters grouped around a *marchande* whose face is out of the picture, a discreet message very much in line with the fifth-edge rule of detachment: just an address in the fifteenth arrondissement, far from the photo site in Les Halles, and a signature. However, on another copy of this card (not won at online auction, and so not reproduced here, but to which I will refer as postcard 8 *bis*), a longer message borders three sides of the photograph side of the card (the message is sprawled across the top and bottom, two lines each, with signature and date stretching from bottom to top in the right margin.) The writer, a woman (who composes in the first person but signs in the plural "Jeanne et Raoul"), closes by engaging with the photograph. She sends congratulations for the engagement dinner of a certain Mlle Rosa, daughter of a brewer in Douai, to whom the card is addressed. She wishes all the dinner guests a "bon appétit" and adds her hope, for the sake of all, "que le repas sera plus frugal que celui de ces malheureux!" (that the meal will be more frugal than the one these poor people are having)—obviously referring to the wretched souls in the photograph having their liquid meal on the pavement. The strange wording of the note—for how much more frugal could a meal be, and would she wish such frugality on her friend's engagement feast?—is difficult to fathom unless we attribute it to a lapsus (maybe she meant to write "moins frugal" instead of "plus frugal"?) or to sarcasm, but in any case the gist of the message is clear, as is Jeanne's verbal recognition of the postcard image. The allusion to the photograph framed by her surrounding words remains one of a very few exceptions to the utter noncorrespondence of image and message that I have encountered while perusing hundreds of these *marchandes d'arlequins et de soupe* postcards. It is worth adding that Jeanne's acknowledgment of the image, and therefore of the existence of such poverty, should not be read as a sign of class consciousness or even as a bit of liberal social commentary; it is more than probable that she, like the newly engaged brewer's daughter, Rosa, is a well-fed bourgeois woman whose world does not touch that of street eaters, and her remark functions more as a snide marker of class distance and indifference than of rapprochement.

—— POSTCARD 6A, VERSO OF POSTCARD 6

This card (Plate 9), whose soup-seller recto we have already considered, has an unusual written verso; unusual first for the sheer length of the message, which is scribbled in minuscule writing from the left to right edge of the card, in defiance of the left/right division into spaces labeled, respectively, "Correspondance" and "Adresse." Seventeen long lines run horizontally, and then nine additional short lines are written diagonally across the only empty space, that surrounding the block-lettered words "Carte Postale," printed across the top. As a result, the

card bears neither address nor stamp, and could not have been sent as is; we can only assume that it was mailed in an envelope (which would have been franked at a higher rate). If the sender chose to write his missive on a card rather than on paper it may have been simply because he had the card at hand. Alternatively, given that the note is largely about the specter of poverty, ill health, and food deprivation (with regard to both the writer's concierge and his own daughter), it is possible that he chose deliberately to write on the flip side of a card representing hungry workers. But since he makes no explicit reference to the image, the echo might instead be coincidental, a fortuitous marriage of image and word.

The father, who addresses his note to his "dear daughter" and signs "your loving father" ("ton père qui t'embrasse"), begins by picking up the threads of a conversation about the financial problems of his concierge, stressing that several years earlier, he had advised this woman to have her daughter learn a trade, since one never knows what life may bring. She, he recounts, had more recently told him that she had been wrong not to have heeded him, "Car le peu que sa fille gagnerait aujourd'hui leur serait d'un grand secours. Certainement que ce n'est pas tout rose d'aller en apprentissage et que la santé s'en ressent pas mal, mais si un jour, on a rien à se mettre sous la dent, c'est encore bien pire" (For what little his daughter might earn today would still be of great help to them. Certainly, apprenticing oneself isn't all rosy and has an ill effect on one's health, but if someday one has nothing to bite into, it's a lot worse). He moves on from this graphic metaphor of hunger, the dark prospect of having nothing to sink one's teeth into—so evocative of the soup eaters—to address his daughter's situation. He, in contrast to his concierge, seems to have had the foresight to send his daughter out to work when she was younger ("croyant bien faire à ton égard, j'ai la conscience tranquille" [thinking I was doing the right thing on your behalf, I have a clear conscience]); however, his pride is mixed with remorse about not having done enough to prevent her from working when the labor became debilitating: "te voyant maigrir de la sorte, j'aurais dû me gendarmer pour t'empêcher de travailler; mais voilà, on ne sait jamais à quoi s'en tenir sur ce qui se passe" (seeing you losing as much weight as you did, I should have made a fuss to prevent you from working; but there we are, one never knows what decision to make at the time something is happening). We see an echoing motif in the two stories of a working-class parent trying to make ends meet, striving to make the right decision for a child in the face of socioeconomic odds impossible to predict. And the father closes his reflection by reporting that he recently managed to get some work ("un petit rien de travail, mais malheureusement c'est déjà fini" [a passing bit of work, but sadly it's already over]). He adds on a brave upbeat: "Enfin, ça a bouché un petit trou" (Well, at least it filled a hole), reverting to the theme of stopping up holes, and most specifically, staving off hunger.

The most unusual aspect of this card, then, is a poignancy that comes of the atypical relevance of its words to its image, and its image to its words. In other

18. – Une Visite aux Halles Centrales
Les Arlequins. Les restes des restaurants sont vendus, chaque plat séparément, 1 à 2 paniers par jour *J. H.*

PLATE 1 Postcard 1, "Une Visite aux Halles Centrales. Les Arlequins," circa 1911. All postcards discussed in this chapter and presented as plates are from the author's collection.

181. — Paris. – Les Halles. – La Marchande d'arlequins.

PLATE 2 Postcard 2, "Paris. Les Halles. La Marchande d'arlequins," circa 1908.

PLATE 3 Postcard 3, "Paris. Halles Centrales. La Marchande d'Arlequins," circa 1906.

PLATE 4 Postcard 4, "Les Marchés de Paris. (Halles Centrales). Marchands d'Arlequins et Marchands de Soupe," circa 1906.

PLATE 5 Henri Meyer, *La Marchande d'arlequins,* 1872. Cover illustration from the satirical weekly *Le Sifflet,* December 1, 1872. Drawing.

PLATE 6 Postcard 5, "Marchés de Paris. Halles Centrales, une Marchande de Soupe," circa 1905.

PLATE 7 Detail of posters on postcard 5, circa 1905.

PLATE 8 Postcard 6, "Paris. Halles Centrales. La Marchande de Soupe," circa 1906.

PLATE 9 Message on verso of postcard 6, circa 1906.

PLATE 10 Postcard 7, "La Soupe aux Halles," circa 1902.

PLATE 11 Postcard 8, "Paris Vécu. La Soupe aux Halles," circa 1904.

PLATE 12 Postcard 9, "Série No. 6. Vues Stéréoscopiques Julien Damoy. Jardin D'Acclimatation. Les Achantis. Le Repas," circa 1907.

PLATE 13 Postcard 10, "Paris. Jardin des Plantes. Le Repas de l'Otarie," n.d.

PLATE 14 Postcard 11, "Exposition Coloniale 1907. Campement touareg. Cuisinier Saharien."

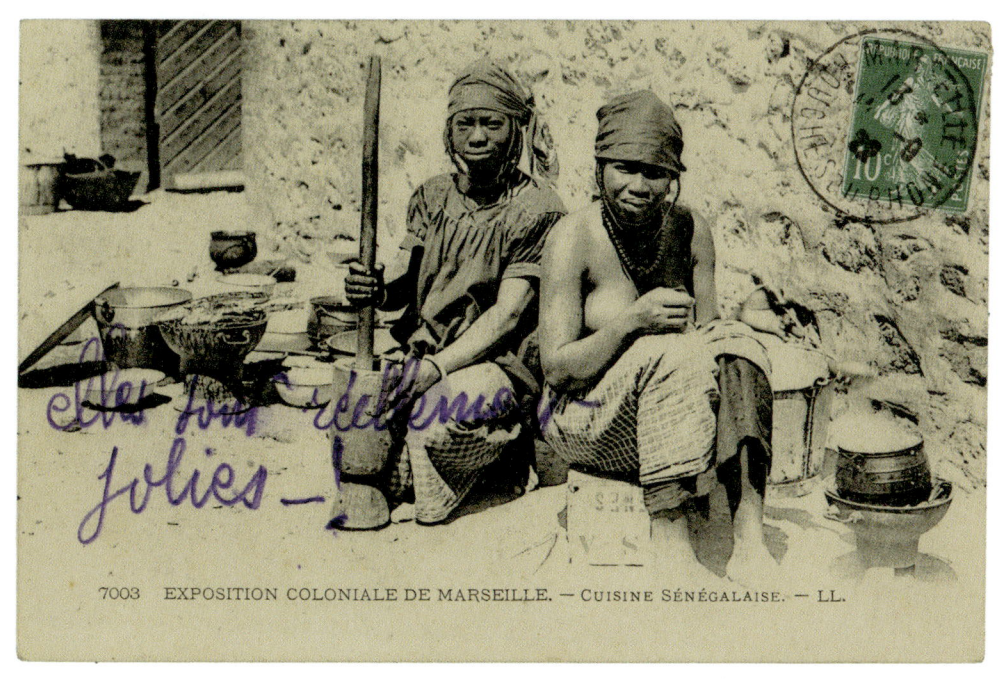

PLATE 15 Postcard 12, "Exposition Coloniale de Marseille. Cuisine Sénégalaise," 1922.

PLATE 16 Message on verso of postcard 12, 1922.

PLATE 17 Postcard 13, "Exposition d'Angers 1906. Édition officielle. Au Village Noir. La Cuisine de la Troupe."

PLATE 18 Postcard 14, "Souvenir de l'Exposition Coloniale de Nogent-sur-Marne 1907. Femmes Canaques de la Nouvelle-Calédonie préparant leur repas."

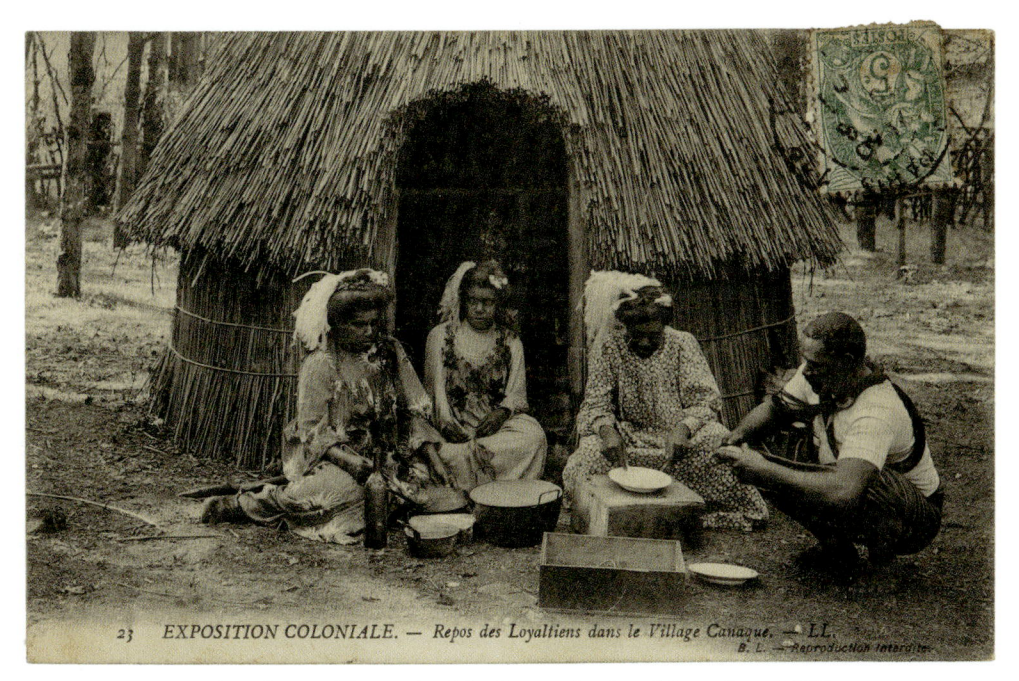

23 EXPOSITION COLONIALE. — *Repos des Loyaltiens dans le Village Canaque.* — LL.
B. L. — *Reproduction interdite.*

PLATE 19 Postcard 15, "Exposition Coloniale. Repos des Loyaltiens dans le Village Canaque," circa 1907.

98 EXPOSITION COLONIALE 1907. — *Campement Saharien.* — LL.
B. L. — *Reproduction interdite*

PLATE 20 Postcard 16, "Exposition Coloniale 1907. Campement Saharien."

PLATE 21 Postcard 17, "Exposition Coloniale 1907, Touaregs faisant le Café."

words, this is tantamount to the breaking of the "fifth edge" that usually divides image and message. The rupture is significant, whether it be intentional or accidental, particularly in view of its rarity.

—— FRAGMENT: A BOY FALLING OUT OF THE SKY

The norm, as I have suggested in passing throughout these pages, is a message completely dissociated from its accompanying photograph: an announcement of a holiday departure, the notification of a new address, a confirmation that the recipient is expected for dinner that evening, or simply, kisses sent from afar. Crowning the repertoire of dispatches is the following indifferent missive on the back of a card (not reproduced here) picturing soup sellers, harlequin sellers, their queuing clients, and a hopeful dog. A woman sends to her friend Germaine, in August 1905, some allusions to an upcoming social event with the hope "que toute la famille se porte bien . . . et que nous allons tous bien danser dimanche pour commencer la saison" (that the whole family is well and indeed, that we will all dance on Sunday to begin the season). Whether cruel or simply insensitive, the inscription of a dancing party on the other side of the picture of hunger is arresting. The workers waiting to buy leftovers on the front might in fact, mutatis mutandis, be about to eat the supper remains from just such a dance party anticipated on the back, and the dance about to take place will no doubt yield leftovers that will be siphoned off in the kitchen and routed to Les Halles to supply just such a harlequin stand, or to furnish the deteriorating ingredients for a soup stand not so different from the one shown. As the ironic juxtaposition of the postcard's two sides ironically suggests, so the cycle goes—with the fifth edge serving for the postcard correspondent as symbolic blinder (filling in for class) to the trickle-down dining implicitly linking the two sides.

The ethical conundrum might be rephrased ekphrastically by turning to W. H. Auden's well-known poem reflecting on Pieter Brueghel's even better-known painting, *The Fall of Icarus* (Figure 16). In "Musée des Beaux Arts," Auden muses on the affective schism the painting represents as the son of Daedalus, his feathered waxen wings melted in his reach for the sun, plummets from the sky into the sea, while around him all are absorbed in their own quotidian tasks and ignore the dramatic suffering of another. Auden's second stanza captures the particular shade of oblivion available to us all in the face of suffering that we do not allow to touch us directly:

> In Breughel's *Icarus,* for instance: how everything turns away
> Quite leisurely from the disaster; the ploughman may
> Have heard the splash, the forsaken cry,
> But for him it was not an important failure; the sun shone
> As it had to on the white legs disappearing into the green
> Water, and the expensive delicate ship that must have seen

> Something amazing, a boy falling out of the sky,
> Had somewhere to get to and sailed calmly on.[72]

What Auden limns here is an inattention that comes from a cognitive-affective lapse that is not exactly a not-knowing, but rather, a state of distraction or self-involvement so extreme that cognition isn't possible beyond the most superficial level: a kind of emotional anesthesia. What is at hand is not exactly a not-looking, but instead a kind of overlooking. Like that postcard writer who turns the picture of hunger over and writes onto it a joyful projection of the dancing season, or like that other writer who glibly hopes that her friend's engagement feast will compare favorably with the diluted meals swallowed by the standing soup eaters, Auden's Brueghel's ploughman may well have heard, but did not heed, the splash and cry of Icarus, and Auden's Brueghel's passing ship surely would have *seen* the boy falling from the sky, but did not *witness* the disaster. Focused instead on its own ambit, the ship did not pause in its path to really *take in* the sight—much less to try to *take on* the drowning boy.

—— POSTCARD 9, POSTCARD 10

Auden's iteration of Brueghel's meditation on "how everything turns away quite leisurely from the disaster" helps to frame—in the abstract—questions about human indifference to the suffering of others, but it can take us only so far in thinking historically about such questions. In particular, it has little bearing on the material factors of class and race that loom everywhere around and across the edges of French turn-of-the-century postcard traces of eating others. I include in this broad category not only the misery of those individuals who are the objects of my specific focus—the impoverished patrons of harlequin and soup vendors represented on postcards—but also that of the imported Indigenous peoples of colonized overseas spaces whose food choices, eating habits, and meal preparations were deemed different enough from French bourgeois mainstream practices to warrant their being not only exhibited in fenced enclosures but also captured on film and affixed to cardstock. I am referring here to postcards featuring mealtimes performed at zoos and colonial villages constructed at the Expositions Universelles or Coloniales in France in the late nineteenth and early twentieth centuries.[73]

So once again I turn to the zoos of the Jardin d'Acclimatation and the various Expositions Universelles and Coloniales whose displays and "Indigenous Villages" are models of spectacular and photographic violation, this time more specifically for food-related exposures. Though I make no claim that stagings of race and of class (and their photographic records) are identical, I believe they are sufficiently analogous to lend each other critical and theoretical support; the growing body of commentary on the first provides particularly useful scaffolding for my work on the second.

FIGURE 16 Brueghel the Elder, *Landscape with the Fall of Icarus,* circa 1558 (attributed to Pieter Brueghel the Elder or his studio). Oil on canvas, 28.9 × 44 inches. Royal Museums of Fine Arts of Belgium, Brussels. Copyright HIP/Art Resource, New York.

Postcard 9, mailed in 1907, bears a stereoscopic image labeled "Jardin d'Acclimatation—Les Achantis—Le Repas" in terse telegraphic style (Plate 12). In the blanks obscured by the dashes lie additional details that perhaps did not need articulation in 1907 but probably do today: notably, that the zoo of the Jardin d'Acclimatation, situated in the Bois de Boulogne, routinely exhibited imported colonial subjects along with exotic animals.[74] What we are seeing, then, in this image—clarified when we cumulate the visual information with the caption and the external details—is a meal shared by what is likely to be a family group of seven Ashantis who have almost certainly been transplanted from their West African home to the zoo-like enclosure west of Paris. Two seated adults and five children kneeling and standing (barefoot and bareheaded, dressed in draped fabrics) are gathered around a low table hidden from our sight, which presumably holds a plate or cooking receptacle toward which they reach, while a stylishly dressed European couple topped by fashionable hats peer over the fence, literally looking down at them from inches away. The internal spectators replicate, from within, our own gaze projected onto the African group from outside the frame of the card. What makes this mirror image of voyeurism especially unsettling is that it is redoubled by the postcard's stereoscopic duplication. Once the card is inserted into a stereoscope, the twinned images are merged into a single three-dimensional one, but without this device, the viewer sees two identical photos juxtaposed: two family groups eating, two pairs of spectators staring

over the fence at a performance of Ashanti mealtime, two picket fences corralling the eaters, and so forth. The effect of all this doubling and dividing for our own two external eyes is an intensification of the visual assault with which we become—doubly—complicit.[75]

When this card is juxtaposed with even a small sampling of other postcards of the era drawn from what constitutes a veritable subgenre—we could call it "feeding time at the zoo"—its force is amplified. Postcard 10 (Plate 13), "Le Repas de l'Otarie" (The Sea Lion's Meal), is among hundreds of its type focused on the meals of seals, lions, tigers, snakes, crocodiles, elephants, and myriad others, all similarly labeled: "repas de" plus the name of the animal. This one bears a photo of a sea lion feeding taken at another Paris park east of the Jardin d'Acclimatation, and home to another zoo: that of the Jardin des Plantes. At full center of the photo an attendant holds a pail of fish while the sea lion reaches its extended neck long for the proffered food, as a child does with his arm in the photo of the Ashanti meal. Behind the fence a group of visitors gathers, rapt, to watch the feeding.

The messages on both cards are virtually interchangeable: each correspondent writes expressly to send news, but transmits little besides word of safe arrival and well-being; each mentions the weather; inquires into the recipient's health; hopes to hear back; and sends love. The messages, combining the phatic and the vapid, appear divorced from their recto images, whether of animal or human mealtime at the zoo. The cards are reduced to writing surface for the sender, much like embossed notepads scribbled on absentmindedly by hotel guests insensible to the logo, or freebie grocery pads sent to charity donors who jot down pantry needs on the bound pages without more than a cursory glance at the printed appeal to fight heart disease, cancer, homelessness, or hunger.

Reading today over the virtual shoulder of the sender and the recipient of these cards, we tend rather differently to look first at the image for as much detail as can be discerned. If the angle of the shot of the sea lion feeding precludes a glimpse into the zoo attendant's cavernous pail, the fish in his extended hand and a second fish he grips in his other hand along with the pail handle reveal the diet of this particular beast. In the shot of the Ashanti feeding, however, as in most postcard photos of mealtimes in human zoos and Indigenous villages, we can no more make out the contents of the meal than we can discern the elements of the harlequin plates or soup bowls. The camera, along with the spectators' gaze, is trained on the tableau vivant of eating others.

—— FRAGMENT: MEALS ON CARDS

Where do photographs of Indigenous feeders (both those who eat and those who prepare food) fit into the larger universe of postcard representations of meals? A search of the *cartes postales anciennes* on the comprehensive Delcampe website using the term *repas* offers a place to start among just short of ten thousand hits.

Animal meals make up a good share of the *repas* inventory images, which include not only zoo feedings of the sort I have been discussing, but also

barnyard feeding scenes of chickens, ducks, pigs, and geese. There are at least as many shots of human animal meals in the corpus, located in the subcategory "Indigène," which includes food being eaten or prepared in the "Villages Indigènes" and other human zoos in the hexagon, but equally embraces meals photographed on-site in the colonies.[76] All of these might be subtitled "culinary exotica." But what about what we might today call "Indigenous French" meals? Hexagonal France, in fact, is not exempt from postcard-circulated food shots, but when it enters the alimentary picture, it is not in the generalized guise of "French cuisine" per se. Viewcards showing meals in mainland France—though the umbrella term "France" is never the printed designation on such cards—show regional populations gathered at meals, often outdoors, sometimes complete with traditional local costumes. Typical labels include "Noces bretonnes," "En Passant Dans Les Vosges," "Types des Pyrénées: Le Repas du cantonnier," "Un Repas de moissonneurs: Environs de Tréguier," "Repas champêtre," "Folklore Bretagne: Repas des mendiants," and "Folklore Berry: Le Repas des moissoneurs" (Breton Wedding, Passing through the Vosges, Common Types in the Pyrenees: The Road Repairman's Meal, The Harvesters' Meal: Vicinity of Tréguier, Country Meal, Breton Folklore: Beggars' Meal, and Berry Folklore: Harvesters' Meal). Though "folklore" is only sometimes an explicit part of the caption, it is the implicit element in all photos of this subgenre. Local food, often displayed in pastoral tableaux of feasting around long country tables, is provincial food, not "French food," and the photographed eaters, often villagers in local garb, are rustic regional types, located somewhere on the continuum between peasants and Frenchmen, generally closer to the former than the latter. This is not to say that respectable urban dining never figures under the rubric "repas"; it does, but by indirection and deflection. Viewcards rarely represent French cuisine by means of bourgeois or upper-class people eating or cooking, but rather, by way of menus and other ceremonial icons and accoutrements. Full frontal exposure of eating and other material alimentary practices is reserved for the margins of French culture.[77]

—— POSTCARD 11, POSTCARD 12

In *La Cheffe, roman d'une cuisinière,* the contemporary novelist Marie NDiaye remarks on "cette façon qu'ont certains convives, hommes ou femmes, de se comporter vis-à-vis de celui ou celle qui cuisine comme avec un amant ou une maîtresse" (this way certain guests, men or women, act with the person who cooks, man or woman, like they would with a lover).[78] A good number of postcard photos of Indigenous food preparation and consumption frame cooking as an act of seduction and ingestion as a gesture of titillation, presupposing and perhaps preordaining that their viewers will be just those leering guests NDiaye describes. But if eating and cooking tend generally to be conflated with sex, as NDiaye suggests, for a nexus of reasons having to do with body boundaries and openings, desire, and pleasure, the history of such conflations is deeply marked

by ideologies of race and class, as is the history of the taboos differentially placed on their public exposure.

On postcard 11 (Plate 14) we face a close-up of a young black male captioned as a Saharan cook in the Tuareg encampment at the 1907 Exposition Coloniale. The photograph traps the man in a Thor or Vulcan-like posture. Bare chested with upper body muscles rippling, he wields an enormous metal pestle poised mid-body at shoulder level, gripped in a taut fist in a suspended motion of pounding. The cook's dark skin contrasts dramatically with the folds of white cloth flowing around his lower limbs and the white fabric swath of the tent against which he is posed. The camera angle accentuates his upper body strength and exaggerates the size of his extended fist and the rodlike pestle raised in a gesture of power, while his crossed legs disappear in the voluminous white billows of cloth that compress and triangulate his lower body. Only the toes of one foot peeking out from the white pantaloon betray the existence of his ill-defined legs, making his lower body appears oddly compromised: dwarfed or even crippled, so that he exhibits an ambiguous specter of superb force that is somehow curtailed or restrained. Whatever educational elements the demonstration might purport to deliver having to do with Tuareg food preparation, its implements (the mortar and pestle, the winnowing pan) and its implementation in the hands of this native cook are shadowed by an implicit racial message about Indigenous male sexuality and the need for its containment, staging, and control.[79] Yet this imperial subject resists absolute subordination to the visual regime; while he faces straight out toward the camera in what is obviously a command performance, he manages to avert his gaze, suggesting that his spirit is elsewhere and his consent absent.

While Indigenous alimentary postcards are often similarly bursting with sexual surcharge, they are typically otherwise gendered. This eroticized Saharan cooking demonstration is unusual in that the camera feeds on a male. The photograph on postcard 12 (Plate 15) tenders the more common scenario of food work and foodstuff gendered in the feminine, in the form of two young Senegalese women seated at center frame on the ground facing obliquely out, surrounded by an array of pots, sieves, and bowls. One, posed with a pestle paused in its enclosing mortar, is fully dressed; the other, slightly foregrounded, is naked to the waist save for a necklace, and paired with a steaming pot planted in a brazier sitting at her feet. The bowls of these nested cooking vessels echo the curved forms of her seated hip and exposed breast. The postcard caption situates the photo at the Marseille Exposition Coloniale of 1922, and ambiguously labels it *Cuisine sénégalaise,* which is equally translatable as "the Senegalese kitchen," "Senegalese cooking," or "Senegalese food," leaving open the question of what or who is available for consumption.[80] The card must have circulated widely, because there are many copies still offered for sale today, some of which are advertised by contemporary vendors with the unofficial added caption: "seins nus" (bare breasts). Denis, the sender of the card in my collection, has defaced the photograph with

a snide commentary thickly scrawled across it in purple ink ("elles sont réellement jolies" [they are really pretty]), and he echoes his graffiti in a message on the verso (Plate 16) informing his friend Marcel that although he himself has not yet seen the Exposition, he offers a foretaste of it ("mais je t'envoie ces charmantes dames" [but I send you these charming ladies]).[81]

Behind and to the left of the mud wall against which the women are posed is another wall (an extension of this house, or an adjoining one), this one dominated by a door that stands ajar, offering a glimpse of a dark sliver of interior space contrasting with the naturally lit outdoor area in which the women are exposed. This intimation of an unseeable dark space is a feature that recurs on many viewcards exhibiting Indigenous meals, and contrasts sharply with the also common alternative view in which the camera encroaches on the alimentary scene to the point of backing its subjects up against a wall, fence, or other barricade beyond which there appears to be no escape.

—— POSTCARDS 13, 14, 15, 16, 17

In postcard 13 (Plate 17), three women inscribe a triangular space at the edge of a tall barricade that is likely the outer enclosure of the "Village Noir" at the 1906 Exposition d'Angers.[82] Here, as in the case of many early "Villages Indigènes" that pretended to serve up lessons in geography, ethnography, and culture, pan-Africans were indiscriminately blended in an ethnic soup whose only specificity was race. Difficult, then, to determine to which tribal group or even colony these women belong, and impossible to know what is in the cauldron on the fire tended by the woman on the right with her arm extended toward it and her back to the fence, or what is held by the pot in between the legs of the two women on the left. Easily decipherable, however, are the facial expressions and the body language of the two women facing out: suspicion and defiance in the tensed arm and the glance at the camera of the women backed to the fence, apathy and a suffering bordering on despair in the eyes and the slumped posture of the woman on the far left.

The photo on postcard 14 (Plate 18) is reminiscent of that on postcard 12 (Plate 15), though without the undress (the Kanaks were renowned for their absolute refusal to comply with stagings of nudity). Here are two "Kanak Women from New Caledonia" seated on mats in front of a thatched hut, "preparing their meal." Decked out in full costume including head coverings and fringed necklaces, they are poised for a demonstration of cooking before an array of what seem to be gourds and empty bowls of various sizes, but paused in the act, to pose. Behind and between them is the arched entrance to the hut, through which looms an obscure interior in which nothing is visible but darkness itself.

The photo on postcard 15 (Plate 19, "Exposition Coloniale—Repos des Loyaltiens dans le Village Canaque")[83] shows a grouping of four Kanaks, three women and a man, seated outside a similar hut in front of its vaulted opening onto a

similarly unfathomable interior. These people "at rest" are ostensibly consuming rather than cooking: they have plates, pans, and cutlery in addition to pots, and appear studiously attentive to the process of eating (or at least visually engaged with the food rather than the onlooking cameras and other spectators).

We change scenes in postcard 16 (Plate 20). While still visiting the 1907 Exposition Coloniale, we shift to the Saharan encampment. In the distance a tall wood fence marks the boundary of the village, but foregrounded at the mouth of a cone-shaped tent are three people. On the right in front of the tent is a crouching woman with her hand in a sieve over a cooking vessel; on the left is another woman standing, feet just inside the tent and body outside; in the middle, half in and half outside the globe of the tent, as if emerging from its shadow, is a white-robed figure who appears to be an adolescent boy. Once again we can see nothing within the dim interior of the tent except for a thin ridge of light emerging at the bottom edge opposite the mouth where the fabric doesn't quite meet the ground. The photo is a study in contrasting light and shadow: the dark and light-patterned, white lace-sleeved dresses of the dark-skinned women, the long white robe of the lighter-skinned boy, the dark tent with its murky interior against the bright daylight with the leafy shadow of the overhanging trees imprinted on the ground. In the left background behind the standing woman a line hung with an array of all-white drying sheets and clothes picks up the foregrounded light and catches our eye.

A motif of light and darkness pervades the photograph on postcard 17 (Plate 21), "Exposition Coloniale 1907, Touaregs faisant le Café" (Tuaregs making coffee). The nominal focus on coffee-making paraphernalia (an embossed metal kettle and a winged device, perhaps for grinding beans, sit in the left foreground) is diverted to the dramatic play of light and dark, visible and invisible, revelation and concealment. The clothed figures once again present a contrast of dark with stark white fabrics, and this juxtaposition is echoed by the dark and white-striped tent covering and the patches of darkness looming in the apertures beneath the tent against the bright daylight surround. The uneven triangular conformation of the six men grouped together, two standing, four seated in a roughly semicircular configuration, is echoed by the bumpy triangular form of the tent beside which they are posed. Crowning and summarizing the doubled motif of alternating exposure and cover-up is the *tagelmust* garment, the combined turban-headscarf worn by all of the assembled men, which covers the entire face, head, and neck of each man except for a thin swatch of skin around the eyes and bridge of the nose.[84] Needless to say, the danger of inhalation of wind-borne sand that explains the origin of the *tagelmust* for the Tuareg people of the desert would not have posed a major risk to the Tuareg encampment in the Bois de Vincennes, despite growing anxieties about dust in post-Haussmannian Paris.[85] Functionality is not really the issue here. Much more germane to a display of the costume in the 1907 metropole is its semiology: its role in a performance of Otherness that

consistently subjugates and marginalizes France's backward overseas colonies to the technologically advanced centrality of the ultracivilized hexagon.[86]

The costume, to be sure, responds to a pedagogical imperative on the part of the conjoined anthropological/governmental team of Exposition Coloniale organizers. It employs a form of (rather tautological) sartorial signage that most immediately goes something like this: "I am a Tuareg and this is how we dress in the desert." But the implicit message is as layered and enfolded as the winding lengths of the *tagelmust,* which would have evoked, to a turn-of-the-century Parisian audience of Orientalism, the stuff of odalisques, harems, and female veiling, assimilating these unhorsed, disarmed, curtained men to veiled women. If, as I suggested earlier, photographs of classed and raced Others framed voyeuristically by the camera's eye as specular objects are already structurally feminized, then these grounded men seated by their tents, re-tented by their veiling attire, and deprived of their preferred equestrian photo support, are positioned in a compounded feminine space. Here it is helpful to build on the work done by Marni Reva Kessler on connections between the French fashion veil and the Muslim woman's veil, the hijab, to suggest that the male *tagelmust* donned in France would also have carried, for French eyes, not only broad evocations of female veiling, but particular allusions to the hijab as a portable curtained-off space or "mobile harem," and as such, would have been similarly "inflected by notions of interiority"[87]—notions the French colonial gaze did not usually associate with Muslim men of the desert.

—— FRAGMENT: INSIDE OUT

The many photographs that impress postcards with scenes of Indigenous peoples eating and cooking *en plein air*—on the grass, under trees and in sunlight, outside huts, shacks, and tents, punctuated by clothes strung up to dry—offer bourgeois French viewers an inversion of their own everyday practices and customs.[88] Nineteenth-century bourgeois ideology decreed that civilized orders live in increasingly interiorized space; take their meals, bare their skin, wash and dry their clothes only out of sight.[89] Conversely, this logic imagined that primitive orders took all of nature as their domus and the theater of their material life. Interior and exterior space were accordingly binarized and hierarchized, as were notions of subjectivity and objectivity, mind and body, culture and nature, individualism and collectivism.[90]

On the postcards at hand we see a dialectics of inside and outside spinning out correspondingly in rather predictable ways, but also spinning out of control: becoming destabilized in the very process of being unrolled. Multiple covers, barriers, containers, and borders (in the form of habitations, garments, fences, darkness, and pots) have gaps or slits or other apertures that invite or at least hint at the possibility of visibility, engaging the observer in a play of hide-and-seek that does not always deliver what is sought. At first glance, it is as if the interiors

of the huts and tents had been evacuated, yielding to the exterior (and the spectator's eye) the inhabitants and their material lives. What was hidden inside has been brought to light. Yet the human figures routed out of their dwellings are positioned directly in front of (or strategically adjacent to) a door or other such opening that leaves starkly and prominently unseen what is in the dark space looming behind. There is an interior that resists, a place of shadow that asserts itself, thrusts itself into sight while maintaining a paradoxical invisibility and secrecy, like the Senegalese woman, disrobed, who shields her bared breasts as best she is able, with a hand and a reproachful stare, or the veiled Tuaregs whose exposed sliver of skin better delivers a sense of their gaze than it does a revealing view of their eyes. What is kept inside in Western bourgeois culture—the body undressing, seducing, eating, laundering—is driven out in these images of non-Western Others forced into the camera light, as if to maintain a reassuring binary fixity. We recall the grammatical bondage of the intimate to interiority, and witness now the apparent violation of both. But the voided interior space remains darkly blank, shielding its secrecy, its intimacy, and its opacity in a graphic gesture of refusal that reminds us of the complex relations binding the forbidden to both disgust and desire.[91] The resistant shadows that determinedly offer and conceal in a striptease performance of invisibility flaunt a heart of darkness that must be maintained as such in order to make the show of routing out into the light effectively function.

Similarly, pretenses of authenticity upon which the Indigenous villages are built coexist with occasionally voiced protests that the scenes of everyday life played out there are theatrical montages rather than mimetic representations. An article in the 1889 Exposition journal, *L'Exposition Universelle de Paris,* reports the dismay of various Indigenous "villagers" forced into role-play, among which, a master jeweler from Senegal who testifies: "We are very humiliated to be exhibited this way, in huts like savages; these straw and mud huts do not give an idea of Senegal. In Senegal we have large buildings, railroad stations, railroads; we light them with electricity. The Bureau of Hygiene does not tolerate the construction of this type of hovel."[92] One revelation insinuates others; if the Senegalese mud huts are cliché constructions, might the Kanak cone tents and the Tuareg long tents be equally mythic renditions of colonial habitations? In much the same way, evidence that the Kanaks staunchly refused to perform in the nude suggests that images of topless African cooks might well be more indicative of a forced compliance with French Exposition directives than a truthful representation of ordinary "primitive" life at home.[93]

Certain peoples were particularly known for their reluctance to display their intimate lives to the public: "Les Kabyles sont mystérieux et s'entendent bien à cacher leur vie" (The Kabyles are mysterious and are very good at hiding their lives), and the Okanda are "fort soucieux de limiter aux visiteurs le spectacle de leur intimité" (very careful to limit the sight of their private life in front

of visitors), journalists observed.[94] That such reserve was noted at the time indicates some awareness on the part of the public of the theatrical nature of the ethnographic displays, an awareness that is further revealed by widely reported attempts, on the part of journalists and of the general visiting public, to gain access to the virtual wings of the Exposition as a space of higher truth. As Van Troi Tran observes, this inner glimpse—what might endow the Indigenous villages with the merit of authenticity—was often sought in alimentary practices, "voie d'accès vers l'épicentre imaginaire de la culture du colonisé" (entryway to the system of beliefs at the cultural epicenter of colonized people).[95] The distinction between the theatrical staging of such practices and their ostensibly more realistic locus in the wings was understood to be temporal rather than spatial: so, for example, time of day was given as critical to viewing an authentic ethnographic experience of colonial eating. The public is advised by various articles to choose their hour wisely: "Allez leur faire une visite matinale" (Go visit them in the morning), one journalists counsels, while another specifies: "Le matin, alors que les visiteurs sont encore peu nombreux, les Malais vaquent aux occupations de la vie domestique, nettoient sans cesse les cases, lavent leur linge, préparent ou consomment leur repas, et ce n'est point là . . . la moins curieuse partie du spectacle" (In the morning, when visitors are still scarce, the Malays attend to household chores, clean their huts relentlessly, wash their clothes, prepare or eat their meals, and this is not the least curious part of the show).[96]

This insistence on the need to seek out the hidden scene of the food show—what Tran articulates as "l'alimentation comme coulisse du spectacle et spectacle des coulisses" (eating as the wings of the theater and the theater of the wings)—is perfectly congruent with that tenet of Western tradition which holds that "the real show happens backstage," meaning, of course, in the most isolated, hidden, inaccessible, off-limits part of the theater.[97] Of course, the distinction between backstage and frontstage spectacles does not hold. The "wings" of Indigenous cuisines at the Expositions, the behind-the-scenes, off-hours show, shared performative elements with what was seen in the designated exhibit spaces and times, for many reasons, among which, that both were equally subject to French monitoring and regional and seasonal product availability.[98] And the Tuaregs, studiously exposed as exotica cast out of tents pitched in the simulated deserts of Paris, nonetheless reconfigured, in their recreated Saharan garments, a Western-like paradigm of interiority. Walter Benjamin's words on bourgeois interior space post–Louis Philippe might just as easily be describing *tagelmust* vestments wound around the desert cast-outs: "The interior is . . . the etui of the private person. . . . An abundance of covers and protectors, liners and cases is devised."[99]

Not the smallest paradox of the logic of Colonial Expositions is that they thrust their representations of the colonies into forced visibility, and then projected an aura of secret space or time behind, throughout, around them, recreating a Western model of specularity in which there is always yet another veil to remove,

another curtain to raise, another cloth to unwind, another threshold to cross. The quest for the infinitely regressive heart of ethnographic authenticity set curiosity in a dance with desire and scrutiny. If voyeurism was the dominant modus operandi for contemporary Exposition-goers who viewed imported *Indigènes* in tableaux vivants, in cooking and other craft demonstrations, and on parade, and reviewed them in postcard photographs, it made future generations—who had only the photos—its heirs. As Barthes reminds us in *La Chambre claire,* the ideology of interiority, of seeking truth beneath the surface and behind the scenes (and, we might add, inside the body, in acts of incorporation) continues to operate over a century later in Western approaches to photography as well as to cinema: "Si j'aime une photo . . . je la regarde, je la scrute . . . pour accéder à *ce qu'il y a derrière . . .* (ce qui est caché est pour nous, Occidentaux, plus 'vrai' que ce qui est visible)" (If I like a photo, I look at it, I scrutinize it to get access to *what is behind it . . .* [what is hidden is for us in the Occident more "true" than that which is visible]).[100] In the case of those of us today who look back at postcard traces of ethnographic displays, the line between research and prurience can sometimes feel a little thin. So we face once more a question of complicity with a form of overlooking—overlooking in the sense of looking excessively, that is, voyeuristically—but also, as a result, looking inattentively rather than looking with, or witnessing.

—— FRAGMENT: HAUNTINGS

In his 2018 *Darwin's Ghosts,* Chilean novelist Ariel Dorfman engages with difficult questions about how to look at invasive photographs and how to look past them, how to use them to look responsibly and responsively, how to undo or at least contest their work of violence, and how—or if—atonement in the present for the violations of the past is possible. The science fictional-magical realist plot is premised on the release, with several generations' distance, of the novel's titular ghosts, the unrested victims of nineteenth-century scientific racism, into a late twentieth-century present—conditioned by instances when two culpable lineages converge in the person of a descendant. The haunting of the adolescent protagonist is due to his doubly tainted descent: on the maternal side, from the German Carl Hagenbeck, the infamous impresario of human zoos, and on the paternal, from the Frenchman Pierre Petit, photographer of the captives caged there (as well as of nineteenth-century artistic and intellectual luminaries such as Victor Hugo, Gustave Doré, and Hector Berlioz).

In 1981, well before photoshopping images became a reality, Fitzroy Foster reaches his fourteenth year and is caught in a birthday photo with the head of a late nineteenth-century Patagonian youth planted on his own Bostonian shoulders. For the next eleven years, every subsequent photo of Fitz replicates the same composite figure. With growing awareness that the boy is at risk of specular predation—in much the same way, we realize, that the human inhabitants

of nineteenth-century zoos and Indigenous exhibition villages were everywhere in the camera's crosshairs—the family homeschools him. Meanwhile, he and his biologist girlfriend, Camilla, leave no postcard and no page unturned in their quest for the story of Fitz's ghost, Henri, the European-imposed name of the Kaweshkar tribesman who has returned to seek revenge for his kidnapping from Tierra del Fuego, Patagonia, in 1881. They painstakingly reconstitute a narrative of Henri's subjection, with his fellow abductees, to an abbreviated life of cross-European tours that include caged displays and zoo exhibitions complete with newspaper announcements of the feeding hours at which raw meat is thrown to the so-billed cannibals, who are obliged to emit guttural grunts of satiation to increase spectators' pleasure and to boost ticket sales.[101] As Fitz and Camilla trace medical probings, anthropological examinations, and endless photos leading them to Henri's early death in captivity in Zurich, they begin to fathom the depths of a life's pillage, and its place within a larger world system of despoiling, desecration, and genocide. We in turn come to understand that the returning spirit they initially refer to as a "colonizer" of the living is more accurately a reverse colonizer. Fitz's original repertoire of names for his ghost (including "ghoul," "vampire," "demon," and "curse") slides into the gentler term "visitor," implying hospitality on the host's part and transience on the guest's. What began as a quest for knowledge in the service of exorcism turns into a protracted process of witnessing and commemoration. At the penultimate moment, Fitz has a brief but profound encounter with the experience of living as ethnographic specimen and photographic victim: exposed with his nineteenth-century Patagonian head and twentieth-century European-Bostonian body as a freak of nature to "an audience of strangers" with a "phalanx of . . . cameras pinning [him] down, strangling [his] face," he experiences in fractional form what Henri suffered integrally and long term, and so completes an apprenticeship in empathy.[102]

This sounds more optimistic in synopsis than it does as it plays out in the novel, where it becomes clear that the time for material reparations is long past and that individual atonement and sadness do not translate into widespread effective action (the few remaining Kaweshkars have forgotten how to live in unison with the natural world; the ocean is clogged with plastic, and the fish are dead). Henri's rescue can only be symbolic. But Dorfman moves toward a hypothesis so tentative that it must be voiced by his character in the interrogative: "What if the appearance of [my] visitor was . . . one timid way in which the species was searching to free itself from the limbic system governed by fear and loneliness, heralding the need to develop the zones of the brain where compassion and empathy and trust reside? What if we treated my visitor as a prophet and not a plague, a challenge instead of a tragedy?"[103]

Darwin's Ghosts does not teach us how to look innocently at photos that violate their objects and then memorialize the crime. But it does propose that any morally acceptable form of specularity must be a long and complex process, a

working through instead of a gawk. Fitz's belated reflections on his misguided hopes of saving the few wraith-like stragglers of a tribe felled by Western imperialist ventures extend also to those long-gone camera victims like Henri—and all those others we have viewed—shot into postcard immortality. Amends are impossible; responsiveness is not: "The only thing one could do . . . was to keep them company, sense their sorrow."[104] Hosting Henri's story instead of his specter means "to see through [his] eyes," and "to know what was done to him, tell his story."[105] The only respectful way of looking, Dorfman suggests, is a looking-with, a process of recognition, witness, and narration that relies upon a pledge to share, to empathize, to see, to know, and to tell. This kind of specularity is neither remedial nor compensatory nor reparational nor penitential; it can never reverse the outrage or redress the damage, and it can never make amends; it is simply a lesser evil, "the only thing one could do."

—— FRAGMENT: BORDERLINES

And where are the harlequins? How far do we need to turn from human zoos and Indigenous villages to pick up the thread that leads back to society's fringes eating its alimentary scraps? In the streets of Paris, leagues away from their birthplaces in Patagonia, Lapland, Australia, West Africa, the Antilles, Indochina (and the list goes on . . .), the imported *Indigènes* would temporarily have inhabited the same metropolitan territory as the urban poor, many of whom were more accurately Indigenous to these spaces. The overseas show people would have been interned on the outskirts of the city (the eastern fairgrounds of the Bois de Vincennes and the western zoos of the Bois de Boulogne); the Parisian lower classes would predominantly have occupied inner-city sites in early and midcentury Paris, but were increasingly expelled to the *banlieue* during Haussmann's tenure as prefect. But although the geographic quarters of the two sectors may not have been identically aligned, their semiotic spaces coincided. If "Indigenous" and "indigent" are what the French like to call "false friends" (*faux amis*), words that erroneously suggest that they derive from a common source, they were nonetheless forced bedfellows in nineteenth-century French social thought.[106]

The organizers of the Exposition Universelle of 1867, the first international event to stage live exotic human exhibits, considered but ultimately rejected a suggestion made by sociologist Frédéric Le Play, commissioner of the Exposition, to incorporate the housing of French workers' families within the exposition so that visitors could observe their lifestyle firsthand. Le Play was, however, able to implement an alternative pedagogical instrument: an exhibit of French workers demonstrating their trades.[107] Two decades later, at the 1889 Exposition Universelle, the social economy exhibit, which featured housing, hygiene, and public assistance for the French working class, was strategically situated across from the colonial area of the exposition, implying that colonization

was "a natural extension of the social work accomplished within France," as Lynn Palermo has noted, and correlatively, that race was not the sole criterion for adjudicating civilized status.[108] In the very carefully calculated architectural topography of the expositions, the proximity of French working-class displays to exhibits of colonized others would graphically have echoed the ideology so clearly adumbrated earlier in the century by Sue's epic fresco of the people of Paris as domestic barbarians and cannibals.

In her discussion of pervasive fears of an invisible menacing Other throughout the fin de siècle in France and England, Kristen Guest draws attention to the "ongoing impulse to construct the poor as other," highlighting metaphors of savagery, primitivism, and cannibalism that analogized the peoples of the colonies and the domestic lower classes.[109] Benjamin Disraeli's well-known evocation of class-riven early Victorian England as a nation divided underscores the construction of the poor as a race apart: "Two nations . . . who are as ignorant of each other's habits, thoughts, and feelings, as if they were dwellers in different zones or inhabitants of different planets; who are formed by a different breeding *and are fed by a different food.*"[110]

That Disraeli's portrayal of England's class schism relies on an alimentary synecdoche is not surprising: once more food traditions and eating habits perform as crystallizations of group identity. Disraeli's alimentary rhetoric belongs to the same social discourse operative in training the camera on eating others in order to visualize racial difference, that is, in order to constitute race in the differential image of what goes into the body, and to construct difference in the racialized image of what is incorporated.[111] As Kyla Wazana Tompkins has argued in her work on alimentary discourses in nineteenth-century America, eating culture is "a privileged site for the representation of, and fascination with, those bodies that carry the burdens of difference and materiality, that are understood as less social, less intellectual . . . less sentient: racially minoritized subjects, children, women . . . animals . . . [which are] closely aligned with . . . the bottom of the food chain."[112] In just this way, knowledge of Indigenous and indigent Others was circulated on postcard photos through representations of their eating practices (at urban markets, exposition villages, and zoos), as if the alimentary moment— "temps de retour au corps et au coeur de la culture"—might offer not only a truly authentic glimpse of the Other, as Tran argues, but also a revelation of the very core—the very most interior space—that is to say, the intimacy of alterity.[113]

On the horizon of that ideal alimentary moment held capable of revealing the bowels of the Other's culture, cannibalism lies immanent. It does not appear literally in photographic images of urban markets or colonial exhibits, precisely because it was a myth, but it is evoked there by the pointedly indiscernible contents of pots, kettles, and bowls; elsewhere, it figures quite overtly in cartoons, caricatures, and narrative accounts of the period, where it is in fact a platitude.[114] Cannibalism lurks everywhere in the discourse of eating Others, because it is

the ultimate eating taboo, the boundary line between nature and culture, the implicit pivot around which turned nineteenth-century ideologies of race and class. While visions of cannibals hover most prevalently over images of Kanak mealtimes, given widespread contemporary legends of flesh eaters in New Caledonia, they are not absent from photos of the eating poor, who, along with other marginalized populations such as criminals and the insane, were subject to charges of anthropophagy along with other varieties of barbarism. Guest refers to this group of alleged domestic cannibals constituted by the urban poor as "borderline" because of its status of "problematic" alterity: "Unlike the colonial subject who is racially and culturally distinct from the colonizer, the 'borderline' other shares significant physical attributes with the dominant population. . . . As a result, marginal groups can neither be dismissed as 'irredeemable savages' nor comfortably assimilated to prevailing norms."[115] Projections of cannibalism onto the urban working class, made in the measure of the anxiety generated by its borderline status, were part of the larger effort to codify difference and contain its threat, a threat that was increasingly posed by class difference in a way more materially present and powerful than that posed by colonial difference. Speaking of an evolving skepticism on the part of French commentators regarding Exposition representations of alimentary "radical alterity"—including hot-coal ingestion, sword-swallowing, scorpion eating, and the like, along with cannibalism—Tran astutely points out a corresponding migration of cannibal phantasms, from race- to class-based: "Dans la déconstruction humaniste du mythe cannibale, surgit une anxiété réelle devant la présence d'un Autre plus proche, plus inquiétant, celui de la foule envahissante et stupide qui fourmille dans l'espace public républicain" (Against the humanist deconstruction of the cannibal myth there emerges a real anxiety before the presence of an Other who is closer and more disturbing: an anxiety about the invasive and stupid mob that swarms in republican public space).[116] This more menacing Other closing in on mainstream bourgeois France, this borderline crowd, immediately evokes that other borderline where nature and culture divide—and converge—the borderline where anthropology (itself a brainchild of the nineteenth century) conventionally locates cannibalism. Cannibalism is arguably the most extreme form of what has been called "gastronomic xenophobia," which we might define as the performance of food in the discursive construction of race, class, and nation: it is the most radical example of the ways in which eating practices construct boundaries and determine borders among national, ethnographic, racial, and social groups, as well as between self and Other.[117] As Jean-Pierre Poulain summarizes, "l'acte alimentaire est fondateur de l'identité collective et, du même coup, de l'altérité" (the alimentary act founds collective identity, and at the same time, alterity).[118] Yet eating is also the ultimate boundary swallower, constantly dissolving the line between self and Other, subject and object.[119] Within the dynamic system of digestion, notions of borders and border lines turn into their opposites: passage, flux, fusion, indetermination, and *borderlines*. *Borderlines*: that is, not only the material edges that

join as they divide, but also the social groups on that edge: the classes and races marked off as unpalatable, indigestible, unassimilable, but who are, in the process, symbolically reincorporated and internalized.

—— CODA. *MAKE BELIEVE: ADULTS*

Postcard collector and essayist Tom Phillips offers an anecdote that speaks to the amount of sheer guesswork involved in talking about old postcards, the risk of error, and the potential for overreading.[120] While cataloguing a group of cards new to his collection, Phillips recalls, he was duly filing one of these, "a fine postcard portrait of a nurse," in the appropriate category, only to be confronted with the danger of facile assumption:

> I turned [the card] over only to read the penciled inscription, "Aunt Ellen dressed as a nurse for the pageant." There was a moment of Borgesian bafflement as I suddenly imagined that all these butchers, postmen, sailors and headmistresses were players in a huge carnival of scrambled identities. The panic passed as I put it in the section marked *Make Believe: Adults,* but I was never to know absolute certainty again.[121]

Such moments of self-doubt and questioning may be familiar to many of us who write about postcards, leaving us similarly unsettled and discomforted. Thoughts of the puzzling presence of various well-dressed gentlemen who are represented at the harlequin counters on a few of the cards return to haunt me, along with a little discomfort about my hypotheses relative to their identities and the roles they could be playing.

A vignette from Colette's early work, *Les Vrilles de la vigne* (a short text roughly contemporaneous with my postcards), recapitulates the scene of uncertainty that harlequin postcards often create. The narrator of "En Baie de Somme" witnesses a group of local fishermen raising their glasses in a portside café in the north of France. Typically outfitted in their blue sweaters and clogs, with their picturesque pipes in hand, the men wait for the tide to turn so that they can return to their boats. One of these figures, notes our narrator, is particularly striking, indeed, "théâtralement beau." When he remains in the café sipping his glass of eau-de-vie after the others have filed out to go back to sea, she asks him if he is taking the day off from fishing, to which he mockingly responds: "Je ne suis pas pêcheur, ma petite dame. Je travaille (sic) avec le photographe pour les cartes postales. Je suis 'type local'" ("I am not a fisherman, my little lady. I work [so to speak] with the postcard photographer. I am a 'local type'").[122] How, indeed, are we to know the "local types" from the actors playing local types, or from the outsiders planted among them for technical assistance or for special effect? And what assumptions about local types do we (or our predecessors) carry with us as viewers that may already have influenced the postcard photos?

Frédéric Vitoux builds an entire novel around a postcard collector's slowly unfolding confrontation with ambiguity and uncertainty. In *Cartes postales,* his

novel about a collector working to construct a narrative around a newly acquired collection of hundreds of family postcards dating from 1902 to 1920, Vitoux has his first-person narrator try to impose order onto the corpus, in the process jettisoning unclassifiable or indecipherable cards, giving greater weight to those that lend themselves to a chronicle. But still the mass of postcard images comprises "autant de rébus" (so many rebuses) rather than a reliable documentary foundation.[123] Confronted by a paucity of clear information and an abundance of confusing details, the narrator is pushed to the antipodes of his original documentary impulse: "Il s'agit alors de TOUT réinventer, de forger à ma guise la famille rêvée, ses menaces, ses deuils, ses joies, ses rivalités, ses espérances. Clarté d'une histoire *recréée*. Encouragement à imaginer. A écrire" (It then becomes necessary to reinvent EVERYTHING, to forge in my own way the fantasy family, its menaces, its losses, its joys, its rivalries, its hopes. The clarity of a *re-created* story. Encouragement to imagine, to write).[124] Modifying the common comparison of novel composition to a mosaic, Vitoux's narrator compares his novel to the fragmentary structure of a capriciously curated postcard collection. Its building blocks may have been carefully catalogued, but they have been triaged, pruned, and rearranged at whim. Rising from an "imperious" and "arbitrary" foundation, Vitoux's postcard fiction is summarized at its close as a hybrid genre, in words likely applicable to any writing about postcards: "tout ici est exact, tout est réinventé" (all this is exactly true, and all is reinvented).[125]

"Reinventing" postcards and "recreating" their stories suggests a kind of overreading: filling in blank spaces, overwriting or even overriding ambiguity, making *up* what one cannot quite make *out* on a photo or a handwritten message; outfitting ghosts in uniforms that make believe they are nurses while their earthly beings lie misidentified in their unquiet graves. In more positive terms, however, overreading inspires a rough paradigm for viewing postcard representations of the lower classes: a way to restore, to turn-of-the-century working-class feeders, the face of their human hunger and a recognition of their loss of individual and social identity through stories that become evidentiary.[126] This may mean at times reading the ostensibly contingent in photos as significant, and proposing hypotheses in the place of certitudes, accepting, as visual anthropologist Elizabeth Edwards has proposed in her work on postcard portraits, that the signs we read in these photographs "are endlessly recodable." Though photographic postcards are kept, viewed, and circulated because they fulfill a haunting human need for stories, these stories are ultimately told less by the photographs than, as Edwards has proposed, "by the different readings brought to them."[127] All the more reason to read harlequin-eater photo cards slowly and closely, in the spirit Dorfman reads caged Kaweshkar tribespeople whose identities were shot into photographs in Paris zoos; all the more reason to try, as he does, to see through their eyes, to know what was done to them, and to tell their story.

FROM STREET FOOD TO STREET ART

TAKING IN LES HALLES WITH ZOLA

Le Ventre de Paris is a novel animated by a dizzying succession of scraps: leftover bits of food, snippets of gossip, tatters of handed-down clothing, memory flashbacks, splotches of lambent colors, flickering light, intermittent buzzing and humming, and patches of printed paper. If the harlequin (in any of its forms) only belatedly receives its explicit name in Émile Zola's text, it is represented materially and conceptually from the very first page, where it appears as a multicolored riot of juxtaposed vegetable blooms whose bursts of greens, reds, and creamy yellows are set against the interspersed blue sleeve of a worker's smock.[1] This early avatar of the harlequin meal highlights variegation and juxtaposition of color and form, but as it does so, it also ushers in a panoply of alimentary and painterly performances that will emphasize differing aspects of the harlequinesque: its trade in leftovers, its various hybrid modes and effects, its foundations in a system of social caste, and its associations with victims of poverty and social marginality. One feature remains consistent from the start, however. By way of his inaugural enactment of harlequin foodways and colorways, Zola flamboyantly marries the edible and the optical, stylizing each in conjunction with the other. He will not disentangle them in the hundreds of pages that follow, though he will vary their relative weight at different points, play them against each other, and stage them in the company of other elements. Consequently, I adopt the alimentary and the visual as the twinned organizing principles of my discussion. The diptych presentation of this chapter focuses on

each in turn, while respecting their essential collaboration and recognizing the impossibility of any hermetic dichotomization.

That Zola began his writing career as an art critic and marinated his reflections on art in an enduring, engaging, and immersive fraternity of painter friends, that he consistently used culinary metaphors in his writing on painting (as was the wont of many art critics at the time), and that he used the artist persona of Claude Lantier as one of the principal funnels for his food descriptions and aesthetic pronouncements in this novel, cannot be overlooked.[2] Given that his art criticism in the years preceding and coinciding with the drafting of *Le Ventre* is often gastrologically troped, and that his food novel inversely trades in a painterly rhetoric, it is tempting to wonder whether the alimentary foregrounding that provides the infrastructure of the novel might in fact be a cover for a critique of painting—a culinary metaphor for art extended into a didactic novel about aesthetics.[3] My claim will be more tempered, however. I take Zola's art criticism as an important and necessary companion to his food writing, but not as an absolute or transparent gloss of it, and I am more inclined to pause at the inescapable intermediate matter of *writing* about perception (visual among other forms) than I am to skip from culinary discourse directly over to perception and painting as if they were not already everywhere mediated in his text by the letters in which they are rendered.

As in Eugène Sue's *Mystères de Paris,* the comestible harlequin in Zola's *Ventre de Paris* migrates from material consumable object, to alimentary practice, to aesthetic perception and performance, yet it would be wrong to conflate the two novelists' methods or results. To a much greater extent than Sue, Zola deliberately manipulates the harlequinesque aesthetic and its modes of breaking down and breaking away, fragmentation, juxtaposition, accretion, and collision, and he consistently fashions painting-in-writing as a crystallization of a harlequin-styled perception. To insist on this writer's purposeful and very directed staging of harlequin optics and praxis is not, however, to say that he always maintains control of their uses, nor that the moments of slippage, insinuation, omission, and inconsistency are any less enlightening than his adroitly sustained exploitations of harlequinesque matter and rhetoric. I therefore consider Zola's studied intermeshing of harlequin modes of eating and contemporary conversations about art with an eye that is equally curious about what gets left out of their deployment, and also, what slips in along with the shadow discourses of social class, colonial expansion, race, and empire.[4]

PART I. STREET FOOD

Although the culinary remains in Zola's marketplace arena eventually join with a more encompassing aesthetic of fragments that includes other modes of experience and perception, the emphasis on foodstuffs is of such monumental sensory proportion that it all but blinds us initially to the rest. For this reason, I defer to

the sheer force of the alimentary spectacle—it is at least as oppressive as it is impressive—in choosing to begin my reflection in its glare.

—— HAVING YOUR FOOD AND EATING IT TOO

And yet, there is very little eating in Zola's novel about food. This is one of the paradoxes of his figuration of the marketplace as the vital organ of Second Empire Paris, the pulsating belly of life and art. From the first sentence onward, we see food everywhere, mounded in pyramids likened to mountains, illuminating shop window displays with an incendiary glow, swelling in waves compared to oceans that often inundate the senses and the streets like a tsunami. Naturalized in this way, that is, likened to nature's prime elements but endowed with a supernatural intensity, the edibles raining down and cresting up over all the surfaces of Les Halles are ominously surreal. And the pathways that would logically conduct this colossal dietary matter along the expected course from the streets and cellars of the market to its intended bodily end—ingestion, swallowing, absorption, and digestion—are rare. Scenes of consumption are far outnumbered by friezes of overblown food, and action shots of chewing mouths and ruminant stomachs are superseded by freezes of cornucopian matter that suggest systemic clogging (physiological and narratological) rather than processing and flow.

Ever since Joris Karl Huysmans remarked that in *Le Ventre*, "Le noyau est à peine visible, mais la chair, la pulpe, ont une saveur inconnue" (The kernel is barely perceptible, but the flesh, the pulp, have an unprecedented pungency), critics have lingered on the narration/description binary, signaling the novel's scanty action and meager plot as compared to its sumptuous and sometimes onerous tableaux and lists.[5] Although I want eventually to dispel the dichotomy of narrative mobility and descriptive stasis by highlighting the microscopic vibratory workings of perpetual motion within the novel's many extended food descriptions, initially I turn to the peripatetic feeders of the novel, who more obviously advance its narrative course along with its alimentary processing. The novel intersperses a succession of catalogues and tableaux that present massive accretions of food, with scenes of ambulatory eating that put product into process. A series of wanderings serves the dual purpose of steering the reader through the commercial spaces of the *quartier* and quickening the prose.

There are a handful of intermittent eaters that walk the profusely produce-strewn, fish-laden, cheese-reeking, butter-mounded, lard-greased stage of Zola's Halles. I emphasize that these eaters *walk* Zola's planks, for it is crucial to note the correlation of consumption and ambulation in this novel. Zola, like Manet, and later Huysmans, highlights the itinerant nature of working-class consumption. Writing about Manet, art historian Frédérique Desbuissons dubs the food represented in such paintings as *La Chanteuse des rues* (*The Street Singer*) (Figure 17), where the street singer exits a café munching on cherries, *la nourriture vagabonde*. Both "vagabond food" and its corollary, which we might call vagabond or

nomadic eating, are useful concepts to hold on to as we scan the modalities of nourishment taken away from the table by the urban poor.[6]

Given the paucity of wandering street feeders, it is worth considering who they are, why they have been assigned their consuming role, and how this role is shaped.[7] In terms of narrative saturation, pride of place goes to the omnipresent Mlle Saget, who crisscrosses the novel and the neighborhood of Les Halles, ogling the market displays with a cavernous basket in hand in which she collects the butt ends of each merchant's wares, the dribs and drabs that have fallen off by day's end and can be begged or cheaply acquired. When this mode of provisioning falls short, she resorts to the merchants who vend the passed-down repasts of the well-to-do along with the specious lure of an equally transmissible social status. That the material goods she collects are simultaneously crystallizations of word scraps, rumors, murmured *faits-divers* and whispers of calumny—what today might be called "sound bites"—is one of those hermeneutic "gifts" that Zola zealously gives his reader, and which often feel like a barrage of packaged metaphors. When we return to Zola's systematic binding, through Mlle Saget, of foods and words in *Le Ventre,* it will be helpful to tug at the wrapping, which works as much as a barrier to what is not put in by the author as it does a container.

Marjolin and Cadine, the itinerant duo of Les Halles, join the cast of visible eaters in this novel. Marjolin, explicitly designated as unofficial tour guide—"le Quasimodo de mes Halles"—in Zola's plans for the novel, serves also to relieve a congestion that might otherwise weigh the narrative down.[8] Zola slyly pretends ignorance about the child's naming ("Une belle fille rousse, qui vendaient des plantes officinales, l'avait appelé Marjolin, *sans qu'on sut pourquoi*") (762; my emphasis) (A pretty redhead who sold medicinal herbs named him Marjolin, *though no one knew why*). But *Marjolin* meets the ear like a masculinized form of *marjolaine* (marjoram), the herb used medicinally as an antidote for indigestion, flatulence, and all manner of digestive disorder. The two cabbage patch children are discovered separately in their infancy, Marjolin literally under a cabbage leaf (625); they become community wards who are fed and lodged by a series of vendors.[9] Eventually raised together by the vegetable seller, la mère Chantemesse, in exchange for their labor, the foster siblings roam the marketplace freely, bedding down shamelessly, and feasting openly on pilfered morsels. This last activity warrants a closer look: the alimentary license seamlessly clinches the sexual and ambulatory abandon the nubile adolescents accord themselves, confirming their animal-like ways and assuring their popular status in the eyes of any reader privy to the bodywork of nineteenth-century social discourses. Together with the young charcuterie apprentice, Léon, who comes bearing stolen offerings of cornichons and goose fat, saucisson slivers and ham ends, Marjolin and Cadine seclude themselves in pavilion cellars or attic bedrooms for cobbled-together repasts whose other found objects are cajoled, nipped from the stalls, or nudged out of strategically jostled baskets: "Le fromage blanc . . . était un cadeau. Un

FIGURE 17 Édouard Manet, *La Chanteuse des rues* [*The Street Singer*], circa 1862. Oil on canvas, 67 3/8 × 41 5/8 inches. Photograph copyright Museum of Fine Arts, Boston. Bequest of Sarah Choate Sears in memory of her husband, Joshua Montgomery Sears.

friteur . . . avait vendu à crédit les deux sous de pommes de terre frites. Le reste, les poires, les noix, les crevettes, les radis, était volé aux quatre coins des Halles" (783) (The fromage blanc was a gift. A fried food vendor sold them two sous' worth of fried potatoes on credit. The rest—the pears, nuts, shrimp, and radish— were stolen from the four corners of Les Halles). The improvised spreads obey only the law of accessibility; whatever goods fall into the nimble fingers of the young thieves land in a heap on their plates in a mockery of culinary harmony and order: "Ils allongeaient la main en passant le long des étalages, chipant un pruneau, une poignée de cerises, un bout de morue . . . ramassant tout ce qui tombait" (783–84) (They reached out as they passed by the stalls, nipping a plum, a handful of cherries, a bit of cod, gathering up whatever fell off). In the novel's commanding judgment filtered through the painter persona of Claude Lantier, such breaches of decorum are morally reproachable but aesthetically laudable: "Et il éprouvait, malgré lui, comme une admiration pour ces bêtes sensuelles, chipeuses et gloutonnes, lâchées dans la jouissance de tout ce qui traînait, ra- massant les miettes tombées de la desserte d'un géant" (784) (And in spite of himself, he felt a kind of admiration for these sensual creatures, gluttonous thieves let loose in the pleasure of all this litter, gathering up the crumbs fallen off a giant's table).[10]

These sundry crumbs cleared from a colossal spread are not conceptually different from the leftovers Mlle Saget negotiates on the cheap, begs from shop owners, or trades in kind—a scrap of gossip for a smudge of pâté or a sliver of ham, for example—from the earliest pages of the novel on (634; 668). Together they announce the more conventional institution of cycled-down dinner rem- nants featured in the later scenes at harlequin stands that vend "la desserte des restaurants, des ambassades, des ministères" (834) (what is cleared from the re- mains of restaurant, embassy, and ministry tables). Well before he presents the official merchants of leftovers, then, Zola has introduced the piecemeal concept of harlequin eating and exposed it as a generalized mode of consumption among the working-class poor at Les Halles.

Muche and Pauline, the young children of the warring fishmonger and char- cutière, respectively, extend the file of flagrant eaters in the novel when they evade their bilateral maternal interdictions on associating with the enemy and join forces. Their illicit forays through muddy streets and their collecting of con- fectionary dregs are the juvenile equivalent of Marjolin and Cadine's nomadic marketplace circuits, and yield bargain booty of similarly haphazard form, no- tably, paper wrappers filled with the sugary rubble of candy displays: "de minces cornets de papier, où les épiciers mettent les débris de leur étalage, les dragées cassées, les marrons glacés tombés en morceaux, les fonds suspects des bocaux de bonbons" (816) (thin paper cones where grocers dump the debris of their showcases: the shards of sugared almonds, candied chestnuts reduced to bits, the deteriorating bottom layers of bonbon jars). Further degraded by Pauline's

sticky fingers shuttling between her salivating mouth and her bulging pockets, the sweet crumbs disintegrate into confectionary dust and chocolatey stains.

Most (and chronologically first) exposed of all consumers in the novel, however, are the bottom feeders: the anonymous soup guzzlers introduced by Claude to the newly returned Florent.[11] Early in his tour of the renovated marketplace Claude presents, via Florent, a *marchande de soupe* surrounded by her famished dawn customers. Descending the tiers of the lowest levels of Parisian society from their tidied "upper crust" to their murky depths—because even the underworld of misery is hierarchized—the narrator, from Claude's perspective, describes the huddled clientele hunched furtively over their soup cups on the sidewalk:

> Il y avait là des marchandes très propres, des maraîchers en blouse, des porteurs sales, le paletot gras des charges de nourriture qui avaient traîné sur les épaules, de pauvres diables déguenillés, toutes les faims matinales des Halles, mangeant, se brûlant, écartant un peu le menton pour ne pas se tacher de la bavure des cuillers. . . . Mais cette diablesse de soupe aux choux avait une odeur terrible. Florent tournait la tête, gêné par ces tasses pleines, que les consommateurs vidaient sans mot dire, avec un regard de côté d'animaux méfiants. (624–25)

> [There were very well-groomed vendors, market gardeners in their smocks, dirty porters whose coats were soiled by the heavy foodstuffs they had borne on their shoulders, poor ragamuffins—all the hungers of a Les Halles morning—eating, scalding their mouths, sticking out their chins so as not to stain their clothes with whatever trickled off their spoons. But this wretched cabbage soup smelled terrible. Florent turned his head, troubled by these full cups that the consumers were emptying wordlessly with the sideways gaze of mistrustful animals.]

The soup eaters—not only anonymous and faceless, but also synecdochically reduced to a bodily need ("toutes les faims matinales")—divert their eyes instinctively. We may wonder if it is the glance of passersby in the street or that of the virtual narrator that they shirk while they gulp down their foul meal with "animal distrust." We are perhaps meant to understand the qualifier as an indication of a wariness induced by what we would today call their "food insecurity," which causes them to wolf down a meal in hand, however humble. But the animal modifier tinges the soup consumers integrally as well as their distrust, suggesting that the impulse to look away be assigned to primitive instinct. The averted gaze should perhaps be ambiguated as a sign of human embarrassment and humiliation as much as caginess. Florent in turn looks away "uncomfortably" from the soup eaters. Though his deflected eye is less harshly qualified, his discomfort is equally vague; it may be attributed to the gut-twisting suffering provoked by seeing others eat in the face of his own ravenous hunger, or alternatively, to the

151

shame of a voyeur watching a scene of voracious feeding with which he may so readily identify.

The equivocation may be Zola's way of having his wretched soup seen and eaten too: he pairs a show of sympathy for hunger and misery with the unwavering gaze of social privilege.[12] This exacting scrutiny renders an image of fetid soup dribbling over the edges of spoons to cake jutting chins that have nowhere to go. The unflinching transmission of such a voyeuristic stare to Zola's public is relieved only by its veneer of aesthetic perception. Florent turns his head away, along with the reader, perhaps, but the artist in Claude is all eyes, touched figuratively and literally by the painterly possibilities of this "tableau tout fait," as he calls it (624) (ready-made painting): "Claude lui-même fût attendri par la vapeur forte d'une cuillerée qu'il reçut en plein visage" (625) (Claude himself was overcome by the strong fumes that a spoonful of soup cast in his face). He aspires to paint this scene of brute need, appetite, and poverty that he equates with "the modern" (624) even as he is quite literally gobsmacked by the rank stench rising from the cabbage brew.

The foul smell is explicitly associated with the soup, but it attaches to the wretches reduced to eating it as well. Nineteenth-century conceptions of the *foule putride* (the putrescent mob) have been well explored by Alain Corbin, along with the idea that the proletariat reeked of their living conditions (including overuse of grease and oil, likely to have been the prime ingredient of street soup). And cabbage soup holds a special place in the iconography of nineteenth-century French poverty; its lingering stench pervades the century's literature. Cabbage is perceived to be not only a common vegetable but also a vegetable for and of the common people. If raw cabbages transfuse the novel's landscape from its opening scene onward, here, not very far in, we find their remains, introduced in the altered state Jean-Pierre Richard has named "the residual."[13]

The particular narrative locus of this soup stand scene within Claude's introductory tour of Les Halles makes it foundational. Positioned at the nadir of alimentary practices, these ambulant soup eaters are the summum of all the Paris underworld consumers Zola parades through his novel. On foot, fingers balancing spoon and bowl, they epitomize the trail of itinerant eaters we encounter throughout, crouched on straw or chicken feathers in cellars, cramped together on attic bedroom floors, making the round of vendors in the streets, and eating out of hand. They exemplify all those who eat on the run because they do not have a place at the table, that emblem of civilization in the bourgeois era that, Carine Goutaland reminds us, is not merely a convenient alimentary prop but a marker of social class modeled on the separation of biological species: "[la table] matérialise la distance entre humanité et animalité dans l'acte alimentaire" (the table materializes the distance between humanity and animality in the act of eating).[14]

By virtue of the form of their food as well as their mode of ingesting it, Zola's soup guzzlers are extreme prototypes of the other active consumers in this novel.

From Mlle Saget to Marjolin and Cadine, Pauline and Muche, we follow a trail of crumbs, fragments, bits, bones, slivers, and scraps. The remains of whole meals are left over, broken off, fallen away, spoiled, decomposed. Soup in *Le Ventre* is no different from the liquefied residues we have followed in other contexts and media (the press, social histories, postcards, as well as other novels): it is the lowest, because the most dissolute, state of disintegrated food, whose constituent parts are lost to sensory recognition. In Zola's scene, soup is further degraded by its rhetorical reduction to splotches and drool, and then even further devolved in the grand finale of the exposition as a foul miasma, following a phase transition that goes from solid, to liquid, to vapor.[15]

As Goutaland along with Roland Barthes, Geneviève Sicotte, and others have argued, meals and the people ingesting them constituted one of the last great areas of repression for literature and the other arts in the nineteenth century, one of the last frontiers of corporeal representation remaining to be crossed.[16] It was a challenge that Zola and other naturalists gladly took up. But I believe it would be an oversimplification to declare victory for "cette volonté d'exposer le corps sans tabou" (this will to expose the body with no taboos), as Goutaland frames Zola's feeding forays, or even to qualify his project as one *aimed* at breaking all taboos.[17] For while Zola may display the eating body in *Le Ventre de Paris,* and may gesture toward its digestion and (even more prominently), its indigestion, he does not zero in on the *bourgeois* eating body, which remains largely untouched and unviewed in this novel.[18] The eaters who are exposed—we might say publicized or even, anachronistically, "outed"—displayed *in the act of eating* in *Le Ventre*—are defined by their low or marginal social status: they are children, animals, and the working-class poor, those lower-class humans infantilized or likened to beasts because of their poverty or déclassé rank.[19] And it is essential to emphasize that their style of feeding does not fit under the rubric of a *meal,* if we understand this term to describe an act that unfolds in time, implies regular occurrence, and entails a round measure of food.[20] Their consumption is represented instead as scavenging: that is, a discontinuous, sporadic activity targeting part objects, and to which no measure of duration, frequency, or wholeness can be assigned. Zola's feeders are his doubly determined bit players: the vital secondary actors to whom he relegates the function of eating and its styling in dribs and drabs. Just as what defines the feed in *Le Ventre* is its fallen status (it is secondhand, residuary, and mixed), what characterizes the active eaters is their lowly social grade. Though the motley consumers are as uneven as the unwholesome scraps they consume, together they fuel the novel's progression, providing a certain energy for its unfolding.

—— LISA'S REMAINS

I have left as a postscript in my catalogue of scrap feeders the case of Florent, the protagonist who does not fit the pattern of the others in that he is a major character and a minor eater.[21] Though Florent is presented throughout the novel as the personification of hunger, the reader rarely has access to his scenes of eating. For the most part, he reacts negatively and even anorectically to edible matter, especially meat, and is viscerally disgusted by the phantasmagoric displays of animal, vegetable, and piscine plenty overflowing from the pavilions and street stalls of Les Halles. There is also little narrative engagement with Florent's alimentary activity (except to underscore the lack thereof) beyond the early account of his retrieval of a carrot fallen on the ground that he ravenously, if improbably, devours whole upon his famished entry into Paris.[22] Later we learn that he regularly takes his dinners with the Quenu family (until he is dismissed from their table), but we hear nothing of the substance of these meals. We are told that he is served an omelet in the countryside but are given no description of this fare. During the protracted and excruciatingly detailed *boudin* fabrication scene in the charcuterie kitchen, Florent observes the blood sausage making but partakes only with his eyes. The only exception to the reticence about his food intake occurs in a flashback to his Guiana days. In his tale of the penal colony Florent evinces the abysmal quality of his prison rations by the need to sort out the rice from the maggots. While this might technically designate him as a piecemeal eater, it is not my principal reason for including him in Zola's infrequent scenes of consumption.

Florent in fact is much more than a picky eater: he becomes himself the picked-over remains of other people's repasts. Chased out of Lisa's household into a petit bourgeois respectability intended to purge the stain of his dissident past, Florent takes on a supervisory marketplace function in the service of the empire as *Inspecteur de la Marée*. When the fishmongers find that this newcomer surveils them too rigorously, one takes particular umbrage. Building on the fabricated rumor that Florent is Lisa's lover rather than her relative, la belle Normande, Lisa's rival, spurns them both in a single turn of phrase: "Si la grosse Lisa croit que nous voulons de ses restes!" (716) ("If that fat Lisa thinks we want her leftovers!"). Handed over from the charcuterie to the fish pavilion, he is disdained as the charcutière's leftovers, at once a table scrap, a cast-off speck marring the shop's pristine display trays, and a bed crumb tossed out and re-served to the fish vendors. Later market gossip will have it that Lisa's alleged ex-lover moves on into the beds of la belle Normande and her sister as well, discursively (if falsely) realizing the fish seller's turn of phrase. Correlatively, the metaphor implicitly tosses Florent into Mlle Saget's market basket, along with so many other meat remnants from Lisa's display, suggesting that he will become part of the busybody's fodder: so much more gristle for her meal, so much more grist for her word mill.

But Florent is a potential dinner course from the moment he enters the novel, borne back to Paris on a cart of vegetables that furnishes the material to describe him in terms evocative of a restaurant menu choice: "Il y rentrait, sur un lit de légumes" (612) (He was returning, on a bed of vegetables). Like a *jarret de porc sur un lit de choucroûte* or a *côte de boeuf sur son lit de poireaux,* Florent is introduced to the reader like a prime cut on its bed of root vegetables served up to the gluttonous people of Paris. And they will not pass up the feast.

—— THE MAN EATEN BY BEASTS

Florent's passage into the Pavillon de la Marée is primed by the well-known scene in the charcuterie kitchen that pairs a graphic narration of the preparation of *boudin,* and a no less visceral autobiographical tale (coyly recounted in the third person by Florent) of an escaped political prisoner of Cayenne discreetly named *l'homme.*[23] Commentators have pointed to the virtuoso construction of the dual narrative lines played against each other, juxtaposing two inverted varieties of carnivorism: in brief, humans eating pigs, and crabs eating humans (against a reinforcing background of predatory mosquitoes, lice, alligators, serpents, and tigers).[24] I want to suggest that the doubling makes for far more than an incongruous counterpoint of alternating narratives; it leads to an unsettling confusion not only of stories but of species, classificatory systems, individuals, and alimentary taboos.

At the very moment of launching the crossed stories, Zola—with a typical abundance of hermeneutic control—ventriloquizes Pauline in order to alert us to the entangled consumption of porcine and human flesh: "Sans doute, dans cette tête de gamine, l'idée du sang des cochons avait éveillé celle 'du monsieur mangé par les bêtes' " (684) (Probably, in her child's mind, the idea of pig blood had awakened that of "the *monsieur* who was eaten by beasts"). But he more subtly hints at the crossing of taxonomical lines by naming Pauline's cat "Mouton" (sheep). This feline in ovine clothing will, in the end, obey a higher dietary law than the *Homo sapiens* specimen embodied in that paragon of bourgeois moral virtue, Lisa; while the charcutière delicately nibbles a length of freshly stuffed blood sausage, Mouton spurns the porcine flesh that has been narratologically contaminated by a trace of the human. But this dénouement is at least as vigilantly prepared as the *boudin* and merits a closer look.

In the beginning, there is the child's demand for a reiteration of Florent's (previously overheard) sinister tale in lieu of a bedtime story, a request that is already a bit macabre, and especially so because Zola has staged, as backdrop, a cozy bourgeois domestic tableau in the charcuterie kitchen after dinner. It features Pauline nestled in her uncle's lap as she in turn cuddles her cat while Lisa and her servant, Augustine, sit sewing, and Quenu and his apprentice, Léon, prepare what is framed as one of the homemade delicacies that are the shop's pride. It is true that Zola's preparatory notes for this scene more ominously call the kitchen "le

laboratoire," as if the cooks might be experimenting with some ungodly recipe, perhaps a Frankensteinian-inspired creation or a witches' brew.[25] Although the laboratory reference, with its implication that the blood of an unholy science is boiling and bubbling on the hearth, remains in the wings of the novel, in the text itself Zola rouses the tone of his meticulously routine description of stockpots, ovens, grills, ceramic tiles, spices, and breadcrumbs by attributing to the ensemble of the *batterie de cuisine* "l'idée mystérieuse et inquiétante de quelque cuisine de l'enfer" (682) (the mysterious and disquieting idea of some infernal kitchen).

We may well recall this comparison a few pages later when Florent mentions that his specific deportation site in Guiana was the inaccessible Île du Diable—even if Zola does not explicitly remind us that he is rhyming "devil" with "hell." The infernal nature of Florent's daily life as prisoner on the remote, forbidding island locked in a churning sea is evoked by his account of forced labor, raised whips, shredded clothing, stomach-turning rations of rotting and infested fare, followed by a near-death flight by sea with two less fortunate escapees on a makeshift raft.[26] Yet the assimilation of Devil's Island to the gory culinary abyss lying just behind the blanched premises of the charcuterie shop is illuminated fully only when the grisly discovery of his dead companion's gnawed body is positioned against the blood and guts of the *boudin* preparation.[27] For as the steamy blend of molten lard, pork flesh minced to a sticky paste, sizzling bacon, and sautéed onion is diluted with pitchers of freshly let pig's blood, Florent is recounting the days of starvation, exposure, and near drowning that bring him to the brink of death, his two companions to a gruesome end—and one of them to carrion.[28] A detail of Léon, readying scraped and hollowed pork intestines to become casing for the sausage mash, is punctuated by Florent describing his friend's eviscerated belly, as if offering up a mockery of talion law: a gut for a gut. Arriving too late to rescue the man stranded in extremis on a sandbar, Florent finds in his place a corpse "étendu sur le dos, les pieds et les mains dévorés, la face rongée, le ventre plein d'un grouillement de crabes qui agitaient la peau des flancs . . . [de] ce cadavre à moitié mangé et frais encore" (689) (lying on his back, his feet and hands devoured, his face chewed up, and his belly full of a swarm of crabs that fluttered the skin . . . on the sides of his half-eaten, still-warm body). The insistence on the fact that the cadaver is fresh kill, as it were, assimilates it to animal meat; more particularly, it echoes the swine newly slaughtered and conscientiously sourced by Léon earlier the same day at the abattoir: "C'était lui qui saignait à l'abattoir. Il prenait le sang et l'intérieur des bêtes, laissant aux garçons d'échaudoir le soin d'apporter, l'après-midi, les porcs tout préparés dans leur voiture" (683) (He himself bled the pigs at the abattoir. He extracted the blood and entrails of the animals, leaving to the slaughterhouse boys the task of delivering the prepared pigs in their cart, in the afternoon).

The carcass of Florent's fugitive companion enters the charcuterie like a Trojan horse, welcomed in under the innocuous cover of a fairy tale. When the

story reveals a disemboweled human belly, scraped clean like the interior of the *boudin*-making pig, the resonances are as unnerving as the barbarisms. When this belly opens to a swarm of crabs, that is, an army of bellies outfitted with appendages, the uncanny note strikes a crescendo. From one paragraph to the next, Zola repeats identical words, "this belly teeming with crabs," changing only the predicate. In the second rendition, the surge of crustaceans in the cavity of the Guiana corpse waft their shadow presence through the shop kitchen, tainting the familiar cooking aromas with a whiff of the foreign: "Ce ventre, plein d'un grouillement de crabes, s'étalait étrangement au milieu de la cuisine, mêlait des odeurs suspectes aux parfums du lard et de l'oignon" (689) (This belly full of teeming crabs was like a foreign presence displayed in the middle of the kitchen, mixing sinister odors with the scent of lard and onions).

I have translated somewhat freely here, understanding *étrangement* to signal an intrusion of the foreign as much as the strange. For this runaway's belly strangely superimposed on the belly of Paris, this belly from afar that comes bearing other bellies, is the belly of Guiana infiltrating domestic interior space. It carries all that is indigestible in Second Empire Paris: poverty, hunger, unrest, political opposition, confrontation with the colonial Other. It will be denied, marginalized, displaced, and eventually ejected, but its subversive effects cannot easily be dismissed. More ripples of Guiana will reach us later, but for now I would like to elaborate on the meaning of the strange belly in the Quenu kitchen. For this foreign body is not only the ghost of Guiana, but also a phantom of the human that comes to pervade the smell, taste, and idea of animal flesh in *Le Ventre de Paris*. And as the specter of the anthropoid comes to hover over sausage and lard, people take on a creaturely charge, overlaid with hoof or wing or shell. So Quenu in his irritation with Léon's clumsy handling of the pig intestine lashes out at him with the rebuke "Mais, animal!" (692).[29] Florent comments on his dehumanizing experience in captivity: "On vivait en bête" (687) ("We lived like animals"), and similarly characterizes his life as a fugitive, relating his trek through the forests of Dutch Guiana where an inhabitant of the lone plantation he passes stands guard with a rifle and throws him food far from the house, as one might succor a stray dog that is both pitied and feared (692). And if earlier in the chapter, Zola exaggerates the already overblown, rounded parts of Lisa's body so as to reduce the charcutière to a belly, is this not better to accentuate her resemblance to a crab? "Elle n'éveillait aucune pensée charnelle . . . elle ressemblait à un ventre" (667) (She aroused no carnal thought; she resembled a belly), Zola says, borrowing Florent's view of her in the mirror, surrounded by cuts of pork. If the immediate context for this comparison is porcine rather than crustacean, the image of Lisa's core inflated to a distended belly is not easily wiped from the reader's memory, and it insists on re-entering our consciousness just pages later when the devoured belly of crabs erupts into the Quenu kitchen. And so, when the *boudin*-making scene draws to a close with Lisa pecking at a

piece of still-warm minced flesh encased in swine gut, do we not see a shadow image of a giant crab-woman gnawing at the innards of a dying man? A dying man who, we remember, is the eponymous "monsieur mangé par les bêtes" of Pauline's bedtime story. That *monsieur* is ostensibly Florent's companion, the fellow escapee who cannot swim to safety when the raft smashes on impact with a sandbank. Yet *le monsieur* and *l'homme* of Florent's narrative tend to merge, both by the proximity of their signifiers and the similarity of their signifieds: *l'homme* and *le monsieur,* Florent and the devoured man, are fellow prisoners, co-fugitives, and friends, and in the end suffer a comparable fate, both scavenged by predators who lie somewhere on an indeterminate continuum of the animal and the human. If Florent survives the predacious rainforest—the raging sea and the parching sun and the devouring crabs—he wanders the jungle ravaged by hunger ("l'estomac tenaillé par la faim" [691]), further identified with his carrion friend by the gnawing in his belly.

As Lisa bites into her morsel of flesh, drawing back her lips like a snarling beast, we recognize a portent of Florent's demise along with an echo of his anonymous companion's brutal death, signaling the implosion of taxonomic structures, narrative plots, individual identities, and alimentary taboos. The suggestion of cannibalism is reinforced by scattered allusions. Florent's embedded tale of three starving men bereft of provisions adrift on a raft on a storm-tossed sea would surely have evoked the wreck of the *Medusa,* and Théodore Géricault's representation of the ship's raft with its fifteen dead and dying survivors, awakening memories of the grim lottery for sustenance, in the minds of nineteenth-century readers closer to the shocking 1816 historical event and its 1819 restaging in paint (Figure 18).[30] The instability of human and animal categories in both the kitchen scene and the story that unfolds within it, the overlap and confusion of identities and narratives, the slippage of scenarios of eating that results in a mystification of who or what is eating what or whom—all this silently evokes a specter of anthropophagy that is materialized by the presence of the grounded raft in Florent's tale.

In her reading of Géricault's painting, Darcy Grimaldo Grigsby has explored the omnipresent terror of cannibalism aroused by vessels stranded or lost at sea in the nineteenth century, even before the wreck of the *Medusa,* in which cases, imagined scenarios of starvation would be projected as dual anxieties onto both land and ocean. If men foundering on a raft induced fantasies of being eaten "by the savage on shore or . . . by [their] own community at sea," she proposes, it was the second, cannibalism *within* the group, "[that] ultimately posed more troubling questions . . . challeng[ing] those very structural oppositions of outside and inside on which identity is so precariously based."[31] In the overlap of human and pig meat, bellies, and guts, in the overlaid scenes of the *boudin* tasted in the kitchen and the starving marooned man devoured on the Guianese shore, there is an angst that is as ominous as it is free-floating.[32]

FIGURE 18 Théodore Géricault, *Le Radeau de la Méduse* [*The Raft of the Medusa*], 1818–19. Oil on canvas, 193 × 282 inches. Photograph: Michel Urtado. Photograph copyright Musée du Louvre, Dist. RMN–Grand Palais / Art Resource, New York.

Anthropophagy rears its human head once more when we read anachronistically backward from the famous castration scene in Zola's *Germinal* to his market novel of a dozen years earlier. Chased by a mob of angry, hungry mineworkers, the sexually predacious and miserly shopkeeper, Maigrat, who has made a habit of trading credit to starving families for sex with their daughters, falls to his death. When a group of women avenge themselves by ripping off his genitals and parading them victoriously like a flag flapping on a pole, there is speculation among those who were not present at the castration scene about just what sort of flesh, and from what animal, hangs bleeding above them. Perhaps it is a piece of a rabbit? wonders one bystander. But no, surmises another, it looks more like shreds of pork: "Ils auront pillé la charcuterie, on dirait un débris de porc" ("They must have pillaged the charcuterie, one would guess it is a scrap of pig meat").[33] Euphemistically speaking, she is correct: they have looted the charcuterie and are waving pig meat. Zola seems to be raiding the same trope in reverse when he writes the *boudin* preparation scene in *Le Ventre,* conflating cannibalism and sex, and arousing the reader's curiosity about just what Lisa might be biting off in the kitchen of her charcuterie.[34]

On a more quotidian level, however, we must see the *boudin* fabrication through to its conclusion. On our return to the charcuterie, we watch as the process is completed by extruding the seasoned forcemeat through a funnel whose

neck is inserted into the prepared membranes, and as the encased sausage lengths are then cooked in large pots of boiling water (693). It is at this point that we find Lisa savoring her *dégustation*. Meanwhile, the uneaten remains of the *boudin* production are coiled, snake-like, around a stick and carried out to the courtyard to dry. What is left of Florent is squeezed out of the charcuterie and into the fish pavilion.[35]

—— PLUGGING UP HOLES

From its opening lines, Florent's account of his seven-year exodus in Guiana is an extreme narrative. It begins with five weeks in a ship's hold bound by leg irons, cheek to jowl with four hundred convicts, devoured by lice and unable to eat. The narrative continues with descriptions of his forced labor on Devil's Island as a malnourished, barefoot prisoner in tatters. The post-captivity phase is different in kind but not in quality from the sea transport and incarceration; it is dominated by encounters with all manner of savage beasts and natural elements of the subtropical world (from serpent to tempest to quicksand); it is dusted with dietary misadventures ranging from chewing on leaves, to the lure of poison berries, to starvation. I call Florent's story "extreme," however, less because its conditions are far removed from ordinary Parisian experience in the second half of the century than because it remains, however marginally, *within* this experience: *on the edge* of the Paris existence that is his. It is a hyperbolic representation of Florent's circumstances, his habits, and his misfortunes throughout the novel.

In Paris as on Devil's Island or in the thick of the Guianese rainforest, Florent is eaten up by hunger, racked with intestinal cramps. Rather logically, his pains are most intense at journey's end as he makes his way overland from Le Havre back to Paris, "pris de crampes et de douleurs, le ventre plié" (606) (racked with cramps and pains, his belly coiled), by which point he bears the marks of his extended ordeal, "l'estomac rétréci, la peau collée aux os" (613) (his stomach shrunk, his skin stuck to his bones). That his suffering is metaphysical as well as somatic, that it is heightened by the surfeit of provisions billowing out everywhere at Les Halles, is quickly evident: "L'odeur fade de la boucherie, l'odeur âcre de la triperie, l'exaspéraient. . . . Un feu ardent le brûlait de nouveau au creux de la poitrine; il y portait les deux mains . . . comme pour boucher un trou par lequel il croyait sentir tout son être s'en aller" (632) (The stale odor of the butcher shop, the bitter odor of the tripe shop, exasperated him. A scorching fire once again burned in the hollow of his chest; he brought his two hands there as if to plug up the hole through which he felt his entire being ebbing). His Paris bellyache will be ongoing, exceeding and surviving his hunger. When Florent is no longer deprived of sustenance, nausea and indigestion come to take the place of the "hole in his gut" and the "gnawing" in his entrails—each of which is pointedly rearticulated to accentuate his kinship with the crab-eaten belly. In short, he will continue to carry his past in the pit of his stomach.

But Florent wears his holes on his shirtsleeves as well. His torn and empty gut is mirrored by his ripped prison garb, which is "si déchiré . . . qu'[il] montrai[t] [sa] peau" (so torn that it revealed his skin). His clothes are no less frayed ("éffiloqués") when he reaches Paris, and his filthy rags ("ces loques noires") induce shame there (686; 604; 629). Though Florent's repatriation provides him with ample hand-me-downs from his brother, these coverings perpetuate the lean and hungry look he wore upon arrival, thanks to his sister-in-law's downcycling of her husband's worn-out, tattered, stained garments: "Elle lui passait . . . son vieux linge, des mouchoirs vingt fois reprisés, des serviettes effiloquées, . . . des chemises usées. . . . La petite Pauline avait des mots cruels . . . sur les taches de ses habits et les trous de son linge" (787) (She passed on to him [her husband's] old underwear, handkerchiefs mended twenty times, frayed towels, worn-out shirts. Little Pauline made cruel remarks about the stains on his clothing and the holes in his underwear).

Pauline's cruelty to her uncle mimics a well-inculcated maternal model. Her mockery of Florent's ragged appearance follows the paradigm demonstrated by Lisa's adamant refusal to maintain within her walls a man whose adversities have included hunger, deprivation, and the consumption of substances repugnant to bourgeois culinary taste. In a throwback to the classical logic of the *vraisemblable,* Lisa argues that the gastrological element of Florent's saga cannot be true because it is unseemly and inappropriate. "'Non!' dit-elle, 'je ne crois pas ça . . . On mange toujours, plus ou moins. . . . Il faudrait des misérables tout à fait abandonnés, des gens perdus . . . Car, enfin, jamais les honnêtes gens ne se mettent dans des positions pareilles'" (690) ("No," she said, "I don't believe that. People always eat, more or less. If not, they must be paupers, lost souls, completely abandoned, derelict"). In one fell swoop, she condemns the veracity and the morality of his calamities. Florent's rent garments present the same element of inconceivability to Lisa's daughter as his twisting innards and evacuated belly do to Pauline's mother: they are unfitting to the Quenu household, a sign that their bearer has been improperly taken in and must now be forced out, reconsigned to his outsider status.[36]

Zola takes great pains to mark Florent as alien to the scene of the novel and especially to its bourgeois space from its threshold, even though his entrance into Paris is in fact a repatriation. To his rescuer's self-presentation, "Je suis de Nanterre, je me nomme Mme François" (605) ("I am from Nanterre, my name is Mme François"), he introduces himself in kind, but with a difference: "Je me nomme Florent, je viens de loin" ("My name is Florent, I come from afar"), he replies, defining his provenance neither by his Provençal origin nor by his former long-term Paris residence but instead, by the distance of his exile. His performance of the deportation story similarly emphasizes remoteness: "Il était une fois un pauvre homme. On l'envoya très loin, très loin, de l'autre côté de la mer" (685) ("Once upon a time there was a poor man. He was sent very far away, very far

away, across the sea"). Twice estranging himself by the repetition of his exile afar, once more by the separating sea, and again by the fairy tale spin he gives to his overture, Florent identifies himself as a marginal man, a stranger who cannot be integrated into the polis.

Even in his role as a dissident, Florent acts at a remove; he is alienated not only from the regime of the Second Empire, but from his revolt against it as well. Florent is less an insurgent than an accidental revolutionary, radicalized more by circumstance than by conviction. If his initial deportation was precipitated by his having been in an inconvenient place at an inopportune time, where he was then defiled by the aleatory trickle of a stranger's blood, his second engagement with insurrection is no less contingent:

> Fatalement, Florent revint à la politique. Il avait trop souffert par elle, pour ne pas en faire l'occupation chère de sa vie. Il fût devenu sans le milieu et les circonstances, un bon professeur de provinces, heureux de la paix de sa petite ville. Mais on l'avait traité en loup, il se trouvait maintenant comme marqué par l'exil pour quelque besogne de combat. (732–33)

> [As if by fate, Florent returned to politics. He had suffered too much from politics not to make of it his cherished lifelong vocation. In a different milieu, in other circumstances, he would have become a good provincial schoolteacher, content in his peaceful little town. But he had been treated as a wolf, and he now found that his exile had delegated him to battle.]

Buffeted to sedition on the tides of chance, Florent cannot quite rise to the moment to connect the pieces of his political strategizing, to make a whole out of snippets and holes. His combat plotting, as scrappy as his attire, is "écrit sur des bouts de paper, raturés" (written on bits of crossed-out paper) and confined to a drawer "qui . . . s'emplit de notes, de feuilles volantes, de manuscrits de toutes sortes" (813; 732) (that was filling up with notes, with loose sheets of paper, with handwritten pages of all kinds).[37]

This would-be revolutionary in patched-up clothing, a stranger who comes into an estranged land spilling his past, hashing his plans, failing to fill the hole in his gut, is a reconstituted Harlequin figure. Left over from the Quenu table, recirculated, unassimilated, he remains a ragged, ravenous outcast from a slandered space. Unlike his traditional Commedia avatars, however, Florent will not serendipitously end up on top. Despite his temporary ascent to a place of mock authority in the administration of the empire, he will be abjected to its periphery once more, perhaps the only Harlequin a realist century deserves.

—— EATING LIKE A BIRD

Florent is at least partly, then, relegated to the troupe of itinerant eaters in *Le Ventre* by the patterns of his Cayenne narrative, on which basis he is charged by Lisa with having ingested "des saletés à peine croyables, tout à fait déshonorantes pour celui que les avait mangées" (687) (unbelievable filth, humiliating for whoever ate it). By way of this allegation he is paradoxically associated with Mlle Saget, his political rival and eventual betrayer, who stands accused by Gavard in much the same terms: "La méchanceté de cette pie-grièche ne l'étonnait plus, 'du moment qu'elle s'empoisonnait des saletés sur lesquelles on avait roté aux Tuileries'" (835) (The spitefulness of this magpie no longer surprised him, "since she was poisoning herself with the filthy foods that had been burped on at the Tuileries").[38] The political stakes in the two cases are diametrically opposed, but the alimentary connotations are parallel, all the more so because, we recall, Florent's post-internment march across the Guianese rainforests had him pacifying his empty stomach with the found food of tree leaves, shrubbery, and berries. This diet on which Florent subsists is that of a magpie, the bird to which Mlle Saget is assimilated ("cette pie-grièche") when she is spotted surreptitiously foraging among the plates of mixed leftovers at Les Halles (834–35).

Magpies are birds of the Corvidae family that lend their name (taken from the Linnean classification, *Pica pica*) to the medical diagnosis of pica, the disease attributed to indiscriminate eaters, which is to say, to individuals who consume matter not sanctioned as food by their culture.[39] These birds are known not just as scavengers for food and odd bits of material that can be incorporated into their nests, but also, as chatterers.[40] In turning the name of the magpie to the character of Mlle Saget, Gavard and his friends find a metaphor that bundles two forms of oral activity, ingestion and emission, and their respective objects, food and utterance, and that corresponds to the behavioral characteristics of this peripatetic market forager-gossiper. Mlle Saget's basket of gathered meal parts is also a container of simultaneously amassed word fragments: bits of whispered scandals, half conversations overheard and misheard, partial scenes gleaned from her endless circulation in the shops and stalls, or glimpsed and reinterpreted from the bird's-eye view afforded by her fifth-floor lookout.[41] Spying, eavesdropping, reading other people's mail, and plotting are her modes, and gossip is her trade; guile and dishonesty rule her traffic in words as in foods.

Just as she pieces together a dinner from multiple handouts or purchases a multicourse meal in bits that are down-sourced from different tables, Mlle Saget composes the equivalent of a serial novel from the diverse windfall rumors she accumulates: "Tout le long du jour, elle s'en allait avec son cabas vide, sous le prétexte de faire des provisions, n'achetant rien, colportant des nouvelles . . . arrivant ainsi à loger dans sa tête l'histoire complète des maisons, des étages, des gens du quartier" (668) (All day long she made the rounds with her empty basket on the pretext of shopping, buying nothing, peddling gossip, managing to

lodge in her head entire histories of buildings, floors, and the people who lived in them). Like so much popular fiction of the era, Mlle Saget's is crossed with the detective novel. It yields not just a police report but an arrest. The nauseating but apparently innocuous food clumped in her hamper is intertwined with noxious spools of narrative threads that unwind a conspiracy plot and help to prepare the dossier for Florent's conviction. Her appetite for the stuff of yet another course to join the sequential provisions in her basket is matched only by her craving for news about her neighbors to string into a narrative. An unsourced dessert or an absent dénouement is equally intolerable to this seeker of closure who cannot abide a void: "Elle tombait malade, quand il se produisait quelque trou imprévu dans ses notes" (668) (She fell ill when she came upon an unexpected blank in her notes).

Somewhat oddly, given the rhetorical centrality of the food scrap–word scrap nexus in *Le Ventre,* it is not until the last third of the novel that we, with Gavard, come upon Mlle Saget at a leftovers stand. We find her queuing up there with other seekers of used food in the Pavillon du beurre, where the remains of other people's food are sold under the general rubric of *viandes cuites* (cooked meats). Although we have followed her trail throughout the marketplace from the earliest pages of the novel, we see her doing business with a "dedicated" merchant of used meals here for the first time. At this belated moment in Zola's narrative, if the scene gives him the opportunity to display his wealth of documentation about yet another specialized operation of Les Halles, it does not really provide any fresh information about Mlle Saget's eating habits. But her visit to the scraps vendor serves two secondary purposes. It formalizes and exaggerates a mode of shopping with which we are by now very familiar, one that involves circulating through different venues to bargain for the fallen-off and deteriorated bits of foodstuffs that can be stockpiled in her basket and pieced together into a meal. It also provides a variation on the motif of word-mongering that has exemplified this bit player's consumer habits from the start. If, in the other shops and stands of Les Halles, Mlle Saget accumulates stores of gossip along with the odds and ends she wheedles (a handful of *mirabelles* here, a plug of cheese there, some smidges of charcuterie elsewhere), at the leftovers counter, as she stows away motley vestiges of fish fry, she acquires myths of their imperial provenance on the side: "La marchande affichait la prétention de ne vendre que des reliefs sortis des Tuileries. Un jour, elle lui avait même fait prendre une tranche de gigot, en lui affirmant qu'elle venait de l'assiette de l'empereur" (834) (The vendor claimed only to sell leftovers from the Tuileries. One day, she even got [Mlle Saget] to buy a slice of lamb, by insisting that it came from the emperor's plate). She might, as Gavard taunts, be devouring the most degraded wastes of the emperor's household, food he has belched upon (or even worse, belched up), but as she prepares to recirculate in her body her shrewdly negotiated dinner dregs, she recycles the fable of their Tuileries origin in her fantasies.

Zola here reveals the tonier side of leftovers: the site of fantasy and imagination, they have the potential to pave a royal path to reverie and illusion, to seed a garden of hope and desire, a refuge from the real. They nourish the spirit more significantly than the body, democratizing the palate as they open the mind's window to imperial palaces. Such is the calculated spiel of the vendors who successfully market their handed-down fare to the working classes like a ladder extended from a higher sphere. When Mlle Saget purchases a lamb slice purported to have come from the emperor's plate, she swallows the myth of imperial origin along with the material meat: "Cette tranche de gigot, mangée avec quelque fierté, restait comme une consolation pour la vanité de la vieille demoiselle" (834) (That slice of lamb, eaten with pride, remained a consolation to the old woman's vanity). Mlle Saget is a little too settled and a tad too bitter to seek her cavalier, her Rodolphe who might bear her off to a Swiss lakeside chalet or a splendid domed city in a grove of lemon trees crowned by stork nests—or even a simple ball at the Tuileries—but she, like Emma before her, reaches out for the rungs; she savors symbol before substance when she ogles the scraps of high tables and prepares to devour the debris from their plates. We tend to forget that our first image of the secondhand eater-tattler is one of yearning, that she turns her gaze skyward from her gable window, privileging the ethereal over the material: "Cependant, la fenêtre du pignon s'était ouverte, une petite vieille se penchait, regardait le ciel, puis les Halles, au loin" (619) (Meanwhile the gable window had opened, a little old lady was leaning out and was looking at the sky, and then Les Halles, in the distance). Hers is a proletarian kind of *bovarysme* that opens the space of dreaming in an impoverished urban world.

For Jacques Rancière, Emma Bovary is one of a number of characters in nineteenth-century realist novels (and his examples are, significantly, all women, further categorized as *filles de paysans* [daughters of peasants]) who are capable of doing anything to satisfy their passions and their aspirations. This new capacity of anyone at all to live any kind of life whatsoever, he says, "ruine le modèle qui liait l'organicité du récit à la séparation entre hommes actifs et hommes passifs, âmes d'élite et âmes vulgaires" (destroys the model that linked the organicity of the narrative to a separation between active and passive men, elite and common souls).[42] The demise of the organic novelistic model, for this critic, means not only a modification of rigid socioeconomic hierarchies dictating who may act, and who may merely be described, who may experience emotion and perceive, and who may not, but also, as a result, a perturbation of the novel form that traditionally subsumed description to narration and parts to a whole. The resulting disequilibrium was disparaged by many period critics: they saw the old authority of action sequences threatened by a regime of immobile images organized in tableaux often compared to still lifes.[43] Rancière, however, refutes such charges of immobility, and reevaluates the long descriptive passages in late nineteenth-century novels in terms of a *textural difference* rather than stasis: a new tissue

of perceptions, thoughts, and affects created by literary democracy. "Ces 'tableaux' . . . sont les différences, déplacements et condensations d'intensités à travers lesquels le monde extérieur pénètre les âmes et celles-ci fabriquent leur monde vécu," he writes (These "tableaux" are the differences, displacements, and condensations of intensities through which the external world penetrates souls and these souls compose their lived experience of the world).[44] He refers to these condensations and displacements of sensation and perception as "vibrations," a term that, we will see, becomes particularly relevant to Zola's novel.[45]

Rancière's linkage of representations of the unendowed classes with a challenge to the dual dichotomies of activity/passivity and narration/description in the traditional economy of the novel is useful to the argument I want to make about Mlle Saget and her fellows in *Le Ventre*. Though she is not among Rancière's specific exemplars and is likely not a literal "peasant's daughter" (we know little about her past except that she hails from Cherbourg, has been in Paris for forty years, is poor but not destitute—more stingy than penniless [668]), Mlle Saget is among the working-class protagonists whose serious characterization has larger implications for the form of Zola's novel.[46] For all that her recirculating shards of food and news are disparaged by the novel's anti-imperial voices as fragmentary, unwholesome, and politically incorrect (she is taking on the emperor's politics with his fodder, swallowing his regurgitated propaganda along with the indigestible bits of his food), *they are what makes Zola's text go round.* They drive the plot and provide the motor force of the narrative. Insofar as what is traditionally known as "action" in narrative texts is operative in this novel, it can be attributed to the work of Mlle Saget. The momentum that propels the plot from Florent's arrival, to his growing familiarity with the market, to his betrayal and expulsion, is produced by the hunter-gatherer walkabouts of Mlle Saget and her cohorts. Her gossipmongering character is not only good for comic relief but also essential to the aspiration toward teleological control.

The point I want to emphasize here is twofold. First, if the plot of this novel is ostensibly identified with Florent's plotting, it is time to reconnect it instead to Mlle Saget's counterplotting: her incessant information gathering qua food shopping expeditions.[47] Second, the leftovers dispersed in *Le Ventre* and predominantly bartered by Mlle Saget (*colporter* is Zola's verb of choice for rumormongering)[48] are everywhere also vehicles for bit-fictions that assimilate her, at least parodically, to the novelist. They take the shape of marketing puff at those least illustrious of vending counters that traffic in leftovers; more generally, they bloom into part-stories that are disseminated every day, all over the marketplace, in the form of rumors, gossip, lies, and idle chatter. While this observation is not revelatory—for the simple reason, as I earlier suggested, that Zola parades it before our attention—it directs our awareness to some analogous narrative splinters, less flaunted by their author, that work as tenuous scaffolding for the infrastructure of his novel.

── **PARENTHESIS: MINCING WORDS**

I have deliberately avoided using the nineteenth-century idiom, arch-familiar to my readers by this point, to designate the leftovers sellers, colloquially called *les marchand[e]s d'arlequins,* and their wares, *les arlequins,* in approaching Zola's close-up of their operation in the last third of the novel. The somewhat awkward decision to temporarily erase the term that grounds my book reflects the curious fact that the word *arlequin* is not used by Zola in this novel until it nears its end, at which point it is not applied to food—and this, despite the fact that he uses the term in other novels and in his plan for this novel, following the example of his primary source on markets, Maxime Du Camp.[49] Zola circumvents the commonplace *arlequin* by using less familiar synonyms and circumlocutions, such as *les rogatons* and *la desserte.* For now, I will merely highlight the omission, and will have more to say about its significance later.

── **ZOLA'S SCRAPS**

When Lisa sneaks away from home to denounce her brother-in-law's suspicious activity at the Préfecture de Police, she finds that her report has been preceded by the disparate pieces of an extensive dossier to which many of her neighbors have already contributed. The prefect displays the file: "'Tenez, voici le dossier.' . . . Il mit devant elle un énorme paquet de papiers, dans une chemise bleue. Elle feuilleta les pièces. C'était comme les chapitres détachés de l'histoire qu'elle venait de conter. . . . Pas un détail n'était passé. . . . Elle trouva un tas de lettres, des lettres anonymes de tous les formats et de toutes les écritures. Ce fut le comble" (862–63) ("Here's the dossier." He placed before her an enormous packet of papers in a blue folder. She leafed through the pages. It was like the detached chapters of the story she had just recounted. Not a detail was left out. She found a pile of letters, anonymous letters in a variety of formats and a variety of handwritings. This was the last straw).[50] Arriving last in line, the cutthroat charcutière is miffed to find the dossier complete without her bit, the story already drafted—with Mlle Saget's name in the position of first collaborator. Florent may not have moved beyond the first chapters of his book on Cayenne, but the writing has been accomplished in his place. The story of his confinement has been related by a chorus of other voices and has been redacted from a perspective that is not his own.

The prefectorial dossier, composed of letters in varying formats and an array of handwritings, is made in the image of Mlle Saget's patchworked meals and her generalized modes of operation, but it also mirrors Zola's *dossier préparatoire* for the *Rougon-Macquart* cycle. Zola's biographer Henri Mitterand describes the presentation of this dossier in terms that resonate deeply with Zola's depiction of the prefect's file on Florent: "Les notes primitives sont éparses, sur des papiers de dimensions différentes, avec des écritures de qualités différentes (les unes jetées négligemment, les autres plus appliquées)" (The early notes are scattered on pages of differing dimensions, with handwritings that differ widely [some flung

carelessly on the paper, others more painstakingly applied]).[51] More pointedly, the police dossier on Florent is cut from the same cloth as Zola's plans for *Le Ventre de Paris,* which similarly include a number of explicit references to sources, as well as extensive notes and citations from some of these.[52]

Multiple fragments of the *dossier préparatoire* for *Le Ventre de Paris* find their way into this novel, sometimes by echo, allusion, or inspiration, but often, too, by a wholesale borrowing of passages that borders on plagiarism.[53] A few examples illustrate Zola's unabashed assimilation of source materials into the fabric of his novel.[54] Many details from Eugène Sue's 1858 *Aventures de Hercule Hardy, ou La Guyane en 1772* insinuate themselves into Zola's account of Florent's jungle escapade (swamps, quicksand, wild beasts of water, land, and air), but the echoes are most explicit in the account of a boa constrictor mistaken for a tree trunk. Sue recounts the fate of a certain Van Hop who sat down on "un énorme boa . . . prenant le reptile pour un tronc de goytier [*sic*]; le boa, lové sur lui-même, était engourdi" (an enormous boa constrictor, taking the reptile for a guava tree; the boa, coiled around itself, was in a torpor), while Zola's Florent, forewarned perhaps by Van Hop's example, is more cautious: "Il restait là des heures, avec l'épouvante de quelque boa, entrevu au fond d'une clairière, la queue roulée, la tête droite, se balançant comme un tronc énorme" (691) (He stayed there for hours, terror-struck by some boa glimpsed in a distant clearing, its tail coiled, its head erect, poised like an enormous tree trunk).[55]

Zola's borrowings from Du Camp's chronicle of Les Halles and the provisioning of Paris are barely reworded in *Le Ventre.* Here is Du Camp on the pounding and amalgamating of butter:

Sur de longues tables . . . [l]es divers échantillons sont pétris avec force et longtemps, comme une pâte de pain. C'est ce qu'on nomme la *maniotte*. Le beurre ainsi foulé devient blanchâtre et prend un aspect crayeux auquel on remédie par l'adjonction d'une teinture mystérieuse que les gens du métier appellent le *raucourt,* composition dont ils cachent la recette avec soin, et qui n'est autre que le rocou, sorte de matière onctueuse et rouge qui entoure la graine du rocouyer. . . . On la remplace souvent par un faux rocou composé de carottes et de fleurs de soucis.[56]

[On long tables different samples are kneaded forcefully and at length, like bread dough. This is called *la maniotte.* This pressed butter becomes whitish and takes on a chalky appearance that is alleviated by the addition of a mysterious dye that people in the trade call *le raucourt* (annatto), whose composition they carefully hide, but which is nothing other than *le rocou* (annatto), an unctuous red substance that surrounds the seed of *le rocouyer* (the annatto bush). It is often replaced by an artificial annatto made of carrots and marigold flowers.]

And here is Zola on the same:

Sur une des tables placées le long de la rue Berger . . . la marchande pétrissait "la maniotte." Elle prenait, à côté d'elle, les échantillons des différents beurres, les mêlait, les corrigeait l'un par l'autre. . . . Elle enfonçait furieusement les poings dans cette pâte grasse qui prenait un aspect blanchâtre et crayeux. . . . Le raucourt sert à rendre à la maniotte une belle couleur jaune. Les marchandes croient garder religieusement le secret de cette teinture, qui provient simplement de la graine du rocouyer; il est vrai qu'elles en fabriquent avec des carottes et des fleurs de soucis. (825–26)[57]

[On one of the tables along the rue Berger the vendor was kneading *la maniotte*. She took samples of the different butters from beside her, mixed them together, correcting one by the other. She drove her fists furiously into this greasy dough that was taking on a whitish, chalky appearance. *Le raucourt* (annatto) gives *la maniotte* a good yellow color. The vendors think they are religiously keeping the secret of this dye, which simply comes from the seed of *le roucoyer* (the annatto bush); it's true that they also make it from carrots and marigold flowers.]

So the composition of *Le Ventre* relies not only on Zola's aesthetic reflections, his observation of days and nights at Les Halles, and his fastidious book research, but also on embedded chunks of other people's texts. Set like so many tesserae in a mosaic, they are reminiscent of rumor fragments hoarded with food crumbs in a gossipmonger's market basket for delayed savoring.[58]

Like Mlle Saget, Zola is a nibbler, a kind of wordpecker intent on collecting and recombining verbal scraps dropped by others. If gossip consists of splinters of other people's talk, reported, redesigned, or reinvented, and pieced together into a narrative, then *Le Ventre de Paris* might be considered to be not only a novel *about* gossip (among other things), but also a specimen of the novel *as* gossip, which is to say, a novel that exhibits its own discursive foundations and invites us to consider the ways in which it overlaps with gossip.[59] For Ross Chambers, the gossiper displays "a certain *knowingness* about 'human nature,'" even if such knowledge is only commonsensical.[60] We have, in the character of Mlle Saget, just such a primitive purveyor of knowingness. She is, as the diminutive ending of her name implies, less a sage than a wise guy or a know-it-all, an accumulator of the raw materials of scandal. She is also, of course, a cover for the more skilled, literary rumormonger who deploys her character in his pages.

Zola is not only a compiler of other people's texts but also a ghostwriter for the aptly named Mlle Saget and her clutch of fellow busybodies, la Sarriette, Mme Lecoeur, la Mère Méhudin, la belle Normande, and Lisa. His writing conveys not just the very audible chatter of the marketplace, but, too, an implicit echo of the reigning system of values, the doxa, that makes such chatter intelligible to the reader. So, for instance, despite the reality that Les Halles was at least as male- as it was female-gendered, the loose-tongued busybodies who populate the novel

are all women (with the exception of the male fringe character, Gavard, who has decidedly nattering tendencies and is therefore feminized).[61] Though this female gendering of the marketplace is contrary to historical fact, it is congruent with the cultural gendering of gossip, and verisimilitude weighs heavier than veracity.[62]

As latter-day readers and critics of this novel, we belatedly join its circle of gossipers: we, too, swallow the fiction, if only because a tight net of writing keeps its residual ingredients packed and palatable.[63] But it seems critical, as I earlier hinted, to identify not only those components that Zola binds together and displays for our consumption (prime among which, the hampered foods and words), but also the less exposed nodes where we catch glimpses of his writing participating in a discourse he does not otherwise acknowledge. Such obscured traces leach out through breaches and cracks in the text.

—— THE GUIANA GAPS

Le Ventre de Paris is a novel that does not suffer holes gladly. From the image of Florent clutching the hollow at his core "comme pour boucher un trou" (632) to Mlle Saget's somatization of missing information ("elle tombait malade quand il se produisait quelque trou imprévu dans ses notes" [668]), we find echoes of Zola's own horror of a vacuum and his mania for fullness and completeness. There is no need to rehearse in detail how fanatically he followed his own dictates of observing and documenting his subjects, nor how absolutely he phrased his aesthetic mandate to render nature in its entirety, "sans exclusion aucune."[64] But we do need to consider how to reconcile the drive toward totalization with the undermining methodology employed to fill in the spaces. The intolerable nature of a void manifest in shifting occurrences of holes, blanks, lacunae, and ellipses provokes darning or piecing or filling in: a conformation of sundry fragments, appropriations, and lies into a visibly recomposed and recycled tissue. We find, then, a curious meeting of two conflicting aesthetics: on the one hand, a striving toward wholeness, and on the other, a display of fictions that reveal their facture and expose fissures and discontinuities they do not close or splice.

Most obvious are the holes, tears, and breaks that are thematized in the narrative: Florent's unwritten book on Guiana and Claude's *oeuvre manquée* along with the gaps in Mlle Saget's notes, the tears in Florent's garments and gut, the composite police files, and the scrappy meals. But there are also chinks of a more discreet nature, narrative omissions that, like dropped stitches in a knit, interrupt a pattern or throw it off ever so slightly. Some of these are attributable to motivated tactical exclusions, while others, I argue, correspond to blind spots in Zola's writing that may reflect larger cultural lapses. Both belong to complex networks of meaning and take some time to tease out.

I turn first to a calculated elision on Zola's part; in such instances absence or displacement signifies and emphasizes.[65] A puzzling lacuna appears in Zola's

inventory of fish sold at the Pavillon de la Marée. In his scan of the display at the divided salt and freshwater stands tended respectively by Louise, la belle Normande, and her sister Claire, Zola delivers a sweeping list of the bounty of sea and river sold by these fishmongers, couching each creaturely class in elaborate visual detail covering its form, range of color, way of catching the light, meeting the nose, and evoking memories and fantasies. We know that he composed preparatory catalogues for each kind of fish and seafood (as well as other products) sold at Les Halles, including, for each, its appearance, varieties, and the season at which it would appear at the marketplace (698n1). While Zola's piscine inventory within the novel is surely not exhaustive, it is very long, spread over several pages (696–99). Significantly, it includes references to fish that play an anecdotal role in *Le Ventre,* like the brill (*barbue*) whose torn belly becomes a subject of dispute between la belle Normande and a customer (721), the spoiled skate that Florent orders removed from the counter (716–17), the eel (718–19) that Claire fearlessly displays in her clasped hand, or the allegedly rotten soles about which Lisa complains to la belle Normande (675). Excluded from the summary, however, are crabs, the marine creatures that feature unforgettably in the narrative. This exception is all the more striking against the background list well filled by other crustaceans, including pink shrimp, gray shrimp (*crevettes roses et grises*) crayfish (*écrevisse*), lobster (*homard*), and spiny lobster (*langouste*). Did Zola omit mention of crabs in his narrative catalogue because Florent's account of "the man devoured by crabs" in Guiana closes the preceding chapter, just pages earlier? Was he hesitant to overrun his reader with crustaceans? Did he have scruples about placing crabs on the market in the fall, which would for some species have been toward the end of their prime? Or might this be simply a question of emphasis, the crab occulted here to give it greater effect in the case that mattered more— the representation of crabs as feeders rather than food?[66] We cannot answer with certitude, but I submit that this may be a strategic blank in Zola's text.

During his first decade or so in Paris, which corresponded to the years when he was laying his foundations in art and literature, Zola frequented salons, galleries, museums.[67] He would surely have visited the Dutch and Flemish paintings held in the collections of the Louvre, which included, at the time he was gestating *Le Ventre de Paris,* a number of fish still lifes. Marie-Thérèse Barrett suggests that Zola would, in particular, have seen Adriaen van Ostade's *Le Marché aux poissons* and Frans Snyders's *Les Marchands de poissons* (Plate 25). It is Snyders's painting, Barrett notes, that might well have been "the most direct source of inspiration" for Zola's piscine displays, not only because of the abundance of species spilling forth, but, too, for its "richness of tone" that corresponds to Zola's verbal representations of marine life.[68] I agree that *Les Marchands de poissons* resonates suggestively with *Le Ventre,* but I find two compelling differences between the painted and written tableaux that are as weighty as their resemblances. Snyders significantly plants a very large crab at dead center of his canvas, with a second

crab slightly to the right. And he shows, through an aperture cut into the back of the stall on the upper left of the painting, the edge of a marine landscape, with the sea meeting the horizon beyond a bordering harbor. The Flemish painter accentuates in his composition the creatures that Zola so remarkably omits from the market and instead refracts to distant Guianese shores, and he also appropriately backgrounds his ocean bounty, implicitly linking it to its originating source. Zola, of course, could not logically plunk down a sea in the middle of Paris.[69] And yet, he cannot seem to keep it entirely away.

The first marine metaphors appear early on (twenty pages into the Pléiade edition of the novel), upon Florent's entry to the marketplace, where they attach to the unlikely subject of vegetables cresting in the sunlight: "C'était une mer. . . . Dans les deux carrefours, le flot grandissait encore, les légumes submergeaient les pavés" (626) (It was a sea. At the two intersections, the tide rose even more, the vegetables swept over the paving stones). The oceanic overflow of peelings and root stumps everywhere underfoot soon spreads to the roiling surround of the crowd: "Il s'arrêta, il s'abandonna aux poussées des uns, aux injures des autres; il ne fut plus qu'une chose battue, roulée, au fond de la mer montante" (632) (He stopped, he surrendered to the shoving of some, the insults of others; he was beaten down, became an object tossed into the rising sea).[70] Florent's increasing discomfort and mounting panic continue to be expressed by the implacable rising tide of vegetables, massing people, and laden wagons, all contributing to his sense of submersion in an unrelenting flood of stimulation: "La mer continuait à monter. Il l'avait sentie à ses chevilles, puis à son ventre; elle menaçait, à cette heure, de passer par-dessus sa tête" (633) (The sea continued to rise; he had felt it at his ankles, then at his belly; it threatened now to surge above his head). Later in the novel Florent's view of Paris from his garret overlook improbably turns the urban skyline into a marine landscape: "Cet immense développement des Halles . . . lui donnait, au milieu des rues étranglées de Paris, la vision vague d'un bord de mer, avec les eaux mortes et ardoisées d'une baie, à peine frissonnantes du roulement lointain de la houle" (713) (This immense expansion of Les Halles gave him, in the middle of the constricted streets of Paris, the vague vision of a seashore, the shore of a bay whose still, blue-gray waters were barely rippled by the far-off swell of the waves). Similarly, the isolation of the pavilion office where he takes refuge from the rumbling activity of Les Halles inspires dreams of "quelque grande mer, dont la nappe l'aurait entouré et isolé de toute part" (728) (a sheet of water from some great sea, surrounding him and isolating him from everything). While the market square may not have immediate marine resonances for readers, it appears to transport the increasingly insular Florent to the shores of his Île du Diable imprisonment by the phantasmatic echoing of the island in his isolation.[71]

Critics have variously interpreted the ocean surges in Paris as hallucinatory images implying the irreality of Florent's political dreams; as a sign of an

anomie-like dissolution of his being that acts as foil to Claude's aesthetic vision; as a transformation of oppressive materiality into a sublimated imaginary; as a return of Florent's repressed experiences (in other words, what we would today call post-traumatic stress); or, in the same vein, as a sign of his anxiety.[72] I would add to these very credible readings Zola's indefatigable vying with Balzac, for whom Paris figured as an ocean (most often, a muddy one).[73] We are not obligated to choose; in fact, the pervasive sea imagery in *Le Ventre* is multidetermined, and we have not come close to exhausting its sources. Without closing down the proliferation of glosses generated by the sea, I would like to focus here on its radical foreignness in the novel's urban context, and to suggest that the insistent apparition of the maritime remote is as germane to Zola and his cultural unconscious as it is to any of his characters.

When Florent begins his work at the Pavillon de la Marée, he is immediately transported back to the coast of Guiana by the touch and smell of the breeze wafting around the fish stand:

> Mais ce qui montait à la face de Florent, c'était un souffle frais, un vent de mer qu'il reconnaissait, amer et salé. Il se souvenait des côtes de la Guyane, des beaux temps de la traversée. Il lui semblait qu'une baie était là, quand l'eau se retire et que les algues fument au soleil; les roches mises à nu s'essuient, le gravier exhale une haleine forte de marée. Autour de lui, le poisson, d'une grande fraîcheur, avait un bon parfum, ce parfum un peu âpre et irritant qui déprave l'appétit. (698)

> [But what was rising in front of Florent was a puff of fresh air, a sea breeze he recognized, briny and brackish. He remembered the coasts of Guiana, the beautiful weather during the crossing. He sensed the presence of a bay, when the water is ebbing and the seaweed is steaming in the sun; the naked rocks dry off, and the gravel exhales a strong sea breath. All around him was the aroma of very fresh fish, a pungent aroma, the sort that is bracing and a bit harsh, distracting to the appetite.]

It is not clear if Florent is recalling the waters of his prison-ship crossing of the Atlantic from France to Devil's Island, or those of the Caribbean that he would have traversed on his perilous shorter flight by raft from the island to the coast of mainland Guiana, but in either case, it is perplexing to find him waxing nostalgic about his exile, having just heard the horrific detail of both these journeys described in his own voice. Florent's involuntary memories of the sea, along with his phantasmatic rehearsals of them, are here and on some other occasions linked to his Guianese incarceration, but also, to the more impersonal category of the remote and the foreign. Toward the end of the novel, a perception of pavilion roofs as gray seas is further abstracted to "distant lands": "Que de rêves il avait faits, à cette hauteur, les yeux perdus sur les toitures élargies des pavillons!

Le plus souvent, il les voyait comme des mers grises, qui lui parlaient de contrées lointaines" (867) (How many dreams he'd had, looking out from up high, his gaze lost over the wide roofing of the pavilions! Most of the time they looked to him like gray seas and spoke to him of far-off lands). The free indirect discursiveness of the contemplation situates it somewhere between Florent's voice and the anonymous narration, unleashing the sea from his proprietary domain. Paris's iconic marketplace is linked to the stormy ocean of Florent's deportation, but also to less specific alien shores—in fact, I propose, to the shores of conceptual alienation.

If Florent, as I earlier argued, bears a heavy air of estrangement upon his re-entry into Paris, a whiff of the foreign that will relentlessly inhibit his social reintegration, the sea, which often shares these significations of otherness, is nonetheless a more ambiguous element. It is, like its ports and shorelines, both an enclosing limit for the land it touches and an opening onto what lies beyond. As John Zarobell has argued in reference to an earlier period in his discussion of Joseph Vernet's (mid-eighteenth-century) *Ports of France* paintings, seaports may have "signified France's boundaries [but] they also symbolized its connection to the outside world through maritime trade."[74] The nation's increasing reliance on its colonies for agricultural goods and for a less material but very critical aura of empire in the nineteenth century only amplified the equivocal relationship of the metropole with its bounding seas and expansive overseas. While the colony in French Guiana is not always explicitly attached to marine intrusions into this novel, it sometimes is, as my examples have shown, and most often is at least implied by them. However, the "colony" named or alluded to in *Le Ventre* is a very reduced one: it is the penal colony established overseas to purge the Hexagon of its ordinary criminals and its political dissidents.

While a fully fledged account of so-called French Guiana is both fascinating and horrifying (the second, from the perspective of the unholy trinity that Raoul Peck dubs "civilization, colonization, and extermination"), it is long and complex.[75] I offer instead a bare-bones outline. The only French colony in South America (but bordering on the Caribbean) was also France's first colony. It was established at Cayenne under the ancien régime in 1664, and though other settlements followed (notably at Kourou and Saint-Georges du Maroni), the original name stuck and is often still used for the entire French Guianese area of conquest. The use of Guiana as a penal colony was linked, according to Charles Forsdick, with the postrevolutionary expansionist project (associated with the 1830 invasion of Algeria); the choice of Guiana as carceral site was motivated by its very resistance to colonization, due to disease and difficult topographic and climatologic conditions. But as an alternative to metropolitan hard labor camps, it offered the double advantage of distance and spaciousness.[76] If Guiana was sometimes used as a place of deportation for counterrevolutionaries in the 1790s, it was only instituted formally as a *bagne* in 1852, and simultaneously was a

HARLEQUINO.

(1570)

Imp. F. Chardin, rue. 5o. r. Hautefeuille. Paris

Plates 22–24 show Maurice Sand's drawings of Harlequin costuming over three centuries. Although the exact historical dating of his three Harlequin plates has been questioned by commentators, these drawings nonetheless depict, quite vibrantly, the costume's evolution.

PLATE 22 *Harlequino (1570),* from Maurice Sand, *Masques et bouffons (Comédie Italienne).* Texte et dessins par Maurice Sand, Gravures par A. Manceau, Préface par George Sand, 2 vols. (Paris: Michel Lévy, 1860), vol. 1. Bibliothèque nationale de France.

PLATE 23 *Arlechino (1671),* from Maurice Sand, *Masques et bouffons (Comédie Italienne).*
Texte et dessins par Maurice Sand, Gravures par A. Manceau, Préface par George Sand,
2 vols. (Paris: Michel Lévy, 1860), vol. 1. Bibliothèque nationale de France.

PLATE 24 *Arlequin (1858),* from Maurice Sand, *Masques et bouffons (Comédie Italienne).* Texte et dessins par Maurice Sand, Gravures par A. Manceau, Préface par George Sand, 2 vols. (Paris: Michel Lévy, 1860), vol. 1. Bibliothèque nationale de France.

PLATE 25 Frans Snyders, *Marchands de poissons à leur étal* [*Fish Merchants in Their Stall*], circa 1600–1625. Oil on canvas, 82.7 × 134.6 inches. Photograph copyright RMN–Grand Palais (Musée du Louvre) / Art Resource, New York.

PLATE 26 Camille Pissarro, *Le Jardinier—Vieux Paysan au chou* [*The Gardener—Old Peasant with Cabbage*], 1883–95. Oil on canvas, 32 1/16 × 25 9/16 inches. Collection of Mr. and Mrs. Paul Mellon / National Gallery of Art, Washington, D.C.

PLATE 27 Several years after Lisa's viewing of the harlequinesque Morris columns in the distance, Jean Béreaud painted a series of such columns up close. Jean Béraud, *La Colonne Morris* [*Paris Kiosk*], 1880–84. Oil on canvas, 14 × 10 7/16 inches. The Walters Art Museum, Baltimore. Acquired by Henry Walters, 1901.

PLATE 28 A poster-covered wall and its pedestrian viewers, juxtaposed with a pot-mender: the pedestrian street scene that was known as a "street museum" or a "gallery for the poor." Louis Robert Carrier-Belleuse, *L'Étameur* [*Mending the Pots*], 1882. Oil on canvas, 25.5 × 38.5 inches. Private collection. Bridgeman Images.

PLATE 29 Jules Chéret, *Pantomime (La Pantomime),* 1891. Color lithograph on paper, 47 3/8 × 32 3/8 inches. Courtesy Clark Art Institute, clarkart.edu.

PLATE 30 Jules Chéret, *Folies-Bergère, Les Girard,* 1877. Color lithograph on paper. Imprimerie Chéret, Paris, 22 × 17.2 inches. Bibliothèque nationale de France.

PLATE 31 Henri de Toulouse-Lautrec, *Confetti,* 1894. Color lithograph. Imprimerie Bella & de Malherbe, London and Paris, 22 7/16 x 17 5/16 inches. Metropolitan Museum of Art, New York. Gift of Chester Dale, 1963.

PLATE 32 Alphonse Mucha, *Cycles Perfecta,* 1902. Offset color lithograph, Imprimerie F. Champenois, 59 × 41 inches. Bibliothèque nationale de France.

PLATE 33 Pablo Picasso, *Les Saltimbanques* [*Family of Saltimbanques*], 1905. Oil on canvas, 83 3/4 × 90 3/8 inches. Chester Dale Collection / National Gallery of Art. Copyright 2012 Estate of Pablo Picasso / Artists Rights Society (ARS), New York.

PLATE 34 Pablo Picasso, *Au Lapin Agile* [*At the Lapin Agile*], 1905. Oil on canvas, 39 × 39 1/2 inches. The Walter H. and Leonore Annenberg Collection, Gift of Walter H. and Leonore Annenberg, 1992. Bequest of Walter H. Annenberg, 2002, Metropolitan Museum of Art. Copyright 2022 Estate of Pablo Picasso / Artists Rights Society (ARS), New York. Image source: Art Resource, NY.

PLATE 35 Pablo Picasso, *La Mort d'Arlequin* [*The Death of Harlequin*], 1905. Gouache over charcoal on cardboard, 26 15/16 × 37 11/16 inches. Collection of Mr. and Mrs. Paul Mellon/ National Gallery of Art, Washington, D.C. Copyright 2022 Estate of Pablo Picasso / Artists Rights Society (ARS), New York.

PLATE 36 Pablo Picasso, *Arlequin* [*Harlequin Leaning on His Elbow*], 1909. Oil on canvas, 28 1/4 × 23 5/8 inches. Private collection. Photograph courtesy of Sotheby's, Inc. copyright 2008. Copyright 2022 Estate of Pablo Picasso / Artists Rights Society (ARS), New York.

PLATE 37 Raymond Mason, *Le Départ des fruits et légumes du coeur de Paris le 28 février 1969* [*The Departure of Fruits and Vegetables from the Heart of Paris, 28 February 1969*], 1969–71. Epoxy resin and acrylic sculpture, 121 × 124 1/2 inches. Paris, Église Saint-Eustache, Chapelle des Pélerins d'Emmaüs. PjrTravel / Alamy Stock Photo. Copyright 2022 Artists Rights Society (ARS), New York / ADAGP, Paris.

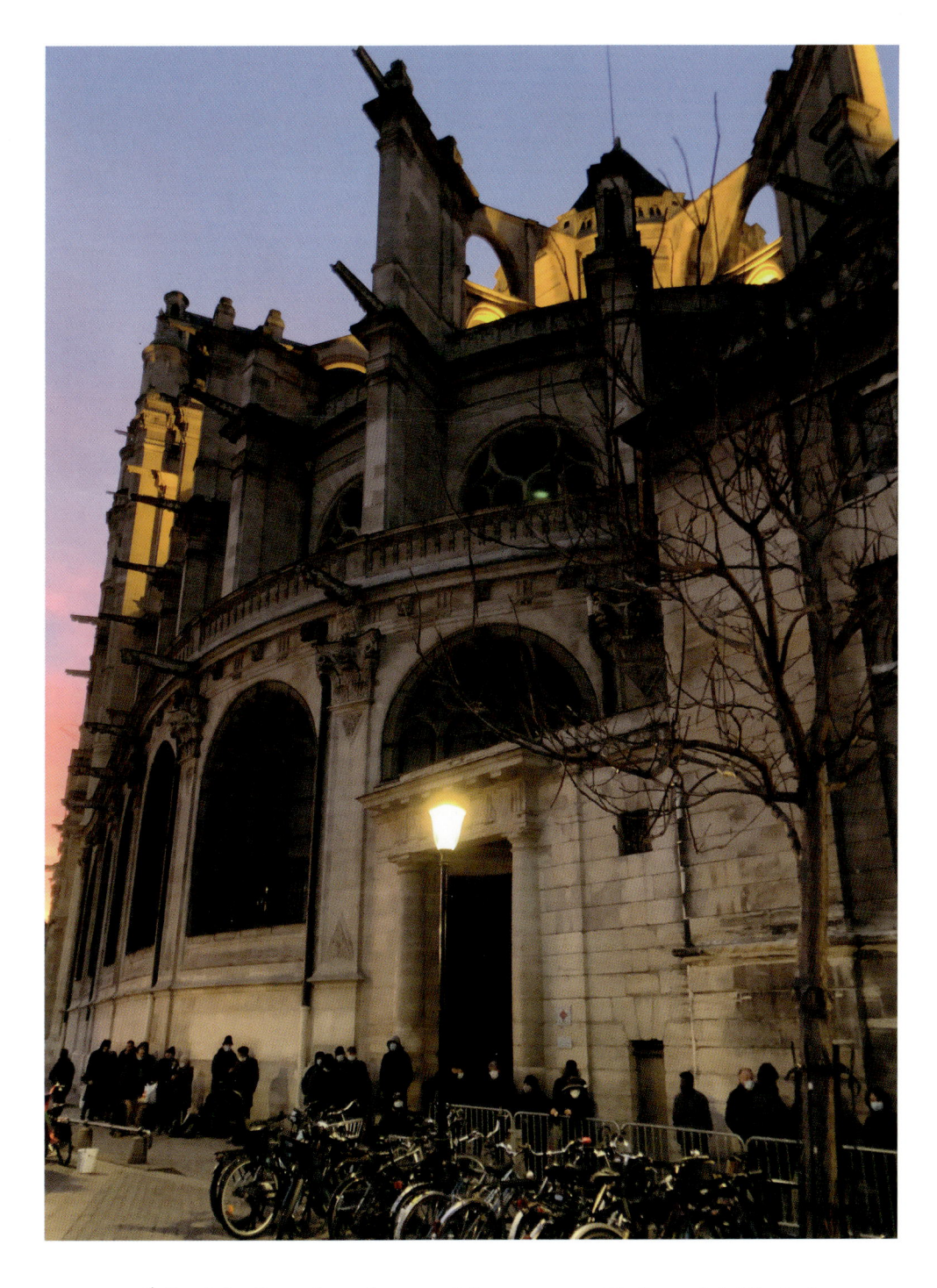

PLATE 38 Église Saint-Eustache and queue of dinner guests at La Soupe Saint-Eustache, March 17, 2022. Author's photograph.

PLATE 39 Servers filling soup bowls at La Soupe Saint-Eustache, January 12, 2017.
Author's photograph.

dumping ground for political opponents of Louis-Napoléon Bonaparte. So harsh were the conditions in France's South American rainforest colony that it was referred to as *la guillotine sèche*—a site of bloodless execution. By 1864, the death toll was recognized as so high that only prisoners from other French colonies were sent there (in addition to political dissidents and recidivists). Only in 1938 was deportation to French Guiana abolished; the process of repatriating prisoners dragged on until 1953. In 1946 Guiana became a *Département d'outre-mer*. In 1964 France chose Guiana as the site of its space center, to be set on the coast at Kourou.

French Guiana was what Miranda Spieler calls a "late-arriving" slave colony.[77] There were not many plantations before the late eighteenth century, partly because the rampant forests provided the enslaved population with ample opportunity for escape and refuge. Even after the first emancipation, however, French Guiana managed to furnish its plantations with a labor force by hijacking Africans on board slave ships—although far from liberating them, they appropriated and enslaved them.[78] In 1848, with the second abolition of slavery, the plantation system definitively began to wither, although immigrant laborers (from South Asia, Africa, China) were harnessed in the place of the formerly enslaved. In the 1860s, the forests were populated by Maroons and Amerindians who had been forced to move inland from the coasts.[79] The plantations, the cash crops, the newly freed African population, the Maroon communities, the indentured laborers, the Indigenous peoples—all these are erased from Zola's overseas story. Erased, but not obliterated, for traces of this spectral colonial world resurface erratically in Zola's novel, like pentimenti barely visible rising willfully from the underlayers of paint. Kept at a distance but also in strange proximity, the larger colonial Guiana cannot be kept out of Paris any more than can the ocean that at least theoretically allows the distant land to be out of view.

—— BELLY OF DARKNESS

Florent's narrative of suffering in the penal colony serves Lisa well as a cautionary tale for her daughter: "Lisa . . . profita de la circonstance pour lui faire la morale; elle la frappa beaucoup, en lui disant qu'on mettait aussi dans le bateau les enfants qui n'étaient pas sages" (686) (Lisa took advantage of the situation to give her a morality lesson; she spanked her a lot, and told her that naughty children were also shipped out). Marking off her brother-in-law as an outlaw, and French Guiana as out of bounds, she packages them together as off limits both morally and geographically. Figuring Florent as a bogeyman and Guiana as a bogeyland, Lisa prophetically justifies Léon-Gontran Damas's cynical remarks of sixty-five years later about the continued troping of the Guiana colony as a penal colony by upstanding inhabitants of the Hexagon: "Toi, dira une mère qui souffre de trouver en son fils l'âme d'un dévoyé, tu finiras tes jours à Cayenne" ("You," says a mother, distressed to see her son go astray, "you will end your days in Cayenne").[80]

For Zola, "Cayenne" stands in tension with Les Halles; it is a space to be kept rigorously out of the city, but also tethered so that it hovers nearby. The meaning of his marketplace core, his belly of Paris, his City of Light, depends on the counterpoised weight of the eclipsed Guiana belly, heavy with what it holds and holds back: the depths of the shadowed, lush rainforest teeming with menacing predators, the gnawing contractions of the prisoners' empty bowels, the raging seas, the unspeakable alterity of the nation's colonized others. They are all vividly figured by the gutted abdomen of the dead man swarming with crabs, splayed on a distant strand displaced and dispersed in the steam rising from the blood-filled intestines simmering on the Quenu stove. This abjected belly in whose depths the empire projects its own hauntings, darkly, is contrapuntally present in the throbbing motor force of the novel, which emanates from Les Halles like the pulse of a colossal digestive system: "comme un grand organe central battant furieusement, jetant le sang de la vie dans toutes les veines" (631) (like a massive, furiously beating vital organ, driving lifeblood through all the veins). If this belly can be heard beating ubiquitously like the fallen heart of the city, and can be seen, transposed like a kitschy emblem all over the novel, its occulted Guianese counterpart is also faintly thudding everywhere—but clearly audible rarely.[81] Let us listen in.

DRUMBEATS

The dark overseas territory that ebbs back to Paris in the persistent form of gray inland seas also leaves, like a watermark, more diaphanous traces. The clamor of gossiping voices reverberating within the iron structures of the market pavilions is rendered as *un frisson sonore de tam-tam* (663) (the throbbing sound of the tam-tam). A variety of drum indigenous to West Africa, the tam-tam became part of the African diaspora in the Caribbean as well. It traveled to French Guiana with the enslaved, though it lost its original name and sociocultural specificity there with the passage of time.[82] The word did not enter the dictionary in France in the sense of the West African drum (earlier entries have it referring to an Asian gong) until the late nineteenth century. But the print record shows that it circulated widely in France in reference to this instrument, its traditions, and its usage in the African or African diasporic colonies, from at least the late eighteenth century forward. We find *le tam-tam* in travel narratives, early ethnographies, assorted newspaper articles, and the text of dictionary entries (under other headings), most often in the explicit or implied context of the barbaric behavior of the "savages" who played it. By the time Zola was writing these passages, then, the tam-tam had not only entered the French language but was becoming a cultural archetype as well, part of a broader discourse on race, empire, and civilization.[83]

The allusion to drumming resounds later in the description of a barroom, site of Florent's political strategizing meetings. When the voices of the conspirators rise in disagreement, the frosted panes of the glass-paneled room vibrate like

drum skins ("les vitres dépolies vibraient comme des peaux de tambour" [749]). Although no place is explicitly indicated except the small corner of Paris where Lebigre's café-bar is located, the metaphoric thrum evokes a foreign space. The voice of the people pitched in gossip or in dissent is represented by a drumbeat, pulsating, vibrating, echoing. That the type of drum is specified in the first case as one belonging to "primitive" populations who never enter this novel directly, and that the pulsations, in both cases, are mediated by the omnipresent working-class population, once again put these two subjugated groups into conversation.

In the early 1870s, the diverse cultures of the colonies and their Indigenous or imported populations would have been unavailable to most Parisians by direct contact, but they surfaced in the media and at the Expositions Universelles.[84] This trace, I suggest, resembles the memory space Patrick Chamoiseau names "Trace-mémoires" and describes as "un espace oublié par l'Histoire . . . [qui] n'est envisageable ni par un monument, ni par des stèles, ni par des statues, ni par le document-culte de nos anciens historiens. *La Trace-mémoires est un frisson de vie* alors que le monument est une cristallisation morte" (a space forgotten by history that can be contemplated neither through a monument, nor through steles, nor statues, nor through the document-cult of our ancient historians. *A memory trace is a life-throb* while a monument is a dead crystallization).[85] Zola's metaphor, *un frisson sonore de tam-tam,* strikingly prefigures Chamoiseau's explanation of the *Trace-mémoires* as *frisson.* I am not suggesting that the resonance is motivated by more than a fortuitous (and ironic) overlap. However, the coincidence is significant in the sense that both writers invoke the *frisson* to describe an impression that is fleeting, discontinuous, and echoing. By attaching it to the tam-tam, but detaching it from a place, Zola composes a figure that simultaneously brackets and calls up the French overseas colonies. In so doing, he instills in his narrative a faint trace, perhaps unwitting, of a world that was largely outside his ken but that could not help but infiltrate his Paris cosmos and text, if almost imperceptibly. This other world is suspended in his writing and his consciousness. We feel its vibrations, however, in a rumbling that I believe is akin to what Rancière has described as "un mouvement perpétuel d'une infinité d'atomes qui s'assemblent, se séparent ou s'assemblent à nouveau au sein d'une vibration perpétuelle" (the perpetual motion of an infinity of atoms that are assembling, separating, or reassembling in a perpetual vibration).[86] The various appearances—or might we better say apparitions—of a Guiana beyond the penal colony in Zola's novel are, like the tam-tam, throbbing traces of an almost-recognition that does not ever take on material form there. Let us hover over a few more of these.

CHARCOAL

When Lisa's daughter Pauline is apprehended by Mlle Saget in mid-escapade with Muche and led home dirty and muddied from burrowing in the plant beds, she is treated like an untouchable by her mother, "[qui] ne savait pas par quel

bout prendre sa fille" (who didn't know where to grab her daughter). Lisa is especially repulsed by the blackened skin of Pauline: "les mains et la figure noircies la dégoûtaient" (821) ([Pauline's] blackened hands and face disgusted her). Before Lisa has set eyes on her sullied daughter and branded her as trash (ordure), however, Zola has equated the child's begrimed body with the skin of a charcoal burner, "toute barbouillée . . . avec ses bras de charbonnier" (817) (dirty head to foot, with a charcoal burner's arms). Much like the figure of the chimney sweep (le ramoneur), that of le charbonnier was stigmatized as filthy, marginal, and savage in nineteenth-century France. In fact, the two figures were sometimes confused, doubtless because of their constant contact with charcoal or coal, their sooty appearance, and their lowly socioeconomic status.[87] I proceed on the assumption that the conflation is testimony to their relative interchangeability in the popular imaginary of the period.[88]

The parallels were many. Le ramoneur, usually a child for reasons of size and accessibility, was most often of Savoyard origin, displaced due to the extreme poverty and population density of the mountainous region. Savoie was annexed to France only in 1860, and its people were perceived as backward, uncivilized peasants. Le charbonnier tended to be Bergamasque (and sometimes Piedmontese).[89] As was the case in Savoie, men from the poor, densely peopled Bergamo area would seek seasonal work (and increasingly, emigrated) over the border in the Alps of Haute Provence, whose forested terrain was familiar, as was the local dialect. From 1860 on, the work of the charbonnier was performed largely by Bergamasque peasants: migrants or seasonal laborers accustomed to work with wood. The job of overseeing the combustion of lumber, often described as "hellish" and "the devil's work," involved managing and being exposed to the arcane forces of nature: fire, wind, and water. It was dangerous labor that required living largely outside of society in the forest. Seclusion slides into ostracism; these people, seen as uncouth foreigners, different in kind as well as in occupation, were social pariahs. Their Bergamasque origin did not help. As we know from the history of the Bergamo-born Harlequin in the Commedia, this mountainous region, which was not far from Savoie and was in many ways its imaginary equivalent, was represented as a backwater of civilization whose primitive people were brutish, stupid, and dark-complected—this last, well before they were associated with charcoal burning in France.

The overdetermined blackness of the stereotypically Bergamasque char-bonnier (and similarly, the Savoyard ramoneur) has marked racial and racist implications, especially as it joins with nineteenth-century French colonialist subtexts seeking to justify imperialism and enslavement on the grounds of pseudoscientific hierarchies that placed blacks closer to animals than to white humans.[90] Descriptions of the charbonnier have him living in nature side by side with wild beasts. Pierre Magnan's early twentieth-century portrait renders this figure by gigantic stature and a black face split by gleaming white teeth: "Le

colosse se redressa. . . . Dans sa figure noircie, ses dents blanches brillèrent pour un sourire de joie"[91] (The colossus drew himself up. His white teeth gleamed in a joyful smile spread across his blackened face). This trope of an exaggerated wide smile and flashing white teeth contrasting with a black-painted face, all too familiar from blackface, cartoon drawings, and verbal description, is one of many that caricature the African. It is often further linked to suggestions of aggression and sexual predation.

It is no accident that Mlle Saget hints at violence and rape when she marches the blackened Pauline home, suggesting that Lisa inspect her daughter for signs of an evil that might have been visited upon her by the scruffy urchin who has led her astray: "A votre place, je la regarderais. Il est capable de tout" (821) ("If I were you, I would look her over. He is capable of anything"). Pauline's "bras de charbonnier" are a powerful signifier that spreads also to Muche, that aggressive *gamin de Paris* who is responsible for her darkened face and arms, her rent garments, and filthy clothing. The blackness of Lisa's child is, of course, heightened by the unremitting presentation of the mother and the mother's space as pale and bleached to the point of transparency: "La blancheur de son tablier et de ses manches continuait la blancheur des plats, jusqu'à son cou gras, à ses joues rosées, où ravivaient les tons tendres des jambons et les pâleurs des graisses transparentes" (667) (The whiteness of her apron and her sleeves echoed the whiteness of the dishes, continuing up to her plump neck and her rosy cheeks, which renewed the soft tones of the hams and the paleness of the transparent fat). That no effort is spared to maintain the empire of whiteness that Lisa embodies suggests that though there may be no blacks in Zola's Paris, nor, even less plausibly, in his French Guianese intrusions there, tremblings of blackness are felt throughout.

ANNATTO

In the cellar of the butter pavilion, we find the *marchande de beurre,* Mme Lecoeur, with her bare arms plunged to the elbows in a mountain of fat. She is kneading different mounds of sundry origin together, like a winemaker seeking to minimize the mediocrities and flaws of certain varietals. In the case of this particular *caviste,* some of the varietals are not merely substandard but blatantly rancid, and her well-pounded amalgam is chalky white, perhaps because she has processed the spoiled butter with lime chloride, a bleaching powder prescribed as a remedy.[92] She has at hand on her table a small pot of red dye, which, the narrator explains, will give the mass of butter "a nice yellow color" (826). There is no secret recipe for the dye, Zola says, miming Du Camp, even though the vendors believe it is their sacred province of knowledge; it is a simple product of *le raucourt,* the seed of the annatto tree, *le roucouyer*—though it is true that they sometimes substitute a dye made from carrots and marigolds. In fact, we wonder if the frugal Mme Lecoeur may have substituted one of the second-rate colorants,

or if she simply skimped on the annatto dye, for la Sarriette, her niece and a former butter seller, mutters skeptically when she peers into the crock of dye: "Il est trop pâle, votre raucourt" (826) ("Your annatto is too pale").

Yet annatto was not a particularly rare ingredient at this point in late nineteenth-century Paris. It was plentiful at the time Zola was writing *Le Ventre,* imported mainly from the French Caribbean–area colonies of Guiana and Guadeloupe—but primarily Guiana. Since Guadeloupean annatto was more bitter, the Guianese source was preferred in the Hexagon, especially for culinary uses.[93] (In France, it was used to dye silk as well as to color cheese and butter—and also margarine, after its advent in 1869.) It was only after 1880 that the cultivation of this spice in Guiana dramatically declined.[94] The history of annatto predated the French presence in Guiana by far. The plant was native to the Amazonian rainforest, from which it made its way to warm regions around the globe with the Spanish over the course of the seventeenth century. Its path through history is glossed by its linguistic translations. Annatto is known in French alternatively as *le raucourt, le rocou,* or *le roucou*—all of which are deformations of the Portuguese *urucú,* which was taken from the Indigenous Tupi language name for the spice, which means "red." Its Latin botanical classification, *Bixa orellana,* combines the word for the plant in the aboriginal Taino language, *bixa,* with the modifier taken from the name of the sixteenth-century explorer and conquistador Francisco de Orellana, who claimed much of the Amazon region for Spain. One might say that the broad lines of world history are contained in this microcosmic botanical pod, summed up in the double name that tacitly acknowledges a pattern of Indigenous origination and foreign annexation.[95]

Zola's silence about sourcing the seed the vendors use to prepare their blended butter for sale might be attributable to oversight or ignorance, or even to a decision to streamline his narrative—though sleek expositions are not his wont, and his food scenes, as we have seen, are barded with minutely researched information. The fact remains that Zola's detailed excursus into the use of annatto in butter blending skirts the question of this colorant's provenance, even though Eugène Sue, one of the principal referents for the Guiana passages of *Le Ventre,* describes the chief of a local tribe painted red, head to toe, with an annatto-derived dye in his 1840 novel set in Dutch and French Guiana.[96] If, however, the rhetoric chosen by Zola's biographer to describe the writer's fieldwork among the workers of Les Halles is given serious credence, perhaps one might consider these local people to take the place, in his scrutiny, of the unmentioned overseas colonized. Zola, recounts Mitterand, "s'est posté au coeur des Halles centrales comme au milieu d'une île inconnue, entouré de tribus dont il lui fallait reconnaître les moeurs, les clans, les commerces, les modes de vie, les manières, au sens ethnographique du terme" (posted himself in the heart of Les Halles as if in the middle of an unknown island, surrounded by tribes whose customs, clans, trading practices, lifestyles, manners—in the ethnographic sense of the word—he

needed to identify).[97] Zola's attention is drawn to what has been called the domestically or the internally colonized, to the obvious neglect of populations overseas. Yet it is worth pondering the imbricated histories of both groups, as Ann Laura Stoler does in her correlation of the French urban poor with the subjugated people in the empire's vast colonial holdings.[98]

PLANTATIONS

Although the structure of first enslaved and later indentured or requisitioned labor upon which the settler colonization of French Guiana depended is completely evacuated from the novel, the shadow of the plantation system falls upon it nonetheless. Florent's account of his trek across the Guianas mentions no workers of any sort, neither formerly enslaved individuals, nor Maroons, nor indentured laborers, but, as we observed earlier, it alludes to an armed man, presumably a European landowner, who emerges from *une habitation* (a plantation) to throw a handout from afar to our starving storyteller (692). It is doubtful that Florent would not have sighted another human being in his travels across the territories of French and Dutch Guiana, from shoreline through rainforests, in the late 1850s. At this time, there were Indigenous (Amerindian) villages on the coastal shores, and nomadic Amerindian peoples in the forests; long-standing Maroon villages (which had become more heavily populated by freed Africans following abolition in 1848) studded the interior, especially in the Western part of the country along the Maroni River. Florent, in his flight from prison, would of course have avoided the more heavily inhabited areas, but though the forests were vast and thick (and for this reason had traditionally provided cover for both Indigenous inhabitants and Africans fleeing enslavement), the chances of crossing no one were small.[99]

France's South American colony is significant to Zola's novel for its contained penal colony; its draconian carceral system and remote geographical situation serve as dramatic ballast to his complacent Paris eaters, a way to impress upon readers the depths of metropolitan savagery and predation by analogy with the exotic examples of distant rainforest jungles.[100] But he prefers to confine realist detail to the Paris spaces, passing over the derivation of the dye, the seeds, and the tree he names in passing in his detailed exposition of butter production, evoking the land and its people only by the echo of an Amerindian language retained in the name of a spice, and the muffled sound of a distant drum. To connect the red seed to its French Guianese origins, to explore its place of cultivation, the system that produced it, the displacement of the Indigenous people who first named and used it, would mean engaging with a story of plantations and indentured migrant labor, a history of enslavement, of covert Maroon villages of formerly enslaved escapees, and a dying population of First Peoples decimated by European diseases. And that part of empire would be beside the point of Zola's Second Empire novel.

In Florent's embedded Guiana-based story, the territory is reduced to its island *bagne,* whose escape routes are confined to churning oceans and wild, uninhabited forests. In a way, then, Zola becomes, over the course of the novel, a little like Lisa, denying Cayenne the greater part of its inconvenient truths. As such, it is inscribed in his novel in the negative image of food-ridden Paris, where it is exploited as a disciplinary measure to instill petit-bourgeois respectability in well-scrubbed, blanched children nurtured by oral histories of insinuated cannibalism, and rocked to sleep on fairy tales of starvation and brutality in the wilderness.

PART II. STREET ART

When we return to the novel's restless cast of street people, we find among them a character whom I have neglected until now for his idiosyncratic relationship to food. Though Claude Lantier is an outlier in the category of vagabond eaters of Les Halles, he is a critical hinge between food and art. Like the other itinerants, he wanders the marketplace, ogles the produce, fixates on provisions displayed in the market stalls. But Claude's obsession with the fungible lusciousness of cauliflowers, eels, hams, table scraps, and their scavengers is famously unhitched from any desire for consumption. As is clear to the newly arrived and famished Florent watching Claude react to his edible surroundings, "[il] ne songeait même pas que ces belles choses se mangeaient" (623) (he didn't even imagine that these beautiful things were edible). Instead, his eyes are afire with painting perspectives and lit by attention to color, light, form, and change. It is less that he is given to asceticism than that his brand of gourmandise is aesthetic: "Claude . . . racontait son grand amour pour ce débordement de nourriture . . . rêvant des natures mortes colossales, des tableaux extraordinaires" (623) (Claude related his great love for this outpouring of food . . . dreaming of colossal still lifes, of extraordinary paintings).

Parting ways with the street feeders he otherwise follows with fascination, Claude pauses to notice (and share) details about them and their edible surround. He tarries, and as he does so, he breaks the flow of the narrative, if we conceive this as a dynamic, forward course in time. In the process, however, he functions as Zola's mouthpiece and his lens (albeit in a trompe l'oeil sort of way, because the aesthetic observations and pronouncements originally attributed to Claude quickly overflow his containing perspective and voice and are generalized to the narrative fabric).[101] But it is Claude, as resident artist of *Le Ventre* and its Halles, who opens the door to Zola's aesthetic theory: his professional inscriptions of a certain Paris and its parade of largely uneaten comestibles give coherence and verisimilitude to a pervasive discourse on modern art, its principles, and its viewing—one that might otherwise seem gratuitous to the plot. Paradoxically, they also explode each marketplace tableau into a shower of meteoric details that generate microcosmic spheres of infinitesimal activity.

In the beginning, there were vegetable patches. I am not, however, speaking of garden plots, but of those contrasting, brilliantly colored splashes of market produce interspersed with bright dabs of workers' garments presented to the reader in the novel's overture. The market, we recall, opens with a riot of vegetal colors compared to blossoms, "cette floraison," with Florent among them nominally constituting yet another flowering, entering the novel first as an aesthetic element, "une masse noire," a dark scrap tempering the multihued patchwork well before his emergence as a character (603–4). The emphasis on color and light, on the ricocheting illuminations that come to count more than the objects that mediate the play of flash, flicker, and fade, takes root there, in the patches that are bursts of matter catching the light in different variations: "Un bec de gaz, au sortir d'une nappe d'ombre, éclairait les clous d'un soulier, la manche bleue d'une blouse, le bout d'une casquette, entrevus dans cette floraison énorme des bouquets rouges des carottes, des bouquets blancs des navets, des verdures débordantes des pois et des choux" (603) (A gas lamp emerging from the shadows illuminated the nails of a shoe, the blue sleeve of a smock, or the edge of a cap, peeking out from among this enormous blossoming with its bouquets of red carrots, white turnips, and green bursts of peas and cabbages). The splotches of passing color streak the page and are then returned to their founding light: "[Florent] regardait . . . les deux lignes interminables des becs de gaz qui se rapprochaient et se confondaient, tout là-haut, dans un pullulement d'autres lumières. À l'horizon, une grande fumée blanche flottait, mettait Paris dormant dans la buée lumineuse de toutes ces flammes" (605) (Florent looked far ahead at the two endless lines of gas lamps that came together and merged in a profusion of other lights. A large white cloud floating on the horizon shrouded the slumbering city in a luminous mist of blazing light).

In his art criticism of the 1860s and early '70s, Zola also turns regularly to a vocabulary of color and light patches to explain the vision and strategies of contemporary painters who were breaking away from received modes. Speaking about Manet, whose work he championed fiercely at a time when the establishment was scandalized by it, he writes: "Il s'est mis courageusement en face d'un sujet, il a vu ce sujet par larges taches, par oppositions vigoureuses, et il a peint chaque chose telle qu'il la voyait" (He placed himself bravely in front of a subject, he visualized this subject in large patches, in strong oppositions, and he painted each thing as he saw it).[102] Sometimes he refers to these "taches"—patches, swatches, dabs, or spots of color—by other terms, such as "plaques," or "masses," or "larges teintes," but across all of these cases, it is clear that he is enthusiastically touting a radically new kind of painting that works by juxtaposing blocks of color. Zola's frustration with detractors who mock a lack of definition in the work of Manet and other new painters is evident in his emphatic rerouting of the observer's eye from the perception of objects and outlines to that of luminescent, contrasting hues:

L'artiste, placé en face d'un sujet quelconque, se laisse guider par ses yeux qui aperçoivent ce sujet en larges teintes. . . . Une tête posée contre un mur, n'est plus qu'une tache plus ou moins blanche sur un fond plus ou moins gris; et le vêtement juxtaposé à la figure devient par exemple une tache plus ou moins bleue mis à côté de la tache plus ou moins blanche. . . . Toute la personnalité de l'artiste consiste dans la manière dont son oeil est organisé: il voit blond, et il voit par masses.[103]

[The artist, set before any subject, lets himself be guided by his eyes which perceive this subject in tonal swatches. A head posed against a wall becomes a whitish patch against a grayish background, and a piece of clothing juxtaposed with the face becomes, for example, a blueish patch beside the whitish one. The personality of the artist consists in the way his eye is organized: he sees how things are lit, and he sees things as masses.]

These are a few examples of Zola's many descriptions of the artistic vision and technique he found exciting and expressive of their moment in time. This practice would come to be nicknamed "the school of the *tache*" by the mid 1870s, by which time Manet and the Impressionists were commonly called "devotees of the *tache*," but these terms were not yet in general circulation at the time Zola was writing these early art pieces, as well as *Le Ventre*.[104] He used the rubric *art moderne*, or simply *le moderne* to refer to a style of painting—and more broadly, of perceiving the subject—in patches, in both this novel and in his art criticism.

For the novelist, "the modern" had a lot to do with apprehending and reproducing the world in illuminated dabs of contrasting color, but it involved other elements as well; elements that were equally iconoclastic and that threatened established aesthetic canons. The notion of *taches* is closely related to, if not quite the same as, that of *bariolage*, the term favored by Zola and his contemporaries to describe color in motion, the kaleidoscopic play of light that was often identified as the epitome of everyday life that modern art sought to capture.[105] Zola uses the word together with *taches* in the early vegetable scene to render the contrast of carrots and turnips: "les notes aiguës, ce qui chantait plus haut, c'étaient toujours les taches vives des carottes, les taches pures des navets, semées en quantité prodigieuse le long du marché, l'éclairant du *bariolage* de leurs deux couleurs" (627; my emphasis) (the highest, most piercing notes were always the bright patches of carrots and the untainted patches of turnips, scattered prodigiously along the market square, lighting it with the *mobile play* of their two colors). However, he conveys the same idea with a varying vocabulary both here and elsewhere in the novel. Combining the concept of *taches* with that of *bariolage*—but in other words—he represents the juxtaposed piles of various leafy vegetables with artichokes, beans, peas, celery, and leeks as well, in a manner that makes clear that variegations in green can create the same kind of radiant, mobile effect as might a multihued ensemble:

A mesure que l'incendie du matin montait en jets de flammes au fond de la rue Rambuteau, les légumes s'éveillaient davantage. . . . Les salades, les laitues, les scaroles, les chicorées, ouvertes et grasses encore de terreau, montraient leurs coeurs éclatants; les paquets d'épinards, les paquets d'oseille, les bouquets d'artichauts, les entassements de haricots et de pois, les empilements de romaines, liées d'un brin de paille, chantaient toute la gamme du vert, de la laque verte des cosses au gros vert des feuilles; gamme soutenue qui allait en se mourant, jusqu'aux panachures des pieds de céleris et des bottes de poireaux. (627)

[While the fiery morning rose in shooting flames at the end of rue Rambuteau, the vegetables awakened bit by bit. . . . Salad greens—lettuce, escarole, and chicory—still heavy with earth, opened to show their bursting hearts; the bundled spinach and sorrel, the artichoke bouquets, the piles of green beans and peas, the heaps of romaine tied with a wisp of straw, intoned the whole scale of green, from the green lacquered pods to the robust green leaves; an unbroken scale that faded into the variegated celery stalks and the bunched leeks.]

The word *panachures* in conjunction with the fiery dawning light ("l'incendie du matin [qui] montait en jets de flammes"), the glinting hearts of the lettuce heads ("les salades, les laitues, les scaroles, les chicorées . . . montraient leurs coeurs éclatants"), as well as the depiction of heaps of differently shaded greens translate the notion of a flickering verdant patchwork, with no need to repeat each time the single word that so efficiently evokes massing, changing, striking color. Zola conveys the visual impression of *bariolage* throughout *Le Ventre* by deploying a lexical network that includes not only frequent recourse to that term as well as to *panachure,* each often with enhancements, as in *"l'éclairant* du bariolage" (627; my emphasis). He also reinforces the sense of a vacillation of color with an alternative lexicon that indicates or connotes the iridescent, the shimmery, the opalescent, the prismatic: all that is visually metamorphic.[106]

The shifting, vivid colors that Zola, like the new artists he admired, puts into play are broadly contextualized by Laura Anne Kalba's work on contemporary color-related experiments with fireworks, garden mosaiculture, fashion, chemical dyes, photography, posters, and trade cards—all manifestations of new technologies of color in French visual and material culture. However, Zola more strikingly also transfers the concept of *bariolage* to other sensorial registers. He renders the radiant variation of daisies as *"ce tumulte* des panachures vives des marguerites" (622; my emphasis) (*the tumult* of the brightly variegated daisies), and once again (in the passage cited above) evokes the vibrant spectrum of greenness paraded by the vegetables as singing: "[les légumes] *chantaient* toute la gamme du vert" (627; my emphasis). Zola invokes other senses to deliver effects analogous to the visually discontinuous, fragmented, vibrant bursts of *bariolage.* The sounds of *grondement* (rumbling) and *bourdonnement* (buzzing or ringing)

intervene frequently in the narrative to relate the pulse of the market and of the modern city (662; 728), as well as their repercussions on individuals, who in turn suffer "les oreilles bourdonnantes" or "la tête bourdonnante" (632; 663) (ringing ears or a throbbing head). A pervasive *vacarme* (din) of chatter and marketing cries fills the air with staccato blasts of unregulated noise likened to yelps and squeaks ("glapissement," "jacasseries") rather than human speech (663). Individual voices go unheard because of an omnipresent "brouhaha" (629).[107] Similarly, eruptions of tactile sensation are frequently expressed by the verbs "grouiller" or "pulluler" (to swarm or to teem), or their substantives, which describe a wide range of beings and things that teem and bristle and swarm, from scoundrels to crabs, as in "un grouillement de vauriens," "un grouillement de crabes" (841; 689). The joys Gavard experiences when he moves into the buzzing, bustling neighborhood of Les Halles are named "chatouillantes" (titillating [literally, tickling]), and the market in motion is defined by "la cohue et [le] tapage de la vente" (the press and the din of commerce) and "ce tohu-bohu de paniers, de sacs de cuir, de corbeilles, toutes ces jupes filant dans le ruissellement des allées" (663; 728; 728) (the hubbub of hampers, leather bags, baskets, and all the skirts swishing down the damp alleys).[108] It would not be wrong to speak of synesthesia here where we find visual sparks and glints thrumming in other sensorial realms as well; nor would it be inappropriate to mention ekphrasis, the process by which the pen exploits the eye.[109] Both are collateral elements of Zola's process, but I do not think either is the point of what he is about in this novel.

In January 1872, at the time that his biographer Henri Mitterand judges he was planning *Le Ventre* (which would begin to appear in serial format exactly one year later),[110] Zola commented on the modern in art and in urban life and on their connection, in an article whose pretext is the painting of Johan Barthold Jongkind:

> J'aime d'amour les horizons de la grande cité. . . . Il y a là . . . tout un art moderne à créer. Les boulevards grouillent au soleil . . . la bande moirée de la Seine . . . est tachée du noir de suie des chalands; les carrefours dressent leurs hautes maisons, avec . . . la vie changeante des fenêtres. . . . Je sais certaines échappées, dans Paris, qui me touchent plus profondément que les grandes Alpes et les flots bleus de Naples. . . . À chaque trottoir un nouveau tableau se déroule. . . . On devine Paris bourdonnant. . . . Ces horizons [sont] chers à mes tendances vers un art tout moderne [. . . qui] pénètre dans la vie multiple des choses.[111]

> [I love the horizons of the big city. An entire body of modern art is there waiting to be created. The boulevards are swarming with people in the sun, the Seine's ribbon of watered silk is stained black with the soot of the barges; tall apartment buildings rise at the intersections, their windows revealing the flux of life. There are certain vistas in Paris that move me more deeply than the great Alps and the blue waves of

Naples. On each street a new tableau unfolds. One senses the throbbing life of Paris. These horizons are dear to my inclinations toward a brand-new art, a modern art that penetrates the multifarious life of things.]

The terms with which Zola describes the modern here in this art commentary are familiar to us as readers of *Le Ventre*: the patches, the moiré, the swarming, the buzzing, the metamorphic multiplicity of urban life ("la vie changeante des fênetres . . . la vie multiple des choses") that it is modern art's charge to capture. This and other passages in Zola's art criticism of the period preceding and roughly congruent with the writing of his marketplace novel closely approximate pronouncements on the painting of modern life in this novel, again, most often attributed to Claude Lantier. It does not necessarily follow, however, that *Le Ventre* is a novel that seeks to *paint* with *words*—that is, to prioritize that first medium and to make the second subservient to it, to task the novel with translating the visual arts. Rather, I believe that Zola means to consider the trenchancy and heft of the modern in its various sensorial registers, and to do this, of course, in his chosen medium: to do things with words that others might do with paint, or clay, or sound. Zola does not often mention Baudelaire in his writings on art, but the novelist's staging of modern life often seems to be echoing the poet's definition of the modern as "le transitoire, le fugitif, le contingent" (the transitory, the fugitive, the contingent), and appears to be shadowing his comparison of the observer-artist to "un kaléidoscope doué de conscience, qui, à chacun de ses mouvements, représente la vie multiple" (a kaleidoscope endowed with consciousness, which, with each movement, represents the multiplicity of life).[112] Like Baudelaire's, Zola's concept of the modern is not only moored to an association of the modern with the crowd, the urban masses, workers, laborers, peasants, and not only anchored in an iconoclastic evaluation of aesthetics as necessarily evolving, breaking with or reinventing traditional genres, but also, is bound to an analogous stylistic temporality cadenced by metamorphosis and rapid transfiguration.[113] As the excerpts from *Le Ventre*'s descriptive passages have illustrated, this style, quickened by kaleidoscopic turns, endows such passages with an internal dynamic that challenges the well-oiled distinction between narration as action and description as inertia, suggesting that a less absolute and ultimately, more useful distinction might be the one Dora Zhang proposes, not between the active and the static, but instead, "between different temporalities."[114]

—— PARISIAN SEASCAPES

The name of the genre known as *nature morte* or "still life" hangs heavy in *Le Ventre de Paris* and critical writing about it, as it does in Zola's dossier for this novel and in his art criticism as well. Claude, of course, never tires of rehearsing his dream to render Les Halles in a "colossal still life." But Zola works the assumptions of "still life" in unexpected ways, and the results tend to deconstruct

traditional concepts of this genre. Similarly, when we read across his fiction and art commentary, the genre known as *marine* (maritime painting, marine landscape, or seascape) is undone and reinterpreted. By the end of all the genre bending, a still life may be reassessed as a seascape, and the hierarchy that traditionally privileges the second to the detriment of the first is put into question.

Historically, still life was low on the academic hierarchy of genres, associated with the painting of domestic or decorative objects done by students, women, and second-rate artists, while paintings of mythological, biblical, historical, and military scenes, portraiture, and even landscape (devalued because it, like still life, did not make use of human subject matter) were accorded higher value. From the seventeenth century until well into the nineteenth, the art establishment generally accepted academician André Félibien's appraisal of still life: "He who makes perfect landscapes is above another who only does fruits, flowers, or shells. He who paints living creatures is more worthy than those who only represent lifeless, motionless things."[115]

Writing in 1867, Zola associated Manet's modernism with his reinvention of still life, and simultaneously, as Jeannene M. Przyblyski has suggested, he "defined . . . still life's modernity in terms of Manet."[116] Przyblyski is referring to a passage in Zola's 1867 study of Manet in which the author vociferously states that this artist's canvases do not seek to represent historical events or philosophical subjects. Zola goes on to say: "[Manet] traite les tableaux de figures comme il est permis, dans les écoles, de traiter les tableaux de nature morte; je veux dire qu'il groupe les figures devant lui, un peu au hasard, et qu'il n'a ensuite souci que de les fixer sur la toile telles qu'il les voit, avec les vives oppositions qu'elle font en se détachant les unes sur les autres. . . . Il ne saurait ni chanter ni philosopher. Il sait peindre, et voilà tout" (Manet treats his paintings of figures like the art schools allow paintings to treat still life; I mean that he groups the figures in front of him, rather by chance, and he then cares only to fix them on the canvas as he sees them, with the sharp oppositions that are created when they are blocked against each other. He neither sings nor philosophizes. He paints, that is all).[117] As he applies techniques associated with still life to figure painting (and, I would add, to other genres as well), Manet, Zola argues, reinvigorates both.[118]

If Zola is important to an evaluation of Manet's modernism, Manet (or more precisely, Zola's appraisal of him and the other "new painters") is vital to an understanding of Zola's modernism in *Le Ventre de Paris,* the novel he would draft five years later, and whose ingredients, I propose, were already simmering in his mind at the time he wrote these words on Manet, still life, and the modern. The influence of still life, as Manet and others were reconfiguring it, on Zola's novel is most obvious in Lantier's perceptions of the marketplace displays and his pronouncements on their potential for painting—though this is just a way into the larger sphere of effects. Circling Les Halles as he initiates Florent to the stalls, shops, and displays, Claude tells the newcomer of his passion for the overflowing

foodstuffs he finds each morning freshly delivered to Paris's center, and also, of his obsessive nighttime fugues through the area as he returns there after dark to dream of "des natures mortes colossales, des tableaux extraordinaires" (colossal still lifes, extraordinary paintings). As Claude explains his attempts to represent, in a vast still life painting, the panoramic spill of vegetables, fruits, fish, and meat over the marketplace square and its branching streets, upon which he wants also to superimpose the figures of local inhabitants, he depicts a vista of heterogeneous juxtapositions that he prizes "pour leur couleur" (for their color). By way of such verbal representations, Zola gives the reader an indication of how very distant Claude's envisaged tableaux are from conventional still lifes and in fact from any fixed painting category. Neither close-ups of domestic comestibles and decorative objects, nor landscapes, nor figure paintings, these imagined still lifes participate in several genres but imitate none (623). They also brashly aim to include the ironwork and glass structure of the market that is so evocative of a railroad station ("ce vaisseau immense de gare moderne" [777]) (this modern, station-like enclosure), brazenly alluding to modern industry and commerce, despite the affront this would constitute to those diehard critics Claude ridicules for their anachronistic belief that "on ne fait pas de l'art avec de la science, [et que] l'industrie tue la poésie" (800) (one doesn't make art with science, and industry kills poetry).[119] And they are predicated on vitality and animation.

In his visions of colossal still lifes, most often built around the figures of Cadine and Marjolin, the creatures whom Claude, with Zola, renders as the incarnation of Les Halles, the artist's claims are not modest; he intends to present, by means of these paintings, "un manifeste artistique, le positivisme de l'art, l'art moderne tout expérimental et tout matérialiste . . . une satire de la peinture à idées, un soufflet donné aux vieilles écoles" (776) (an artistic manifesto; positivism in art, a modern art that is experimental and materialist: a satire of the painting of ideas, a snubbing of the old school).[120] From a certain perspective—one of aesthetic theory—it matters little that Claude fails time and again to realize his venture, since Zola quite literally writes the manifesto in his place, in this novel as well as in his art criticism.[121] And so it seems important to add to the details of Claude's unpainted but verbally articulated manifesto some of the perceptions of still life and the modern in this novel that are not charged to his artist's vision: those that somehow escape the persona of verisimilitude in which Zola so diligently strives to enclose most of them, and that are more indirectly articulated or less professionally motivated.

Nature morte or still life at the most fundamental level strives to represent objects that are either dead or inanimate, as the French and English terms together express.[122] But the nature of the genre as it is reinterpreted in *Le Ventre* defies this accepted definition. Initially we find the challenge to the conventions of still life attributed to Claude, when the artist is enraptured by the mounded vegetables illuminated in the morning sun: "Il soutenait qu'ils n'étaient pas morts,

qu'arrachés de la veille, ils attendaient le soleil du lendemain pour lui dire adieu sur le pavé des Halles. Il les voyait vivre, ouvrir leurs feuilles, comme s'ils eussent encore les pieds tranquilles et chauds dans le fumier. Il disait entendre là le râle de tous les potagers de la banlieue" (627–28) (He insisted that they weren't dead, that, after having been picked on the eve, they were waiting to bid the morning sun farewell on the streets of Les Halles. He saw them as if alive, opening their leaves, as if they still had their roots warmly and safely embedded in the dung. He thought he could hear, through them, the death rattle of all the vegetable gardens on the outskirts of Paris).

Dead, dying, or alive?—the categories are blurred by the mirage of light falling on harvested vegetation. Later, however, the narrative dispenses with the filter of Claude's aesthetic authority in order to make a similar observation in the artist's absence. The saltwater fish that daily surround Florent in his post as Inspecteur de La Marée are clearly dead, and yet their depiction eerily situates them in a death that continues to look like life.[123] Surveying the arrival of the fish in the morning, "Florent put croire qu'un banc de poissons venait d'échouer là, sur ce trottoir, râlant encore, avec les nacres roses, les coraux saignants, les perles laiteuses, toutes les moires et toutes la pâleurs glauques de l'océan" (696–97) (It seemed to Florent that a shoal of fish had run aground there, on the street, still gasping, with their pearly pink tones, their bleeding corals, their milky pearls, all the moirés and pale blue-greens of the ocean). As his gaze runs the course of the display, it discovers that "pêle-mêle, au hasard du coup de filet, les algues profondes, où dort la vie mystérieuse des grandes eaux, avaient tout livré: les cabillauds, les aiglefins . . . les congres, ces grosses couleuvres d'un bleu de vase, aux minces yeux noirs, si gluantes qu'elles semblent ramper, vivantes encore" (697) (jumbled together in the chance scoop of the net, the seaweed sheltering the mysterious depths of the waters, had delivered a haul: cod, haddock, eels, fat, muddy-blue snakes with their slitted black eyes, so viscous that they seemed still to be alive and crawling). Zola's still-life representation of the profusion of fish sinuously tangled in seaweed and shimmering on the stands shows dark-eyed piscine bodies arcing, their skin viscous as if they had not stopped swimming in the ocean depths, as if they were in fact still drawing their last breaths, still alive (râlant encore . . . vivantes encore).[124]

Like Florent's imagined swerve of the expired conger eel through its fluid domain, this lengthy passage glides from the iridescent array of fish at Les Halles to the sea breezes over Guiana, as if the silty, saltwater residue on the epidermis of the sea creatures brought to market in Paris might somehow stand in for the vast ocean sweep bounding France's distant colony. We drift from the saline scent carried by the nacred fish scales whose jewel tones have been bathed and muted by the waves ("lavées et attendries par la vague") to the sea itself: "Ce qui montait à la face de Florent, c'était un souffle frais, un vent de mer qu'il reconnaissait, amer et salé. Il se souvenait des côtes de la Guyane, des beaux temps de la traversée.

Il lui semblait qu'une baie était là, quand l'eau se retire et que les algues fument au soleil; . . . le gravier exhale une haleine forte de marée" (698) (What was rising in front of Florent was a puff of fresh air, a sea breeze he recognized, briny and brackish. He remembered the coasts of Guiana, the beautiful weather during the crossing. He sensed the presence of a bay, when the water is ebbing and the seaweed is steaming in the sun . . . and the gravel exhales a strong sea breath).[125] Whether involuntary sensory memory or phantasm, this oddly nostalgic return of the prisoner to the site of his incarceration has, as we have noted, provoked a fair share of critical ink. What has not yet been considered, to my knowledge, are its resonances with Zola's comments about making and exhibiting art, in an article (mostly) about Courbet written a few years earlier, which helps to gloss the fish tale transit of Florent to Guiana by connecting it to the spaces of art in Zola's marketplace.

In May 1868, a short piece by Zola titled "*Le Camp des bourgeois,* illustré par Gustave Courbet," appeared in *L'Événement illustré.* Ostensibly a review of the book whose title and illustrator are given in the article heading—but whose author oddly is not—Zola's pages are in fact part puff for the illustrator, his colleague and fellow traveler, and part personal aesthetic manifesto. The book,[126] published shortly before Zola's account of it, was written by Étienne Baudry, a wealthy bourgeois châtelain who lived largely from the profits of his vineyards (before they were struck with phylloxera) at Rochement, near Saintes in Charentes-Maritime. He was unhappily married to a younger woman who depended on servants for her every whim, if Baudry's account of their marriage is credible. *Le Camp des bourgeois* is both a satire of certain elements of their household and those like it and a draft of the author's Fourier-influenced socialist vision for society (though Baudry sounds rather like a Sunday socialist and a weekday dandy, grooming his hair with cognac and generating in the range of 150 undergarments to be laundered weekly by his domestic staff.).[127] Baudry had hosted (and financially supported) his friend Courbet for at least several months in 1862, during which period the artist painted his host's well-forested estate. *Le Parc de Rochemont* shows a wooded landscape traversed by a barefoot rider mounted on a donkey named Balthasar that, according to Baudry, had thrown Courbet when he attempted a similar trot during his residency at the château.[128]

Courbet's sojourn at Rochemont would come to bear on Zola's novel of a decade later not only by the legacy of Baudry's donkey's name, Balthasar, passed on with a whetted edge to Mme François's horse Balthazar; but also, more significantly, it led to Baudry and Courbet's collaboration on the book that the artist illustrated, and in one chapter of which he is cited. Zola engages at length, in his review, with Baudry's paraphrase of Courbet's ideas on displaying art, which were formative in his own thinking. Courbet, Zola says in his article, referring to him as "le Franc-Comtois," would have welcomed the opportunity to participate in this treatise that lambastes all those who do not toil and who depend on

the labor of others; he would have been delighted by "ce plaidoyer en faveur des paysans, des rudes enfants de la terre" (this advocacy for the peasants, the crude children of the earth).[129] Having set up Courbet as a devotee of peasants—indeed, as all but a peasant himself—Zola proceeds to rehearse the tenets of the artist's theories that are important to his own aesthetic projects (and to which I will return). He appends to Courbet's remarks about the need to democratize art his own suggestion that Les Halles would provide an excellent alternative site for both creating and exhibiting art—an enterprise whose double prongs he prefers not to sever.[130] And he builds to a close with this invocation to future artists: "Allons, à l'oeuvre, artistes de l'avenir! Peignez les différentes pêches, les mille espèces de poissons, racontez-nous les jours d'orage et les jours de calme de la grande mer" (Let's get to work, artists of the avant-garde! Paint the different fishing hauls, the thousand species of fish, tell us about the great sea in its stormy days and its days of calm).[131]

Zola's brief commentary is densely packed and calls for some sorting. To do so I will, however, unlike Zola, separate the making and the showing of art, turning first to the writer's bundling of fish painting with the rendering of stormy and smooth seas. Slipping from various fishermen's catches and the diversity of their hauls to the vastly opposed presentations of the ocean in the light of tempest or calm, Zola invites artists of the avant-garde—"artistes de l'avenir"—to be modern precisely by imitating this verbal slippage in their practice: that is, *to tell* of the changing sea *by painting* its different fishing hauls and their yield of thousands of specimens. What he is suggesting, I believe, is a vision of representation according to which, somewhat paradoxically, a close focus on facets of an object up close is evocative of much more than a myopic perspective. Zeroing in opens a more sweeping kind of perception. "Paint for me in detail the bounty the fisherman brings back from the sea, and you will be conjuring the murky roughness of the waves slapping the cliffs, or the placid limpidity of a sheet of water glistening in a cloudless lull," he is advising, in other words. A still-life-like representation of fish set out for sale on a Paris market counter, if done with vision and skill, may also be a marine landscape by its powers of evocation. For Maupassant, this potential, in Zola's hands, was expansive and unequivocal: "Ce livre sent la marée comme les bateaux pêcheurs qui rentrent au port" (This book smells of the sea like fishing boats coming back to port).[132]

Perhaps the larger point is that such a painting is neither still life nor seascape, but both, or something in between: an iconoclastic kind of art that breaks boundaries and smashes categories and formulas in its juxtaposition of ways of seeing. The sort of representation toward which Zola exhorts artists in his review of 1868 is, of course, exactly what he himself goes on to do, in words, in his novel of 1872–73. The allusions to Parisian inner seas in *Le Ventre* are, as I began to suggest earlier, mightily overdetermined; they are not just a nod to a recurrence of Florent's traumatic island exile, not just hallucinatory, not just a dissolution

of matter and being, but additionally, a statement on painting, on writing, on a certain aesthetic that relies on synecdoche: here, a view of fish that will present nothing less than their originating (albeit absent) marine environment.

Later in the same month that he wrote his review of the Baudry-Courbet collaboration, Zola wrote an article that turns at greater length to marine painting. "Les Actualistes," also published in *L'Événement illustré,* appeared on May 24, 1868. Writing here about artists who take up the gauntlet of the modern with courage and originality, seeking to be true rather than to please, Zola praises the work of Claude Monet "après les oeuvres si remarquables de Manet et de Courbet" (after the remarkable works of Manet and Courbet), and expounds at length on his first-rate capacity as a painter of seascapes ("un peintre de marines de premier ordre").[133] Zola appreciates Monet's marine paintings for their roughness, honesty, and synesthetic potential: when we see the artist's painting of a ship coated with tar, his critic says, we hear it and smell it, we breathe in the salty air, "nous entendons la voix sourde et haletante du vapeur, qui emplit l'air de sa fumée nauséabonde" (we hear the muffled panting of the steamer, which fills the air with its sickening fumes).[134] He further congratulates Monet for renouncing conventional images of the ocean that make it look alternately like fireworks, red currant jelly, or candied sugar caught by a ray of sun, and for choosing instead to paint the waves as they really appear, viscid and dirty ("glauques et sales"), muddy, slimy with the silt of the ocean floor ("des vagues boueuses, jaunies par la vase du fond")—using the same mud-laden vocabulary that he would go on to apply to eels four years later in *Le Ventre* in order to signal their almost-aliveness by naming the traces of their native element that continue to adhere to them on land.[135]

It is Manet, however, who deserves the last word here, not only because I, with Zola, turned first to him as the leader of the modern vanguard and the primary innovator of still life at that time, but also because he, too, was a painter of marine life, by which I mean both the sea and the creatures that live in it, with no watertight distinctions between the two. Zarobell has noted the thorny determination of what, in fact, defines a marine painting in the nineteenth century. He asks: "Is it any scene that includes water, or does it have to be all sea? What about harbor or beach scenes? Does there have to be a ship or sailboat? Salt or fresh water?"[136] To these questions I would add, how about fish on a table, still gleaming with salt crystals on a cloth they have dampened, or freshly shucked oysters, still cupping brine?

As we have seen, Zola, in his appraisal of the Baudry-Courbet book, makes a logical leap from fish on a display counter to their ocean domain, with no mention there of Manet. But a glance at some of Manet's piscine still lifes in the context of his sea paintings suggests an analogous bridging on his part, one that may have influenced Zola's thinking as well. Scholars before me have remarked on how sea creatures that figure in domestic settings in certain of Manet's

commonly considered still lifes evoke the sea, as, for example, Kessler does when she suggests how, in *Fish (Still Life)* of 1864, "we taste the oceanic salinity of a just-shucked oyster" or breathe in a residue of "mingled . . . brine and rotting fish" when our senses respond to a brush of light on a dead mullet that dampens a soiled cloth with its scent.[137] Allison Deutsch speaks of the "undulations" of the tablecloth on which the fish in *Still Life with Fish and Shrimp* (also painted in 1864) are posed, claiming that the painter's strokes make it "look more like a sea than pressed white linen," and suggesting that the corners of the cloth flow into the surface "like a breaking wave." Describing the technique of another 1864 fish still life, *Eel and Mullet,* she proposes that the artist's thick, flowing strokes produce an effect that "resemble[s] nothing so much as seasickness."[138] Manet's fish still lifes of 1864 in fact coincide with his early ventures into scenes more convention-ally recognizable as "sea paintings," among which, the naval scene, *The Battle of the Kearsarge and the Alabama,* inspired by the U.S. Civil War combat off the coast of Cherbourg. Julie Wilson-Bareau and David Degener argue that this painting deploys a mode of presentation similar to that of *Fish (Still Life),* with the fore-grounded waves of the battle scene, like the folds of the cloth and the knife in the still life, thrusting the eye of the viewer toward the point of dramatic focus, the sinking ship in the first case and the fish in the second.[139]

Zola particularly admired in Manet what he perceived as an abnegation of subject and a refusal of academic genre rules. He found the hierarchy of genres to be dissolved in brushwork that did not alter its chosen mode of dabbing con-trasting areas of pigment on canvas, whether to paint a capsized battleship or a landed mullet. "Le sujet pour [Manet] est un prétexte à peindre" (For Manet, the subject is a pretext to paint), Zola insists, specifying that the artist's way of see-ing, like his technique, far from following the discriminatory habits of Academy eyes, was organized consistently across the gamut of subjects and genres: in each case, we recall, Manet, according to Zola, "sees how things are lit, and sees things as masses."[140] In the same vein, Zola writes back against detractors of Manet's *Olympia* who take the painter to task for the alleged obscenity of unveiling to the public "cette fille de nos jours, que vous rencontrez sur les trottoirs" (this girl of today, that you find in the streets), protesting that the subject meant nothing, that Olympia's pedestrian body was there for purely aesthetic ends, so that the artist could translate onto the canvas "les vérités de la lumière et de l'ombre, les réalités des objets et des créatures" (the truths of light and shadow, the realities of objects and creatures).[141] This claim of a complete dismissal of subject was doubtless ex-aggerated on Zola's part (not to mention projected upon Manet), for if we heed the writer's art critical comments and follow his own choice of characters in *Le Ventre,* it is clear that being modern for him means exposing—*as art*—the humble and the everyday.[142]

—— THE RAILROAD STATION AND THE MARKETPLACE

Claude's comments in *Le Ventre* on what a coup—what a *chef-d'oeuvre*—it would be for an artist to capture the marketplace are worth revisiting. The painter is possessed by the idea of fixing the kaleidoscopic expanse of Les Halles on a canvas by focusing on its crystallization in two figures who are given to us as simple and instinctive, and who are located on a spectrum fluctuating between the bestial and the puerile: "[L]es belles brutes . . . Cadine et Marjolin s'aimant au milieu des Halles centrales, dans les légumes, dans la marée, dans la viande" (776) (Cadine and Marjolin, those fine animals, making love right in the center of Les Halles amidst the vegetables, the seafood, and the meats). This work would be not only a slap in the face of old-school art, and a manifesto of modern art, its experimentalism, and its materialism, but, too (and we hear echoes of Zola's comments on Manet), "une satire de la peinture à idées" (776) (a satire of intellectual painting).

And yet, the very thought of representing, in serious art—be it novel or painting—the likes of cabbages, turnips, and carrots bloomed by the pen into a hundred sun-lit flowers, the sea-monstrous eels in their viscous, enmired convolution, the amputated limbs of swaddled calves poking out of their wrap like a macabre display of murdered children—all this is of course related to an "idea," and a provocative one at that. So, too, is the array of vendors: the fish sellers carrying on their bodies the unscrubbable whiff of their wares and sometimes, too, a stray scale stuck to a cheek; the well-larded, increasingly porcine charcutière; the butter maker with her varicosed arms plunged into an unctuous, rancid paste; the fruit vendor wearing pairs of ripe cherries, pendant on her ears; the elderly salad *marchandes,* hunchbacked and broken, with age-beaten faces red in the setting sun. The clients are not lacking ideational motivation, either: the miserly gossip stealthily purchasing greasy leftovers, the tearful servant trying to return a spoiled fish she has been sold by a spiteful merchant, the hungry throng lined up to buy a cup of reeking cabbage soup.

The dominance of cabbage in the preceding paragraph, which begins and ends with this lowly vegetable, is a gesture of fidelity to its insistent role in the novel, present everywhere, given as birthplace of Marjolin and fundament of Florent's renaissance. Cabbages, along with root vegetables, connoted the peasantry, rusticity, poverty, lack of alimentary sophistication, cooking and eating as necessity rather than as art. It follows that cabbages in painting were often seen as vulgar, and were derided, along with other humble vegetables, as lacking serious aesthetic substance. Camille Pissarro, dubbed "the cabbage painter" by unfriendly critics in synechdochic summary of his propensity to paint the peasantry, was mocked by many for his ostensibly low aspirations, but lauded by Zola (Plate 26).[143]

We are well familiar with the revolution in aesthetics that was operated by the realists and naturalists which made it possible—against the dictates of official good taste—to write the people and their cabbages into serious literature and to paint them into art, and it is worth repeating that the connection of the popular

body with its biological functions, feeding prime among them, was a last frontier in this upheaval, one broached already by Balzac, and then of course more vigorously breeched by the likes of Flaubert, Zola, the Goncourts, Huysmans, Rachilde. Zola's marketplace exhibitions of the materiality of foodstuffs make more than manifest the idea of alimentary representability: they flaunt it, albeit in the class-bound forms we have observed. And these fictional displays, taken together with his pronouncements outside the novel on the conjunction of food and art in the marketplace, push this idea toward doctrine and even manifesto.

In his review of Baudry and Courbet's *Camp des bourgeois,* Zola indeed sets forth the market, its consumable goods, and its working-class population as viable subjects of art, but he also makes a more radical point. To Courbet's suggestion that museums be closed and replaced by the waiting rooms of railroad stations so as to broaden art's audience, Zola proposes going a step further.[144] "Je veux apporter ma petite pierre à l'édifice," he asserts. "Courbet n'a peut-être pas encore songé que les Halles centrales offrent un développement de murs admirable et que la bonne peinture serait là au frais. . . . Nos bonnes et nos femmes, en allant au marché, ont besoin de voir un peu de vraie peinture!" (I want to build onto Courbet's project. It may not yet have occurred to him that Les Halles offers a marvelous expansion of wall space, and that good painting would be well kept there. Our maids and our wives need to see some real art on their way to market!).[145] Art should be made not only *about* the people but *for* the people, Zola says. Although we often have the feeling, reading the naturalists, that their "lowering" of focus makes the working class not only a lure for the eye but a magnet for derision, here Zola otherwise suggests that the people may become arbiters of taste as well as victims of consumption.

While modern readers will flinch at Zola's condescending recommendation that "our maids and our wives" might profit by glimpsing good painting on their way to market, it is nonetheless true that the officially prescribed audience for art (understood as the sanctioned art of the Salons, museums, and galleries) in the nineteenth century was composed of bourgeois men. Zola's pronouncement that viewing need not be gendered and need not be classed places him out of the strictly elitist camp. It also suggests that in 1868 when he wrote these words proposing the expansion of Les Halles as an alternative museum space, and specifying that the market food displays could also themselves generate art, becoming virtual exhibits, Zola was already contemplating the novel that would become *Le Ventre de Paris.* Although it is common wisdom that this novel was not part of the plan for the twenty originally conceived novels of the *Rougon-Macquart* series, and that Zola only began thinking about a marketplace novel very shortly before he wrote it, I believe that this excerpt from the Baudry-Courbet review tells a different story.[146] Although he did not at the time have the characters etched and the plotlines drawn, it is very clear that in 1868 Zola was thinking seriously about what would become the deep structures of this

novel: the sites of art's making and exhibiting, the composition of its public; the expansion of its subjects and of the conditions of representability; and, very specifically, the practical and aesthetic uses of Les Halles.[147]

It is also probable that Zola was playing on more than one register with the notion of markets, that he was thinking of Les Halles not only as a food market but also, more generally, as a locus and a metaphor of commercial exchange. In a sardonic piece that first appeared in *La Tribune,* also in 1868, under the title "Causerie" (one of many in which Zola rails against the politics of the Académie des beaux-arts with its juried Salons, medals, and prizes), he recommends that the Salons be transformed from competitive events to "des marchés ouverts aux produits des artistes" (markets open to artists' products), markets open to all, whose exhibits would constitute both gallery and boutique, showplace and sales space combined.[148] If we juxtapose the two 1868 articles I have mentioned and look ahead to his *Ventre de Paris,* we may better understand just how overdetermined a marketplace Les Halles was in Zola's thinking and writing. An emblem of exchange, it is at once a hub of egalitarian circulation, a gargantuan food emporium, a site of aesthetic inspiration, an unbounded art repository, and a massive outdoor museum: in short, what Zola calls "le bazar du beau" in his "Causerie" of December 1868.[149] He revalorizes the marketplace, its products, and its people as worthy of representation, and further grants this population the privilege of spectatorship.

——— THE CHARCUTIÈRE'S ART

Over a decade later, Zola would come back to the question of art and audience, further expounding on the question of who constituted or should constitute the viewing public. In 1881, by which time the working-class presence at museum and Salon expositions had become somewhat more accepted, Zola commented about the increasing attendance of *la foule,* as he phrases it, at such events, alluding notably to the recent withdrawal (in January 1881) of the conservative Academy sponsorship of the Salons.[150] The passage is worth quoting at length:

> Le public me paraît également tirer un bon profit des Salons annuels. A mesure que les expositions sont sorties du cercle étroit de notre Académie de peinture, la foule a augmenté dans les salles. Autrefois, quelques curieux seuls se hasardaient. Maintenant c'est tout un peuple qui entre. . . . C'est la vraie foule qui y circule, des bourgeois, des ouvriers, des paysans, les ignorants, les badauds, les promeneurs de la rue, venus là une heure ou deux pour tuer le temps. . . . Certes, je ne prétends pas que cette cohue apporte là un sentiment artistique quelconque, un jugement sérieux des oeuvres exposées. Les boutiquiers en robe de soie, les ouvriers en veste et en chapeau rond, regardent les tableaux accrochés aux murs, comme les enfants regardent les images d'un livre d'étrennes. Ils ne cherchent que le sujet, l'intérêt de la scène, l'amusement du regard, sans s'arrêter le moins du monde aux qualités de

la peinture. . . . Mais il n'y en a pas moins là une lente éducation de la foule. On ne se promène pas au milieu d'oeuvres d'art, sans emporter un peu d'art en soi. L'oeil se fait, l'esprit apprend à juger. Cela vaut toujours mieux que les autres distractions du dimanche, les tirs au pistolet, les jeux de quilles et les feux d'artifice.[151]

[It seems to me that the public also takes good advantage of the annual Salons. As the exhibitions have left the narrow circle of our Academy of Painting, the crowd has increased in the rooms of the Salon. Earlier, only a few curious souls ventured in. Now there is a veritable throng. There really is an assortment of people circulating there: one finds bourgeois individuals, workers, peasants, ignoramuses, gawkers, and pedestrians, arriving there to kill an hour or two. Of course, I do not claim that this mob brings the slightest artistic sensibility, nor a serious opinion about the works exhibited. Shop owners dressed in silk, men in workers' jackets and round caps, all look at the paintings hung on the walls like children look at the pictures in a book they've been gifted. They only look for the subject, the center of the scene, and what diverts the eye, without stopping at all to consider the properties of the painting. . . . Nonetheless the crowd is slowly being educated. One doesn't walk among works of art without carrying away a bit of art within. The eye begins to habituate, the mind learns to judge. At least this is better than other Sunday distractions, shooting matches, a game of ninepins, fireworks.]

The tone is patronizing, as is the assumption that workers only attend art events "to kill time," as is, too, the expression of paternalistic concern for the betterment of the multitudes. Yet Zola is admitting and inviting a democratic audience for what he considers to be modern, experimental art, encouraging the idea that culture and taste are acquired rather than innate value systems.

Most of the aesthetic discussion in *Le Ventre de Paris* focuses on the aspiring artist (or better named *artiste manqué*) Claude Lantier. There are, however, several encounters with art in the novel that converge on Claude's decidedly philistine charcutière aunt, Lisa Macquart, which put her in a role of spectator or even (unintentional) art curator.[152] These instances help us better to understand Zola's consideration of the people's position in art and the place of art in popular culture, and hint at a connection of street art to street food. For while it is most obviously Claude Lantier whose trompe l'oeil artist's vision introduces much of nascent modernism and Pre-Impressionism into *Le Ventre de Paris,* it is in fact Lisa's more pedestrian gaze that turns the eye of the novel to street art in a series of manifestations that I will point out in order of appearance.

Claude narrates the first incursion of art into the charcuterie and is in fact its creator, while his aunt views and judges. The artist's takeover of the Christmas Eve charcuterie window display has been well commentated in support of various hypotheses (including, most notably, aftershocks of the Commune and its attendant food scarcity), but in the present context, I read this tableau as an

aesthetic confrontation, a meeting of new art and popular spectatorship.[153] Speaking in Claude's voice, Zola is explicit about his enthusiasm and awe for this spectacular window dressing that the artist considers to be his masterpiece, "une véritable oeuvre d'art . . . mon chef-d'oeuvre" (800–801) (a real work of art, my masterpiece). Brushing aside the shop apprentice, Auguste, and the banal display he had been assembling, Claude composes his work, not with paint or charcoal or ink, but with the materials that might conceivably (if unconventionally) otherwise be the subject rather than the medium of a painted representation: breaded pigs' feet, terrines, beef tongues and black puddings, a joint of ham, streaky bacon, sausages, even an entire truffled turkey—all organized in this case by Claude so as to juxtapose colors in a flagrant pageant of flesh. To his proud eyes it is an act of aesthetic revolt, "barbare et superbe . . . avec une cruauté de touche" (barbaric and superb, touched with cruelty), while it both draws and unsettles the hordes of people who gather before the bursts of color, and it terrifies the charcutière, who finds the shop window both incendiary and indecent (801). Lisa throws her nephew out the door so that the dull apprentice Auguste can take over once again, returning Claude's aesthetic statement to a prosaic spread of meats and pâtés.

Priscilla Parkhurst Ferguson has aptly called Claude's window art an "installation"; we might even call it a work of proto-performance art, because despite its coincidence of subject and medium, it is less a mimetic representation than a demonstration, an exhibition.[154] For as Gérard Genette famously argued, many years ago, "l'imitation parfaite n'est plus une imitation, c'est la chose même" (the perfect imitation is no longer an imitation, it is the thing itself).[155] What exactly the particular "thing itself" might be in this case is a matter for reflection. In the most patent of terms, Claude has represented a diverse panoply of animal flesh in a spectacular array of colors. Meat is meat. But in Claude/Zola's hands, it has also become a show, a performance, a statement, a veritable performative act. Well before J. L. Austin wrote his theory of language as performative, Claude is doing things with foods, an act Zola is replicating (and staging) by doing things with words.[156] They are each making something happen by manipulating their medium, be it meat or language, rather than simply copying or repeating. The things that are done in the process have to do with taking art out of its frame, challenging those who "mettent l'art dans une boîte à joujoux" (800) (put art in a toy chest), as Zola disparagingly put it, in Claude's mouth. The revolution Zola cares passionately about is not the one represented by the Commune, but rather, the upheaval he wants to effect in aesthetic taste and politics. Zola's game, along with Claude's, is to "révolter un peu ces braves gens" (800) (stir up these good people a bit). Included in this group of "good people" are not only the establishment artists and art critics of the Academy, but also a potential popular audience epitomized by his upwardly mobile aunt Lisa, born to the provincial working classes and evolved into a Parisian shop-owning petite bourgeoise.

The one-time incandescent Christmas Eve display in the charcuterie, a work destroyed even as it is completed, seems to underscore in hyperbole the doctrine of the modern as transitory, kaleidoscopic, and fleeting; its banishment is as much a sign of its aesthetic success as of its popular condemnation. A second materialization of art in the charcuterie, however, is more decor than event: it attracts less attention but is a more permanent shop fixture. The display window, like that of many food establishments of the period, is furnished with two retractable shields against the sun: both an awning and a shade ("un store"), protection for the perishable goods on display. The scene pictured on the shade is described in detail: "il représentait, au milieu d'une clairière, un déjeuner de chasse, avec des messieurs en habit noir et des dames décolletées, qui mangeaient, sur l'herbe jaune, un pâté rouge aussi grand qu'eux" (840) (it represented, in the middle of a clearing, a hunt luncheon, with the gentlemen in black suits and the ladies in décolleté, eating, on the yellowed grass, a red pâté as big as they were). If only one of the two women in Manet's *Déjeuner sur l'herbe* is painted *en décolletée—* the other is fully nude—and if fruit rather than pâté is the prominent food displayed there, an allusion to that painting is unmistakable (Figure 19). Zola has chosen to feature the controversial work he has defended and championed vociferously in print on the screen opening onto the charcuterie, writing large Manet's painting while vulgarizing it by adding the gigantic red, human-sized pâté, much as Manet mocked the Old Masters by borrowing and distorting the iconography of the pastoral genre (natural landscape background, human subjects, basket of fruit) in his picnic luncheon scene.[157]

We cannot know whether Zola superimposed this image on the charcuterie window as an aesthetic statement, a cunning joke, or both. His staunch journalistic support of Manet's *Déjeuner* would not preclude his publicizing here the work and the manifesto it condenses, otherwise, though rather oddly. And his own depiction of eating away from the table in *Le Ventre* (the garret picnics Cadine and Marjolin prepare with the fruits of their urban gleaning, the marketplace snacking of Pauline and Muche, the leftovers habit of Mlle Saget) further ambiguates the question. The only explicit information on this iconic screen is that it figures in the rivalry between la belle Normande and la belle Lisa: Louise becomes irritated when the charcuterie shade is down ("le store de la vitrine . . . l'exaspérait, lorsqu'il était tiré" [840]). Is this because the image offends her, excites her jealousy, or hides its owner? Lisa's perspective on this image is not transparent either. Although it is tempting to attribute the charcuterie screen to one of her nephew's experiments in modern art—which she is on record as abhorring—Zola gives us no evidence of Claude's intervention here, so we must assume that Lisa has chosen the picture with its giant *pâté sur l'herbe* as publicity for her shop. Once again, we cannot be sure. This interpolated *Déjeuner,* unmediated by the character and unexplained by the narrator, is delivered like a wink from author to reader, a discreet commentary on the osmotic passage of painting from the New Masters to a popular audience.

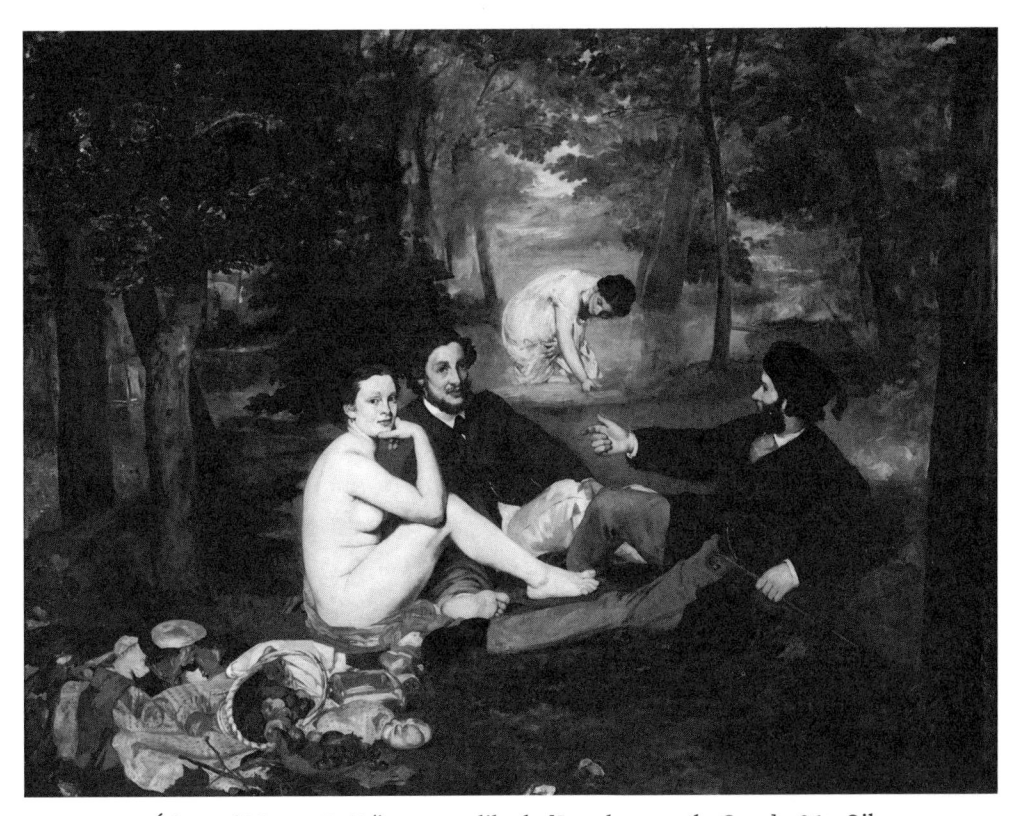

FIGURE 19 Édouard Manet, *Le Déjeuner sur l'herbe* [*Luncheon on the Grass*], 1863. Oil on canvas, 81.5 × 104.3 inches. Photograph: Benoît Touchard / Mathieu Rabeau. Photograph copyright RMN–Grand Palais (Musée d'Orsay), Art Resource, New York.

Lisa plays a more active observer's part in the next rendition of the arts, which follows directly. When the setting sun allows the charcutière to raise the shade, which we must, I think, read here as a theater curtain of sorts, we shift from la belle Normande's frustrated perspective of the pictured luncheon scene and its obstruction of her rival to la belle Lisa's unobstructed panoramic view through the shop window over the outdoor marketplace. She looks out at the open area of Les Halles from her counter, where she sits placidly knitting, and surveys the humming everyday life of the square; beyond a swarm of street urchins glimpsed through a lattice of plane trees and the market porters at rest, smoking their pipes, she notices "aux deux bouts du trottoir, deux colonnes d'affichage [qui] étaient *comme vêtues d'un habit d'arlequin par les carrés verts, jaunes, rouges, bleus, des affiches de théâtre*" (840–41; my emphasis) (at opposite ends of the street, two columns that looked as if they were dressed in a harlequin costume with their green, yellow, red, and blue squares made of theater posters).[158] The immediate context for this *arlequinade* is theatrical: the curtain of the charcuterie is raised, Lisa becomes both spectacle and spectator, and the show begins. Its "Harlequins" are stick figures: winking columns dressed in colored patches composed of theater posters. One theater opens onto another. And there will be a third: Lisa

will soon venture out to buy tickets for a melodrama; she and Quenu will have their night at the theater.[159] But theatricality is but one of many threads spooled together by this delayed and overdetermined appearance of the harlequin costume and the harlequin word.

—— *COMME UN ARLEQUIN*

The *arlequin* is named belatedly here in the penultimate chapter of the novel, just fifty pages from its close. We have seen Harlequin and harlequins suggested everywhere, from the visual effects of the very first pages where the juxtaposed vegetable bouquets evoke the patchwork of Harlequin's clothing, from a generalized impression of *bariolage* in the Paris streets and market stands, to Florent's torn and bedraggled appearance, to the piecemeal mode of eating that anticipates the actual harlequin stand scenes later on in the novel. And yet the word *arlequin* makes but a single explicit appearance in this novel, curiously displaced from its expected use in the leftovers stand episodes.

In his preparatory plans for the *marchande d'arlequins* scene at the market, Zola uses the term *arlequins* interchangeably with *rogatons,* but then erases the more common of the two, *arlequin,* when he writes the scene into the novel. His major source of published information for Les Halles in general, and in particular, for the harlequin vendors and the overall operation of marketing leftovers—from originating high table, to middleman, to Les Halles cellar staging, to display and sale at stands—was Maxime Du Camp's authoritative contemporary account of daily life in Paris, the mammoth *Paris, ses organes, ses fonctions, et sa vie jusqu'en 1870* (originally appearing in six volumes between 1869 and 1875, with the section on *l'arlequin* in volume 1, chapter 8, "Les Halles centrales"). It is indispensable to look back at Du Camp's precise commentary about accepted terminology for the industry of leftovers, for he is unequivocal on the matter: "Ce qu'ils vendent se nommait jadis des rogatons, mais l'argot a prévalu, et cela s'appelle aujourd'hui des *arlequins*" (What they are selling used to be called *rogatons,* but slang has prevailed, and today they are called *arlequins*).[160] Although the author of this source that Zola assiduously follows is adamant about the current alimentary lexicon, Zola chooses to use an outmoded term in his novel, both at the site of Mlle Saget's clandestine purchase and in the follow-up account of the taunting she receives once word of her degrading meal has circulated (834; 842).

The one-time use of the *arlequin* word in *Le Ventre* occurs in a context apparently unrelated to food, enclosed between the two deflections of *arlequins* to *rogatons,* like the stuffing in a sandwich. It is there, just a handful of pages following the renamed harlequin purchase and a single page before the taunting reiteration of this retitling, that Zola charges to Lisa's gaze the observation of another kind of Harlequin, this one, as we have seen, explicitly articulated ("deux colonnes d'affichage [qui] étaient comme vêtues d'un habit d'arlequin par les carrés verts, jaunes, rouges, bleus, des affiches de théâtre" [841]). Zola's erasure of the anticipated *arlequin* in the two surrounding alimentary cases adds weight

PARIS. 4 — Les Halles.

FIGURE 20 The photograph on this card, taken at least a quarter of a century after Zola had compared a pair of poster-clad Morris columns at Les Halles to Harlequins, is one of many that depict the era's fascination with decorated columns, walls, kiosks, urinals—any surface plastered with bright patches of posters. Postcard, "Paris 4. Les Halles," circa 1905. Photograph. Author's collection.

to its more unusual insertion in this description of theater publicity. Contemporary readers expecting to see the customary word used to designate the leftovers plates would be all the more attentive to the jack-in-the-box effect of the earlier occulted *arlequin* as it pops up here in an unaccustomed context.

The troping of the poster-clad columns as *arlequins* is, significantly, accomplished by simile rather than metaphor. The comparison of collaged theater announcements to the Commedia figure or his costume would not have been familiar enough to readers in the early 1870s to have worked metaphorically in this context (Figure 20). Zola does not say that Lisa sees, at either end of the sidewalk, "deux arlequins": instead, he spells out a rather laborious simile so that readers will understand the assimilation of the patchworked columns to Harlequin's clothing. His explanation-by-way-of-comparison recalls Du Camp's exposition, in his account of the harlequin trade at Les Halles, of how the mixed plate got its name: "De même que l'habit du Bergamasque est fait de pièces et de morceaux, leur marchandise est composée de toutes sortes de denrées" (Just like the costume of the Bergamasque is made of bits and pieces, their merchandise is made of all kinds of goods).[161]

The swerve from gastrology to the arts in Zola's dislocation of the term *arlequin* from Mlle Saget's doubly represented leftover dinner fare purchases to the dual vibrantly postered advertising columns bounding the panoramic sweep of

Les Halles reminds us of its Commedia origins, a path retraced by Du Camp's analogy. And it does more than that; it binds kitchen, theater, and visual arts in their most popular, working-class forms, reminding us that if all roads lead back to the abiding presence of the Commedia character and its diamond-spangled avatars, this Harlequin was mediated, in the nineteenth century, by the alimentary phenomenon deployed in his name and everywhere infused with sociopolitical connotations. Borrowing all the traits of its theatrical ancestor but filtering them through food, the comestible harlequin in *Le Ventre* migrates from a material object to a practice, to a concept, to an aesthetic, and at every point in the trajectory (which is vibratory rather than linear) it bears marks of its indigestible alterity. This radical otherness is projected at the penultimate moment by the charcutière's gaze onto columns of words superimposed on brilliantly hued patches crowded together in the waning light (Plate 27). It has metamorphosed from earlier painterly views of dappled vegetables verdant with visionary paint, still-life fowl daubed with truffled black, meat joints dripping flaming reds and unctuous pinks.

From here we might gather up the elements of an explanation for the omnipresent buzz that pervades Les Halles on various sensory levels, be it *bariolage,* drumbeat, hustle bustle, or swarm. Might these multisensorial pulsations be the unarticulated tremors of an epistemological climate change? They are very like those "silent revolts" that "ferment in the masses of life which people earth" that caught the attention and the pen of Charlotte Brontë, and later, Rancière.[162] It is in this context that the unrealized status of Claude's art does matter, vitally in fact, even if Zola's writing replaces his missing painting. After all, Dr. Pascal, another of Zola's alter egos, strains to complete a draft of the family tree that is a facsimile of the writer's own, even as he lurches into death. Claude's *oeuvre manqué* is significant not only because failed art is always more provocative to the novel than are finished masterpieces, but also, more precisely, because his inability to materialize in paint the fruits of his thought is commensurate with the elusiveness of its subject. The subject—in sum, the perpetual, unbridled motion-in-place of the market—is emblematized by the incessant *vagabondages* of Marjolin and Cadine, their *grandes tournées* that engage the painter to follow (776, 778). That they can never be still long enough to pose is what makes them the compelling figures of modernity, at once the embodiment of the new still life, and the incarnation of its impossibility. And so we have, instead of Claude's colossal still life, its vibrations: an unremitting background hum; a crackling of light; a leftovers plate of mixed illusions; the patchworked harlequin colors on twin columns blinking at dusk.

EPILOGUE

From the beginning, *The Harlequin Eaters* has had one foot in the real and the other in the imaginary, while proceeding on the premise that they were joined at the hip and could not—nor should not—ever fully be severed. It seems appropriate, then, not to unbalance this stance in closing. As I step outside the book in order both to look back and to think ahead, I turn first to some lingering aesthetic considerations and last to a heritage of material remains.

—— LE SALON DES PAUVRES

> Look at the harlequins! . . . All around you. Trees are harlequins, words are harlequins. So are situations and sums. . . . Come on! Play! Invent the world! Invent reality![1]

At the end of *Le Ventre,* as we have seen, Zola moves the reader away from both food and painting, transposing his marketplace patchworks onto a lithographic display that he presciently tropes as harlequinesque in advance of what would become a turn-of-the-century cliché. Two decades later, posters—still largely associated with the gutter even as they began their ascent into galleries—would excite controversy as they shifted the harlequin concept to a new medium while retaining all the resonances of earlier discourses about the streets and the people who walked there and ate there. A detour through the poster-hung byways of fin

de siècle Paris with a glance at the comments they elicited will illustrate the abiding presence of a harlequin aesthetic that is increasingly pared of its alimentary materiality but that vehiculates nonetheless connotations of vulgar behaviors linked to riotous appetites and disharmonic appearances (Figure 21).[2]

During the early 1870s, at the time Zola was writing *Le Ventre de Paris,* color lithography was commonly identified (and disparaged) as a commercial technique rather than a fine art or even a graphic art, and its application to poster production was further vilified for the vulgar outdoor venue of its display and its ostensible popular audience. Illustrated posters were seen as a déclassé bastard child, "born on the street . . . the offspring of an encounter between art and advertising, aesthetics and function," as Ruth Iskin puts it.[3] Early admirers were a small but vocal minority. If the last two decades of the nineteenth century are now recognized as the golden age of poster art, the flourishing of this medium was slow in coming, and was certainly not universally acclaimed.

Although the first modern illustrated poster appeared in 1830, and theater posters and others that used the basic form of black print on colored backgrounds were familiar Parisian sights by midcentury, the means to print colors inexpensively was not available until Jules Chéret developed it in 1869, thereby facilitating a gradual burgeoning of the aesthetic realm he would come to rule.[4] Throughout the 1870s, although advertising posters were omnipresent and spread exponentially in the Paris streets, only a few individuals marginal to the art establishment collected them as art in these early years and carried them to a more respectable indoor scene; it was only in the 1880s that dedicated poster galleries began to open, with a first exhibition at the Galerie Vivienne in 1884. By the time the Exposition Universelle of 1889 took place, however, *l'affichomanie* was in full bloom and Chéret was its laureate. The trend was served not only by technological advances such as innovations in color printing, but by legal and industrial developments as well. The Press Law of 1881 liberalized conditions of posting, which opened opportunities for printing companies to expand. The rapid growth of mass production nationwide in turn increased the need for effective advertising. As commentators argue, posters underwent a tidal shift in reception between 1890 and 1900. Though they still papered the streets, they came to join the ranks of fine art collectibles; their reputation as local, outdoor artifacts gradually ceded to a recognition of their international status, and concomitantly, the ranks of their public moved from low brow to high.[5] By 1910, posters were thriving along with a host of other untraditional visual art movements, including art deco, art nouveau, albums, photographs, and postcards.[6]

Given this chronology, Zola's singling out of the poster-decked columns of Les Halles as a notable background spectacle in his *Ventre* of 1872–73 was, to say the least, precocious—all the more so if we consider the anachronism of these pillars in his narration of 1858–59 Paris.[7] While the writer does not overtly praise the poster-plastered columns in *Le Ventre,* his tone is admiring, and the rhetoric

FIGURE 21 View of poster-bedecked turn of the century Paris. Postcard, "Paris. Rue Mouffetard," circa 1906. Photograph. Author's collection.

of vividly pieced *arlequin* costuming that he applies to them joins this novel's dominant aesthetic of *bariolage* and patchwork. A dozen years later in his writing career, Zola would address the poster question in more detail, at which time he situated himself squarely in the camp of those critics who championed posters as art. In *L'Oeuvre* of 1886, he has his band of aspiring artists stand in awe before a circus poster, "une affiche tirée en trois couleurs, la réclame violemment enluminée d'un cirque forain" (a poster in three garish colors advertising a traveling circus); the young Turks collectively cry out in admiration before this alternative to the rigidities of official art. Seven years afterward, in an issue of the journal *La Plume* devoted to poster art, Zola was among the intellectuals, artists, and literati commissioned to offer tribute to the genre, which he lavished with praise for its vibrant originality and enlivening of the streets.[8]

The streets, indeed, were at once the crux of the poster problem for its detractors, and the heart of the poster extravaganza for its devotees. The sidewalks and gutters of Paris (hardly neutral sites) were rife with connotations of sexuality, vagrancy, and poverty. In an age of rising bourgeois interiorization, they were too open, too base, too *out*. The masses who congregated there—literal lowlifes—presented the specter of potential mixing to all those whose paths and gazes might cross there. Any passing flâneur walked in a foreshadow of egalitarianism that also cast a pall of potential degradation on whatever visual objects lay ahead.[9] The very accessibility of a spectacle that was found openly and free of charge in the street was cause for either alarm or excitement—again depending on one's perspective on the matter. Conversations about street posters had a proletarian subtext that was already implicit in the habitual venues of these posters: they were particularly prominent in working-class neighborhoods like Les Halles (where a *mobilier urbain,* an infrastructure of props preconceived as support for poster display, was ubiquitous, and where the vast Haussmannian construction projects in progress provided ample additional space to mount posters on temporary walls and scaffolding). A long history of associating bright colors and images with crowds also underlay reactions to the perceived menace of the vividly hued, boldly designed rectangles that were plastered all over urban thoroughfares and that papered popular arrondissements with particular abundance. Gustave Le Bon's pronouncements of 1895 on the susceptibility of the crowd (especially women and children) to images and bright colors echoed earlier color theorists and a wide range of commentators who had issued similar warnings.[10]

But proximity to the people was only one of the stigmas attached to the street life of posters. Their open-air habitat exposed the cheap paper material on which they were printed to the elements as well as to the whims of passersby, who often tried to peel them off, either in disgust and with an intent to obliterate, or in admiration, with a desire to appropriate.[11] Posters were constantly and regularly torn down and replaced for more utilitarian purposes as well, since marketing demands required a rapid turnover of advertising. As early as 1858, Victor Fournel remarks that "le colleur placarde tous les matins et le chiffonnier enlève tous les soirs!" (the billsticker posts every morning, and the ragpicker tears down every evening!).[12] The ephemeral nature of the medium constituted it as an emblem of instability for its detractors and a crystallization of modern mobility for its advocates.[13]

From the 1860s onward, critics on both sides refer to the poster phenomenon as a street art made for the people, with the "art" designation understood rather in the sense of an artifice or a joke by its most serious detractors, and as an educational or social welfare measure for the masses by many of its supporters. In 1868, Timothée Trimm (pen name of *Le Petit Journal*'s flamboyant journalist Léo [Napoléon] Lespès) refers flippantly in passing to the poster-lined walls of Paris as a pedestrian museum, "une sorte de musée pour les passants" (a kind

of museum for passersby).[14] The allusion became more pointed with time and under other pens, often developing into something like a sociopolitical declaration in the guise of an aesthetic opinion, *pour ou contre,* than it was in Trimm's innocuous quip.[15] Maurice Talmeyr, one of poster art's most conservative critics, sneeringly referred to hoardings as "le musée . . . colorié à l'usage du peuple, devenu musée de plein air, et placardé sur les murs!" (a brightly colored museum for the people's use, which has become an open-air museum hung on walls!). He not only popularizes the street poster; he further degrades it by feminizing and debauching it, making clear that his poster lady is a tramp, a streetwalker: "l'affiche est . . . cette femme . . . qui se déshabille ou se rhabille à volonté. . . . Elle nous appelle, nous cligne de l'oeil . . . elle *fait le mur"* (the poster is a woman who takes her clothes off and puts them on again freely. She calls out to us, winks at us . . . she walks the walls).[16] Jules Claretie more neutrally remarks that "l'affiche donne à Paris son musée d'images, son exposition . . . en plein-vent" (the poster gives Paris her museum of images, her open-air exhibition).[17] Jean Jullien approves the role street art may take in uplifting the people: "ces fresques du pauvre améliorent la vision du peuple en art" (these poor man's frescoes improve the people's taste in art), as does Camille Lemonnier, who calls poster hoardings "le Louvre des foules, l'école d'art, publique" (the crowd's Louvre, the people's school of art).[18] And Félicien Champsaur apostrophizes the genre's reigning monarch, Chéret, in a string of ironic homages that will come to be much echoed by other commentators: "ce Fragonard de la rue . . . ce Watteau des carrefours . . . ce Delacroix du trottoir . . . ce Tiepolo de la place publique" (this Fragonard of the streets; this Watteau of the corners; this Delacroix of the gutters; this Tiepolo of the public square).[19]

It is but a tiny step from the street as museum or gallery to the gutter as Salon (Plate 28). In terms of status as well as chronology, first came the Salon, then the Salon des refusés, and last, the "Salon des pauvres," or the "Salon de la rue," yet another set of idioms with which to snub both a new art medium and an entire social class in a single breath—unless the speaker was progressive and intended to elevate both by defiantly associating them. John Grand-Carteret cuts to the chase in his connection of the official Salon with wealth, privileged location—and unredeemable dullness—which he opposes to the free dynamism of street art: "Gaîté des murailles et joie des yeux, l'affiche a . . . conquis sa place dans la société moderne, opposant aux Salons payants et ternes des salles d'expositions, le Salon public et gratuit de la rue" (The poster, enlivening the city's walls and charming our eyes, has won its place in modern society, offering as alternative to the dull and fee-based Salons, the public and free Salon of the streets).[20] Jules Bois writes with a sympathetic if pitying attitude toward those financially and aesthetically impoverished in his article "Le Salon du pauvre": "Ceux-là n'ont que la rue, la rue telle qu'elle est, le Salon des pauvres" (Those people only have the streets, the streets as they are, the Salon of the paupers).[21]

Against the rhetorical backdrop of the fin de siècle postermaniacal "Salon en plein vent" or "musée en plein air" (outdoor Salon/open-air museum), Zola's proposal to put art on the street almost a quarter of a century earlier seems lit by a mantic aura. His suggestions that "les Halles centrales offrent un développement de murs admirable et que la bonne peinture serait là au frais" and that "nos bonnes et nos femmes, en allant au marché, ont besoin de voir un peu de vraie peinture" are eerily prognostic of the turn-of-the-century prose of avant-garde journalists who applauded the move toward an urban democratic aesthetic that Roger Marx and Gustave Kahn would theorize as "l'art social" or "l'esthétique de la rue" (social art or street aesthetics) in the years leading up to and following the turn of the century.[22]

Critics who stood in awe and excitement before poster art commended it in much the same terms that Zola had admired "new" painting in the 1860s and 1870s: they spoke of its pulsating force, its *bariolage,* its patches of contrasting color, its mobile effects, its noisiness, and its effervescence. Like Zola depicting city streets as urban still life that induced a shiver of all the senses, they spoke of poster art as a quivering and tremulous form. For Talmeyr it was "le frisson du jour" (the latest thrill [literally, the latest shudder]), while more enthusiastic reviewers (and some detractors as well) routinely compared it to ebullience, intoxication, phosphorescence, palpitation, champagne, kaleidoscopes, and the shimmer of butterfly wings. Adding metaphors born of the technological moment, they often invoked its "electric" nature.[23] Huysmans, in an 1879 review deploring the stasis of Salon art, opposed its mediocrity to Chéret's street posters, which, in contrast, represented "de l'art qui palpite et qui vive!" (art that pulses with life!).[24]

For Talmeyr, the evanescent poster, "posée le matin, déchirée le soir" (stuck up in the morning, torn down in the evening) is the mirror of modern life, "la vie fébrile et hachée, miroitante, multicolore" (feverish, jerky, shimmering, multicolored life)—both of which he deplores.[25] His description of the fragmentary, nervously brilliant sparkle of the modern duet (life echoed by art) begins to sound a lot like a demonized double of Zola's Paris, embodied by twin Harlequin pillars, although Talmeyr does not invoke Harlequin's name. Other contemporary critics do, however. For Augustin Boyer d'Agen, the postered walls of Paris offer another version of the harlequined columns of Les Halles: "Voici que les murs de Paris s'habillent de papier, varient en plein soleil leurs couleurs claires et multiples comme le domino d'Arlequin, éclatent de rire dans leur costume flambant neuf au nez de la police ébahie, de ce rire railleur, de ce rire brillant" (The walls of Paris are outfitted in paper now, and, in their blazing new costume, flash their many bright Harlequin colors in the sun, bursting with laughter in the face of the police, a laughter that sparkles and mocks).[26] Camille Lemonnier as well is reminded of the theatrical Harlequin when he looks at illustrated posters, and he waxes effusive about the correlation: "L'Affiche illustrée, l'image en couleur, en bariolure, en encres électriques, le tulipage des nuances en

bouquets et en prismes, *l'arlequinade des tons effrontés et pétaradants*. . . . C'est non seulement la Rue qui s'allume et flambe et grouille comme une colossale lanterne magique. . . . C'est encore l'illusion pour tout et pour rien" (The illustrated poster, the multicolored image in electric inks, the different hues flaring into prismatic and plumed forms, *the harlequinade of bold and spluttering tones*. . . . It's not only the streets that are lit up and blazing, swarming like a giant magic lantern. . . . It's also the teeming of illusion about everything and nothing).[27]

Harlequin rhetoric may, of course, have leached out to commentators of the illustrated poster from its thematic content, since some of Chéret's work is inspired by characters of the Commedia dell'Arte and features figurations of Arlequin, Pierrot, and others (Plate 29). But the motivation does not even begin to stop there. Commentary on posters is infused not only with prominent allusions to their clashing tones and patched design, along with their popular origin, but also with a recurrent appreciation of their acrobatic energy, their metamorphic vitality, their nervous frangibility (Plate 30). For Boyer d'Agen, illustrated posters are the image of a world "que la vapeur emporte aux quatre coins de l'espace" (that the steamship carries off to the four corners of space), and of a life "[qui] se coupe, se hache, s'anatomise jusqu'aux infiniments petits" (that is cut, chopped, dissected into infinitesimal bits).[28] The transience of place and the pulverization of days are inscribed in the vanishing lines, etched silhouettes, and dappled hues of its choppy art (Plate 31). Others emphasize the quality of mélange inhering in poster art. Some critics speak admiringly of the mixing effect that characterizes so many aspects of modern poster inspiration and display. Grand-Carteret remarks on "[le] côté très curieux de l'affichage actuel [qui] réside surtout dans le mélange des genres et des séries. Réclames industrielles, qu'il s'agisse de spécialités pharmaceutiques, de liqueurs, ou de vêtements; étoiles des cafés-concerts; images pour les fêtes, les théâtres et les bals, tout cela se coudoie, constituant sur les murs et sur les palissades une galerie pittoresque de l'effet le plus heureux" (that very curious element of contemporary billposting, which consists in the mixture of genres and series. Industrial ads, whether they be for pharmaceutical products, liqueurs, or clothing; café-concert stars; holiday, theater, or dance-hall images, all those rub shoulders, forming a picturesque gallery on the walls and the street hoardings) (Plate 32).[29] For Talmeyr, on the other hand, poster heterogeneity is, unsurprisingly, a negative attribute. He finds hodgepodge traces of cultures disparate in time and place to be particularly present in contemporary American posters, where he notices "on ne sait quoi du moyen âge corrigé par on ne sait quoi de japonais, on retrouve un peu de tout cela, si *indigeste* que semble le mélange, dans beaucoup d'affiches américaines" (a certain Middle Ages element revised by a certain Japanese element; something of the sort is found—no matter how *indigestible* the mixing seems—in many American posters).[30]

The digestive metaphor returns the concept of aesthetic mixing to the alimentary shadow of the harlequin plate. So, too, do observations about

nineteenth-century poster culture that bring our attention to its "compensatory function": to the refuge and dreamspace opened by street posters and shared, suggest Le Men and Bargiel, with popular fiction and romances peddled in the streets. This consolatory function is common also, I have argued, to leftovers purchased from harlequin vendors who hawk tales of the high-born origins of their wares along with the material goods. The consumers of "rêves et féeries" purveyed by advertisers on their harlequin walls find distraction from life's trials and drudgeries on the very streets that serve these up as daily fare, not unlike Mlle Saget, who comes upon ostensibly imperial *arlequins* that transport her to dinner at the Tuileries in the course of her quotidian marketplace excursions.[31] Both objects, gustatory and visual, participate in a reenactment of the *bovarysme* we first explored in chapter 1.

This is not to say, however, that the poster *arlequin* and the plated *arlequin* operate in parallel mode as practices. In simplest terms, the alimentary *arlequin* is defined by a passing down of material goods and intangible signs, while the art print *arlequin* evolves in an upward-moving direction: a little like its eponymous Commedia character, it takes off from the street and climbs the social rungs. The street urchin is eventually rehabilitated and welcomed into high bourgeois dining rooms.[32] Yet we have seen that the welter of crisscrossed social lines and passages is more complex and multidirectional than any sketch allows. The scraps of high tables trickle downward, further degraded at each step, but the promise held out by their dream-laced provenance lifts the eater upward to dine with the gods—or at least to take bites from their earthly avatars. Meanwhile, erstwhile low art ascends from the gutters as the *affiche* is gradually redeemed by the well-to-do, but its taint of street dust and whiff of grease and glue can never entirely be brushed away. The shifting forms of nineteenth-century Harlequin reincarnations belong to neither low nor high, origin nor end; they negotiate between low and high, they mediate aspirations and anxieties, and they mix social and aesthetic hierarchies. The path is jerky, nervous, and energetic, prone to erratic shifts, reversals, and shuttling moves.

And that path does not end within the pages of this book; that is to say, it does not end when the poster craze subsides. A sequel might look ahead to Nabokov's emblematizations—only alluded to in these pages—of transformative processes and techniques as abstracted Harlequins. Or it might take us back a generation to the intersecting projects of Gertrude Stein and Pablo Picasso, which coincided with and persisted beyond the rise of Harlequins depersonified as patchworked pillars. We could read the writer's disjointed and reassembled syntax alongside the artist's splintered spaces and bodies. We ought especially look at the life and death of Picasso's early repersonified Harlequins in their suits of many-colored diamonds, then watch them decompose, dissolve, and evolve into geometric recompositions where painted patches are fractured into sculptural cubes and anything, as Nabokov later knew, can be a Harlequin: trees, words, situations

and sums, and also houses and hills, pitchers, fruits, noses and hips, café table assignations, violins and pipes (Plates 33, 34, 35, and 36). And we should not forget Picasso's early history as an impoverished young artist in turn of the century Paris, living a precarious existence, shoddily housed, almost certainly eating harlequin meals. Newly arrived from Spain, speaking little French, living an outsider's life with suspect friends, Picasso was pegged as anarchist, marked as foreign, marginal, and politically dangerous by the police, who surveilled him much as they did the *saltimbanques* and other street artists who inspired his painting. The crossed threads of Picasso's art and life would, then, coming full circle, once more tack the harlequin aesthetic to the culinary harlequin and its metonyms of class and race.[33]

More prosaically, a sequel might look further forward to the shifting social practices of reducing waste, managing scarce alimentary resources, and recycling unused provisions. It would consider twenty-first century reforms in France, from the unpopular mandate of *le doggy bag* for restaurant leftovers, to wider initiatives designed to recuperate and recirculate used goods—all grouped under the label *la récup*. In a synecdochic gesture that stands in for a yet unwritten book, I close with one instance of the alimentary harlequin's evolution in the streets of twenty-first century Paris.

—— RECUPERATING LEFTOVERS: THE SACKS OF THE SAINT-EUSTACHE SOUP KITCHEN (PARIS, JANUARY 2017–MARCH 2022)

If you track our relationship with leftovers over time, you will understand a lot about . . . how we live.[34]

The history of Les Halles and of L'Église Saint-Eustache are conjoined. One might say that the market and the church evolved together, in synchrony, over the ages. In 1183 King Philippe Auguste enlarged the marketplace; thirty years later, in 1213, what was then the small Chapelle Sainte-Agnès became a parish church through the financial intervention of a bourgeois named Jean Alais, whose favors to the king earned him the right to tax fish sold at the market. The construction of the actual church of Saint-Eustache was begun in 1532 and continued for over a century (until 1637), during which time both market and church were serving an increasingly large population. Throughout history there was a close connection between the two institutions. There is a window gifted by the guild of charcutiers in the seventeenth century in what is still called the Chapelle des Charcutiers, where a *messe des charcutiers* (a charcutiers' mass) continues to be celebrated annually in late November. During the Terror, Saint-Eustache was vandalized, forbidden to the Catholic cult, and rebaptized (somewhat fittingly) "Temple de l'Agriculture." (Other churches were renamed in similar fashion: Notre-Dame de Paris was called "Temple de la Raison"; L'Eglise de Saint-Roch,

"Temple du Génie"; Saint-Médard, "Temple du Travail"; Saint-Etienne-du-Mont, "Temple de la Piété filiale," etc.) It was only in the mid-nineteenth century (1846–54) that Saint-Eustache, although long since restored to Catholicism, would be fully repaired and renovated—by none other than Victor Baltard, the architect who would, under the Second Empire, begin the (re)construction of that other, mercantile church: the glass-and-iron pavilions of Les Halles that characterized the market in its heyday.[35]

For approximately five centuries, then, Saint-Eustache and the market vendors stood side by side and intermingled at the geographic and symbolic center of Paris, which continues to be referred to as "Les Halles" although the marketplace was moved out to the southern suburb of Rungis in 1969. Innumerable paintings and photographs celebrate the longstanding cohabitation: the church towering over the market, the fruits and vegetables of the street vendors and pavilion merchants tumbling out of their containers right up to the steps of the church.[36] When the decision to move the market to Rungis became definitive, one artist, Raymond Mason (1922–2010), himself a transplant, British-born but Paris-recreated, expressed his reverence and nostalgia in a sculpture that today graces one of the chapels of Saint-Eustache, La Chapelle des Pélerins d'Emmaüs. The bas-relief, *Le Départ des fruits et légumes du coeur de Paris le 28 février 1969,* shows the synergy of market and church that I allude to above, and emphasizes a spiritual connection: the sculpture (itself reminiscent of an altarpiece) displays human figures carrying produce like offerings from the market, with the church looming heavy right behind (Plate 37).[37]

Against this historic context, it seems appropriate that Saint-Eustache nightly sponsors a benevolent dinner service during the winter months of December through March (Plate 38). It has done so since the winter of 1984, when, as a precursor in this kind of venture, it opened with a handful of volunteers and the goal of serving a hot soup and a bagged meal, feeding just thirteen people the first night. Now almost forty years later, it serves an average of 260 meals a night with a minimum of thirty to thirty-five volunteers working a dinner shift, and others working during the day to gather supplies and prepare them for cooking. Each dinner includes a hot soup, a main dish of chicken, fish, or meat served with pasta, rice, or a vegetable, a freshly prepared salad, pastries, cake, and coffee, each course served separately, in ritual French fashion, and distributed sequentially by volunteers working in discrete queues (Plate 39). A different volunteer crew under the leadership of a supervisor (*un responsable*) services each dinner seven days of the week, with a commitment to work that same night every week for the duration of the four-month season. Those in charge of cooking arrive by 5:30 p.m. and the other crew members join them toward 6:00. The evening's menu is chalked onto a large slate that is displayed near the entrance to the church (Figure 22). Dinner is served from 7:30 to 8:30, and then a thorough cleanup of the premises begins, to leave everything clear and ready for the dinner preparation of the following night.

Jeudi 17 mars
2022

—Soupe de légumes

— Daube de bœuf
et sa semoule du
soleil

— café

FIGURE 22 The freshly chalked evening menu is ready to be posted outside for dinner guests at La Soupe Saint-Eustache, March 17, 2022. Author's photograph.

I originally learned about La Soupe Saint-Eustache from lawyer Catherine Girard, a friend who has worked as a volunteer with the program for several years and is now the supervisor of the Thursday night dinner. A mixture of curiosity and admiration drew me to attend when I finally found myself in Paris on a Thursday during the short season of the Saint-Eustache dinner; I have been welcomed back in successive winters when I am able to be there. When I first arrived under the peristyle of the church where dinner was being prepared and served, I was drawn in by fragrant waves of a chicken curry simmering in huge pots and then by a convivial and diverse group of volunteers spread over a range of years and origins.[38] Among them were young professionals, students, job seekers, and retirees; the group, dominated by French nationals, included French residents of American, Beninese, Colombian, Italian, and Senegalese origin. I was given a sky-blue volunteer's apron (called "une chasuble," like the liturgical garment) and a name tag with the Saint-Eustache logo, along with a glass of wine against the chill of the air and the rain, and put to work cutting bread into croutons to be served with the soup course or main course, as the diners requested. I was invited to taste the sauce at several points, and asked for input about whether it

needed more seasoning, and of what sort. The dinner task I was assigned, carrying through my prep work, was to stand outside the church with my freshly cut croutons, along with the salt and pepper-grinding volunteers, to be ready to offer my wares to the *invités* (guests) as they moved off the serving line with their hot soup and chose their condiments. Since I was an initiate, I was not able to engage with the diners as well as my fellow volunteers, who were able to continue past conversations with many of the guests they recognized as regulars, asking about family members, or health and work updates. As I came to understand from the actions of the volunteers, the service is intended to be not only material but humane. An official message articulates the gestures of the dinner servers: "C'est essentiel de leur apporter chaleur, réconfort, écoute et soutien" (It is essential to offer them warmth, comfort, a listening ear, and support), wrote Gérard Seibel, the former president of the Association de La Soupe de Saint-Eustache, on the organization's website.[39]

The quality of the meal and the seriousness of its preparation were unexpected. I took note of how the cooking personnel slid the pasta into huge pots of boiling water at the very last moment possible so that it could be served al dente beneath the curry, and I admired the *bariolage* of the purple cabbage salad with its liberal garnish of verdant Italian parsley and a vinaigrette that was sampled by at least five people to make sure the acid-oil-mustard ratio was well balanced. A range of pastries, *viennoiseries,* and macaroons collected from local bakery surplus was stacked on trays, apportioned, and put aside for serving. I had a passing thought that the cuisine was better than many restaurant meals I've had in the United States—or France, for that matter. The cooks took care and drew pride from their concern that all be impeccably prepared for the guests. The dining population fit no preconceived notion; to an outside eye, the blue aprons were necessary to sort out the servers from the served. The message implied and intoned was that these diners accepting to be fed outside their own domestic space by volunteers in the cold could have been anyone, myself and my friends included. It was explained to me that the population served at Saint-Eustache (and doubtless, other soup kitchens like it) is gradually shifting from a formerly largely homeless group to one that is dominated by poor workers whose budget simply cannot easily be stretched to cover all contemporary needs, which increasingly, according to Girard, include crucial expenses of connectivity and contactability such as iPhones, laptops, or tablets for multiple family members, as well as more traditional costs of basic lodging and vital sustenance.[40] Unlike many social service organizations, La Soupe Saint-Eustache has no income ceilings; it welcomes unconditionally everyone who shows up.

I took photographs of the food, the volunteers, and the dinner service, but respected the privacy of the diners; it was clear that they do not want to be photographed. The website, explaining its own lack of photographs of dinner guests, confirms this preference for privacy and anonymity. Some diners engage in

banter, help the servers, continue past conversations. Those in wheelchairs or otherwise uneasy on their feet sit on the sidelines of the queue and are served individually by volunteers. A handful of guests return after their meal to ask for carryout portions.[41] Others, like ghosts, are present but almost invisible, shy, or embarrassed about taking handouts.

I could not help but take special notice of packed, lime-green plastic sacks—on other nights, they might be pale blue, white, depending on which are donated—that are given to each diner with the soup course, and I asked a volunteer about their contents (Figure 23). It was explained to me that each guest is offered a takeaway bag containing a length of baguette, a protein such as canned fish or cheese, and yogurt, fruit, or some other dessert to tide each one over until dinner on the following day.[42] Each sack is knotted on top, but loosely, so that it can be easily opened without ripping, and later reused. Some guests, though they come for the dinner, cannot bring themselves to accept the takeaway offering. As one woman who refused hers protested, "Je n'en suis pas là!" ("I haven't fallen that low!"). Thinking about this later, and about what the difference was between accepting the dinner at the church but not the bag of provisions for the next day, I thought it likely that this was part of the phenomenon I discussed briefly in chapter 1 in reference to doggie bags and the reluctance of the French bourgeoisie to take home leftovers from restaurants. If it is the case that La Soupe Saint-Eustache has so well succeeded in its mission to serve its guests warmth, commensality, and conversation along with a material dinner, and if what counts in French culinary mores is a dining experience that is both socialized and spatialized, ritualized like a restaurant meal and situated in a designated venue, then perhaps the soup kitchen takeaway sack is the symbolic equivalent of the doggie bag: the take-out meal is a kind of uncomfortable remainder that sticks in the craw, screams of a charitable handout, harks back to a tradition of poverty and begging, and the shame that attaches to both.

After returning to Boston following my first dinner service at Saint-Eustache, I wrote to my contacts there with some follow-up questions, asking in particular about their method of gauging the number of guests and the quantity of ingredients, and about the fate of any food left over from the dinner service. I assumed that waste management would be a chronic problem for the meal providers, given both the desire to ensure there would be plenty to serve all guests who might arrive on any given night, and the unpredictability of their numbers. How, I wondered, did the staff mitigate the rather incongruous risk of leftover leftovers? The provisioning and preparation for each night, I learned, is based on a rough head count of the number of diners served the previous night.[43] The approximation seems to work. As for the after-path of leftovers from the dinner service at La Soupe Saint-Eustache, the response I received from Thursday supervisor Girard was deeply evocative. And so it seems appropriate, in closing, to defer to her words, whose small ironies suggest that at least in some urban

FIGURE 23 The crypt of Saint-Eustache with sacks of provisions prepared for dinner guests to take away for the next day. La Soupe Saint-Eustache, December 16, 2021. Photograph by Joëlle Balaresque Hériard-Dubreuil. Courtesy of Joëlle Balaresque Hériard-Dubreuil.

corners of France, a tradition of culinary hierarchy and a deep-rooted stigmatization of leftovers can be tweaked:

> We rarely have leftovers, as we serve and serve the guests until the *marmites* are empty. Nevertheless, it can happen. As the soup and the salad [would deteriorate] during the night, volunteers may eat them after the closing. No problem either if they want a part of the main course—Christian [the Thursday night shift volunteer in charge of cooking at the time] is really a chef! If [main-course] leftovers remain [at the end of the dinner service], they are poured into a covered plastic bucket—all the *marmites* must be washed—and [they are donated] for the day team's lunch the day after.[44]

ACKNOWLEDGMENTS

The greater part of this book was written between 2016 and 2022 in a time of serial devastation ranging from the political to the epidemiological to the environmental to the personal. I began drafting my chapters alongside Donald Trump's terrifying rise to power, and finished them in the aftermath of the Covid-19 confinement and its reverberating isolation. Along the way, the omnipresent falling away of sociality, civility, and the earth as we've known it was accompanied by a sequence of deep personal losses. It seems important to acknowledge the climate of bereavement that hosted this book and surrounded its unfolding, both as evidence of the mood piece that in some subliminal ways the project cannot help but have become, and as testimony to the power, nonetheless, of what was left over, salvaged, repurposed, and savored. If, echoing Elizabeth Bishop, I've often been overwhelmed by the sense that "so many things seem filled with the intent / to be lost" ("One Art"), I've also frequently marveled at all that was unexpectedly reaped from an outwardly barren scene of depletion and mourning. Old circles have been reaffirmed and reinvigorated, new connections forged, and sustaining sources rediscovered. The kindnesses of friends and colleagues have been generous and vast. The course of researching and presenting, even when by Zoom, has led to close friendships and collaborations. And the burrowing process of writing has been a form of reflection, and at times even meditation and replenishment.

Two organizations have somehow managed to play the unlikely role of bridging the institutional and the personal. For forty years the Nineteenth-Century French Studies Association has provided an intellectual home that stretches well beyond the annual colloquium. In so many cases I can no longer distinguish the colleagues from the friends, and I want to extend a collective thanks to all those, too numerous to name, whose questions, comments, and challenges helped prod the many small segments of the book that auditioned there into something stronger, bigger, and better for the feedback. I want also to acknowledge some specific debts. Andrea Goulet, Cathy Nesci, and Kathy Richman were generous and abiding conversationalists on all things Eugène Sue. Mike Garval conversed regularly on postcards and culinaria, to my profit, and Marni Reva Kessler engaged in endless food-related discussions at the interstices of the visual arts and literature. Margaret Cohen was a savvy *Atar-Gull* interlocutor. David Powell shared theories and references on ekphrasis and proved how well Zoom cocktails could punctuate life and knowledge. Thanks too for contributions wide and sundry to fellow dix-neuviémistes Anne-Marie Baron, Göran Blix, Peter Brooks, Evelyne Ender, Hannah Frydman, Nelly Furman, Nicolas Gauthier, Sima Godfrey, Melanie Hawthorne, Susan Hiner, Sharon Johnson, Cheryl Krueger, Judith Lyon-Caen, Claire Lyu, Isabelle Naginski, Kevin Newmark, Martine Reid, Richard Shryock, Jessica Tanner, Peggy Waller, Nick White, and the ever-missed Ross Chambers. For the past ten years, the Oxford Food Symposium at St. Catherine's College has offered an analogous forum, fostering the writing of *The Harlequin Eaters* from start to finish. The Trustees and organizers took an initial leap of faith at the 2014 Symposium in inviting a newcomer to give a plenary talk and demonstration of the harlequin trade—even though she hadn't yet published anything on the project. Ursula Heinzelmann, Cathy Kaufman, Paul Levy, Elisabeth Luard, Mark McWilliams, and Claudia Roden were among those organizing that 2014 initiation. I benefited from all manner of generosity, ranging from Ursula's persuasive invitation to give an unacademic performative talk, to Elisabeth's loan of an antique hearth pot lugged all the way to Oxford from her home in the Cambrian foothills of Wales, to Cathy's donation of leftover shrimp tails to the next day's harlequin display, to Mark's unfailingly expert editing and wicked offbeat humor. A conversation I had there with art historian Gijs van Hensbergen about Picasso and his early years of poverty in Paris confirmed and inspired the book in its early stages. Carolin Young, who first introduced me to the Oxford Food Symposium and its wondrous community, played a formative role in the history of *The Harlequin Eaters*. Years back, she quite literally walked me through the history of the ancient Halle aux blés, the grain exchange in the center of Paris, and presented me with a slice of Paris market life. In these latter days, never can I enter the gallery space of the Pineault Collection at the former Bourse de Commerce (Stock Exchange) without referring to it first, to the bemusement of my Paris friends, as La Halle

aux blés, a primal space in which the Stock Exchange and then the art museum were later parenthetically planted.

The book might not have hatched without the influence of two colleagues who are sadly not here to see it emerge. Lawrence J. Schehr, one of the earliest scholars of French literature to engage intellectually and politically with gastronomy, met an untimely death before my work was more than a glance in this direction. When in 2012 Patrick Bray invited me, with a group of colleagues, to honor Larry by speaking each to one of his interests at a symposium held at the University of Illinois at Urbana-Champaign, I took the risk of discussing Balzac's *Gambara* as a literary bridge between low culinary culture and high musical culture, to celebrate Larry's exemplary literary-critical forays into food. My thoughts had earlier turned to this nexus, yet it felt fraught at the time for a woman scholar who wanted to be taken seriously to turn her writing to cooking. Once I had turned to food matters, however, I couldn't stop, and so in memorializing Larry I received the uncanny gift of a culinary voice from beyond the grave. A few years later, I had the good fortune to become acquainted with Priscilla Parkhurst Ferguson, a scholar whose groundbreaking cultural-sociological analyses of French gastro traditions were becoming vitally important to my new project. From our very first dialogue over a well-laid lunch table in New York I felt my work evolving not only because of the influence of her scholarship, her shared references, and her encouragement, but also, especially, her example. My exchanges with Priscilla heartened my persuasion that the domestic arts and the intellectual crafts must cohabit and cross-fertilize in order to conjointly thrive. I took her writing and her conversation as brave models for my growing sense of a need to break (with) the binaries of material product and symbolic creation, corporeal labor and intellectual musings, alimentary praxis and spiritual ideation. This book is the lesser because Priscilla was not here to critique the manuscript.

Invitations for talks at academic venues other than my own allowed me to share bits of the book in process and to benefit from dialogue with others. My thanks to Sabine Arnaud at the Max Planck Institute in Berlin, Patrick Bray, formerly at the University of Illinois at Urbana-Champaign, and his colleague Zsuzsanna Fagyal, the Cornell Alumni Association of Northern California, Dan Edelstein of the French Culture Workshop at Stanford University, Mike Garval at North Carolina State University at Raleigh, Sylvaine Guyot and Catherine Courtet of the Festival d'Avignon Rencontres Recherche et Création, Laure Katsaros at Amherst College, Máirtín Mac Con Iomere at the Dublin Institute of Technology, Thomas Parker at Vassar College, Lauren Fortner Ravalico at the University of Charleston, Maurice Samuels and Pierre Saint-Amand at Yale, Jessica Tanner at the University of North Carolina, Chapel Hill, and Nick White at the University of Cambridge. Claire White asked a brilliant question following the Cambridge talk that crystallized the entire project for me. On radio or on blogposts, I was

interviewed by Fuchsia Dunlop for BBC America, Judith Kogan for *The Splendid Table,* Thomas Parker for *Wonders and Marvels,* and Tanu Wakefield for the *Stanford Humanities Center Newsletter*. The opportunity to air and to test early harlequin thoughts and theories was invaluable.

At the University of Minnesota Press, I was fortunate to be helmed by director Douglas Armato, who "got" the book from the first and, with rare intelligence and (perhaps even rarer) Francophilia, expertly piloted its publication. It was a joy to work with editorial assistant Zenyse Miller, who navigated the manuscript through the initial stages of production with unfailing care, skill, and good humor. I'm very grateful to managing editor Laura Westlund and art director Rachel Moeller for all their good work in the latter stages, and to Shelby Connelly, Heather Skinner, Carina Bolaños Lewen, and Eric Lundgren for pulling together the many strings that tied together these pages. My deep thanks as well to all the Press's staff members who worked silently behind the scenes to turn the manuscript into a material book.

Without support for time away from the classroom and the office, the book would still be in files of conference papers on my desk. The John Simon Guggenheim Memorial Foundation and the Stanford Humanities Center believed in this project in its early stages and made it financially possible for me to have the time necessary to advance it. At Harvard University, I received aid for research travel, art reproduction, permissions, and other publication expenses from a variety of sources. It is my pleasure to acknowledge Dean Robin Kelsey, former deans Claudine Gay and Diana Sorensen, the Deans' Competitive Fund for Promising Scholarship, the Anne and Jim Rothenberg Fund for Humanities Research, and the Provostial Fund for the Arts and Humanities; also the Murray Anthony Potter Publication Fund and the Robert Bacon Fund of the Harvard Department of Romance Languages and Literatures, and chairs Mariano Siskind and Josiah Blackmore. None of these subventions would have been useful without the magical touch of Kathy Coviello, Mike Holmes, and Jill Kronberg, who turned straw figures into golden reimbursements and usable currency.

Beyond funding, the Stanford Humanities Center provided sun-drenched office space along with a nurturing academic community and abundant earthly nourishment to boot. Caroline Winterer and Andrea Rees Davies ably steered the Center during my stint there, and Marta Sutton Weeks provided the fellowship endowment. Contributions from specific fellow fellows helped shape the book. Susan Gagliardi convinced me that postcards deserved their own chapter; Charlie Kronengold and Carol Vernallis offered insights from music and cinema, food and wine, and happy experimentation with the latter two; Dafna Zur engaged with me not only on harlequins but also on matters ranging from kimchi to the relative place of dogs in different cultures; Susan McCabe exchanged Word texts and dream texts; Charles Postel provided useful references on minstrelsy and its links to Harlequin, and, with Michael Strange, a more practical introduction to

Dungeness crab. Apologies are surely in order for the inevitable oversights and lost memories of other fruitful conversations and shared ideas.

On the closing end of the project's timeline, I Tatti, Harvard's Renaissance Center in Florence, provided a short-term apartment in an Edenic setting along with divine lunches and access to a library that allowed me to tie up the loose ends of the book. It was there that I finished my research on the alimentary harlequin's Commedia genealogy and wrote the book's Appendix. My gratitude to director Alina Payne, her spectacular staff, and I Tatti's incredibly knowledgeable and accommodating librarians.

Harvard's Widener and Houghton Libraries and their excellent interlibrary loan services admirably served my research needs throughout the project, as did the Schlesinger Library at the Harvard Radcliffe Institute, and the Harvard Photographic Services beautifully reproduced the antique postcards and many of the book's illustrations. In France, the holdings of the Bibliothèque nationale de France, the Bibliothèque historique de la ville de Paris, and the Bibliothèque du Musée du quai Branly were especially valuable to my research. A special note of appreciation to the librarians at the BHVP for their unfailing expertise and humane professionalism. When I first began working with postcards, I had the good fortune to meet a French postcard collector and historian living in a Boston suburb. Xavier Donat generously shared with me his wealth of knowledge about the genre, along with some preliminary scans.

There aren't enough expressions in English to adequately convey my gratitude to the manuscript's core readers, official and unofficial. Mike Garval and Andrea Goulet read the entire manuscript and graced it with their wise suggestions and infinite knowledge; Marni Reva Kessler took more time than she reasonably could have had to read the material on postcards, posters, and Zola's art criticism with her expert art historian's eye and her superbly attuned writer's ear and to make invaluable suggestions; Gabriella Safran, one of a handful of people who know Eugène Sue's *Les Mystères de Paris* almost cover to cover, read the Sue chapter twice, in different versions, and offered incandescent observations on Sue's writing and my own. To these first readers, *merci du fond du coeur*.

Other colleagues and acquaintances (and in a few cases, kind strangers) shared morsels of expertise and wisdom. My dear friend and Charlottesville colleague Farzaneh Milani helped me think through representations of nomadic male veiling on postcards with her characteristic combination of knowledge, support, and provocation. My Cornell undergraduate classmate and erstwhile traveling companion Joan Holladay, though a medieval art historian, was always ready to guide my nineteenth-century art historical forays in the right direction, following up more tamely on those more recklessly fun hitchhikes and train rides across France and Switzerland of so many years ago. Through Joan, Daniel Sherman generously made time to answer a stranger's queries on nineteenth-century museum culture and history. Karen L. Carter and H. Hazel Hahn graciously answered my

e-mail inquiries and shared their knowledge about poster history. Emily Braun, Johanna Hecht, Gijs van Hensbergen, Stephan Wolohojian, and Marina van Zuylen jumped in at a late-breaking moment of crisis to help me locate a key missing image. And Marlena Corcoran unknotted German grammar points not easily open to non-native speakers.

I'm tempted to say that Françoise Rubellin taught me all she knows about the Comédie Italienne in France, but she knows far too much, and I, too little, for me to make that claim; instead, I simply thank her for sharing materials, references, time, and a lovely Closerie des Lilas summer lunch. Raymond Sokolov came to speak to an early class I offered on nineteenth-century gastronomy and ended up teaching me a lot about my subject; he has continued the conversation with his usual humor and his wisdom about all things culinary—and more. Some years back, Barbara Ketchum Wheaton invited me to her seminar on reading historic cookbooks at the Schlesinger Library, and has freely circulated volumes in her collection and chunks of her saucy wisdom ever since. My art history colleague Jeffrey Hamburger gave practical counsel that helped guide me through the morass of illustration acquisition and permissions, and Deidre Lynch exchanged intercultural stories of scraps and scrapbooks. In my home department of Romance Languages and Literatures, Virginie Greene fielded medieval Harlequin questions; Sylvaine Guyot reviewed some Commedia material; Christie McDonald and Michael Rosengarten gifted me a family heirloom Zola edition from which the cover illustration came; Alice Jardine, Susan Suleiman, and Annabel Kim rethought my subtitle with me, and Annabel was a mine of creative translation discussion.

Emma Zitzow-Childs was there on the ground when the writing of this book began and, miraculously, again when it ended, to assist meticulously with all the details of citation checking and readying the manuscript for submission. She kept me on schedule and the manuscript honest. Kylie Sago and Jacob Meister deftly facilitated various research tasks. To them and to the many other current and former graduate students (including, most recently, Madeleine Wolf and John D'Amico) who listened actively and taught me so much by their writing and collaborative thinking in class, my thanks and abiding affection.

Lucie Kasova and Rhonda Kellner helped me to continue to exercise my body as well as my mind during the many months of Covid lockdown and gym shutdowns. For the online yoga, the meditation, and Pilates, my thanks to them, and also to the other class participants for the political discussions, the laughter, the movie and TV recommendations—in short, for the remote community that bolstered both body and soul.

In Paris, Catherine Girard first spoke to me of the "Soupe Saint-Eustache" and invited me into its fold. All that I learned about alimentary sustainability and recycling in contemporary France from my visits there over the years, and from working side by side and chatting with its circle of volunteers, made its way not

only explicitly into the book's Epilogue but implicitly into its background. One of the Thursday team members, Joëlle Balaresque Hériard-Dubreuil, kindly provided the photograph of takeaway food sacks packed in the Saint-Eustache crypt, ready to be distributed to the dinner guests. Guy Lassalle and the late Christian Flacelière answered questions about food preparation and food waste in France.

My extended human nest in Paris has provided material and intellectual space for more years than any of us would like to count: Catherine Girard, Michèle Joigny, the late Claude Joigny, Claude and Roland Lazard, Aurélie Lazard, Régine Plas, Anne-Marie Baron, and Jacqueline Carroy deserve special recognition. Their enduring friendship is an extraordinary privilege. Closer to home, the sal(o)onista group of Alice Jardine, Kathy Richman, Nancy Salzer, and Hope Steele has engaged me in collective conversations spanning politics and prose, potables and plumbers. Our real and virtual encounters have provided salvation in a time of global madness. Carol Oja has been an unfalteringly present dinner companion whose intelligent and sane camaraderie never fails to buoy me up and to remind me that the best things at Harvard are the colleagues who become friends. A bit farther afield, Debbie Lesko Baker's lasting friendship has been profoundly significant and dear to me over the years and the miles. She holds bits of my past that would otherwise crumble into obsolete troves of meaninglessness.

Larry (Sandy) Sandburg, first cousin and friend, early on gleaned the association between my nineteenth-century stories of leftovers and contemporary work with food salvage, and sent me every news story he came across that had any potential relevance. Laura Beizer and Steve Seidner, my sister and brother-in-law in San Antonio, held down the fort there in ways that helped me to finish the book. For that, my fervent appreciation. I am as certain as if I were remembering the details of a past event that had my parents lived to see the publication of *The Harlequin Eaters,* my father would immediately have put the book in a protective plastic or, more likely, handmade brown-bag wrapper and would then have proceeded to read every line between the two covers; my mother would instantly have put the book into (local) circulation. This "memory," at once fabricated and authentic, makes me smile.

My daughter, Jenny Beizer, stepped in at many moments over the years when I needed technological and practical assistance, from word processing to the tooth-on processing of pastries and baguette ends to make facsimile harlequin plates for that early performative talk she attended at St. Catz, Oxford while still in her teens. More significantly, she has fledged into a magical human endowed with kaleidoscopic powers, so that she is at one moment an anchor in a time of turbulence; at another, a droll distraction from gloom; at still another, a compass in an ethical gyre; and, always, a reminder that what we leave unfinished when we rise from the table may be the most splendid and durable part of the feast.

APPENDIX

A BRIEF HISTORY OF THE COMMEDIA DELL'ARTE IN FRANCE

Nineteenth-century French audiences knew Harlequin in the form he had retained, with modifications, since his incarnation in mid-sixteenth-century Commedia dell'Arte[1] (and its evolution, in France, as the Comédie Italienne). It was in France, however, not in Italy, that Harlequin would come to dominate and to incarnate the spirit of the Commedia. Delia Gambelli argues most cogently that the passage from a folkloric character to a coherent theatrical persona happened in late sixteenth-century France, albeit at the hands of an Italian actor.[2] Harlequin, like his Commedia fellows, was a recurrent character whose type was fixed but whose role was fluid and was, to a certain extent, reinvented by each actor who played him—usually until the actor's death. In some families the Commedia was a multigenerational vocation, and in at least one—that of Domenico Biancolelli, the most famous Harlequin, and his son, Pierre-François Biancolelli—the role was inherited. Within the practice of the Commedia, an actor became identified with the single character he or she played (and vice versa), and reforged the role according to personality, individual performing style, and technique.

The notion of technique is critical to the essence of the Commedia dell'Arte; the term *arte* here has the sense of a specialized trade, so that *Commedia dell'Arte* refers to a theater of professionals with specialized technical training. Correlative to this foundational understanding of the Commedia players as tradespeople is a new concept of theater as merchandise, and an aesthetic model that is

economically based: the troupe had goods to market, which imperative shaped many of the general production practices. So, for example, the company was itinerant, traveled widely in search of new venues, and adapted its product to local needs and expectations.[3]

It was in large part the mercantile underpinnings of the Commedia that led to the development of its more specifically theatrical practices as well: a certain division of labor, with each actor incorporating a single character; the enormous improvisational work of the players, who in essence became authors as well as actors of their roles; and their use of what Claude Bourqui calls "prefabricated elements," meaning that each actor was responsible for memorizing an extensive individualized cache of monologues, dialogues, and routines in order to interconnect these parts with those of the other actors in different scenarios in a varying repertoire of plays.[4] The mastery of this material (a term I use advisedly to emphasize the market aspect of what was in the process of becoming a theatrical object) together with its fluid recombinations made for the possibility of a near-boundless array of diverse productions, each constantly reinvented as a conglomerate of many separate parts. The story recedes to the position of background thread loosely connecting the more significant effects of the actors' individual performances.

This was a theater of fragments. As Bourqui remarks, the storyline of the Commedia play might *almost* appear to be made in the image of a classic Harlequin costume, "assemblage de morceaux disparates qui, ajustés et cousus selon la commodité, forment un ensemble bariolé, mais constituent néanmoins un habit" (an assemblage of disparate pieces that, when fit and sewn together as opportunity allows, form a variegated composite which nonetheless constitutes an outfit)—and the qualifier is due to the fact that the Commedia spectacle is even scrappier, and even more focused on disparate details than is Harlequin's ensemble, which nonetheless, comes together as such.[5] We note that here once again the weight of the analogy falls upon patchiness and variegation to the exclusion of all else that might count both for Harlequin and the genre of the Commedia— not to mention its alimentary derivative—and it is worth flagging this gap as an echo of earlier discussion in this book. Even flawed, the comparison is telling, at the very least because it hints at the enduring structural and aesthetic centrality of Harlequin both within the Commedia and then later, within the theater(s) of its heirs, as the players and their increasingly central Harlequin make their way out of Italy.

The Commedia in its heyday (roughly 1550 to 1750) reached widely throughout Western Europe and beyond. It knew a limited itinerancy from the start, its troupes traveling predominantly through northern and central Italy, and also, abroad to neighboring areas of Europe: France, Spain, the German states, and the Low Countries. By the end of the sixteenth century, their forays had spread into Austria and England, and then in the seventeenth, to Sweden, Poland, and

Russia. The Commedia made incursions into other genres as well as geographies; by the early eighteenth century it featured in paintings and engravings by Claude Gillot, Jean-Antoine Watteau's teacher, and then Watteau, and Nicolas Lancret, to mention a few of the best-known artists captivated by the Italian theater. It appeared across the decorative arts in eighteenth-century Europe, most especially in porcelain sculptures, famously represented by the Meissen figures of the stock Commedia characters from Germany.[6]

By the eighteenth century, the Commedia had become so thoroughly institutionalized that its troupes were no longer itinerant; its companies were established in fixed venues in Italy and France (with Paris as the only enduring site outside Italy). The Commedia as genre had at this point, by general critical consensus, begun to petrify. It is its Paris petrification (along with its prior establishment and subsequent evolution there) that is my principal object, and so it is to that city that I return my narrative.

Commedia troupes played in Paris as early as 1572, for the court and also in public theaters; by the early 1640s they were performing under the king's patronage at the Petit Bourbon. By 1661, the Commedia was officially established in Paris and was housed at the Palais Royal jointly with Molière's company (which would come together with others by royal order to constitute the Comédie Française only in 1680, seven years after the playwright's death). Soon afterward they were subsidized by the king as the "Comédiens Italiens du Roy," and moved to the Hôtel de Bourgogne. The Italian troupe that settled in Paris became known as the Comédie Italienne or the Théâtre Italien; its members continued to perform mostly in Italian during the first years there, but by the late 1660s, in response to their audiences, they were integrating French passages into their theater.[7] The use of French by the Italian players increased to the point that, by 1680, it was necessary to have a native French speaker author the French scenes, which were written, while the Italian scenes were improvised; performances interspersed the two languages and dual styles. By 1692, however, French had taken over, and scenes in Italian were rare. These major changes were crowned by the expulsion of the Italian company in 1697 on the grounds of an alleged insult to Mme de Maintenon, Louis XIV's morganatic spouse.[8] Though some twenty years later, in 1716, the Italians (now represented by a different troupe) were invited back to Paris by the Duc d'Orléans under the Regency, and were from this point on designated as the "Nouveau Théâtre Italien," in apposition to the banished and newly renamed "Ancien Théâtre Italien," nothing would ever be the same.

For one thing, the Italian troupe had dispersed upon banishment from Paris. Some of its actors returned to Italy, others ventured into England and Continental Northern Europe, and still others turned to plying their trade in the *théâtres des foires,* the temporary theaters that sprang up during the season and on the site of the two complementary Paris fairs.[9] By the seventeenth century, both fairs had advanced from rustic stands slapped together on mud and straw to more

structured shops and booths lining the streets. They attracted very mixed crowds whose range included "[des] bourgeois, 'gens de qualité', charlatans, voleurs et prostituées" (members of the bourgeoisie, "gentlefolk," charlatans, thieves, and prostitutes), in Dominique Lurcel's formulation.[10] Starting in the early to mid-seventeenth century, mountebanks, magicians, animal trainers, stilt walkers, tightrope walkers, acrobats, puppeteers, and other street performers thronged in the streets around the commercial stalls, and were soon joined by actors on rustic wood stages. Harlequin was now up on the boards next to the fair vendors, guzzling wine, gobbling macaroni, and gesturing naughtily with sausages amidst vendors of such stuff. If by the first years of the eighteenth century these portable stages and makeshift theaters were replaced by more conventional theaters, already by 1670 performances were in progress, building gradually to full-fledged plays from a smattering of bit dialogues, dance acts, and marionette shows filling in the intervals between acrobatic street acts.

In 1690, when a spectacle of dance and marionettes was joined by a troupe of actors who performed a short play in a theater constructed at the Foire Saint-Germain, the Comédie Française reacted in a spirit of rivalry that would continue to structure the development of theatrical companies and genres in Paris. Seeking to execute the privilege (*droit à la parole*) it had been granted when it was founded in 1680, the Comédie obtained a royal order to demolish the Foire Saint-Germain theater, and the show was effectively shut down. Since a corresponding privilege had been granted to the Académie royale de musique (*droit au chant*), not much room was left to other theaters. The decision to shutter the Foire spectacle in 1690 was intended to close down other such spectacles by example; meanwhile the Théâtre Italien was officially barely tolerated, even before its exile in 1697. With the formal establishment of political censorship in 1705 added to the virtual monopoly of the two authorized theaters, any competing enterprises, such as the Théâtre de la Foire, would need to summon unusually crafty resources to avoid extinction. Such resources, called by Lurcel "des trésors de ruse, de souplesse et d'invention" (mines of wile, adaptability, and invention) seem to be made in the image of Harlequin himself.[11]

And in fact it was precisely in the gap left by the departing Italian players that the Théâtre de la Foire found a niche for itself, *constructed* a niche in the image of those players and their theater. Audiences found the same characters wearing their well-known masks, bearing the familiar bawdy spirit, the naughtiness, and the attitude of revolt, performing the gestures, gags, and routines (*lazzis*)—but now with all the dialogue translated into French. All that was pleasing to spectators in this transposition of the Théâtre Italien to the Foire, however, was cause for displeasure to the Comédie Française, which was threatened by the success of the Foire, all the more so because the official theater, mired in tradition and rules, stuck in the shadow of its great classical trio, was rapidly losing its audience. And as Jeffrey Ravel argues, the expulsion of the Italian players by the king

in 1697 was grounds enough to establish the Commedia and its heirs as a countercultural theater, a theater of subversion: "le souvenir de l'expulsion de 1697 a été abondamment entretenu, et souvent remodelé à des fins contestataires" (the memory of the 1697 expulsion was heartily sustained, and often renewed for confrontational purposes).[12]

In the competition that ensued over the next three decades, the Foire would provoke the authority of the Comédie Française by mocking it. Its actors retaliated against legal interdictions by outwitting them, and had recourse to inventiveness and modification in the face of official violence—once more putting into play the talents that are characteristic of Harlequin.[13] When, for example, in 1707 a court order forbade the use of dialogue in the Théâtre de la Foire, the players resorted to monologue of a sort: a string of monologues succeeded each other in such rapid succession that the line between monologue and dialogue was all but erased. When, in response, all spoken language was forbidden, in 1709, the actors of la Foire turned to pantomime, the use of nonsense words spoken in alexandrine mockery, and written signs. Soon afterward they would resort to vaudeville—putting new words to old tunes—sung dialogues, in fact. This did not sit well with the Académie Royale de Musique, but eventually (in 1713 and 1714), it ceded (for a price) its privilege to two well-paying troupes that débuted in 1715 at the Foire Saint-Germain under the progressively more common rubric of "Opéra Comique."

At the beginning of its reign, the Théâtre de la Foire had what is described in other words as the audience it deserved: "un public bigarré, composite, à l'image même des pièces de la Foire" (a motley, composite public, made in the very image of the Foire plays)—and, we should add, an audience described, like the Théâtre, as a mirror once again of its star, Harlequin.[14] But this "colorful" public shifted from a heavily popular audience to one dominated by the more fortunate, in large part because prices were raised at the Foire theaters out of a necessity that was as much symbolic as financial: making rates commensurate with the "legitimate" theater went a long way toward transforming the Théâtre de la Foire from a marginal entertainment site for a very mixed crowd into a mainstream venue for the wealthy bourgeoisie and the upper class.

So we begin to see a pattern emerging. The audience of the Foire theaters, together with the spectacle they borrowed from the Italians (who had inherited and adapted it from the early Commedia dell'Arte) are rendered by commentators in a language that reproduces them both in the mold of Harlequin. Motley, composite, unrefined, risqué, wily, rebellious, they are revolutionary in the strictest sense of the term: turning the world upside down. Such is the Harlequin effect, rippling outward to the entire theater in which he moves.

Along with higher ticket prices came a move to gentrify the Foire plays: there was an effort to cleanse the image of the Théâtre de la Foire, as there would be to sanitize the Théâtre Italien on the part of those thespians who set about

reestablishing the rebaptized "Nouveau" Théâtre des Italiens when they were invited back to Paris in 1716.[15] These two paths continued in ways that were not simply corresponding but eventually, convergent, as both the Foire and the Italiens became less daring and subversive, more conventional and comfortable.[16] The two troupes increasingly shared forces: at times they used the same authors, their actors crossed back and forth between venues, and they also began, in 1759, to venture out to the Boulevard theaters, which had the advantage of being open year-round. In 1762 the Comédie Italienne bought out the lease of the Opéra Comique, which then survived only until the last quarter of the eighteenth century, though under an increasingly altered and even suppressed identity, partly in response to a radically decreasing "appetite" on the part of the audience for their offerings, to use the metaphor Bourqui borrows from a variety of period descriptions—which once again contains an allusion to Harlequin's hunger and prodigious gluttony.[17]

In its last gasps, the Théâtre Italien performed the works of Louis-François Delisle de la Drevetière (known, among other works, for his *Arlequin sauvage,* a kind of Rousseau-inflected interrogation of what constitutes the civilized and the savage being), and of Pierre de Marivaux (who had a much less enthusiastic reception in the eighteenth century than he does in his twenty-first century revival). But the reality of mid-eighteenth-century productions of the Nouveau Théâtre Italien, especially after its merging with the Opéra Comique, diverged radically from the original spirit of the Commedia dell'Arte. All the efforts of Luigi Riccoboni, and later, of Carlo Goldoni, who undertook a reform—both striving to adapt the old Commedia forms to the tastes of contemporary French audiences—fell short of the mark. Though the last great Harlequin actor, Carlin, continued to perform that role from 1742 until his death in 1783, the rubric of the Théâtre Italien ceded to that of the Opéra Comique in 1793.

Though the Commedia as an institution was for all intents and purposes eclipsed by the nineteenth century, its legacy was not. It lingered on in France throughout that century in the Théâtre du Boulevard, in the vaudeville, in the Opéra Comique, the Opéra Bouffe, pantomime, and in the short *arlequinades,* interludes that played between theater acts and spread with particularly incandescent energy to England, where the acrobatic element was dominant and fostered the rise of the clown. The prime mover of the Commedia and its successors, Harlequin, never lost his audience. In the mid to late nineteenth century, there was a nostalgic revival of the Commedia. Among its champions was George Sand, who not only wrote Commedia plays, but had them performed by her friends. First acting live, and engaging in pantomime and ballet performed to Chopin's piano, they eventually moved on to improvised fairy tales, comedy, and drama, mixing genres as they played with and reinvented excerpts from the Commedia, the Italian Comedy, and compilations of comic operas. Later, lacking sufficient actors, they moved on to puppetry, animating the theater of

marionettes George designed with her son, Maurice (between 1854 and 1872).[18] Maurice wrote, under his mother's tutelage and with her prefacing, the encompassing illustrated history of the Italian Theater, *Masques et bouffons.*

Late symbolist and early modernist composers, artists, poets, and novelists harnessed elements of the Commedia and especially Harlequin in the name of the ephemeral, the sparkling, the fragmented, the torn and restitched. Remnants and revivals of this theater and its most enduring personage persisted and resurfaced through the twentieth century and continue into the twenty-first, in name or in spirit.[19] The continued borrowing of the Arlequin mystique, in France, for the name of such disparate and distant derivatives as rugby teams, restaurants, movie theaters, hotels, repertory companies, recreation facilities, fabric designs, candy brands, and wine labels stands in ironic testimony to Harlequin's longevity.

NOTES

All translations from French in the text and notes are my own unless otherwise indicated.

PROLOGUE

1 Balzac, *Gambara*. Balzac mentions *le regrat* in passing in other texts as well.
2 Although references to *affichomanie* can be found as early as the 1830s, the term did not become current until the 1880s, when the form of *affiches* or posters took on full color and full (if controversial) glory.
3 Balzac, "Falthurne," 703.
4 Barkan, *The Hungry Eye*, 2.
5 While the book focuses on harlequin practices in France's largest urban center, my broader arguments extend well beyond Paris to attitudes and ideologies that informed the nation as a colonial empire.

ONE —— THE EMPEROR'S PLATE

1 I use Eric Hobsbawm's widely accepted term, as elaborated in his trilogy, to refer to the period stretching from 1789 to 1914, from the French Revolution to the beginning of World War I. See *The Age of Revolution: Europe 1789–1848* (New York: New American Library, 1962); *The Age of Capital: 1848–1875* (London: Weidenfeld & Nicolson, 1975); and *The Age of Empire: 1875–1914* (London: Weidenfeld & Nicolson, 1987).
2 See, for example, Suzanne, "Les Coulisses de la Cuisine," 47; Ferrières, *Nourritures canailles*, 356; Zola, *Le Ventre*, 341–53.

3 Or occasionally, *un bijoutier*; leftovers vendors were usually women. Maxime Du Camp explains, in 1870, that *arlequins* used to be called *rogatons,* "mais l'argot a prévalu" (but slang prevailed). Du Camp, *Paris,* 165. As I argue in chapter 3, the term was thoroughly popularized and came into general usage with Eugène Sue's blockbuster novel serialized in 1842–43, *Les Mystères de Paris.*

4 Often this was done on the sly, behind the backs of owners who thought that what their guests had not eaten was being delivered to *les bonnes soeurs* or other charitable institutions; sometimes they were aware and conceived of the profit as a kind of bonus to their staff.

5 Also relegated to subterranean space were such activities as force-feeding pigeons to prepare them to look their plump best upon death, cutting up animal carcasses, plucking chickens, coloring butter—the activities we might bunch under the rubric "food grooming," which were removed from the public eye.

6 The *arlequins* were sold in Pavilion XII, in the area dedicated to *viandes cuites* or "cooked meats," one of the euphemisms for resold leftovers. They were also dispatched to the neighborhood markets and cheap restaurants of Paris. The presence of harlequins in the markets (Les Halles and local ones) predated the Baltard Halles, but their ways and means are less well documented.

7 Privat D'Anglemont, *Paris Anecdote,* 42–44.

8 Aron, "Sur Les Consommations avariées," 553; my emphasis.

9 See Ferrières, *Nourritures canailles,* and Aron, *Le Mangeur du XIXe siècle,* for the two most comprehensive treatments; other references will appear where relevant in my text.

10 See Briffault, "Des Gens qui ne dînent pas," for a rare exception.

11 Grimod de La Reynière, *L'Almanach des gourmands,* passim; Hamp, *Mes Métiers,* 143–44.

12 Barbaret, *La Bohème du travail,* 369–70.

13 Cham's illustration shows what we surmise to be currents of electrical force charging through the cloud-like vapors rising from the potage. Chavette, *Restaurateurs et restaurés,* 9–10; illustration, 12.

14 Barbaret, *La Bohème,* 366.

15 Rouff, *La Vie et la passion,* 8; Escoffier, avant propos, 5–6; Ferrières, *Nourritures canailles,* 358, 360; Castelnau, *Les Petits Métiers,* 49.

16 Mercier, "Mets hideux," 1183.

17 Hamp, *Mes Métiers,* 142–43.

18 Castelnau, *Les Petits Métiers,* 48.

19 Charles Darwin's *Origin of Species,* published in 1859, was first translated into French by Clémence Royer in 1862; the debates and theoretical spin-offs it incited, among which, different versions of social Darwinism, were multiple.

20 I will have more to say about the conflation of humans and other animals throughout the pages that follow; I note in passing that my section subtitle, "Of Beasts and Men," is tellingly borrowed from the title of a book by the nineteenth-century German impresario Carl Hagenbeck. In addition to writing *Von Tieren und Menschen,*

Hagenbeck's claims to fame include founding the modern zoo and, more infamously, pioneering the human zoo, an institution I explore in chapter 3.

21 Coffignon, *L'Estomac*, 181–82.

22 Du Camp, *Paris*, 165.

23 Imbert, *Les Trappeurs parisiens*, 117–19.

24 Goncourt, Préface, *Les Frères Zemganno*, 111.

25 Imbert, *Les Trappeurs parisiens*, 117–18.

26 Aron, *Le Mangeur*, 274.

27 Ibid., 275. Aron's narrative, while useful, is composed of largely unattributed bits of firsthand accounts, lifted from the earlier texts and juxtaposed on his page, like an in-print imitation of the alimentary composite that is his subject. Ferrières's scrupulously annotated and incisive chapter "L'Arlequin" in her *Nourritures canailles* (343–62) is a better starting point.

28 Chavette, *Restaurateurs et restaurés*, 110.

29 Ibid., 111.

30 Ibid., 112–13. "Les dépotoirs de la Villette" were what we could call "holding tanks" for liquid sewage; at the time Chavette was writing, the question of the day was how to get rid of this matter more hygienically. See Barles, "Experts contre experts," 65–80.

31 Coffignon, *L'Estomac*, 219–21.

32 Ibid., 217.

33 Hamp, *Mes Métiers*, 143.

34 Ibid., 144.

35 Coffignon, *L'Estomac*, 151.

36 Aron, *Le Mangeur*, 275.

37 Coffignon, *L'Estomac*, 184, 260.

38 See Paillet, "Ramasseur des bouts de cigares," 111–12.

39 Du Camp, *Paris*, 165.

40 Ibid., 166.

41 Castelnau, *Les Petits Métiers*, 49–50.

42 Zola, *Le Ventre*, 825–26. I look at this scene from another perspective in chapter 4.

43 Hamp, *Mes Métiers*, 62–63.

44 Castelnau, *Les Petits Métiers*, 51–52.

45 Ibid., 50.

46 Zola, *Le Ventre*, 834.

47 Suzanne, "Les Coulisses," 46.

48 Coffignon, *L'Estomac*, 181.

49 Ferrières, *Nourritures canailles*, 351.

50 Sclaresky, *Paris si étranger*, 39.

51 Castelnau, *Les Petits Métiers*, 46–47.

52 Zola, *Le Ventre*, 870–72; Sclaresky, *Paris si étrange*, 38.

53 Sclaresky, *Paris si étrange*, 38.

54 Du Camp, *Paris*, 169.

55 Castelnau, *Les Petits Métiers,* 51.

56 Chavette, *Restaurateurs et restaurés,* 109–10.

57 Suzanne, "Les Coulisses," 46. In contrast, Suzanne continues, a laborer with many children could feed his entire family economically with another line of goods from the same stall, which also vends, but at a much lower price than the more extravagant mosaics, various ragoûts and stews whose defining meat has disappeared: lamb stew reduced to its potatoes; veal with carrots whose carrots predominate; beef with cabbage condensed to cabbage. Available as well are various stews or soups whose ingredients are so merged as to be almost indistinguishable.

58 Coffignon, *L'Estomac,* 181.

59 Pastoureau, *L'Étoffe du diable,* 11, 13, 40, 99.

60 Revel, *Un Festin,* 282–83. On the codification of cuisine, see Ferguson, *Accounting for Taste.*

61 Grimod de La Reynière, *Manuel des amphitryons,* 195. Jocelyne Kolb gives a short background on *l'ambigu* in her study of the doubled meaning of taste, physical and spiritual, in *The Ambiguity of Taste,* 7–8.

62 Douglas, *Purity and Danger,* 35.

63 Du Camp, *Paris,* 165.

64 Ferrières, *Nourritures canailles,* 358.

65 Flandrin, *L'Ordre des mets.*

66 In an anecdote that dramatically illustrates temporal chaos projected onto the consumer as well as her objects of consumption, Coffignon paints a portrait of la mère Jadis (Grandma Olden Days), an itinerant vendor who haunts the harlequin stalls by predilection. She earned her nickname from her infamous habit of peppering every utterance with the disjunctive time marker "in the olden days." With each encounter, the elderly woman persistently reinserts into the present a distant past in which she remembers herself as one of the belles of Paris. As she chooses her plates from the harlequin display, she projects onto each of the recycled dishes her recollections of its original incarnation in her more privileged days of dining. Her conversation is a harlequin in time, with its fragments of different temporal layers juxtaposed, wantonly cohabiting the same moment. Coffignon, *L'Estomac,* 182–83.

67 As Pierre Bourdieu has demonstrated, the sequencing of meals, and the privileging of this conformation of eating as the right and proper one, is class dependent. See Bourdieu, *Distinction.*

68 Ferrières, *Nourritures canailles,* 358.

69 Du Camp, *Paris,* 165.

70 Hamp, *Mes Métiers,* 143.

71 Ibid., 143; Aron, *Le Mangeur,* 276.

72 Barbaret, *La Bohème,* 366–68.

73 Ibid., 368.

74 Kalifa, *Les Bas-fonds.* See, too, Pike, *Metropolis on the Styx,* and Pike, *Subterranean Cities.*

75 Kalifa, *Les Bas-fonds,* 27.

76 Ibid., 37–38.

77 The frequent narrative use of "we" in accounts of the harlequin trade is a rhetorical flourish used to emphasize distance from the matter at hand, as in Aron's description here. Aron, *Le Mangeur,* 274–75.

78 Kalifa, *Les Bas-fonds,* 38.

79 Gissen, *Subnature,* 21.

80 Ibid., 25.

81 Castelnau, *Les Petits Métiers,* 48–49.

82 This gaze is represented in visual as well as narrative representations; chapter 3 brings the visual into focus with a concentration on photographic postcards.

83 Du Camp, *Paris,* 165.

84 Chavette, *Restaurateurs et restaurés,* 109.

85 Castelnau, *Les Petits Métiers,* 48.

86 Mellot, *La Vie secrète,* 43.

87 Imbert, *Les Trappeurs,* 116–17.

88 Ibid., 119. Imbert is referring to Ivan Andrievitch Krylov (1769–1844).

89 Ibid., 122. I am grateful to Stephanie Sandler for sharing with me her knowledge about Krylof and his Trishka.

90 As we shall have occasion to see later, this sort of affliction is also typical of the Harlequin character, as is the tendency to best his social betters, despite his clownlike presentation.

91 "Dis-moi ce que tu manges, je te dirai ce que tu es" is Aphorism IV in Brillat-Savarin, *La Physiologie du goût,* 19.

92 MacClancey and Macbeth, Introduction, 5–6.

93 On rags and ragpickers in the nineteenth century, see Compagnon, *Les Chiffonniers.*

94 Ferrières, *Nourritures canailles,* 360.

95 Pastoureau, *L'Étoffe du diable,* 47.

96 Castelnau, *Les Petits Métiers,* 48.

97 He adds, however, to his description of a truly repulsive lineup of food carcasses, a note to the effect that one could also find the occasional chicken just lacking its wings, timbales that have only been partly spooned into, or a roast whose twine has not been removed—all of which he takes as examples of the enormous amount of waste in bourgeois households. Coffignon, *L'Estomac,* 181.

98 Du Camp, *Paris,* 165.

99 The French metaphor for window shopping, *faire de la lèche-vitrine,* or "window licking," is literalized here. Those who could not afford to dine at the French table could lick the portals of its dwelling.

100 Coffignon, *L'Estomac,* 183.

101 Imbert, *Les Trappeurs,* 115–16; my emphasis.

102 Spang, *The Invention of the Restaurant,* 234.

103 Gaultier coined the term in 1892 to refer to a state of dissatisfaction, like a latter-day quixotism, in which the subject, prone toward escapist fantasy, ignores everyday

reality and instead imagines being a hero or heroine in a romance. Gaultier, *Le Bovarysme: La Psychologie.*

104 Gaultier, *Le Bovarysme: Essai.*

105 Sue, *Les Mystères,* 49; Zola, *Le Ventre,* 619. For Coffignon and Imbert, see earlier in this section ("Savor the Harlequins").

106 Here I am both jumping off from, and to a certain extent, parting ways with (or at least splitting hairs with), a practice of reading that is referred to as a "hermeneutics of suspicion," a term introduced by Paul Ricoeur to describe a way of reading texts to uncover their hidden, masked, or repressed meanings, as a detective might approach a plot. Paul Ricoeur, *Freud and Philosophy.* Rita Felski (among others) has written incisively and extensively on what this practice of reading means for critics and for texts, and on looking toward new hermeneutic forms. I am arguing, however, that within the notion of "suspicious reading" there is already a split into two forms of this reading. For a streamlined introduction to what is at stake in this hermeneutic approach, see Rita Felski, "Suspicious Minds." For a more extensive analysis, see Felski, *The Limits of Critique.* And for another thinking through of this approach, see Lyu, "Blank Space and Affect."

107 Again, I am not suggesting that we should—or can—dismiss the force and the authority of what I am calling the "degradational discourse" through whose filter we "know" harlequin ways of eating, but rather, that this discourse be tempered by listening more closely to other voices. The very longevity of the dominant degradational representation of the harlequin speaks to its impressive influence: twenty-first-century attitudes toward taking home leftovers from restaurant meals in France still cower in its shadow. In July 2021, the French government passed a law requiring that restaurateurs offer take-out containers to their customers to avoid the waste of discarding leftovers, after several years of encouraging the practice without actually enforcing it. In the interim, the subject of doggie bags elicited considerable debate among the French. Although a majority of French citizens supported the measure in order to combat waste (in 2016, journalists reported that 75 percent of the population believed that leftovers-to-go were good for the economy and the environment), almost the same proportion (70 percent) admitted that they had not, *could* not themselves do the deed. They cited foremost among their reasons for avoiding the doggie bag the fear of seeming "cheap" or "tight," the resemblance of leftovers to garbage, associations of leftovers eaters with beggars, disgust at the image of different foods or courses commingling in the doggie bag, and the stigma of handed-down family memories of late nineteenth-century *arlequins.* See Beizer, "Why the French Hate Doggie Bags."

108 Thévenin [*sic*], *Promenade gastronomique,* 3. My thanks to Michael Garval for this reference.

109 For a brief history of the Commedia dell'Arte, its successors, and Harlequin's place within it, see the Appendix.

110 Maurice would write an illustrated history of the Italian theater, prefaced by his mother: Sand, *Masques et bouffons.* See too Attinger, *L'Esprit de la Commedia,* 439–40, and Jacques Chesnais, *Histoire générale,* 189–93.

111 For Michele Bottini, "Arlecchino is . . . the symbol of Commedia dell'Arte, the essence, the soul and the heart." Bottini, "You Must Have Heard of Harlequin," 55.

112 Desvignes, "Prénom Arlequin," 17–18. For David Trott, Harlequin was "le symbole même du spectacle italien." Trott, "Du Jeu masqué," 178.

113 Leoni, " 'L'Autre Scène,' " 186.

114 See Rubellin, "Un Rôle fundamental," 40.

115 See Bottini, "You Must Have Heard of Harlequin," 59.

116 See Monaghan, "Aristocratic Archeology," and Sand, *Masques et bouffons,* 69–70.

117 Mazouer, *Le Personnage du naïf.*

118 Trott, "Du Jeu masqué," 178ff.

119 Ibid., 183.

120 Bottini, "You Must Have Heard of Harlequin," 58; Riccoboni, *Histoire du théâtre italien,* cited by Chilton, *Harlequin Unmasked,* 37.

121 Bourqui, *La Commedia dell'arte,* 128–29.

122 See Desvignes, "Prénom Arlequin," 19; Bottini, "You Must Have Heard of Harlequin," 56.

123 Rogin, *Blackface,* 19. My thanks to Charles Postel for conversations about connections between Harlequin and blackface. See, too, Gates, *Figures in Black,* 51–53, for a brief historical reprisal of the "curious relationship between Harlequin and the American Minstrel Man" (51), and Lott, *Love and Theft,* 21–22, for specific references, and throughout for comments about how blackface performed relationships between races that are suggestive for thinking about how the masked figures of European Commedia performed class relationships.

124 See Rubellin, "Un Rôle fondamental," 40; Bottini, "You Must Have Heard of Harlequin," 59, Chilton, *Harlequin Unmasked,* 43; Attinger, "L'Evolution d'un type," 86, 91; and Sand, *Masques et bouffons,* citing theater historian Jean-François Marmontel, 69–70.

125 Sand, *Masques et bouffons,* 72.

126 Bottini, "You Must Have Heard of Harlequin," 59.

127 Desvignes, "Prénom Arlequin," 18; the actor Biancolelli famously gave him a parrot's voice.

128 See Rubellin, "Un Rôle fondamental," 42.

129 Desvignes, "Prénom Arlequin," 17.

130 Maurice Sand points out that although Harlequin's costume retained its multicolored patches, they became symmetrical in the seventeenth century. Sand, *Masques et bouffons,* 72. The clothing painted onto Meissen porcelain Harlequins shows some variation from the Commedia: often the outfit is vertically divided, with the two jacket halves or the two pant legs bearing unmatched patterns, as if, Chilton

suggests, to denote a double personality. Often, too, the costumes were adorned with playing cards, alluding to the factor of risk or chance presented by the character. Chilton, *Harlequin Unmasked,* 39–41.

131 Chilton, however, links the rabbit tail to deceptiveness. Ibid., 41.

132 Sand, *Masques et bouffons,* 76.

133 See Attinger, "L'Evolution," for example, 95–96. It is worth mentioning that the English adjective "zany" is derived from the Commedia's zanni character.

134 Desvignes, "Prénom Arlequin," 19.

135 Ibid., 19.

136 Bottini, "You Must Have Heard of Harlequin," 56.

137 Desvignes compares Harlequin to a later entertainer-anarchist, the singer Georges Brassens, the iconic social outrider and insubordinate, in her article whose significant title bears repeating in its entirety: "Prénom Arlequin, nom de famille, peuple," 21–22, 27.

138 Ravel, "Trois Images," 60.

139 The citation is from Bottini, "You Must Have Heard of Harlequin," 56.

140 Nabokov, *Look at the Harlequins!,* 9.

141 Yeats, "Among School Children."

TWO —— URBAN CANNIBALS

1 [A character from the Italian Comedy, whose costume is made of patches of all colors. By extension, a Harlequin costume, a whole formed of disparate parts. 2. Popular: meal remnants, and especially meat remnants, so-called because this dish, which is sold for pet food but which the poor do not disdain, is composed of scraps put together by chance. 3. Familiar: he is a Harlequin, said of a man who has no firm principles, who changes his mind constantly. J. J. Rousseau, *Émile II*: Our Harlequins of all sorts imitate beauty only to degrade it.]

2 The first documented use of the term I have been able to trace is in Vidocq's *Mémoires,* 543; he also annotates the term. Here, as throughout, I translate the alimentary *arlequin* by the standard English for the theatrical *arlequin,* retaining the term "harlequin" for both; I distinguish between them by capitalizing the character's name, Harlequin.

3 *Les Mystères* was first published in serial form in the *Journal des débats* from June 1842 to October 1843. For a detailed timetable, see Gauthier, *Lire La Ville,* 30.

4 Sue, *Les Mystères,* 49. All subsequent page references to this novel are given in my text and are taken from the Lyon-Caen edition.

5 For Gauthier, this note is a distancing mechanism signaling social exoticism. See "Le Tapis-franc," 45–46. I do not disagree, but I read Sue's exoticizing practices as eliciting a more visceral disgust as well. Andrea Goulet rightly situates Sue's exoticization of the poor (what we might otherwise call "slumming") in the realm of the "domestic

exotic," though this category, as we shall see, does not remain separate from the foreign exotic. See Goulet, "Apache Dancers," 25ff.

6 Bourgeois tastes or the bourgeois "habitus," in Pierre Bourdieu's terms, "[shift] the emphasis to the manner (of presenting, serving, eating . . .) and [tend] to use stylized forms to deny function." Bourdieu, *Distinction*, 6. Bourdieu further reminds us that there is a distinction to be made between the "taste of necessity" and the "taste of liberty," and in the case of unmoneyed people like le Chourineur who do not have the luxury of liberty, substance and abundance take priority; there is no pretense of reflectively organizing a meal, sequencing and ordering its various components; similarly, there is no denial of the material functionality of eating, no moderation of verbal expressions of enjoyment, no suppression of the bodily noises of processing such pleasure. Bourdieu, *Distinction*, 6–7; see also 177–208.

7 We cannot forget Brillat-Savarin's second aphorism that distinguishes animals, men, and refined men in this way: "Les animaux se repaissent; l'homme mange; seul l'homme d'esprit sait manger" (Animals feed; man eats; only the wise man knows how to eat). Brillat-Savarin, *La Physiologie du goût*, 19.

8 Belenky, "From Transit to *Transitoire*," 408. See, too, Belenky, *Engines of Modernity*, for an expansion of this article.

9 See Kalifa's study of nineteenth-century representations of the dregs of society; as I earlier noted, he emphasizes not just a bottom space, but a downward movement: "c'est un monde qui est entraîné vers le bas, dans un mouvement toujours descendant." The concept of *residuum*, the residue, is critical to his discussion of the people and the classes who inhabit the lower depths, and who drip, trickle, drain down from above, echoing descriptions of the harlequin meal oozing down the socioeconomic food chain. Kalifa, *Les Bas-fonds*, 37–38.

10 See chapter 1 for an extended exposition of merging representations of food and eater.

11 Fleur-de-Marie's abstention is overdetermined. She must close her mouth to crass foodstuff as a kind of symbolic remediation for having opened her body indiscriminately to men; eating, like beating, like sex, involves a penetration of body boundaries.

12 "'A local proverb says, to beat a negro is to feed him.' Dutertre confirms the colonial assumption that Africans do not need to be fed, that a good beating is all the food they need." Loichot is citing the seventeenth-century apologist for slavery, Jean-Baptiste Dutertre, here. Loichot, *The Tropics Bite Back*, xvii.

13 Revel, *Un Festin*, 282–83. It is worth noting that diversity in cuisine ("l'accumulation barbare de produits hétéroclites")—or what we might today call "fusion cuisine"—is associated by Carême, according to Revel, with the savage, the foreign, the non-French.

14 Bourdieu, *Distinction*. See especially 6; 177–99.

15 I take the liberty of retranslating Roland Barthes's "fading des voix"; see Barthes, *S/Z*, 43–44.

16 I refer here primarily to the leaching down of food and the related specter of a democratization of alimentary matter and culinary codes, and secondarily, to a growing democratization of reading. While at the time of writing this early scene Sue would have been largely addressing a bourgeois upper-class public (a statement supported both by sociohistorical studies and by a slow reading of Sue's text), in the course of the sixteen-month serial publication of *Les Mystères de Paris,* his audience expanded and diversified. See Lyon-Caen, *La Lecture et la vie*; Gauthier, *Lire La Ville*; Nesci, "De La Littérature comme industrie"; Christopher Prendergast, *For the People?*; Thérenty, *La Littérature au quotidien* and "Mysterymania." As Lyon-Caen has suggested, the drama surrounding the readership of *Les Mystères* played on preexisting bourgeois anxieties about the rise of a proletarian reading class. More recently, Carolyn Betensky has provocatively argued that the much-debated influence of the working-class reading of this novel is a fantasy already recuperated, premodeled within the novel, where it enfolds an equally fantastic benevolent bourgeois reading of and by the working class. See Betensky, "Reading Fantasies."

17 See Spang, *The Invention of the Restaurant,* for an account of the Paris restaurant's evolving public-private negotiation of space and class contact. See Tompkins, *Racial Indigestion,* especially chapter 1, "Kitchen Insurrections," on the kitchen as "the space into which disorder, garbage, contagion, dirt, noise, and other abject sensory experiences are projected" (17).

18 It is an exaggerated example indeed, because, for all the class blending an eating establishment like a tavern might imply, the presence of very wealthy patrons—let alone royalty—in a tavern of the ilk of the *tapis-franc, cabaret,* or *guingette* would have been rare. The second sentence of the novel translates and details the composition of the clientele: "Un repris de justice, qui, dans cette langue immonde, s'appelle un ogre, ou une femme de même degradation, qui s'appelle une ogresse, tiennent ordinairement ces tavernes, hantées par le rebut de la population parisienne: forçats libérés, escrocs, voleurs, assassins y abondent" (35) (An ex-con, who, in that foul language is called *un ogre,* or a similarly degenerate woman, who is called *une ogresse,* usually runs such taverns, haunted by the dregs of the Paris population: they are teeming with freed convicts, crooks, thieves, and assassins). Gauthier argues that the *tapis-franc* corresponds to the *salon* as an urban center of gravity, a *lieu de rencontre* for diverse individuals. See Gauthier, "Le Tapis-franc criminel."

19 For a far-reaching exploration of the *chiffonnier* and his not unrelated work of gathering rags (and other nonfood scraps), see Compagnon, *Les Chiffoniers de Paris.*

20 See James, preface to *Portrait of a Lady,* 7.

21 The verb *piper,* from the Latin *pipare* (to squawk or to cheep) is documented in the twelfth century in France and is still used in the expression *ne pas piper mot* (to not breathe a word). The nouns *pipelet, pipelette,* however, for a male or female concierge, are more recent (the *Petit Robert* has them entering the dictionary in 1870)

and come from Sue's concierge couple. As an example of usage, the *Petit Robert* offers the sentence "Il est bavard comme une pipelette" (He is as chatty as a concierge). For an analysis of the *portier* and *portière* as embodiments of surveillance bridging public and private space, see Marcus, "The Portière."

22 My metaphors here are mixed; they all contain ideas of transmission, communication, dispatch, and transfer. We could speak in terms of a railroad stationhouse, to be *almost* chronologically correct, or more anachronistically, a telephone switchboard, or an air control tower. The most tempting metaphor, however, is, tellingly, the most modern and therefore the most anachronistic: the internet, and specifically, contemporary social media such as Facebook: vast networks of transecting lines, colliding points, and abutting lives. Sue's novel is uncannily prophetic of our current social networkings.

23 The Epilogue to *Les Mystères,* composed mostly of epistolary scraps, is a crystallized version of the novel's patchwork fabric. It includes, notably, a long letter (from one of Rodolphe's beneficiaries, Rigolette, in France, to Rodolphe in Gerolstein) that flits madly from one character to another in an attempt to fill in the unnarrated spaces of their lives.

24 Rodolphe's immediate goal is to learn more about Germain, the son of a friend whom he employs, who has mysteriously disappeared, but his aims are wider: "En louant dans la maison de la rue du Temple la chambre naguère occupée par Germain, Rodolphe facilitait ainsi ses recherches, et se mettait à même d'observer de près les différentes classes de gens qui occupaient cette demeure" (200) (By renting the room formerly occupied by Germain in the house on rue du Temple, Rodolphe facilitated his investigations, and put himself right where he could observe up close the different classes of people who lived in this space). Though grammatically speaking, *arlequin* is a noun, as used in apposition here, it is a modifier.

25 Pastoureau, *L'Étoffe du diable,* 47. See also Ferrières, to whose brief but brilliant analysis of the *arlequin* I am indebted. Ferrières, *Nourritures canailles,* 343–62.

26 Ibid., 26.

27 Batchelor, *Chromophobia,* 22–23.

28 Monnier's 1831 illustrated "scène populaire," *Le Roman chez la portière,* would be translated into a vaudeville play in 1855.

29 A "Titus-style wig" refers to a style inaugurated by the emperor Titus, repopularized during the revolution by the Jacobins. See Sue, 201n4.

30 This "tigered horse" is described in somewhat more detail as looking like a tiger, one "pocked with red-brown spots" (Sue, 214). The *Petit Robert* informs us that the notion of "tigerness" in France was rather vaguely applied to the general category of great cats—leopards, panthers, tigers, either spotted or striped—until later on in the nineteenth century. The point here seems to be the irregularity of this horse that has patches of color. It is significant that Picasso sought to position himself eccentrically, that is, to mark off his own artist's difference, his iconoclasm, by a similar strategy, seeking out striped clothing, insisting especially on vertically striped pants because,

he believed, in order to paint well, it was necessary to "se zébrer le cul" (stripe his ass). See Pastoureau, *L'Étoffe,* 133.

31 My compression of the *Oxford English Dictionary* (1971) definition of "offal."

32 See Fréjacque, *Du Pica,* 4–5, for a period source; for more recent analyses, see Edwards, *Offal*; MacClancy, Henry, and Macbeth, *Consuming the Inedible*; and Young, *Craving Earth.*

33 For a study of hospitals in nineteenth-century fiction, see Lamiot, *Littérature et hôpital.*

34 Medical signatures on the body were not invented by Sue; it was the practice of nineteenth-century doctors to sign the bodies of certain hysterical patients. See Beizer, "The Textual Woman," in *Ventriloquized Bodies.* A more recent case in which an American surgeon prepped his hysterectomy patients by branding the initials of his alma mater onto each uterus before surgery shows that the tradition has not ended. See Beizer, "Textual Women."

35 Shelley, *Frankenstein,* 226, 253.

36 It is possible to find modern reconceptualizations of Harlequin figures harking way back to medieval court jester predecessors sporting such a hat with two drooping tips, but they are not historically congruent with nineteenth-century versions of the costume.

37 It is tempting to read here an allegory of socialism gone bad, turned into capitalism, and not only for etymological reasons that trace the term "capitalism" back to the head, metonymically represented here by the cap turned inside out to become a makeshift purse. The hat-purse circulates among the common people who might be seen as controlling their own profits, but it is the ruling class representative, Fleur-de-Marie, who has masterminded the scheme. Marx somehow overlooked this scene in his scathing critique of *Les Mystères de Paris* as redemptive rather than revolutionary literature. See Marx and Engels, *The Holy Family.* An extended consideration of Marx's critique of Sue follows in Part II of this chapter.

38 The context there is the "inexplicable" attraction, like physical resemblance, notes the narrator, that draws Fleur-de-Marie toward Rodolphe, which attraction becomes "understandable" for her (if ever so much more complicated for the post-Freudian reader) once she learns that he is her father.

39 See Rivers, *Face Value,* for a history of linking physical to moral and intellectual characteristics, and a close-up analysis of nineteenth-century novelistic appropriations of the practice.

40 If race today is far from a lucid construct, its nineteenth-century antecedents were wildly fluid: rural populations and urban workers, along with overseas colonized populations, were represented as belonging to "another race." See Part II of this chapter as well as chapter 3.

41 Sue's thinking, if we transpose social and racial biases, was not unlike the indigenous child removal policies and practices in nineteenth- and twentieth-century United States, Canada, and Australia that aimed to "civilize the savage born." In the

words of Col. Richard A. Pratt, founder, in 1879, of the Carlisle School in Carlisle, Pennsylvania, the first of many schools whose mission was to reeducate Native American children: "Transfer the savage born infant to the surroundings of civilization and he will grow to possess a civilized language and habit." Cited in Mazo and Pender-Cudlip, *First Light*. See, too, Jacobs, *White Mother* and *A Generation Removed*.

42　Sue's representation of the people is part of a diptych that needs to be juxtaposed with its matching panel, his representation of exotic racial alterity (which follows in Part II of this chapter) for each to inform the other. And both representations echo and (re)produce the larger sociomoral constructs of his time.

43　As Paolo Tortonese well summarizes the contradiction, "Since responsibility is mixed with sociological causality, it ultimately deprives guilt of its fundamental premise: the free will without which neither sin, remorse, nor redemption make any sense." See Tortonese, *"The Mysteries of Paris,"* 188.

44　See Bory, *Eugène Sue*. Similarly, John Wood states that "le roman à mesure qu'il se développe le porte de plus en plus vers un rôle de réformateur et de redresseur de torts" (as the novel develops, it brings [Sue] more and more toward a role of reformer and righter of wrongs). Wood, "Situation des *Mystères de Paris*," 32. Umberto Eco offers a more complicated and qualified Marxist-influenced evaluation of an evolution of Sue the dandy to Sue the reformer "who aims at changing something in order that in the end everything will stay the same." Eco, "Rhetoric and Ideology," 556–57.

45　Sue, "Le Parisien en mer."

46　Sue, "Préface" to *Atar-Gull,* 1315–19.

47　Some of Sue's more subtle critics have noted internal changes in the unfolding of *Les Mystères de Paris,* particularly after Part IV—not surprisingly, since the author had written the first four parts before their serial publication began, and wrote the remaining six parts and epilogue in dribs and drabs as publication continued. See Gauthier, *Lire la ville,* 29–31, and Lyon-Caen, *La Lecture,* 176–89. It is indisputable that ideas for reformist projects (rarely smoothly integrated in the narrative) inundate the later parts of the novel. Eco notes that after Part V, "the action is slowed down and gives place to long moralizing lectures and 'revolutionary' propositions" (Eco, "Rhetoric and Ideology," 555). Lyon-Caen and Prendergast painstakingly analyze, with equal finesse though to different ends, the claim that Sue's readers in effect "wrote" the greater part of the novel by their impassioned epistolary reactions and suggestions to what had already appeared. Lyon-Caen (*La Lecture*) argues that reader reaction modified Sue's themes and concerns, while Prendergast (*For the People*) contests any public influence on the deep structure and ideology of the novel. Betensky, as I began to suggest earlier, proposes that a more insidious grateful working-class reading of bourgeois reading is already programmed within Sue's novel.

48　While I do not harbor the illusion that Sue's bourgeois contemporaries or near contemporaries (think: Victor Hugo, the brothers Edmond and Jules de Goncourt, Émile Zola, to name a few of the most prominent ones) were considerably more evolved in their social reformist writings, Sue is so hyperbolically extreme in his

statements, so colorfully contradictory in his rhetoric that he stands out from the rest in flamboyant relief. Anne O'Neil-Henry's argument that Sue's formal and stylistic choices over the course of his writing career were cannily made for strategic commercial reasons, and that he "picked up on trends and tailored elements of his existing work according to contemporary fashion" runs parallel to my reading of his internal swings within *Les Mystères*. O'Neil-Henry, *Mastering the Marketplace*, 91.

49 In Loichot's terms, such a portrait of people as cannibals takes the designation of "cannibal zone," which she explains as "the zone in which people have been systematically imagined as cannibals according to their geographical location . . . or ethnicity and race." Loichot, *Tropics Bite Back*, 144–45.

50 Kalifa, *Les Bas-fonds*; see especially 122–42.

51 Ibid., 10–11.

52 To be clear, I am referring to the second chapter, "L'Ogresse," and the last chapter of the novel's main body, "Le Doigt de dieu"; the mirroring texts are, technically, penultimate framing devices. The novel has an epilogue that carries the reader and the most significant surviving characters safely out of Paris and off to a wonderland called Gerolstein (presumably part of the Germanic Confederation) far from the roiling masses of Paris and the minor plot threads that remain to be tied up by letters from abroad. And it has an opening chapter that introduces the reader to that Othered Paris analogous to James Fenimore Cooper's American frontierland: Sue's Paris is an urban range qualified as a "mire" and an "impure cesspool," overrun by swarming "savages" and "barbarians at our elbows" who speak a "mysterious" language whose metaphors are "dripping with blood" (35, 37).

53 The noun *cannibale,* from the Arawak *caniba,* is assumed to be a corrupt form of the name *cariba* (bold or hardy), by which the indigenous Antillais designated themselves, while the noun *canaille* (riffraff, rabble) has as its root the Latin *canis* (dog). Columbus and his followers believed that the Arawak term for cannibal was derived from the Latin *canis*; this was a case of both false etymology and antique lore that included Cynocephali, dog-headed humans, in a sequence of monstrous races presumed to eat human flesh and drink human blood. See Lestringant, *Cannibals,* 15–22.

54 See chapter 1, and Part I of this chapter.

55 Kilgour, *From Cannibalism to Communion,* 8.

56 While the joke appears to be on le Chourineur and his kind, who seem to have prodigious digestive systems that allow them to eat all manner of refuse, what is going on at another level is what we might call "social indigestion," extending Kyla Wazana Tompkins's term "racial indigestion": the lower classes are what stick in the gorges of their social betters. Their speech, like their food, does not go down easily. Tompkins, *Racial Indigestion,* especially chapter 3, 89–122. Goulet makes a similar argument about popular disorder in terms of dance, characterizing "le chahut" as the underside of socially accepted dance forms. Goulet, "Apache Dancers," 37–40.

57 Lyon-Caen, *Dossier* to Sue, *Les Mystères de Paris,* 1220, 1225.

58 To be clear: it is not that Fleur-de-Marie *cannot* speak prison slang, for we hear her speak one sentence of it to le Chourineur at the opening of the novel, after he strikes her: "N'approche pas, ou je te crève les *ardents* avec mes *fauchants*" (40) (Don't come any closer, or I'll bust your eyeballs with my claws); it is rather that she *does not*; and after uttering this single warning to le Chourineur she switches codes, with the arrival of her unknown savior (Rodolphe), never to lapse into the low language again. Fleur-de-Marie's inconceivably well-bred diction, like her improbably wholesome voice and her disdaining of plebeian plates, like so many other elements of this novel, might be considered less as unbelievable threads to be pulled from the text than as the ground zero for our reading. As Edgar Allan Poe, who admittedly had a bone to pick with Sue's *Mystères* concerning plagiarism, commented on this novel: "The incidents are consequential from the premises, while the premises themselves are laughably incredible." Poe, *Marginalia* 176, 292.

59 Derrida speaks of the incorporation of what one is eating as "un procès, un processus, différencié et temporalisé, au cours duquel il faut bien qu'il y ait un moment où ce que je mange fait déjà partie de moi (par exemple une fois mâché, mastiqué, ensalivé: la bouchée passe toujours par un moment où elle fait partie de moi avant de disparaître derrière ma bouche)" (a proceeding, a process, differentiated and temporalized, in the course of which there has to be a moment where what I am eating is already part of me [for example, once chewed, masticated, salivated: a mouthful always moves through a moment at which it is part of me before disappearing beyond my mouth]). Derrida, *Manger l'autre* 11, 2. Conversely, in a reflection on Saint Augustine, Derrida remarks: "On définit le propre par cette convertibilité irreversible en moi . . . Même les nourrices, note A[ugustin] rendent aux enfants les aliments qu'elles ont mâchés, ce que le sens du goût en a soustrait et transformé dans le corps de la nourrice ne pourra être rendu, restitué à personne. Et il en va de même pour les narines. Tu peux aspirer l'air que j'aurai rendu, tu ne pourras aspirer ce qui aura été converti en ma nourriture" (The proper/clean is defined by an irreversible convertibility into myself. . . . Even baby nurses, Augustine notes, give infants food they have chewed, but whatever the sense of taste has drawn out of this food and transformed in the body of the nurse cannot be transferred or restored to anyone else. And it's the same for the nose, you can breathe in the air that I have exhaled, but you cannot inhale what has already been converted into my nourishment). Derrida, *Rhétorique du cannibalisme* 7, 17. I am suggesting that what is taken away, ineffably even, by a first bite, first taste, first lick, first inhalation or exhalation, has as its counterpart an addition, conceivably also ineffable.

60 Miller, *The Anatomy of Disgust,* especially 89–108.

61 Visser, *The Rituals of Dinner,* 313–15.

62 Weil, "Let Them Eat Horse," especially 96–102. See, too, F. Xavier Medina's comments on the changing status of animals throughout history and the relationship between their status as subjects and as consumable meat, in "Eating Cat."

63 Kilgour reminds us that eating is characterized by ambivalence: "it is . . . an act that involves both desire and aggression, as it creates a total identity between eater and eaten while insisting on the total control . . . of the latter by the former. . . . It assumes an absolute distinction between inside and outside, eater and eaten, which, however, breaks down as the law 'you are what you eat' obscures identity and makes it impossible to say for certain who's who." Kilgour, *From Communism to Cannibalism,* 7.

64 Berenstein, " 'A Child Is Being Beaten,' " 152–53.

65 For Karl Marx, Rodolphe makes of le Chourineur a completely devoted sycophant: he calls him a moral bulldog. Marx and Engels, *The Holy Family,* 164.

66 Fleur-de-Marie's tale of torture appears in retrospect to have greater parabolic than real status; just after recounting it to le Chourineur and Rodolphe, she smiles, and appears by some miracle to have regenerated the tooth, to have remained intact: "Et elle entr'ouvrit en souriant une de ses lèvres roses, en montrant deux rangées de petites dents blanches comme des perles" (58) (And as she smiled her parted rosy lips revealed two rows of tiny, pearly-white teeth). Seeking logic, one might wonder whether la Chouette pulled a late-falling baby tooth, though the child believes she was seven or eight at the time. In any case, the point is symbolic rather than logical, since the narrative very deliberately reveals her two rows of perfect teeth immediately after the story of the extraction, as if echoing Rodolphe's unrealized project of restoring her purity. As in so many other moments of our Sue experience, we need to suspend our disbelief and keep reading.

67 Describing her chambers in the palace of Gerolstein, he writes of "L'appartement occupé par Fleur-de-Marie (nous ne l'appellerons la princesse Amélie qu'officiellement)" (1176) (The apartment occupied by Fleur-de-Marie [we will only call her la princesse Amélie officially]).

68 Batchelor, *Chromophobia,* 17–18. Batchelor in turn cites Bakhtin's *Rabelais and His World,* 320. I am grateful to Irene Carvajal for conversation and references from an artist's perspective.

69 Peter Brooks notes "Rodolphe's attempt to revirginize Fleur-de-Marie" in his foreword to Sue, *The Mysteries of Paris,* xv.

70 Goethe, "Pathological Colours," para. 135, 55.

71 Blanc, *Grammaire des arts du dessin,* cited by Batchelor, *Chromophobia,* 23–25.

72 Isidore of Seville, *Etymologies,* xix.17.1. Michael Taussig derives the word *color* from the Latin *celare* (to conceal) and argues that it is related to deceit in many languages. Taussig, *What Color Is the Sacred?,* 18.

73 Taussig, *What Color Is the Sacred?,* 9, 17–18.

74 Le Corbusier, *Journey to the East,* cited by Batchelor, *Chromophobia,* 42.

75 Batchelor, *Chromophobia,* 41.

76 Ibid., 22.

77 Taussig, *What Color Is the Sacred?,* 96.

78 A useful example drawn from modern popular material culture is coloring books; initially an American artifact of this very same tradition, they teach children to keep

their color inside the lines. The evolution of the Harlequin costume might also be understood within this aesthetic hierarchizing, in which renegade color is made submissive to the mastery of design. Originally presented as haphazard spots and stains of color strewn on a light background, the costume became formalized as blocks of patterned color. Stylized in this way, the blots are regularized and contained. In Part I of this chapter, I elaborate on this evolution. See Maurice Sand, *Masques et bouffons,* 72; see also the progression of evolving Harlequin costumes illustrated throughout. See, too, Michel Pastoureau on *le tacheté* (the spotted): "Le tacheté est un semé irrégulier. Non seulement les petites figures sont disposées de manière désordonnée mais elles ont elles-mêmes une forme irrégulière . . . elles traduisent une idée de désordre, de confusion, de transgression" (The spotted is an irregular kind of spangling. Not only are the small configurations arranged in a disordered manner, but they themselves have an irregular form . . . they convey an idea of disorder, confusion, and transgression). Pastoureau, *L'Étoffe du diable,* 40.

79 Laura Anne Kalba convincingly argues that the force of Impressionist use of color was tied to material color production (in chemistry, optics, commerce, and various other forms of technology) in that era. See Kalba, *Color in the Age of Impressionism,* especially 1–13. See, too, Batchelor, *Chromophobia,* especially 21–49. See chapter 4 of *The Harlequin Eaters* for more on this.

80 The appropriateness of multihued patches and rags to the masses had already been theorized by Goethe, who had announced not only the appeal of bright colors to children and uncivilized nations, but also the allure to these groups of "the motley" and "the juxtaposition of vivid colours without an harmonious balance." Goethe, *Theory of Colours,* para. 835, 326.

81 Here once again Sue is true to Goethe, who notes, "People of refinement have a disinclination to colours." *Theory of Colours,* para. 841, 329.

82 The African site of the original trade in black captives and of the delivery of the white captives is left vague by Sue, who identifies it as "vers le sud de la côte occidentale d'Afrique" (towards the south of the west coast of Africa); *Atar-Gull,* 159. Subsequent page references to this novel are given in my text (83–92) and are to the Laffont edition. Henri Mitterand assumes the site to be the coast of Senegal, but Clint Bruce makes a rather convincing case that it is (though *anatopically,* given the history of such expeditions and the location of trading posts) somewhere south of the equator near the Orange River, which forms the border between what are today Namibia and South Africa. Bruce further argues that *anatopia* is the ruling principle in the geography of *Atar-Gull* for both Africa and the Caribbean: a way to defy verisimilitude and to "evok[e] the colonial project in its entirety." He makes a strong case, but Sue seems to me to be too weak a vessel to carry it. See Mitterand, "L'Esclave et le paralytique," 98; Bruce, "Looking at the Colonial Atlantic," 249–52.

83 "Je les aide à se débarrasser de leurs prisonniers, et après tout je rends service à tout ce monde-là; autrefois ils se mangeaient comme des bêtes féroces, et les *Namaquas* de la rivière Rouge font encore de ces plaisanteries-là, parce qu'ils n'ont aucun

moyen d'exportation" (164) ("I help them to get rid of their prisoners, and after all, I'm doing a service for those people; otherwise they would eat each other like savage beasts, and the *Namaquas* of the Red River still indulge in such pranks because they have no other means of export").

84 Loichot points out that the tongue holds a specific place in the context of enslavement, where two practices were common: that of cutting out the tongue of Africans perceived as rabble-rousers by plantation owners, and that of using the tongue as a suicide weapon, for swallowing one's tongue was the only means of self-inflicted death available to a shackled person. The two acts are hyperbolic versions of already pathologized practices of speaking and eating. See Loichot, *The Tropics Bite Back,* 45–46.

85 The year after publishing *Atar-Gull,* Sue wrote two texts in which cannibalism played a critical role: a short story published in *Le Saphir,* "Relation veritable des voyages de Claude Belissan, clerc de procureur," and a maritime novel, *La Salamandre.* In the first, a foolishly philosophical clerk, too full of his Rousseau, leaves civilization behind after being jilted by a woman. Seeking a kinder world in French Polynesia, he is put ashore on an island in the Marquesas, where he meets his end in the mouths of members of a local tribe, after mistakenly assuming a fraternal welcome from the vividly painted chief he embraces as his equal. During the ensuing cannibal feast, the chief is served the gastronomical tribute of Claude's ears—perhaps because they are plumped up with Rousseau. His Polynesian brother turns out to be less noble than savage. In *La Salamandre,* Sue offers a scene of white cannibalism clearly modeled on the wreck of the *Medusa.* The surviving crew and passengers of the *Salamandre,* cast off from the sinking ship on a flimsy raft, are soon without food and water and become victims of *la calenture,* a fever well described in various medical dictionaries and treatises of the period, which was presumed to strike sailors, mostly in the tropics. Struck by too much sun, red-lipped, fiery-eyed, and stained dark, they are subject to mirages and delusions—visual and imaginary disturbances—that here lead to unfortunate meal choices. We hear echoes of Isidore of Seville's suggestion of a vital connection between light, heat, and color through the etymology he derives of the Spanish *color* from *calor*; these white men have become like primitives, their heightened color and their fever altering their behavior and assimilating it to the unruly nature of savage, childlike, colorful Others. For an extended modern review of calenture, see Alhadeff, *The Raft of the Medusa,* 45–83.

86 The slave trade and cannibalism are repeatedly juxtaposed in Sue's novel, as in the earlier-cited case when *le père* Van-Hop explains that the *grands Namaquas* no longer practice cannibalism since they sell off their enemies as slaves, while *les petits Namaquas* do because they don't have trade outlets (88).

87 Montaigne, "Des Cannibales"; see especially 303–4.

88 Though as Christopher L. Miller points out, it is rather late in the game for Sue to be "exposing" the slave trade, which, at the time he wrote *Atar-Gull,* was "finally, effectively, and almost entirely put out of business." Miller explains that the law of March

4 (1831), together with an agreement with the British, "imposed real enforcement on the high seas and truly criminalized the slave trade." Miller, *The French Atlantic Triangle,* 277–78. Sue gets on the boat a little late.

89 The Montyon "prix de vertu," to be awarded annually henceforth by the Académie française, was founded in 1782 by Antoine-Jean-Baptiste-Robert Auget de Montyon. It was expressly intended for a poor French citizen who had performed a virtuous action. See Blix, "The Storming of the Academy." In 1832, the year following the publication of *Atar-Gull,* the prize was awarded to Eustache Belin, a former slave and "bon nègre" who had betrayed his fellow slaves to save his master's family during the Haitian revolution. Christopher Miller and Léon-François Hoffmann remark on the uncanny timing, assuming that "la réalité dépasse la fiction" (truth is stranger than fiction); I add to the mix my strong conjecture that Sue had heard rumors about the following year's awarding of the prize and rewritten it ironically into his novel. Quotes are from Hoffman, *Le Nègre romantique,* 207–8; see, too, Miller, *The French Atlantic Triangle,* 296.

90 Sand, *Masques et bouffons,* 76.

91 Detienne and Vernant, *Les Ruses de l'intelligence,* 10. As Susan Buck-Morss has so compellingly suggested, the nineteenth century had also more recent models for the master–slave dialectic than the Greeks; they had only to look back to the late eighteenth century to see the slaves in Saint-Domingue rise up against their masters. See Buck-Morss, "Hegel and Haiti."

92 It is interesting that while Atar-Gull poisons the plantation animals and Wil's daughter, he reserves for the plantation master a slower, crueler death by negative control of diet.

93 Detienne and Vernant, *Les Ruses,* 22.

94 Sue does grant that Cooper has talent to surmount the episodic problem, however: "Je sais qu'il était donné à un talent tel que le vôtre, Monsieur, d'encadrer, de resserrer dans le cycle de l'unité, les scènes immenses que vous avez décrites, et de résoudre un problem insoluble pour tout autre" (*Atar-Gull,* 1319) (I know that only someone as gifted as yourself, Monsieur, would be able to frame the immense scenes that you have described, to contain them within a single unity, and to resolve a problem that would be unsolvable for anyone else). Sue offers no mention of Homer, whose *Odyssey* does not seem to have suffered too badly from the problem of multiple seaports. My thanks to Gabriella Safran for this observation. For Margaret Cohen, *Atar-Gull* and Cooper's maritime novels are belated examples of the "maritime picaresque." See Cohen, *The Novel and the Sea,* 8.

95 Here readers recognize the vocabulary of melodrama, a genre built on the contrasts of excess, of which Sue was a major practitioner. See the classic studies by Brooks, *The Melodramatic Imagination,* and Prendergast, *Balzac;* see Cohen on the echo of melodrama in Sue's turbulent ocean scenes: *The Novel and the Sea,* 173–74.

96 Poe, *Marginalia* 176, 292.

97 Bory, *Eugène Sue,* 127.

98 One contemporary critic, S. Silvestre de Sacy, joked that this novel obeyed a triple ruling principle, the antithesis of classicism's "trois unités": "les trois multiplicités." Quoted by Tortonese, *"The Mysteries of Paris,"* 184.

99 In his chapter on *Atar-Gull,* Christopher Miller poses the question of "whether [Sue's] irony can be translated into a serious message" and concludes, a bit uneasily perhaps, that it can. Like Miller, I find Sue's irony unsettling and puzzling, but in the end more self-corrosive. See Miller, *The French Atlantic Triangle,* 274–99, especially 297–98; also Bruce's fascinating "Looking at the Colonial Atlantic," on Sue's irony (which Bruce attaches to European claims to knowledge about Africa rather than slavery), an irony the author finds somewhat more convincing than I do.

100 Cecily, who, by Rodolph's plotting, will tempt Jacques Ferrand to his death, is the incarnation of nineteenth-century European stereotypes about the Creole woman, oversexed, colorful, overheated, irresistible: "à la fois svelte et charnue, vigoureuse et souple comme une panthère . . . le type incarné de la sensualité brutale qui ne s'allume qu'aux feux des tropiques" (869) (at once svelte and fleshy, athletic and as supple as a panther . . . the incarnation of brute sensuality that only gets switched on under tropical lights). Should we be surprised that her head is covered with a cloth "aux couleurs tranchantes . . . bariolé de pourpre, d'azur et d'orange" (869) (of garish colors . . . streaked with purple, blue, and orange)?

101 See Goulet on the spatializing of social issues in *Les Mystères* and *The Wire,* and the related task of containing popular violence. "Apache Dancers," 34, 36.

102 Algeria was not the initial solution considered for le Chourineur; Rodolphe had intended to establish him in a butcher shop (a step up from the slaughterhouse) north of Paris. But when he asked le Chourineur to slay some sheep (testing him for recidivism to his former passion for slaughter), so extreme a crisis was provoked (returning him not only to the trauma of his slaughterhouse days but also to the act of human murder, with allusions to cannibalism, that followed) that Rodolphe understands professional butchery is no longer a viable outlet; le Chourineur has shown signs of a "sainte exaltation du remords" (176) (saintly glorification of remorse) that has grown over his savage instincts.

103 The site of Tom Wil's death in *Atar-Gull* is the (no longer existing) rue Tirechappe near Les Halles in the then 4th, now 1st arrondissement; the tavern where le Chourineur dies in the violent orgiastic last scene of *Les Mystères de Paris* is on an unspecified street somewhere farther south-central in the city, in what would today probably be the 13th or 14th arrondissement; the crowd is heading toward what was then "la barrière Saint-Jacques," now the Place Saint-Jacques in the 14th. At the risk of bombarding my reader with yet another example of Sue's double-voiced discourse, I offer it for purposes of emphasis: "La cohésion, l'augmentation inquiétante de cette race de voleurs et de meurtriers est une sorte de protestation vivante contre le vice des lois répressives . . . Encore une fois, ces êtres déshérités, que Dieu n'a faits ni plus mauvais ni meilleurs que ses autres creatures, ne se vicient, ne se gangrènent

ainsi incurablement que dans la fange . . . où ils se traînent en naissant" (1149) (The cohesion, the alarming increase of this race of thieves and murderers is a sort of living protest against the vice of repressive laws. . . . Once again, these disinherited souls that God made neither better nor worse than his other creatures, turn irrevocably to crime, to corruption only in the mire . . . where they are submerged from birth).

104 Guy Geltner writes: "Few punishments are not corporal . . . Most licit penalties—now as in the past—can involve bodily damage, brief or lasting physical alteration, or simply mild, acute, or chronic pain, even if they are not ostensibly violent or designed to be painful or general consequential to an offender's body." See Geltner, *Flogging Others,* 20.

105 Derrida points out that eating *with* the Other may mean both eating in the company of the Other and eating the Other along with another food: "Manger avec l'autre . . . le partage du repas, la commensalité . . . mais 'avec' pouvait d'autre part . . . désigner aussi une modalité du 'manger l'autre': on mange avec l'autre, comme on dit prendre son petit déjeuner avec du café . . . comme on boit du vin avec du fromage. . . . Question de compagnie et d'accompagnement. Et ces deux régimes, si on peut dire de l'avec, ne sont pas contradictoires ou incompatibles" (Eating with the other . . . sharing the meal, commensality . . . but "with" could also, on the other hand, designate a modality of "eating the other": one eats with the other, in the same sense that we talk about having breakfast with coffee, drinking wine with cheese. . . . It is a question both of company and of accompaniment. And these two modes of "with," so to speak, are neither contradictory nor incompatible). Derrida, *Manger l'autre* 5, 124.

106 The essay bears the notable distinction of being Freud's only work that begins with a focus on a feminine perspective, though his handling of this perspective has been much criticized for its assumptions about women, viewing, and masochism.

107 See the essays in Person, *On Freud's "A Child,"* for the first, and for the second, Doane, *The Desire to Desire*; Doane, Mellencamp, and Williams, eds., *Re-Vision*; Massé, *In the Name of Love*; Rodowick, *The Difficulty of Difference*; Silverman, *The Threshold;* Williams, ed., *Viewing Positions.*

108 Jacques Lacan, *"On Bat Un Enfant,"* 118.

109 Viñar, "Construction of a Fantasy," 183, 187–88.

110 As Umberto Eco observes, "It happens that Sue behaves sometimes like a mere observer who has no power over a world that escapes him, whereas at other times he lays claim to the divine right of the novelist to be omniscient." "Rhetoric and Ideology," 562.

111 Though Marx coauthored *Die heilige Familie* with Engels, he wrote the greater part, and most significantly, was the author of the chapters (V and VIII) on *Les Mystères de Paris.* His target was the group of new Hegelians, and especially a certain Herr Szeliga, who had sung the novel's praises, so in taking aim at them he needed to demolish Sue's work.

112 See Eco, "Rhetoric and Ideology" (557). Marx, *The Holy Family,* chapters V, VIII (176, 180, 194).

113 "Rudolph has only to take a look at the existing legislation in other counties. *English law fulfills all his wishes."* Ibid., chapter VIII (198).

114 Ibid., chapter VIII (199–200); chapter V (63).

115 Charentenay and Goudmand, "Fiction et idéologie." The number given in parentheses refers to the corresponding paragraph in the electronic text.

116 See Lyon-Caen's *La Lecture* and Prendergast's *For the People?* for the best treatments of the debate.

117 *Dandy mais socialiste* is the title of the reprinted edition of Bory's biography of Sue, and expresses the core of his judgment of Sue. Eco, "Rhetoric and Ideology," 555; Lyon-Caen, *La Lecture,* 186. Among Lyon-Caen's closing reflections on Sue's volatile stances are the following: "Sue *a tissé* dans son oeuvre *tous les fils* qui constituent . . . la question sociale" (186) (Sue *wove* into his work *all the threads* that compose . . . the social question); "Ce caractère fondamentalement *composite* du roman" (186) (This fundamentally *composite* nature of the novel); "La nature *feuilletée* du *texte*" (186) (The *foliated* nature of the *text*); "De *nombreuses composantes* du discours complexe des années 1840" (187–88) (The *numerous components* of the complex discourse of the 1840s); "*Une mosaïque* de discours sur le travail et la misère" (188) (*A mosaic* of discourses on work and poverty) (my emphasis).

THREE —— POSTCARDS FROM THE EDGE

1 Derrida, *La Carte postale.*

2 My thanks to Xavier Donat, a professional collector, for his assistance in dating this card. It is not always possible to do so with any precision, and one looks to clues that allow an approximation of the date: a legible postmark, a dated message, the card's formatting (which changed in France between 1903 and 1904). See Bourgeois and Melot, *Les Cartes postales,* 28–31. I have been able to situate all the cards I discuss as within the first twelve years of the twentieth century, and I give more precise indications when they are available.

3 Oddly, the legend, "Les restes . . . sont vendus, chaque plat séparément," explains the image erroneously, contradicting what we see, for however blurred the pictured plates are, they do patently present a mixture of scraps.

4 On the fate of food presumably withdrawn from circulation, but in fact recirculated outside of urban bounds and regulations, see chapter 1.

5 In a chapter on the artist Fernand Pelez, a contemporary of the postcard photographs I am considering, Linda Nochlin suggests that "the [generic] figure of the impoverished old man . . . seems to be a primary signifier of misery for many artists at the turn of the century." Nochlin, *Misère,* 152.

6 As I explore in more detail in chapter 1, the *marchande d'arlequins* negotiates the social and economic space between wealthy homeowners and restaurant proprietors, whose leftover food makes its way to her custodial and curatorial services (through

the intervention of house servants and restaurant staff), and the working-class population that feeds on the reworked remains. Although as a small tradesperson she too was a member of the laboring classes, she had a steady job, income, and source of food. It was not uncommon for a *marchande d'arlequins* to retire early on her earnings.

7 Bennett, "The Exhibitionary Complex," 124. On the complicity of criminology, medicine, and photography in a vast enterprise aimed at making identity legible, see Didi-Hubermann, *Invention de l'hystérie,* especially 32–68, and Tagg, *The Burden of Representation.*

8 The pervasive complexity of this panoptical system of classification cannot be overstated, nor can the intricacy of its network of overlapping subbranchings. To this day they still map how (and even whether) we access the various spheres of nineteenth-century social life. For example, until I learned that the *marchande d'arlequins* was categorized within *les petits métiers,* or alternatively under the rubric "*Paris vécu,*" my ability to find published or archived materials was severely limited. That these rubrics correspond to postcard headings suggests the strong possibility that they originated within this medium and from there passed to other systems of knowledge.

9 The postcard caption "Les Arlequins" and its referent are supremely ambiguous: as preceding chapters discuss, the term is slang for leftover food, but connotes too its raggedy consumer, connected to its Commedia antecedent, the character Arlecchino, Arlequin, or Harlequin, through the plate of scraps that takes his name.

10 This is Susan Sontag commenting on Godard and Gorin's 1972 film, *A Letter to Jane.* Sontag, *On Photography,* 108.

11 As Roland Barthes's photographic mantra, *ça-a-été* (this has been), insists, the genre is identified by its registering of *what has been,* a capture that attests to, certifies, authenticates, ratifies, establishes, and guarantees its object to have been real. Nobody who sees a photo of something can deny "que *la chose a été là*" (that *the thing has been there*). Barthes, *La Chambre claire,* 120; see especially 120–39. There has long been a tendency among photographers and their audiences to believe, even if not wholly, in the transparency of the genre. Some of its best critics have argued that photos had evidentiary status well before the category of documentary was introduced in 1926, with the advent of cinematic documentary. See, for example, Solomon-Godeau, *Photography at the Dock*; Rosler, *Decoys and Disruptions,* especially "In, Around, and Afterthoughts (On Documentary Photography)" and "Post-Documentary, Post-Photography"; and Tagg, *The Burden of Representation.*

12 As Sontag reminds us, "Nobody takes the same picture of the same thing. . . . Photographs are evidence not only of what's there but of what an individual sees, not just a record but an evaluation." Sontag, *On Photography,* 88. But if it is true that we would today find it naive to defend the ostensible transparency of the photograph, its access to a preexistent "reality" that we recognize as constructed rather than simply reflected, it is also true that photography is one of those windmills whose power we continue to harness even as we pretend to tilt against it.

13 The two sides of postcards have not always presented as they do today, with one side reserved for an image and the other, divided so as to accommodate an address and a message. Before late 1903 in France, the address side (originally known as the recto) was not divided; any message had to be written around or over the image on the other side, known as the verso. The recto/verso nomination changed with the divided back. For more information on this and other general postcard history, see Bénard and Guignard, *La Carte postale*; Bourgeois and Melot, *Les Cartes postales*; Cure, *Picturing the Postcard*; Garval, "Visions of Pork Production"; Hossard, *Recto-Verso*; Klich and Weiss, *The Postcard Age*; Malaurie, *La Carte postale*; Phillips, *The Postcard Century*; Prochaska and Mendelson, *Postcards*; Ripert and Frère, *La Carte postale*; Schor, *"Cartes postales"*; Staff, *The Picture Postcard*; Stephens, "Framing the Eiffel Tower"; Zeyons, *La Belle Époque.*

14 Such photographs, shorn of their postcard format, can be found recirculating in a variety of chronicles of the period dating from the late nineteenth century to the present. They are offered in representations of Paris that span a range of foci: explorations of the darker corners of the City of Light, chronicles of small tradespeople and the daily life of the poor, sociohistorical studies of Les Halles and other marketplaces, histories of French restaurants. For some recent examples, see Gaudry, *Mémoires du restaurant*; Mellot, *La Vie secrète*; Sante, *The Other Paris.*

15 I prefer this spelling to the more common *pastness* for its emphasis on passage and temporality.

16 "L'effet . . . n'est pas de restituer ce qui est aboli . . . mais d'attester que cela que je vois, a bien été La photographie a quelque chose à voir avec la résurrection" (The effect is not to reinstate what is no longer there, but to attest that what I see, *has been.* . . . Photography has something to do with resurrection). Barthes, *La Chambre claire,* 129.

17 "Je ne suis ni un sujet ni un objet, mais plutôt un sujet qui se sent devenir objet . . . je deviens vraiment spectre" (I am neither subject nor object, but rather, a subject who feels himself becoming an object. I am really becoming a specter). Ibid., 30.

18 Reported anonymously from an October 1904 article in *Le Figaro illustré* by Ripert and Frère, *La Carte postale,* 76. Similarly, Hossard looks back to early photographic postcards as "une sorte de 'pour voir comment c'était avant'" (a kind of reminder "to see how it used to be"). Hossard, *Recto-Verso,* 54. Christian Malaurie relates photographic postcards to mourning, and adds that "la nostalgie idéalise le temps d'avant la diligence, du chemin de fer ou du cabaret. Ce 'bon vieux temps,' ce siècle . . . l'exhume comme un trésor, il le forge au gré de ces rêves" (nostalgia idealizes the times before the stagecoach, the railroad, or the cabaret. Our century digs up these "good old days" like treasure, it forges them to fit our dreams). Malaurie, *La Carte postale,* 201.

19 Yriarte, *Paris Grotesque,* 4–5.

20 For art historian and philosopher Georges Didi-Huberman, looking back at photographic images of bodies taken at the fin de siècle in the Salpêtrière Hospital,

the impression of spectrality is both a technical and a philosophical problem. He discusses veiling and haloing effects as phenomena of light and shadow related to the early state of the art (especially in the 1880s–90s)—effects that, unnervingly, are still not completely understood today. Didi-Huberman, *Invention de l'hystérie,* 89–90. Though he signals that such mechanical and methodological problems are at least vaguely attributable to technological technicalities such as slowness of the apparatus, time of pose and exposure, and chemical procedures, Didi-Huberman also places himself in the context of other philosophical theorists. Thinking back through philosophers including Walter Benjamin and Roland Barthes, he muses on the fact that the photograph is fundamentally an impression made by light, which endows it with an eerie, ghostlike quality. Invoking the legend of Veronica's veil, in which a cloth used to wipe the sweat and blood from Jesus's dripping face miraculously took on an image of his face (similar to the Christic visage imaged on the Shroud of Turin), Didi-Huberman compares the photograph to the revelation of such an invisible imprinting: the emanation of a body caught across space in a representation. Didi-Huberman, *Invention de l'hystérie,* 92–93. For Barthes as well, the photo is "littéralement une émanation du référent" (literally an emanation of the referent). While Barthes maintains that photography was invented not by painters but by chemists, he also qualifies it as phantasmatic and supernatural: "une *magie,* non un art" (*magic,* not art). Barthes, *La Chambre claire,* 126, 128. Well before Barthes and Didi-Hubermann, Nadar had spoken of the invention of photography as a materialization of "le spectre impalpable qui s'évanouit aussitôt aperçu" (the impalpable specter that disappears as soon as it is perceived). Nadar, *Quand J'Étais Photographe,* 13. (Nadar was the nom de plume of Gaspard-Félix Tournachon, one of the earliest French photographers, best known for his photographic portraits of writers, artists, musicians, and other period celebrities.) Speaking further (and, we imagine, tongue in cheek) of photography's unsettling emergence in the early nineteenth century and of the "superstitious hesitation" it inspired, Nadar evokes magic and spirits: "envoûtements, évocations, apparitions" (enchantments, ghosts, apparitions), and goes on to conjure up sorcery, potions, and Satan: "La nuit, chère aux thaumaturges, régnait seule dans les sombres profondeurs de la chambre noire, lieu d'élection tout indiqué pour le prince des ténèbres. Il ne fallait qu'un rien vraiment pour de nos filtres faire des philtres" (Night, dear to magicians, ruled the murky depths of the darkroom, that special lair ready-made for the prince of darkness. The merest trifle turns our filters into philters). Nadar, *Quand J'Étais Photographe,* 14. A few decades later, in his reflections on the development of photography, Walter Benjamin referred to its stereotype as "this black art from France." See Benjamin, "Little History," 275.

21 Tagg mentions the prephotographic portrait machine, the physionotrace, invented in 1784 and used until the daguerreotype was perfected, as instrumental in conventions of profile portraiture. The process involved a wood armature that traced, by candlelight, the silhouette of the sitter's face onto a copper engraving plate that

could then be used to print it. The precision of the portrait depended on its being done in profile. See Tagg, *Burden of Representation,* 35–36.

22 Ibid., 36, 194–95. Tagg reads Daumier's satire as applying to the sitters' self-presentation as well as the photographers' perspective; his "natural man" presents himself bluntly to the camera, as is, while his preening "civilized man" prepares a visage and an angle for the camera.

23 Nadar, *Quand J'Étais Photographe,* 14–18.

24 In *Reading National Geographic,* their book on the photographic workings of ideology in that magazine, Catherine Lutz and Jane Collins discuss how facing the camera and returning its gaze opens the photographed subject to minute scrutiny and evaluation "as . . . type." They offer compelling statistical evidence to support the thesis that "those who are culturally defined as weak—women, children, people of color, the poor, the tribal rather than the modern, those without technology—are more likely to face the camera, the more powerful to be represented looking elsewhere." See Lutz and Collins, *Reading National Geographic,* 199.

25 Ibid, 199.

26 Feminist film theory going back to the 1980s explored how viewing positions under the regime of patriarchy are split along male/female axes aligned with an active surveyor and a passive surveyed. Solomon-Godeau among others argued that photography, like film, encourages power viewing relations structurally analogous to the gendered spectacular model, regardless of the gender of photographed subjects. Solomon-Godeau, *Photography at the Dock,* 263. Solomon-Godeau, building on Laura Mulvey's work, offers examples of analogous viewing positions not necessarily predicated on women and men, yet perfectly accorded to the feminine/masculine power structure: "The terms by which Sicilian peasants became camera fodder for a paying and desiring 'master' are not structurally dissimilar to less exotic photographic transactions: artist-photographer and working-class model, ethnographer/anthropologist and native subject, documentarian and down-trodden victim" (263).

27 Schor, *"Cartes postales,"* 216.

28 See the groundbreaking work of Catherine Nesci, *Le Flâneuret et les flâneuses.*

29 Sontag in fact calls the photographer "an armed version of the solitary walker reconnoitering, stalking, cruising the urban inferno, the voyeuristic stroller." *On Photography,* 55.

30 Schor, *"Cartes postales,"* 216; see too Walkowitz, "Urban Spectatorship," 205–7.

31 McCauley, *A. A. E. Disdéri,* 53–54.

32 The postcards in this series, printed by the Paris editor Ernest Louis Désiré Le Deley, all bear a similarly formatted logo.

33 The iconography of Marianne in the guise of *la semeuse* dates from 1886, when the revolutionary emblem of the figure in her Phrygian cap was recreated for the Republic, in the form of a sower, for a medal awarded by the Ministry of Agriculture. It was later appropriated for use on coins and stamps. The specific image we see on this stamp dates from 1903. Laurent Binet argues that Marianne as sower is a reactionary attempt to obliterate her revolutionary roots. See Binet, "Marianne."

34 The irony of the juxtaposed Marianne *la semeuse* stamp and the photographed scenes of hunger may not, in fact, be entirely arbitrary; one of the games people played with postcards during their turn-of-the-century heyday involved choosing a stamp whose image entered in dialogue with the postcard image or conveyed a secret message, or whose positioning or angle of placement had a signification. See Cure, *Picturing the Postcard,* 21; Bénard and Guignard, *La Carte postale,* 126–27.

35 Sartre, *L'Être et le néant,* 95–96.

36 We recall that pride sometimes drove consumers whose circumstances reduced them to *arlequins* to pretend to be purchasing these leftovers for their pets. See chapter 1.

37 For two excellent summaries, see Spang, " 'And They Ate the Zoo' "; Clayson, *Paris in Despair,* 163–91. While commentators suggest that accounts of the animals Parisians ate during this period of scarcity reach mythic proportions, there is a general consensus that such stories have at least a large kernel of truth. The crucial element here is that it was generally rumored that the least-moneyed Parisians devoured whatever animals they could kill or procure from providers, and that these animals ranged from pets to exotic beasts.

38 Spang reports that one restaurateur billed horsemeat filets as more exotic escalopes of elephant. Spang, " 'And They Ate the Zoo,' " 772. The consumption of horsemeat by humans had been legalized only recently, in 1866—paradoxically at a moment when the horse had reached the apogee of appreciation and even adoration as a human partner in riding, racing, and affection. See Weil, *Precarious Partners,* 86–88. Many commentators and illustrators then as now are ill at ease with what some explicitly name a cannibalistic element in the eating, by humans, of loved and respected companions like dogs and horses, and the evocation of a more literal cannibalism. See Clayson, *Paris in Despair,* especially 170–77.

39 The image, by caricaturist Henri Meyer, was a front-page caricature in the satirical weekly *Le Sifflet* (December 1, 1872).

40 Bizet, *Chiens au travail.*

41 Ibid., 7.

42 The Neurdein label, circulating under the imprints "ND" and "ND Phot.," was known throughout France. Étienne and Louis-Antonin Neurdein, sons of photographer Jean César Adolphe Neurdein, were much-lauded postcard editors who took prizes at the Expositions Universelles of 1889 and 1890. Their company later merged with LL (Léon et Lévy) and was called "Lévy et Neurdein réunis."

43 Saillard, "L'Artification," 71. It was only in 1923 that cooking was officially recognized as an art, the ninth of the *beaux-arts.*

44 For background on French Culinary Exhibitions, see Saillard, "L'Artification," and Trubek, "Culinary Expositions in Britain and France," chapter 7 in *Haute Cuisine.*

45 Poulain, "La Nourriture de l'autre," 128; see also Lévi-Strauss, *Le Cru et le cuit* and *L'Origine des manières de table*; Bourdieu, *Distinction*; Chang and Meehan, *Ugly Delicious.* David Chang has poignantly shown, in the episodes of this series, that there are few more humiliating ways to exert everyday cultural hegemony than

to mock the foods, diets, and alimentary practices of those perceived as cultural Others.

46 Neither the play publicized by the poster nor the hour of its performance is visible, though the word "rideau" suggests that there is more printed detail blocked by the superimposed culinary advertising than meets the camera's eye.

47 The law giving industrial and commercial workers a day off after six successive days of labor, and stipulating that this day would be Sunday, was passed on July 13, 1906, after six years in process. See Beck, "Esprit et genèse."

48 Bourdieu, *Distinction,* 6.

49 The line in the play reads "Vivre? Les serviteurs feront cela pour nous" ("Live? The servants will do that for us"). Villiers de l'Isle-Adam, *Axël,* 249. In her work on misery, Linda Nochlin observes that while today questions of the representability of misery intersect with ethics, the focus in the nineteenth century was instead on "how accurately and how convincingly one could document misery and outrage." Nochlin, *Misère,* 24–25. Nochlin and Martha Rosler stand on different ends of the spectrum here; Nochlin asks why visual documentation takes the brunt of moral outrage while verbal narrative is not charged, whereas Rosler contends that photographing the socially devalued further debases them, and interrogates the ethics of documentary representation itself. See Rosler, *Decoys and Disruptions.*

50 Sontag, *On Photography,* 14.

51 Claude Fischler observes that in Latin "*intimus* est le superlatif de *interior.*" Fischler, *L'Homnivore,* 9.

52 Barthes, *La Chambre claire,* 153; my emphasis.

53 The undivided back betrays the origin of the postcard as pre-1904 (or at least pre-December 1903, when the new format took effect). Postcards bearing messages with fewer than five words were franked at the lower rate (however, the distance traveled figured as well in the rate). See Bénard and Guignard, *La Carte postale,* 74–78.

54 Alloula, *The Colonial Harem.*

55 Maxwell, *Colonial Photography,* ix. See, too, the catalogue of the 2011–12 exhibition at the Musée du quai Branly, whose essays and images are fundamental (Blanchard, Boëtsch, and Snoep, *Exhibitions*), and the essays in Blanchard et al., *Human Zoos.* Among a number of good sources on imperialism, postcards, and/or photography, see Edwards, *Anthropology and Photography,* and Geary and Webb, *Delivering Views.* On the emergence of anthropology as a discipline in the age of imperialism, see Conklin, *In the Museum of Man,* and Hale, *Races on Display.*

56 Maxwell, *Colonial Photography,* 17.

57 Ames, "From the Exotic," 313.

58 Hodeir, "Decentering the Gaze," 234.

59 Daeninckx, *Cannibale,* 28ff.

60 Hodeir, "Decentering the Gaze," 237.

61 Ibid., 247. The most notable protest was that of the Communist Anti-Imperial League, broadly supported by the surrealists, which mounted a counter-exhibition

to the 1931 Exposition Coloniale called *La Vérité sur les colonies.* The Contre-Exposition was intended to subvert the imperialist, colonialist stance of the official exposition, but has been criticized for relying on similar premises. The surrealists had issued a similarly anti-imperialist pamphlet, *Premier Bilan de L'Exposition Coloniale* earlier that year. See, for example, Antle, "Introduction"; Norindr, *Phantasmatic Indochina,* 52–71.

62 Merriman, *Ballad of the Anarchist Bandits,* 172. See too Nye, chapter 6 ("The Politics of Social Defense: Violent Crime, 'Apaches,' and the Press at the Turn of the Century") in *Crime, Madness, and Politics,* 171–226.

63 Sue, *Les Mystères,* 35; see my chapter 2. Trouillot, chapter 1 ("Anthropology and the Savage Slot: The Poetics and Politics of Otherness") in *Global Transformations,* 7–28.

64 Maxwell elaborates: "In the last decades of the nineteenth century the meaning of the term 'race' was shifting and unstable. It was sometimes used as if it were synonymous with species, sometimes with culture and sometimes with nation, and sometimes to denote the ethnicity of sub-groups within national groupings. . . . This mobility of meaning can be attributed to competing ideas about the role played by skin colour and physical features, as against religion, education and other environmental factors, in determining the different levels of progress achieved by individuals and groups. Although the concept of race was predominantly used to distinguish people of Anglo-Saxon descent from people of colour, it was also occasionally used to separate the citizens of metropolitan nations from colonial settlers on the periphery. Some settlers, it was commonly thought, had forfeited their claims to pure whiteness because they were affected by tropical climates or mingling with darker-skinned people, or because they were relatively impoverished." *Colonial Photography,* 15–16.

65 Mélonio, "1815–1880," 339.

66 Walkowitz, "Urban Spectatorship," 208.

67 See Benedict, "Rituals of Representation," 29.

68 "Anthropological displays" was one of the euphemisms commonly used for live colonial exhibits of humans; I use it here for the postcard records of these as well. See Maxwell, *Colonial Photography,* 4.

69 Derrida, *La Carte postale,* 16. While the trajectory of the *arlequin* is more dramatically downward than that of the postcard, both cultural artifacts worked as democratizing social elements circulating among all classes.

70 Historians and critics of the postcard draw attention to the fragmentary nature of the genre, which was especially prominent and even shocking in an age of letter writing; its brevity in an age when epistolarity was a class privilege made it a more democratic form of communication. See, for example, Schor, *"Cartes postales,"* 210–11; Staff, *The Picture Postcard,* 47; Ripert and Frère, *La Carte postale,* 76. The surrealists, who prized the fragmentary, were postcard fans, and one of theirs, Paul Éluard, was a major collector. See Éluard, "Les Plus Belles Cartes postales," in Prochaska and Mendelson, *Postcards.* For Derrida, however, the postcard is not

radically different from the letter, but is instead the degree zero of the letter: "une lettre à l'instant même où elle a lieu . . . se divise, se met en morceaux, tombe en carte postale" (*La Carte postale,* 90) (at the very instant that a letter happens, it is divided, falls into pieces, becomes a postcard).

71 With the advent of the divided back, the terminology "recto/verso" evolved; while before 1903 the address side was the recto and the image, the verso, the terms gradually changed place as the image became the feature. See Hossard, *Recto-Verso,* 23; Bourgeois and Melot, *Les Cartes postales,* 28.

72 W. H. Auden, "Musée des Beaux Arts" (1940; reproduced by permission). William Carlos Williams wrote a similarly inspired poem, "Landscape with the Fall of Icarus" (1960).

73 This category of Indigenous colonial eaters exhibited in France could (and by rights, should) be extended to include postcards made from photos by French photographers in the colonies. I limit my corpus not only because of its potential enormity but also to keep the focus on what was being exposed, viewed, produced, circulated, and recorded as Other while inhabiting the same space that was producing indigent-eater postcards.

74 The year 1907 was also the date of the first Paris Exposition Coloniale, which was held on the other side of Paris, in the Bois de Vincennes, and featured entire villages of transplanted peoples.

75 Stereoscopic views were all the rage in late nineteenth- and early twentieth-century postcarding. As the second caption on the lower right of the postcard indicates, this image belongs to the category of "Vues Stéréoscopiques Julien Damoy." Jean-Baptiste Julien Damoy was a very successful grocer and wine merchant who also published many stereoscopic postcards. On stereoscopy and stereography, see Bénard and Guignard, *La Carte postale,* 92; Cure, *Picturing the Postcard,* 17–20, 167.

76 Another category, less frequent but still significant, is composed of soldiers photographed at mealtimes, often stationed in the colonies, and sometimes in their barracks; apparently they constitute another "type." Lower-class urban eaters, including harlequin consumers and soup eaters, are never included under the banner of "repas"; the classificatory system puts them instead under the rubric of "marchandes d'arlequins," "marchandes de soupe," and "petits métiers," as I discuss earlier.

77 I refer here to frank images of eating and food preparation rather than to undressed or otherwise sexually marked eaters, though as will become clear, the sexual innuendo is deliberate.

78 NDiaye, *La Cheffe,* 45.

79 The people displayed in Indigenous villages were ostensibly Indigenous to the cultures they were set up to represent, and often were in fact imported to the metropole from their own shores—cajoled, seduced (with promises of tourism and wages), tricked, or kidnapped—but sometimes they were pressed into service from the Paris streets, and were not Indigenous to the cultures they were hired to inhabit. See Hodeir, "Decentering the Gaze," 250n16.

80 Valérie Loichot's term, "situational cannibalism," is apt here. It applies to accusations of cannibalism made on the basis of associations with race or ethnicity rather than proved by evidence; details such as a large cooking pot and the presence of blackness serve to set the scene. Loichot, *The Tropics Bite Back,* 122–23.

81 For accounts of food in the restaurants and displays of the Expositions Universelles and Coloniales, see period commentaries, such as Arène's "Les Cuisines exotiques," in which a series of *quiproquos* linking food to the bodies of the servers is characteristic, for example: "Nous pourrions, peut-être, comme diversion, aller faire un tour au restaurant Roumain. On dit que dans leurs robes d'or, les servants roumaines sont particulièrement appétissantes" (211) (We might, as a diversion, pass by the Romanian restaurant. I've heard that the Romanian waitresses, in their gold dresses, are particularly appetizing). See, too, Tran's *Manger Et Boire,* for a retrospective account that includes in passing allusions to the erotization of meals and eating by male authors; see especially 197–98, 211, 239. Meals offered in Exposition restaurants were generally held to be "fundamentally the same as the food that nourishes the natives [but] cooked with 'more finesse' and in a wholly separate space. The visitor to the *Esplanade* can therefore partake of an authentic meal without worry." Sago, "The Colonial Marketplace," 364; see Tran, *Manger Et Boire,* as well.

82 Colonial or ethnographic villages at French Expositions were not randomly arranged; they were cartographically organized around the more central pavilions (which represented only North African and Asian colonies), according to perceived evolutionary hierarchies. Palermo details the 1889 layout: "The ethnographic villages [represented] sub-Saharan black Africans, New Caledonian Canaques (considered a hybrid black-Asian racial group), and the Tonkinese. . . . Asian and North African superiority over blacks was implied in that the last group's representation remained completely limited to ethnographic villages. . . . The black race occupied the lowest position in racial and cultural hierarchy in anthropological circles. . . . This racial group was accordingly relegated to the back row of the exhibit ground." Palermo, "Identity under Construction," 295. On the evolutionary sequencing of villages from most "primitive" to more "advanced," see also Benedict, "Rituals of Representation," 30.

83 The postcard caption does not designate the date of this Exposition, but the canceled stamp indicates it is the same Exposition Coloniale of 1907.

84 The combined turban-veil, called *tagelmust* (Tuareg) or *litham* (Arabic), is traditionally worn by Tuareg men as a protection against the wind-borne desert sands.

85 On anxieties about dust and dirt in early twentieth-century Paris, see Kessler, chapter 1 ("Pathologizing the Second Empire City") in *Sheer Presence.*

86 The relative weights of political centrality and marginality should not make us forget that by 1889, France's colonial holdings covered an area ten times the size of the metropole. See Palermo, "Identity under Construction," 286.

87 Kessler, *Sheer Presence,* 115–16. For more on the relationship of the French veil to Muslim veiling, see Kessler, chapter 4 ("The Other Side of the Veil") in *Sheer Presence.*

For detailed analyses of the Muslim veil in its own context, see Mernissi, chapter 5 ("The *Hijab,* the Veil") in *Women and Islam*; and Milani, *Veils and Words* and *Words, Not Swords.* I am grateful to Kessler and Milani for conversations about this postcard.

88 The question of where bourgeois and upper-crust picnics or fancier meals on the grass fit into this seemingly binaristic logic of interior and exterior space is fascinating and complicated. In preindustrial and industrializing French society, eating "en plein air" was a daily necessity for those whose working and living conditions allowed no alternative, while for those whose social and economic status carried with it leisure time, forays into nature were increasingly indicated by hygienist discourses. But such (alimentary and other) sojourns into the outdoors were not a way of life in the sense they were for populations marked by European ethnographic discourses as "primitive" and "natural."

89 For a historical analysis of the evolution of French architecture in conjunction with evolving mores, see Eleb-Vidal and Debarre-Blanchard, *Architectures de la vie privée.*

90 See the essays in Lajer-Burcharth and Söntgen, *Interiors and Interiority,* for detailed perspectives on the development of interiority as a social and aesthetic Western value. The introduction by Lajer-Burcharth and Söntgen (1–13) provides a historical account of how subjectivity in the nineteenth century came to be associated with inner space following the generic models of autobiography, painting, architecture, and psychoanalysis.

91 On the cooperative relations of disgust and desire, see Stallybrass and Whyte's classic study, *The Politics and Poetics of Transgression*: "Differentiation . . . is dependent upon disgust. . . . The bourgeois subject continuously defined and re-defined itself through the exclusion of what it marked out as 'low'—as dirty, repulsive, noisy, contaminating. . . . But disgust always bears the imprint of desire. These low domains, apparently expelled as 'Other', return as the object of nostalgia, longing and fascination" (191).

92 Quoted in Palermo, "Identity under Construction," 291.

93 "[Les Canaques] ont refusé de s'exhiber nus en tant qu'hommes qui veulent rester des hommes" ([The Kanaks] refused to be exhibited naked, as men who chose to remain men). Quoted in Tran, *Manger Et Boire,* 233–34.

94 Ibid., 220–21.

95 Ibid., 224.

96 Ibid., 221–22. On the theatrical nature of the expositions, see too Leprun, *Le Théâtre des colonies.*

97 Tran, *Manger Et Boire,* 223. On the "real show . . . backstage," see Stefanie Diekmann (who is here quoting the tagline from the Canadian television series *Slings and Arrows*), in "Scenes from the Dressing Room," 93. Though Diekmann's focus is on cinema rearticulating theatrical traditions, cinematic renditions of backstage space are part of a larger cultural discourse. See, for example, Emile Zola's 1880 *Nana* for a prime example of novelistic uses of this tradition.

98 "Le fait de vouloir éviter les heures d'affluence pour obtenir un coup d'oeil plus juste sur la vie quotidienne de colonisés atteste déjà d'une conscience des limites du spectacle et des effets d'une interaction entre les visiteurs et les visités. Mais aussi, la présence des 'indigènes' d'outre-mer sur le sol métropolitain a également, comme nous pouvons nous en douter, des effets sur ce qu'ils mangent et surtout sur ce qu'ils boivent" (Wanting to avoid the surge hours in order to have a better look at the daily life of the colonized people is testimony to a conscience of the theatrical boundaries and the effects of interaction between the visitors and the visited. But also, the presence of "Indigenous" people from overseas on metropolitan soil also has an effect, as we might suspect, on what they eat and especially on what they drink). Tran, *Manger Et Boire,* 228.

99 Walter Benjamin, "Paris, Capital," 155.

100 Barthes, *La Chambre claire,* 154–56.

101 Dorfman, *Darwin's Ghosts,* 88 and 152.

102 Ibid., 282–84.

103 Ibid., 269.

104 Ibid., 253.

105 Ibid., 94, 165.

106 According to the *Oxford English Dictionary* (1971), "Indigenous" comes from the Latin *indigenus* (to be born in, native), while "indigent" derives from the Latin *indigere* (to lack or to want).

107 See Barth, "Des Hommes exotiques," 181.

108 See Palermo, "Identity under Construction," 296.

109 Guest, "Are You Being Served?," 109–10.

110 Benjamin Disraeli, *Sybil, or the Two Nations* (1845), quoted by Guest, "Are You Being Served?," 110; my emphasis.

111 I include class difference under the banner of race, having argued that class is racialized in nineteenth-century Western European ideology.

112 Tompkins, *Racial Indigestion,* 8.

113 Tran, *Manger Et Boire,* 223.

114 Once again Loichot's concept of "situational cannibalism" (*The Tropics Bite Back,* 122–23) should be invoked in reference to such contexts that evoke the cannibal trope with no evidence of literal anthropophagy. As for the debate on whether cannibalism in fact exists, I do not place myself in the camp of those who contend it is a myth; I mean here that the purported cannibalism of the colonized exposed in nineteenth-century metropolitan France was a myth. See the essays and illustrations in Blanchard et al., *Human Zoos,* for a discussion of the cannibal myth at the human zoos; see, too, Daeninckx's historical novel *Cannibale.*

115 Guest, "Are You Being Served?," 109–11.

116 Tran, *Manger Et Boire,* 238. The connection between racially marginalized and socioeconomically marginalized Others plays out on a more positive note of alliance in Daeninckx's *Cannibale,* where the Kanak captive, Gocéné, escapes from his cage at

the 1931 Exposition, and is saved from being gunned down by the Paris police by an unknown figure in the crowd who turns out to be Francis Caroz, "un ouvrier sans histoires qui ne supportait pas qu'on tue des innocents, qu'ils soient noirs ou blancs" (106) (a worker who had never been in trouble, who did not tolerate the killing of innocent people, whether they be black or white). Caroz is sentenced to three months in prison "pour rébellion contre les forces de l'ordre dans l'exercice de leur mission" (104) (for resisting the forces of order in the exercise of their mission).

117 I borrow the term from Allan and Burridge, who use it somewhat differently, in relation to linguistics, in *Forbidden Words,* 188. On cannibalism as the controlling image of the Caribbean Other in imperialist thought, and modes of resistance to it, see Loichot, *The Tropics Bite Back.*

118 Poulain, "La Nourriture de l'autre," 128.

119 Kilgour's *From Communion to Cannibalism* is an excellent place from which to approach this paradox. See Tompkins, *Racial Indigestion,* as well.

120 What I call *overreading* here is a speculative mode invited by the temporal distance and laconic style inherent to the medium, and heightened by the lack of correspondence between the photographs and the penned words.

121 Tom Phillips, introduction to Fenton, Edwards, and Phillips, *We Are the People,* 23.

122 Colette, *Les Vrilles de la vigne,* 1040–41. My thanks to Michael Garval for bringing this text to my attention.

123 Vitoux, *Cartes postales,* 18.

124 Ibid., 30; Vitoux's emphasis.

125 Ibid., 57, 201.

126 *Overreading* as I conceptualize it here resonates distantly with Nancy Miller's classic strategy for approaching the silences of women's writing by looking for signs of its material conditions of production. Though my focus is neither women nor literal authorship, what is at stake for the objects of lower-class feeding photos is their capture in what used to be called a feminized position, and their loss of agency. See Miller, "Arachnologies."

127 Edwards, "Little Theatres of Self," 35.

FOUR —— FROM STREET FOOD TO STREET ART

1 This opening frame not only evokes the classic costume of Harlequin by reference to a clashing of primary colors, and with that a legacy of variegation; it also conjures the specter of residue by the images of overwhelming excess. And, in fact, the abundance of raw cabbages, which are a prominent part of the spectacle, will shortly devolve into its own dregs, turned into fusty fumes of soup. Zola, *Le Ventre de Paris,* 603. All subsequent page references to this novel are given in my text and are from the Lanoux and Mitterand Pléiade edition.

2 On culinary troping and art in Zola specifically, see Leduc-Adine, "Le Vocabulaire"; Becker, "Zola." On the rhetoric and motif of cooking in art in the nineteenth century

more generally, see Desbuissons, "The Studio and the Kitchen" and "Yeux ouverts"; Deutsch, *Consuming Painting*; Goutaland, *De Régals*; Kessler, *Discomfort Food*. See, too, the collected essays in Reverzy and Marquer, *La Cuisine*.

3 Zola frequented artists and lived in their intimate circle, dining, vacationing, discussing with them, visiting exhibitions, and writing about art in the two decades between 1863 and 1883. Zola, *Écrits sur l'art*, Préface par Jean-Pierre Leduc-Adine, 7. Zola's recourse to culinary rhetoric in his articles about art and literature dominated these writings from 1865 to 1868. See Becker, "Zola," 173.

4 Surprisingly little heed has been paid to the intervention of colonization, empire, and race in this novel. This makes two sources all the more valuable. Jennifer Yee wrote several pithy pages of commentary on the contrapuntal role of the penal colony in *Le Ventre* in her *Colonial Comedy*, 137–41. Schehr noted earlier that "Devil's Island and Cayenne are signs of a colonial economy" and that "slave ships, slavery, forced uprooting, and renomadization of the other" are figures of empire that cause Florent's demise, without, however, attaching these to Zola's novel in any specific way; *Subversions of Verisimilitude*, 94.

5 Huysmans, "Émile Zola et *L'Assommoir*," 522. Dora Zhang offers an excellent sweep over the history of narration/description paradigms and a challenge to their traditional binary opposition in her *Strange Likeness*.

6 See Desbuissons, "Yeux ouverts," 63–65.

7 While it is not very complicated to run through the small troupe of visible feeders in *Le Ventre,* it is a bit thornier to make sense of the casting, which does not align with the consecrated division of the novel's characters into *les gras* and *les maigres.* The most extended treatment of this opposition, enunciated by Claude Lantier (804–6) as a parable that reduces all humankind (and specifically the main players of this novel) into two types, is in Scarpa, *Le Carnaval des Halles*. See, too, Scarpa, "Retour ethnocritique," and Sicotte, *Le Festin lu*. Though one might logically expect to find the eater's part attributed to the more corpulent personae, beginning with the fleshy embodiment of the titular belly, the charcutière Lisa (née Macquart) Quenu, this is not at all the case, but I dispute the argument that Zola's consumers align neatly with the lean and hungry, as has been argued. See Scarpa, *Le Carnaval*, 247; Scarpa, "Retour ethnocritique," 208–9; Goutaland, *De Régals*, 67–68. For Éléonore Reverzy, the *gras/maigre* binary is paired with sex and gender roles, with the forces of devouring women ready to set upon Florent. I find this opposition too schematic. See Reverzy, *La Chair de l'idée*, 120.

8 See Zola, *Ébauche*, folio 62/16; folio 94/48 in Becker, *La Fabrique*.

9 The fact that Florent rides into Paris among the cabbages as he is reborn there on his return from Guiana assimilates him to Marjolin, suggesting that he, too, is a marginalized being, a metaphorical foundling.

10 Priscilla Parkhurst Ferguson calls Cadine and Marjolin's food forays *"flâneries gourmandes,* substitutes for consumption . . . [for] a perpetually frustrated gourmandise." Ferguson, "The Sensualization," 220–21. It is true that the pair do not acquire all

the delicacies they covet, but they are among the few characters seized in the act of indulging their gourmandise and enjoying its fruits.

11 For a succinct but evocative history of the place of soup in culinary culture, with an emphasis on its historically low status, see Thouvenot, "La Soupe dans l'histoire."

12 By the time he was writing *Le Ventre,* in 1872–73, Zola was enjoying a modestly comfortable bourgeois existence. His early years in Paris were certainly marked by penury, though he was never reduced to soup stands or other such forms of portable eating. Mitterand, *Zola,* 1:592 and following.

13 See Corbin, *Le Miasme,* 163–88; 174. Jean-Pierre Richard discusses "the residual" in his analysis of Joris-Karl Huysmans's *A Vau-l'eau,* in which text he notes "le dégoût complexe du résiduel, de l'engorgé, du coagulé, de l'aliment anal" (the complex disgust caused by the residual, the swollen, the coagulated—by food that evokes the anal). Richard, "Le Texte et sa cuisine," 147. On the connotations of cabbages in art, see Deutsch, *Consuming Painting,* 113–43.

14 Goutaland, *De Régals,* 12.

15 For an analytic history of the miasma and odor in the imaginary of the eighteenth and nineteenth centuries, see, once again, Corbin's *Miasme.*

16 Goutaland, *De Régals,* 14–22; Barthes, *Sade, Fourier, Loyola*; Sicotte, *Le Festin.*

17 Goutaland, *De Régals,* 15.

18 It is worth emphasizing that Zola *indicates* digestion or indigestion by naming one or the other periodically, usually metaphorically, but he does not *show* either.

19 Among the many animals represented in the act of eating in the novel are crabs, pigeons, cats, horses, snakes, lice, and mosquitoes.

20 The *Petit Robert* (1984) gives as the first definition of *le repas* the following: "Nourriture, ensemble d'aliments divers, de mets et de boissons pris en une fois à heures réglées" (Nourishment, the totality of various foods, dishes, and drinks taken together at regular hours). The *Oxford English Dictionary* (1971) gives as first (obsolete) definition, significantly, "a measure," and as second, "any of the occasions of taking food which occur by custom or habit at more or less fixed times of the day, as a breakfast, dinner, supper, etc."

21 Originally, Zola did not intend Florent (whom he called at the time "Charles") to play a major role; in his *Ébauche* for the novel he insists on keeping him in check: "Il ne faut pas donner à Charles trop d'ampleur" (Charles should not play too large a role). See Zola, *Ébauche* (folio 65/19), in Becker, *La Fabrique.* While he did not in the end limit Florent's role to the extent planned, he did make him eminently expendable to the Paris cosmos, which twice ejects him with little effect on its own continuation.

22 If we cheat a bit and look ahead to *L'Oeuvre,* the 1886 novel focused on Claude Lantier's evolving art, we find a statement on the aesthetic valorization of carrots: "Est-ce qu'une botte de carottes . . . étudiée directement, peinte naïvement, ne valait pas les éternelles tartines de l'École . . . ? Le jour venait où une seule carotte originale serait grosse d'une révolution" (Is not a bunch of carrots, studied directly, painted naively, worth as much as the tired confections of the École des beaux-arts . . . ? The

day was coming when a single original carrot would carry within it a revolution). Zola, *L'Oeuvre,* 44. In *Le Ventre,* Florent's carrot is unglossed, though it joins the paradigm of humble vegetables Claude is hungry to paint.

23 The place name "Cayenne," site of the first French settlement in French Guiana, was used often to refer to the entire expanded colony in the nineteenth century, and sometimes still is. The historical premise of Zola's novel is that Florent was arrested by contiguity with anti-imperial protesters against Louis-Napoléon's coup d'état in December 1851, and sent in 1852 to one of the newly institutionalized Guianese "Camps de Transportation" (the term used for deportation at the time) on L'Île du Diable; that he escaped in 1856, spent two years traversing French and Dutch Guiana before returning to the shores of metropolitan France and making his way overland to Paris in the fall of 1858 when the novel opens; that one year later, he is arrested again for revolutionary activity and sent back to the South American penal colony.

24 See, for example, Goutaland, *De Régals,* 244–46; Scarpa, *Le Carnaval,* 221–24; Shryock, "Zola's Use"; Verret, "Un Roman de l'enfermement."

25 See Zola, *Ébauche* (folio 22), in Becker, *La Fabrique.*

26 Zola's documentary sources on life in the transportation camp and/or in larger Guiana include the eyewitness accounts of Delescluze, *De Paris à Cayenne,* and Jusselain, *Un Déporté.* He also interpolated descriptions and scenarios from a number of novels, including Belot and Daudet, *La Vénus de Gordes,* and Sue, *Les Aventures.*

27 Bill Buford's description of the making of *boudin* in twenty-first-century Lyon following traditional practices is startlingly close to Zola's, though it begins with a graphic narration of the pig killing, which Zola, with unusual circumspection, removes from our eyes and relegates to the slaughterhouse, telling us only that Quenu's helper takes care to bleed the pig himself and to transfer the fresh blood immediately to the charcuterie. See Buford, *Dirt,* 98–105.

28 The other companion survives the marine passage, only to die by exposure and starvation once he has swum to the coast from the sandbank.

29 And as prelude to the entire scene we have Claude's appraisal of Marjolin in similar terms: "Quelle brute, quelle belle brute! . . . Et dire que cet animal-là est heureux!" (681) (What a beast, what a fine beast! And to think that this animal is happy!)

30 There are many accounts of the shipwreck and events following, both contemporaneous and subsequent. For a penetrating analysis of how representations (especially Géricault's) of the *Medusa* catastrophe crystallized the cultural imaginary, and a comprehensive bibliography, see Grigsby, "Cannibalism, Senegal." See, too, Alhadeff's *The Raft of the Medusa* and his later *Théodore Géricault* for additional race-centered readings of Géricault's painting.

31 Grigsby, "Cannibalism, Senegal," 187.

32 The fact that Zola is dealing in pig flesh rather than any other kind of animal meat underscores the cannibalistic inferences; as Garval has poignantly argued, there was, in nineteenth-century France, "not just camaraderie but equivalency" between

humans and their pigs, who were domesticated, companionable, intelligent. Garval asks: "Are we too eating our own when we consume animals who resemble us?" See Garval, "Visions of Pork Production," 18. Pastoureau, in his book on the pig in history (notably subtitled *Histoire d'un cousin mal aimé*), postulates "Manger du porc, c'est, plus ou moins, être cannibal" (To eat pork is more or less to be cannibalistic). Pastoureau, *Le Cochon*, 127. Scarpa comments that in this scene "on est presque dans une cuisine du sacrifice humain, qui suggère une forme de cannibalisme euphémisé" (we are almost in the preparations for human sacrifice, which suggests a euphemized form of cannibalism). Scarpa, *Le Carnaval*, 22. As I read *Le Ventre*, its cannibalistic notes eerily resemble Géricault's *Radeau* rendition of it in that both are, in Grigsby's words on the painting, "remarkably unanchored, sliding from one group to another" ("Cannibalism, Senegal," 186).

33 Zola, *Germinal*, 1454. Lawrence Schehr argues that Zola uses food in an incrementally more semiotic way in *Germinal* than he did in *Le Ventre*. See Schehr, *Subversions*, 87–123.

34 As Grigsby reminds us, "Eating and sex are both . . . exercises of power and ultimately . . . forms of incorporation." More specifically, cannibalism and sex are double, "on the one hand eliciting the fear of assault, one's bodily violation by a superior power; on the other, the anxiety (and pleasure) catalyzed by the disorienting disassembling of the self's borders" (Grigsby, "Cannibalism, Senegal," 202).

35 Pressured by Lisa's alternating threats and cajoleries, he accepts the position that very night, and takes up service three days later.

36 It is difficult to balance Pauline's self-righteousness regarding her uncle's attire with the scene of her degradation some thirty pages later when she returns home from her vagabondage with Muche mud-spattered, mottled with chocolate, drenched, and ragged, "les bottines boueuses, les bas tachés, les jupes déchirées, les mains et la figure noircies" (821) (with muddied boots, spattered stockings, torn skirts, face and hands blackened). If she becomes *malpropre*—unclean and improper—as a graphic representation of her unlicensed excursion from the starched whiteness of home, and, in the process, comes to resemble the uncle she disparages, could we not consider this in the light of Stallybrass and White's classic formulation that "disgust always bears the imprint of desire"? See Stallybrass and White, *Politics and Poetics*, 190. Michel Serres's reflections on the clean, the dirty, ownership, and disappropriation are also germane to thinking about the bourgeois compulsion to call out and eject the unclean in order better to stake out property lines. See Serres, *Le Mal propre*.

37 In Claude's words, Florent is more of a poet of revolution than an activist, better suited to dream and to write than to fight: " 'Vous m'avez l'air de faire de la politique absolument comme je fais de la peinture. Vous vous chatouillez, mon cher. . . . Vous êtes un artiste dans votre genre, vous rêvez politique . . . Ah! grand poète que vous êtes!' " (849) ("To me, you seem to do politics in exactly the way I paint. You pleasure yourself, my friend. You are an artist in your own way, you dream your politics. Ah, you are indeed a poet!"). Yet Florent's project for a book on "Cayenne" doesn't come to fruition; it exists in much the same fragmented state as his battle tactics.

38 And again, "Elle . . . se nourrissait des saletés dont la clique bonapartiste ne voulait plus" (842) (She fed herself the filth that the Bonapartists no longer wanted).

39 As I have argued elsewhere, historically there has been a slippage in the literature about this condition (which was already noted as a pathology by the Greeks and the Romans) between a physical and a moral diagnosis. The black-and-white speckled plumage of the magpie translates behaviorally to the patchy feeding habits of the pica patient, who is often, for pre-twentieth-century doctors especially, a woman, which is to say, the capricious owner of a flighty appetite; or alternatively, in the early nineteenth century, a slave: marginal, hungry, scavenging, and like a woman, volatile; like the avian model, pecking erratically at trash heaps for shiny, ostensibly useless or disgusting scraps. See Beizer, "Colette's *Côtelettes,*" 316–18; on pica in the nineteenth century, Fréjacque, *Du Pica*; on pica more generally, MacClancy, Henry, and Macbeth, *Consuming the Inedible,* and Young, *Craving Earth.*

40 The magpie is "well known for its noisy chatter . . . its habits of pilfering and hoarding are proverbial," according to the entry in this name in the *Oxford English Dictionary* (1971).

41 See 819–20, for example. Florent and Mlle Saget have in common a high perch that is at once an aerie: a lofty, compressed dwelling space that is a sign of their lowly socioeconomic status, and a belvedere that provides a lookout over the streets below and an elevated space propitious to dreaming. This is one more evidence of the unexpected rapprochement of these two otherwise antagonistic characters.

42 Rancière, *Le Fil perdu,* 29.

43 Zhang discusses comparisons of realist description to still life, especially Dutch painting. *Strange Likeness,* 18.

44 Rancière, *Le Fil perdu,* 28–29.

45 Ibid., 34; 36.

46 Zola's notes for *Le Ventre* (*Ébauche,* folio 1; folio 107/61) give the added details that she is sixty-two—approximately twice his age at the time of writing—and that she would have been pretty (in her youth, we assume): "Elle a dû être jolie." This detail did not make it into the novel, but it suggests the level of granularity with which Zola conceived the character. In Becker, *La Fabrique.*

47 The novel's last chapter opens with the words "Huit jours plus tard, Florent crut qu'il allait enfin pouvoir passer à l'action" (869) (A week later, Florent thought he was finally going to be able to spring into action). Needless to say, he does not become an action figure here or ever, but Mlle Saget arguably does.

48 See, for example, 668; 835.

49 In the *Ébauche* (folio 127/11), Zola speaks of the "marchands de viandes cuites, rogatons ou arlequins." Becker, *La Fabrique,* 810.

50 Zola goes on to detail the heteroclitic components of the file: "Elle reconnut une écriture de chat, l'écriture de Mlle Saget, dénonçant la société du cabinet vitré. Elle reconnut une grande feuille de papier graisseuse, toute tachée de gros bâtons de Mme Lecoeur, et une page glacée, ornée d'une pensée jaune, couverte du griffonnage de la Sarriette et de M. Jules; les deux lettres avertissaient le gouvernement de

prendre garde à Gavard. Elle reconnut encore le style ordurier de la mère Méhudin, qui répétait, en quatre pages presque indéchiffrables, les histoires à dormir debout qui couraient dans les Halles sur le compte de Florent. Mais elle fut surtout émue par une facture de sa maison portant en tête les mots: *Charcuterie Quenu-Gradelle,* et sur le dos de laquelle Auguste avait vendu l'homme qu'il regardait comme un obstacle à son mariage" (863) (She recognized the chicken scratch that was Mlle Saget's handwriting, denouncing the group that met in the glazed-glass room. She recognized a large sheet of greasy paper, streaked with Mme Lecoeur's fat penstrokes, and a glossy sheet decorated with a yellow pansy and covered with the scribbling of la Sarriette and M. Jules; both letters warned the government to beware of Gavard. She recognized too Mme Méhudin's trashy style, and her repetition, on four almost illegible pages, of the monotonous stories about Florent that were circulating at Les Halles. But she was especially struck by a bill from her shop bearing the heading *Quenu-Gradelle Charcuterie,* on the back of which Auguste had denounced the man he regarded as an obstacle to his marriage).

51 Mitterand, *Zola,* 1:710. Mitterand uses the more contemporary term *dossier génétique* in his discussion (1:723).

52 See the reproduction of this dossier in Becker, *La Fabrique.* See, too, Woollen, "Les 'Transportés' "; Mitterand, "Étude" in Zola, *Le Ventre de Paris,* 1609–25, for more on Zola's sources.

53 Mitterand, speaking more generally about Zola's planning and writing practices, more tactfully calls such borrowings a "sponge effect": "Il y a parfois un effet-éponge dans les lectures de Zola: lorsque celles-ci surviennent au milieu de son travail d'invention romanesque, ou de son travail d'ecriture, elles y déposent des traces, échos, emprunts thématiques ou réminiscences, qui s'ajoutent aux documents délibérément réunis et aux dépôts de la mémoire lointaine" (1:738) (Zola's readings sometimes have a sponge effect: when they surface in his novelistic preparatory notes or in his writing, they leave traces, echoes, thematic borrowings or reminiscences that attach themselves to the deliberately collected documents and to the storehouse of distant memories). For his contemporaries, however, Zola was a reputed plagiarist, and they did not mince words on the subject. The Goncourt brothers, Henry Céard, and Alphonse Daudet all bemoaned Zola's appropriation of their writing. See Armstrong, "Vers Les Fondements."

54 An inventory of such cases would be both tedious and laborious, but it would also be impressive. Zola's extensive borrowings from Victor Hugo's *Notre-Dame de Paris* are too well known to further rehearse here; but see Baguley's "Le Supplice de Florent," 91–92, for a summary, as well as Zola's notes in the *dossier préparatoire,* in Becker, *La Fabrique.*

55 Sue, *Les Aventures,* 4; "un goytier" is probably an error of transcription and should be "un goyavier," a guava tree.

56 Du Camp, *Paris,* 163.

57 Similarly, Du Camp's description of conveying leftovers to the merchants at Les Halles is almost textually repeated by Zola. Du Camp writes: "Chaque matin, [les

marchands] ou leurs agents traînant une petite voiture fermée et garnie de sou-
piraux . . . vont faire leur tournée dans les cuisines avec lesquelles ils ont un contrat.
Tous les restes des repas de la veille sont jetés pêle-mêle dans la voiture, et ainsi
amenés aux Halles jusque dans la *resserre*. Là, chaque marchand fait le tri dans cet
amas sans nom, où les hors-d'oeuvre sont mêlés aux rôtis et les légumes aux en-
tremets. Tout ce qui est encore reconnaisssable est . . . *paré* (c'est le mot) et placé à
part sur une assiette. . . . Le client n'y assiste pas. . . . Lorsque tout est terminé . . . on
fait l'étalage habilement" (Each morning the vendors or their associates, dragging a
small, closed carriage equipped with vents, make their rounds in the kitchens they
contract with. All the leftovers from the prior evening's meals are thrown into the
carriage in a jumble, and brought to the storeroom. There, each merchant triages
this unnameable heap, where the hors d'oeuvres are mixed with the roasts and the
vegetables with the sweets. Everything still recognizable is *arranged* [so to speak]
and set aside on a plate. The client is not present. When all is finished, the display is
skillfully prepared). *Paris,* 165. And here is Zola's version: "Chaque matin, de petites
voitures fermées, en forme de caisses, doublées de zinc et garnies de soupiraux,
s'arrêtent aux portes des grandes cuisines, rapportent pêle-mêle la desserte des
restaurants, des ambassades, des ministères. Le triage a lieu dans la cave. Dès neuf
heures, les assiettes s'étalent, parées . . . morceaux de viande, filets de gibier, têtes
ou queues de poissons, légumes, charcuterie, jusqu'à du dessert, des gâteaux à peine
entamés et des bonbons presqu'entiers" (Each morning, small, closed carriages
shaped like crates, lined with zinc, and equipped with vents, stop at the doors of
fancy kitchens, and bring back a jumble of leftovers from restaurants, embassies,
and ministries. The triage is done in the cellar. By nine a.m. the plates are displayed,
arranged . . . pieces of meat, game filets, fish heads or tails, vegetables, charcuterie,
even dessert, cakes hardly tasted and bonbons that are almost whole). *Le Ventre,* 834.

58 In fact, on more than one occasion Zola referred to literary bits borrowed by one
author from another as *miettes* (crumbs) in his articles. See Armstrong, "Vers Les
Fondements," 6n37.

59 I am using the terms "novel about gossip/novel as gossip" as Ross Chambers set them
out in his very suggestive article, "Gossip and the Novel," 213. My discussion of gossip
and gossipers in *Le Ventre* extrapolates on Chambers's analysis of those other texts.

60 Chambers, "Gossip," 214.

61 Marie Scarpa reminds us that Zola has feminized a Paris *quartier* that in fact had
a male-dominated population, and that he might alternatively have chosen to
emphasize—but didn't—masculinized professions, such as *les forts* (the porters) or *les
fonctionnaires* (the administrators). Scarpa, *Le Carnaval,* 203. For a study of market-
place women in an earlier era, see Jarvis, *Politics in the Marketplace.*

62 As Chambers maintains in "Gossip," "The verisimilar is the gossiper's domain" (214).
Similarly, the rumors that are spread about Florent—many of which are flagrantly
and even absurdly untrue—are sustainable within the logic of the novel because they
confirm a Second Empire discourse of complacent solidarity among those who are,
however insecurely, on the inside, even as it fans their suspicion of those on the

outside. That the stories circulating about Florent confirm this shared knowledge system makes them credible and trusses his fate as scapegoat. On the structure of exclusion and scapegoating in Zola see, too, Naomi Schor's classic study, *Zola's Crowds,* especially 21–34, and Cooke, "Theorizing the Scapegoat." Zola begins to part ways with the verisimilar, however, in endowing Mlle Saget and the other rumormongers with agency.

63 In a plenary address at the Nineteenth-Century French Studies Colloquium, Ross Chambers noted that "literature is gossip, and literary criticism is gossip about gossip" (my paraphrase). Chambers, "Irony and Misogyny."

64 See Zola to Antony Valabrègue, 18 August 1876, in *Correspondance,* in *Oeuvres complètes,* 48:256.

65 I postpone to the second part of this chapter another case having to do with the terminology for leftovers.

66 While the various species of crab inhabiting the waters around France and French Guiana would likely have overlapped little, if at all, varieties of this crustacean were well integrated into the diet of both cultures.

67 Mitterand, *Zola,* 1:498. In his 1877 novel *L'Assommoir,* Zola famously shows a working-class wedding party finishing its festivities by a visit to the Louvre.

68 Barrett, *"Le Ventre de Paris,"* 49–50. Snyders's painting includes some twenty species, according to Barrett's count, while Zola's numbers twenty-seven.

69 Paris is not only landlocked but kept from direct access to the ocean by the fact that the Seine is not navigable by oceangoing ships all the way from Paris to the point where it empties into the English Channel, at Le Havre. See Kaplan, *Provisioning Paris,* 84–85; Sciolino, *The Seine,* 253–60; Steel, "A Tale of Two Cities," 39.

70 See, too, the recurrent assimilation of the crowd to a sea, as, for example. "Des flots de foule s'étaient massés, qui faisaient sur chaque bord des tas de têtes moutonnantes" (699) (The crowd had massed in waves, with bobbing heads cresting like seafoam on all sides of the pavilion).

71 In French as in English, the word *isolation* is derived from the word for island, *île,* from the Latin *isola.*

72 See, respectively, Piton-Foucault, " 'L'Original introuvable,' " 134–35; Prendergast, "Le Panorama," 68; Sealy, "Dreams in Iron," 221–22; Baguley, "Le Supplice," 95; Marin, *Le Livre enterré,* 131.

73 See Beizer, *Family Plots,* 113–18, for a synopsis of Balzac's Paris as ocean. Jennifer Yee relates the swamps, quicksand, and liquid mud of Florent's escape from Guiana to the Paris that "threatens to swallow up Florent" by way of the similarly pulpy filling for the blood pudding in the *boudin* preparation rather than the recurrent marinescapes that pervade the city. Yee, *Colonial Comedy,* 139.

74 Zarobell, "Marine Painting," 18.

75 Peck, *Exterminate All the Brutes.* See, too, the book of that title on which the series was partly based, Lindqvest, *"Exterminate All the Brutes."*

76 Forsdick, "Postcolonializing the *Bagne,*" 239.

77 Spieler, *Empire and Underworld,* 1.

78 Ibid., 5; 73; 139.

79 Ibid., 192

80 Damas, *Retour de Guyane,* 66. Damas goes on to say, in this essay of 1938, that when French Guiana was not reduced to a prison colony, it was alternatively stereotyped as a madhouse, a cemetery, or a fractious political scene. Writing almost sixty years later, Patrick Chamoiseau also remarks on the popular equation, outside of Guiana, of this land with its prison colony: "Dans l'Imaginaire commun, la terre guyanaise s'était vue phagocytée par la représentation du bagne. Jusqu'en 1946, et même au-delà, dire 'Guyane française' c'était dire tout bonnement: 'Bagne'" (In the collective Imaginary, the land of Guiana has been engulfed by representations of its penal colony. Until 1946, and even beyond, to say "French Guiana" was quite simply to say "penal colony"). Chamoiseau and Hammadi, *Guyane,* 18.

81 Zola's consistent replacement of the traditional Western symbol of the life force, the heart, by the belly transplants gluttony and greed in the place of sentiment and courage. As Geneviève Sicotte reminds us in the context of her discussion of bourgeois values of comfort overtaking passion, "les romantiques opposaient le coeur au ventre, voyant dans le premier l'authenticité et la force, et dans le second l'adhésion moutonnière aux valeurs du troupeau; la bourgeoisie reprend l'opposition, mais la tourne en dérision puisqu'elle voit bien qu'elle est désormais passée de l'autre côté de la barrière. Le bourgeois sait que 'son coeur a pris du ventre'" (the romantics opposed the heart to the belly, seeing in the first authenticity and strength, and in the second a sheep-like adherence to herd values: the bourgeoisie appropriates the opposition, but mockingly, recognizing that it has crossed over to the other side: a bourgeois knows that "his/her heart has become paunchy"). Sicotte, *Le Festin,* 54n11. More specifically, the verse that Sicotte is quoting, taken from Tristan Corbière's "Le Déclin" (*Les Amours jaunes,* 1873), corresponds so well to Zola's novel that one wonders which of the two authors was inspired by the other: "Son coeur a pris du ventre et dit bonjour en prose" (His/her heart has become paunchy and says hello prosaically). Zola has some good fun with his multifarious deployments throughout the novel of "le ventre," which appears not only as a substantive organ and body form and as a metaphor for digestion and sex (among other things), but also, in its adjectival use, as a shape. Everything and anything from the facades of houses to people's fingers is described in *Le Ventre* as "ventru," pot-bellied, big-bellied, paunchy, or bulging, so that we seem to be submerged in a universe of bellies, their mutations, and their transfigurations.

82 See Blérald-Ndagano, *Musiques et danses créoles.* Blérald-Ndagano is clear: "On s'aperçoit que le terme tam-tam, employé en Afrique, a disparu de l'usage, au profit de tambour, sauf lorsqu'il s'agit de revendication nationaliste" (58) (We note that the term "tam-tam," formerly used in Africa, is no longer used, having yielded to "tambour," except when nationalist claims are at stake). Traditionally in Africa, the tam-tam was used both as a musical instrument and to send messages over

distance; this second practice subsided in the colonies. Ibid., 57–58. However, it left its mark on lexical usage in France, where *le tam-tam* retains a secondary meaning of "charivari, publicité tapageuse, scandale bruyant" (a din or racket, rowdy publicity, raucous scandal) (*Petit Robert*, 1985). See, too, Pindard, *Musique traditionnelle créole*, for more on drums and music in Guiana and its neighboring Caribbean islands.

83 Speaking from a twenty-first-century standpoint (but one clearly entrenched in a long history), Nicolas Darbon calls the tam-tam an example of "[une] succession de clichés coloniaux," "un mythème de la négritude," "[un] symbole anti-colonial" (a succession of colonialist clichés, a mytheme of negritude, an anti-colonialist symbol), suggesting how a cultural artefact has been appropriated and reappropriated. Darbon, *Musique et littérature en Guyane*, 98; 196; 201.

84 Both the Exposition of 1855 and that of 1867 included an Exposition Coloniale; French Guiana was among those represented in 1867. We know that Zola attended the 1867 Exposition Universelle, although I have not found any detailed itinerary of his visit. See Mitterand, *Zola*, 1:545–46.

85 Chamoiseau and Hammadi, *Guyane*, 16–17 (my emphasis). Chamoiseau's photo essay concerns itself most directly with traces of the *bagne*, the penal colony, but opens the broader possibility of telling other silenced stories (13–14). See also Forsdick, "Postcolonializing," 254.

86 Rancière, *Le Fil perdu*, 34.

87 For an example, see Peccatte, "La Noirceur du petit ramoneur." To complicate matters further, the term *le charbonnier* could refer to the seller of charcoal, *le charbon de bois* (as opposed to *le charbon de terre*, or coal), the main source of fuel and power in France until late in the nineteenth century, as well as to the charcoal burner himself, who fabricated charcoal from wood in the forest. See Bouttoud, "Prix et marché."

88 For the iconography of the *ramoneur*, see both Peccatte, "La Noirceur du petit ramoneur," and Garval, "Change of Hearth."

89 See Musset, "Charbonniers," which informs my reading of Zola and *le charbonnier*.

90 Zola was far from immune to the racism that defined his zeitgeist; witness this commentary on *Le Nègre endormi*, Provençal sculptor Philippe Solari's (now lost) sculpture of a black man: "La tête est superbe, petite, aplatie: une tête de bête humaine, idiote et méchante. Le corps a une souplesse féline, des membres nerveux, des reins cambrés et puissants. . . . Tout est logique dans cette figure qui pourrait être la personnification de cette race nègre, paresseuse et sournoise, obtuse et cruelle, dont nous avons fait une race de bêtes de somme" (The head is superb—small, flattened—the head of a human beast, wicked and imbecilic. The body shows a feline grace, nervous limbs, an arched and powerful back. Everything is consistent in this figure that could well be the personification of the Negro race, lazy and shifty, dull and cruel, a race whose people we have turned into beasts of burden). Zola, "La Sculpture," 16 June 1868, in Zola, *Écrits sur l'art*, 228. (Originally published in *L'Événement illustré*.)

91 Musset, "Charbonniers," 145.

92 See Coffignon, *L'Estomac,* 181, on the processing and reuse of butter. On treating with lime chloride, see Blanquet, *La Cuisinière,* 493–94, cited in Kessler, *Discomfort Food,* 62–63. See Kessler's chapter 2, "Clarifying and Compounding Antoine Vollon's *Mound of Butter*" for further detail on the various methods of disguising rancid butter.

93 This information is reported in an anonymous entry under the title "Annatto (Bixa Orellana, L.)," 6.

94 See Mam Lam Fouck, *La Guyane française.* Mam Lam Fouck gives cotton, sugarcane, and annatto as the dominant crops in French Guiana beginning in the eighteenth century, though they each evolved differently over the course of the nineteenth century: cotton production declined, as did that of sugarcane, faced with competition from the developing production of beetroot sugar in France, while annatto production, "benefitting from a near-monopoly on the metropolitan market, managed to maintain itself in spite of depreciating values" (141–42). Even after the abolition of slavery, the production of annatto held fast and then rose to a high in 1869 and a near high in 1878 (219, 229). Intermittent lulls in cultivation and exportation were responsive to lowered prices, suggesting that the spice was plentiful and easily available in France, which purchased 80 percent of its colony's exports. It was only in the 1880s that annatto plantations began to undergo massive abandonment, as French Guiana ceased to be an agricultural colony, largely due to the discovery of gold; it would progressively shift in the direction of mining and penitentiary establishments (230). See, too, Miranda Spieler, who notes that "the main crop in nineteenth-century Guiana was rocou (*bixa orellana*), a plant native to the New World. The seeds, which smeared red on the bodies of local Indians, became a yellow dye for French cheese and cloth." Spieler, *Empire and Underworld,* 139.

95 For more on annatto, see Beizer, "Traveling with a Hairy Heart."

96 Sue, *Les Aventures*: "Le chef de la tribu . . . avait le corps entièrement teint en rouge vif, au moyen de la semence d'arnoka mélangée dans de l'huile de castor" (24) (The entire body of the tribe's chief was painted in bright red, using a dye made of *arnoka* seed mixed with castor oil). Though Sue writes "arnoka," I have not been able to find this spelling in any dictionary, but the phonetically similar "arnotta," diverging by a single phoneme, is given as another word for annatto by Ulbricht et al., "An Evidence-Based Systematic Review." Sue's Guianese novel tells the rocambolesque tale of a Dutch youth of French extraction who sets out to the Guianas to prove his mettle, in spite of his lack of it. The novel is a compendium of tropical exotica, a picture of forests swarming with escaped slaves and native tribes, set against renditions of rampant flora and fauna that seem to anticipate the paintings of the *Douanier* Rousseau. It takes place largely in Dutch Guiana (now Surinam), but it crosses into French Guiana; the novel's frontiers, like those of the Guiana territories, are fluid. For a travelogue history of the Guianas, see Gimlette, *Wild Coast.*

97 Mitterand, *Zola,* 2:119.

98 Stoler reminds us that the French urban poor were resettled abroad, especially in the Algerian countryside, when they were perceived as increasingly dangerous; and how can we forget Rodolphe's plan for le Chourineur, in Sue's novel, who was destined for Algerian shores for much the same reasons? See Stoler, *Duress,* 81.

99 Spieler (*Empire and Underworld*) mentions too that beginning in 1852, the Western frontier contained a zone of ex-convict villages; the plan was for these men to intermarry with Maroon women and create a new body of settlers (158–59); additionally, there was a wave of immigration from Africa between 1854 and 1859, as well as an incursion of immigrants mostly to the eastern part of French Guiana from China, India, and elsewhere during roughly this period (166). The population of Amerindian peoples diminished drastically over the course of European settlement, due to disease and dispersal, so that by the 1850s there remained fewer than a thousand individuals, less than one-tenth of the Amerindian population in 1600. See Hurault, *Français et Indiens,* xviii.

100 For Spieler, Zola's silence about the population of mainland French Guiana, "wild and empty of people" (109–10) in Florent's account of it in *Le Ventre,* has to do with avoiding a conflation of political prisoners with felons; I find his airbrushing of the population more indicative of an evasion of race.

101 Prendergast among others speaks of a sense of convergence between "l'attitude esthétisante du peintre, Lantier, et celle de Zola lui-même" (the aestheticizing attitude of the artist Lantier and of Zola himself) in "Le Panorama," 66.

102 Emile Zola, *Mes Haines,* "M. Manet" (7 May 1866), in Zola, *Écrits sur l'art,* 116. The scandal provoked by Manet's art was due to a variety of factors: perceptions of his privileging color over line, carrying on the old battle that pitched one against the other, the raw materiality of the paint and the visibility of the artist's hand in its application, and his choice of subject matter.

103 Zola, *Mes Haines,* "Edouard Manet" (1 January 1867), in Zola, *Écrits sur l'art,* 151.

104 See Deutsch, *Consuming Painting,* 63. As Deutsch explains, *tache,* as used by critics of Impressionism, was construed not in the reverent way Zola used it, but in the denigrating sense of a spot or stain, and evoked "messy patches of unregulated pigment" (63). As I elaborated in earlier chapters, color, especially blotchy color and uneven pigmentation, has a long association with "primitive peoples," including women, children, working-class populations, and racialized others. See Kalba, *Color,* 3; Pastoureau, *L'Étoffe du diable,* as well as my chapters 1–3.

105 The French term has no direct English translation. Kalba defines *bariolage* as "the multiple and shifting play of colors that characterized the modern world." Kalba, *Color,* 10. Acknowledging the problem in translation, Prendergast suggests that *bariolage* "broadly connotes a multiple and mobile play of colour." Prendergast, *Paris,* 35.

106 A few examples among a multitude of occurrences are the rows of crowded houses lined up "dans une débandade de couleurs" (619) (in a stampede of colors); the

"lueurs flambantes" (blazing gleam) of butchered pig flesh (632); the "moires," "nacre changeante," "robes lamées," "rouge enluminé," "couleurs irisées" of the fish displays (697–98) (moiré, flickering mother-of-pearl, lamé robes, illuminated red, iridescent colors); the "dorures et les bariolages" (gilding and the mobile colors) of the Saint-Eustache lateral chapels and the "reflets de prisme" (prismatic reflections) falling on its altar paintings (808); the "bigarrure blanche et noire" (white and black medley) of the pigeons' plumage (871).

107 Lionel Ruffel uses the concept of *brouhaha* metaphorically to explore the myriad forms of knowledge production and discourses in contemporary (twenty-first century) culture in his *Brouhaha* without, however, giving any history of its precursors in the nineteenth century. On noise in Paris, see Boutin, *City of Noise,* and Wolf, "The Noise of the Text."

108 For the most part, Zola does not use smell and taste as vehicles for conveying what is rapid, changing, modern. Odors tend to linger (we recall the cheeses), and taste, we have seen, does not figure very much at all in the novel.

109 The bibliography on ekphrasis is long and still evolving, as is the concept. To begin, one might look at a few classic studies: Krieger, *Ekphrasis*; Mitchell, *Picture Theory*; Spitzer, "The 'Ode on a Grecian Urn.'" My thanks to David Powell for conversations on ekphrasis.

110 Mitterand, *Zola,* 1:105; 116–17.

111 Zola, *Causeries,* "Jongkind" (24 January 1872), in Zola, *Écrits sur l'art,* 252–54. These notes on the modern are typical of what we find in Zola's writings on art; this one is exemplary because it is chronologically coincident with *Le Ventre de Paris.*

112 Baudelaire, *Le Peintre,* 27; 22.

113 My claim is not that Zola's sense of the modern matches Baudelaire's, but that there are striking similarities. Zola's emphasis on the people includes the peasantry, unlike Baudelaire's, and other details of a break with aesthetic tradition are not everywhere the same for the two writers.

114 Zhang, *Strange Likeness,* 48.

115 Quoted by Shackelford in "Impressionism and the Still-Life Tradition," 20.

116 Przyblyski, "Makings," 28.

117 Émile Zola, "Édouard Manet, étude biographique et critique" (1867), in Zola, *Écrits sur l'art,* 153.

118 Przyblyski comments: "Inaugurated by the denial of 'philosophy,' by the advent of painting as such, and by a positive embrace of the inconsequential subject matter that had long doomed still life to the bottom of the academic hierarchy, figure painting is reduced to a process of objective visual transcription—a matter only of colored marks and touches seen and painted—and still life becomes the standard by which such visual objectivity and reductive sensationalism is to be measured." Przyblyski, "Makings," 28.

119 In fact, the iron of the Baltard Halles was manufactured by the same foundry at Argenteuil that produced the iron scaffolding of the Gare Saint-Lazare. See Deutsch,

Consuming Passions, 124. Elsewhere in the novel Zola compares the ironwork of Les Halles to "une babylone de métal" (781).

120　In his *Ébauche* for the novel (folio 62/16), Zola decides very early on that the character who will eventually be Marjolin will be the essence of Les Halles, much as the hunchback denizen of Notre Dame de Paris was the cathedral's embodiment: "Il me faudrait dans l'oeuvre un personnage épisodique, qui fût le Quasimodo de mes Halles" (I need an episodic character in this work, one who would be the Quasimodo of my Halles). In Becker, *La Fabrique,* 734.

121　From a novelistic perspective, as we shall see, Claude's failure matters deeply.

122　Shackelford calls formulaic still life "an art of stasis," and points out the paradox of Impressionism's engagement with it, given the popular view of this movement as "an art of sunlight and motion . . . that captured fleeting effects in the out-of-doors." Shackelford, "Impressionism," 20. Zola, of course, places most of his inanimate produce, fruit, fish, and other edible goods outside, where the passage of light can put ostensibly static objects in motion.

123　Significantly, Zola spends much less time in this novel overlooking the freshwater fish, many of which arrive alive and pinching, if carelessly touched, in basins of water.

124　In a chapter on Manet's *Fish (Still Life),* Kessler locates the collected fish (mullet, gurnard, oysters, and eel) represented in this 1864 painting at a similarly blurred point between death and life and speaks of still life's generic "impulse to unsettle a sense of temporal stability" while attributing to Manet's painting a particularly fraught evocation of the coalescing of life, dying, and death. Kessler, *Discomfort Food,* 217n7; see also, especially, 1–7; 20–24. Might Zola have had in mind Manet's *Fish (Still Life)* when he was writing this passage on the fish displayed at Les Halles? Or might he and Manet have discussed the fragile and fleeting life course they seem both to have been focusing on portraying, either in the Friday evening gatherings of the "bande à Manet" at the Café Guerbois, or *en tête-à-tête*? (See Mitterand, *Zola,* 1:497 and following, on these informal gatherings, which were regular events from 1866 on.)

125　See, too, 703 for a reprise of this phantasm.

126　Baudry, *Le Camp des bourgeois.* Illustrations de G. Courbet. In her biography, Baudry's granddaughter reports that Courbet's drawings for his friend's book were done grudgingly and under pressure from Baudry, and that the engraver, Émile Bellot, botched Courbet's efforts. Melia-Sevrain, *Étienne Baudry,* 132.

127　See Melia-Sevrain, *Étienne Baudry,* 181–82; Bonniot, *Gustave Courbet* (derivative of Melia-Sevrain's book); see, too, Shaw, "Étienne Baudry."

128　See Courbet, *Le Parc de Rochement.*

129　Zola, "*Le Camp des bourgeois,* illustré par Gustave Courbet," in Zola, *Écrits sur l'art,* 229–33, 232. While Zola assumes that Courbet authored or coauthored the chapter in which his views are cited, it is much more likely that Baudry was paraphrasing a conversation Courbet had previously had with Sainte-Beuve and perhaps others. Marius Vachon cites an 1862 letter from Sainte-Beuve to Charles Duyveyrier in which

he recounts Courbet's vision of using railroad stations as "des églises nouvelles pour la peinture" (new churches for art). Vachon, *Les Arts,* 194–96; 195. See also Melia-Sevrain, *Étienne Baudry,* 131–32.

130 The question of where to exhibit art, imbricated with the matter of which artists were to be exhibited, and for what public, was the subject of heated political debate throughout the 1860s and can be followed in part through the history of the Salon and the Salon des refusés in the nineteenth century. See Mainardi, *The End of the Salon.*

131 Zola, "*Le Camp des bourgeois,* illustré par Gustave Courbet," in Zola, *Écrits sur l'art,* 233.

132 Maupassant, *Célébrités,* 9–10.

133 Zola, "Les Actualistes" in *Mon Salon,* in Zola, *Écrits sur l'art,* 206–11; 206; 208.

134 Ibid., 208. The picture he is referring to is *Navires sortant des jetées du Havre,* painted in 1867, and the only one of Monet's paintings admitted to the Salon of 1868.

135 Ibid., 208; 209.

136 Zarobell, "Marine Painting," 17.

137 Kessler, *Discomfort Food,* 5.

138 Deutsch, *Consuming Painting,* 41; 44.

139 Wilson-Bareau and Degener, "Manet and the Sea," 89.

140 Zola, "Édouard Manet," in *Mon Salon,* in Zola, *Écrits sur l'art,* 158; 151.

141 Ibid., 161.

142 My sense of Zola's insistence that subject is of no importance (for Manet, for himself, for the modern) is that it was secondary to the materiality of the art; that all subjects were equally valid, as Flaubert famously claimed in order to valorize his representation, in *Madame Bovary,* of a small town in Normandy: "Yvetot donc vaut Constantinople" (Yvetot is the equal of Constantinople). Obviously, the choice of painting a prostitute as central figure, or a black woman as maid, in *Olympia,* or of lingering on fishmongers in *Le Ventre de Paris,* has tremendous ideological significance.

143 Pissarro was, notably, labeled "Maraîcher impressionniste. Spécialité de choux" (Impressionist market gardener. Specialist in cabbage) by Félix Fénéon. See Deutsch, *Consuming Painting,* 113, and more broadly, 113–43. Concerning the muddied, grotesque fish displays and the raw depictions of butchery products, Zola goes where well-mannered writers ought not to venture, showing us the stage in between beasts in the field, the sea, or the air, and their dressed transformations on the table.

144 Here is Zola's paraphrase of Courbet's suggestion: "Le maître déclare carrément qu'il faut fermer les musées et les remplacer par les gares de chemin de fer. Personne ne va plus au Louvre, tandis que tout le monde voyage de temps à autre, quand ça ne serait que pour aller manger une friture à Asnières. C'est donc dans les salles d'attente qu'il faut maintenant accrocher les tableaux" (The maestro states bluntly that we should close the museums and replace them by railway stations. No one goes to the Louvre anymore, while everyone travels from time to time, even if it's only to go eat a

fish fry in Asnières. So it is in the (railway) waiting rooms that we should be hanging paintings now). Zola, "*Le Camp des bourgeois,* illustré par Gustave Courbet," in Zola, *Écrits sur l'art,* 233.

145 Ibid. While there may be a tongue-in-cheek element in Courbet's and Zola's proposals, I take both in at least semi-earnest. Hachette, the publishing company where Zola had his day job as clerk and publicist from 1862 to 1866, had recently begun selling books in the railroad stations under the rubric "Bibliothèque des chemins de fer" (see Mitterand, *Zola,* 1:340–41). If books could be displayed and sold there, why not paintings? (There is, of course, an added layer of irony for contemporary museumgoers who frequent that former *gare* now transformed into museum, the Musée d'Orsay.) Zola's notion of turning the walls of Baltard's expanding Halles into an outdoor museum will later be realized, as we shall see. When Zola writes that "les Halles centrales offrent un développement de murs admirable et que la bonne peinture serait là au frais," he was surely referring to vertical surface space in the streets surrounding Les Halles—kiosks, Morris columns, urinals, building walls where posting was allowed—rather than to the literal walls of the pavilions of Les Halles, externally made of glass and internally hung with animal carcasses and other food products, trade tools, newsprint wrapping, and other commercial implements. In *L'Oeuvre,* Zola will have Claude expand on the idea of street art: "Ah! tout voir et tout peindre! . . . Avoir des lieues de murailles à couvrir, décorer les gares, les halles, les mairies" (Oh! to see all and to paint all! To have leagues of walls to cover, to decorate train stations, market halls, and town halls)—perhaps recalling, too, Manet's 1879 proposal to the Paris Préfet de Police that he paint murals representing Les Halles, the railroads, and all the rest of modern life, in the new Hôtel de Ville. Zola, *L'Oeuvre,* 46; 1418–19n3.

146 We might hypothesize that *Le Ventre de Paris* became the forum for Zola's art criticism in the early 1870s. This novel was written following a period (1869–1872) when Zola published little if any journalistic art criticism due to a combination of political events and the politics of art journalism. For claims that Zola was not thinking about *Le Ventre* until shortly before he wrote it, see Mitterand, *Zola,* 1:730; 2:105; 107. Mitterand does note, however, Zola's long fascination with Les Halles, even well before the Baltard renovation, beginning with his 1858 arrival in Paris (1:243–44) and continuing as he documented the novel (2:77; 110–12).

147 Here, as I move back and forth between visual art and writing, often using the term "art," I am assuming that Zola is targeting both domains, mutatis mutandis.

148 Zola, "Causeries" (20 December 1868), in Zola, *Écrits sur l'art,* 247.

149 Ibid., 247.

150 Scholars concur on the lack of hard data that would allow us to measure with any degree of precision the class-based attendance at art museums and Salons in the nineteenth century (personal email conversation with Daniel J. Sherman, July 2, 2021). We can make some reasoned guesses, however, about a certain measure of proletarian spectatorship in the last decades of the century based on evidence of

derogatory attitudes toward a working-class presence in engravings that mock the people in the galleries, and in commentary such as Zola's. Engravings by Daumier and others that show a very popular Sunday audience at the Salons (both because they were free this day, beginning in 1857, and because workers were, too) suggest that the working class was viewed as a ludicrous audience for art. Sherman argues that the late nineteenth-century public at art museums was increasingly bourgeois (though his focus is the provinces) in his *Worthy Monuments,* despite their self-consciously condescending mission as "instrument of civilization" (236; 238), and Patricia Mainardi contends that in the Third Republic, culture became a distinction that took the place of traditional criteria of birth and breeding, blurring formerly clear class distinctions while creating a social anxiety. See Mainardi, *The End of the Salon,* 139.

151 Zola, "Après une promenade au Salon (1881)" (23 May 1881), in Zola, *Écrits sur l'art,* 441–42. (Originally published in *Le Figaro.*) Readers will remember Zola's account in *L'Assommoir* of 1877 of the Gervaise-Coupeau wedding party's postprandial romp in the galleries of the Louvre, written in much the same spirit as this passage of four years later.

152 Claude is himself a child of the people, it should be remembered, though he has nominally hoisted himself out of the working class by his talent and dedication to art, which gained him recognition in childhood by a wealthy patron who then funded his education.

153 Critics have suggested that *Le Ventre de Paris* and in particular, the violently juxtaposed colors of Claude's Christmas window reflect or evoke the Commune, near in time to Zola's drafting of the novel if less so to its diegetic events. Scarpa summarizes a certain critical convergence: "Si la critique est unanime maintenant pour reconnaître dans le personnage de Florent les traits d'un Communard, nous n'imaginons pas . . . que Zola ait pu écrire le roman des Halles . . . sans qu'il y ait un rapport, au moins inconscient, avec l'épisode de famine épouvantable qui vient de se produire" (If critics are now unanimous in recognizing the traits of a Communard in the character of Florent, we cannot imagine that Zola could have written the novel of Les Halles without there being a rapport, at least an unconscious one, with the terrible episode of famine that the Commune has so recently produced). Scarpa, "Retour ethnocritique," 215. See too, Deutsch, *Consuming Painting,* 26, on class warfare. Ferguson comes closer to my own evaluation in speaking of Lisa's "fear of the power of art." Ferguson, "The Sensualization," 217.

154 Ferguson, "Sensualization," 217.

155 Genette, "Les Frontières," 56.

156 See Austin, *How to Do Things.*

157 *Le Déjeuner sur l'herbe,* originally called *Le Bain,* was shown first at the Salon des refusés in 1863, where it was generally mocked and derided for reasons related to both style and social dynamics. See Przyblyski, "Makings," 28. Zola picked up its defense in print as early as May 1866; he continued to champion the artist with specific

references to *Le Déjeuner.* See Zola, "M. Manet" (1866), "Édouard Manet" (1867), "Édouard Manet" (1868), "Exposition des oeuvres d'Édouard Manet" (1884), in Zola, *Écrits sur l'art,* for substantial examples.

158 It is hard to overlook the posture of Lisa knitting, as she looks out at the scene in which the *arlequins* reappear; is she catching the dropped stitches of the Guiana narrative to patch them into a smoothed-out surface? Or is she, like Mme Defarge, knitting the fate of those—Florent and his co-conspirators—whom she will soon more actively work to eliminate? (Zola, we recall, was working for Hachette in the 1860s at the time they had acquired the rights to publish Dickens's novels in translation; *A Tale of Two Cities* was published by Hachette as *Paris et Londres en 1793,* in 1861.)

159 The play they see, Philippe D'Ennery and Gustave Lemoine's *La Grâce de Dieu* (first performed at la Gaïté Theater in 1841 and in 1861 picked up by the Theater of La Porte Saint-Martin) is a melodrama that bears an uncanny resemblance to the story of Harlequin, the poor country oaf from the mountains of Bergamo in the Italian Alps. *La Grâce de Dieu* is set in the French Alps, in Savoie, a region similarly distant, off the beaten track. Its Savoyard inhabitants were, like the people of Bergamo, reputed to be poor, boorish, uneducated, uncivilized mountain folk. The melodrama evokes once more the Savoyard-Bergamasque affinities put into play by the figures of the *ramoneur* and the *charbonnier.* The plot hinges to a large extent on the encounter of these hillbilly peasants with an urbane Parisian society, much as the Harlequin plays of the Commedia and their successors relied upon a meeting of the rustic countryside and the city.

160 Du Camp, *Paris,* 165.

161 Ibid.

162 Brontë, *Jane Eyre,* cited by Rancière, *Le Fil perdu,* 28.

EPILOGUE

1 Nabokov, *Look at the Harlequins!,* 8–9.

2 In an article that appeared too late to be accounted for in the body of this book, Denis Saillard notes that the law of June 11, 1896, made the installation of new harlequin sellers at Les Halles illegal—but allowed existing *marchand/e/s d'arlequins* to be grandfathered in until their death. In fact, although the harlequin trade faded dramatically following the passage of this 1896 law and the extreme food shortages brought about by the vagaries of history, notably World War I, traces of harlequin sellers can be found, according to Saillard, until as late as 1939. See Saillard, "Bijoutiers et Arlequins," 44.

3 Iskin, *The Poster,* 174.

4 Chéret was and is generally considered to be the "poster king," *le roi des affiches.* For a concise overview of the phenomenon known in French as *affichomanie,* see Cates, "The French Poster." I owe the dating back to 1830 of modern illustrated poster making to Cates, 57. The colored backgrounds of advertising posters began as a legal necessity, because white backgrounded posters were reserved for official government notices. For extensive background material on postermania in France,

see Bargiel and Le Men, *La Belle Époque*; Carter, " 'Masterpieces for Ragpickers' "; "Joris-Karl Huysmans"; "L'Age de l'affiche"; "Spectatorship"; "The Specter"; "Unfit for Public Display"; Hahn, "Boulevard Culture"; *Scenes*; Iskin, *The Poster*.

5 Carter, "L'Age de l'affiche," 17; Hahn, *Scenes,* 199. Defenders of the poster, such as Ernest Maindron, often insisted on tracing its origins way back through Western history and across the civilized world, as if to endow the contemporary poster with a noble lineage and connect it to recognized centers of civilization (Greece, Rome, Egypt). See Carter, "L'Age de l'affiche," 18–20.

6 Hahn, *Scenes,* 183–84.

7 The columns he is speaking of are most likely Morris columns, part of the *mobilier urbain* or street furniture that was created under Haussmann's modernization of Paris in an effort to put some order into the chaotic, untidy spread of posters across the city. Haussmann's installation of a support system specifically designed for posters included kiosks, urinals, hoardings (*panneaux d'affichage*), and, following a competition in 1863 won by the Morris Company, columns, which took the name of this company. Morris columns would not have existed as such in 1859 at the time they are ostensibly spotted by Lisa in the distance, shortly before Florent's second expulsion. This is just one of a number of time warps in *Le Ventre* (which include, too, references to pavilions at Les Halles that were not yet constructed in 1858–59) that come about when Zola is more interested in the narrative value of life in the early 1870s than in the verisimilitude of what would have been present in the 1858–59 diegetic moment. For details of Haussmann's indirect contributions to poster art, see Hahn, *Scenes,* 143–60.

8 Zola, *L'Oeuvre,* 79. Zola's tribute to the medium in *La Plume* was short and unambiguous, and acknowledges Chéret's contributions to his own work: "Chéret a fait pour certains de mes livres, des affiches qui sont des chefs-d'œuvre. Et je trouve que cet art de l'affiche, si vibrant, si original, est devenu le charme et la gaîté de nos rues" (Chéret has made posters for some of my books, and these posters are masterpieces. For me, the vibrancy and originality of poster art has made our streets lively and attractive). Zola, "Quelques Opinions," 503. While Zola admired Chéret and the illustrated poster of his era as art, he mocked the effects of poster advertising on the gullible. In "Une Victime de la réclame," a short story roughly contemporaneous with *Le Ventre de Paris* (it was published in different versions between 1866 and 1872), Zola's protagonist, called simply "Claude" in the last revision, was a sucker for anything billed under the rubric of innovation and progress. He lived and died by the dictates of advertising, indiscriminately buying every product encouraged by posters, and was eventually killed by a panacea that claimed to restore his youth. See Zola, "Une Victime."

9 One scholar, Maurice Rickards, in his *Banned Posters* of 1969 goes so far as to call the poster "by birth a guttersnipe . . . the Eliza Doolittle of the graphic arts." Cited by Carter, "Spectatorship," 31n84.

10 Le Bon, *Psychologie des foules.* See commentary by Carter, "Masterpieces," 361; "Specter," 156–58. Carter points out that the aura of suspicion that touched street

posters was heightened by a long tradition that associated them with revolt and sedition, since billposting had typically been legal during periods of revolution (the French Revolution, the Revolution of 1848, the Commune). Carter, "Masterpieces," 138–41. See the preceding chapters (especially 2 and 4) for more on color and its associations with class.

11 Writing in the anarchist review, *Le Père Peinard,* in 1893, Félix Fénéon goes so far as to urge his readers to strip off the posters and reaffix them to the walls of their homes: "Quand elles sont en place depuis peu, ou quand il tombe de la lance, ou bien quand elles sont plaquées sur des épaisseurs de papier faisant carton, il y a mèche de les décoller, bondieu . . . mais attention aux flics. . . . Une fois de retour à la case . . . épingler votre choppin sur le mur . . . Un Lautrec ou un Chéret à domicile, c'est ce qui éclaire, mille dieux! . . . Donc, à bon marché on peut se procurer de la peinture plus hurf que les croûtes au jus de réglisse qui font la jubilation des trous du cul de la haute" (When they're freshly posted, or when it rains, or when they're laid on superimposed layers of paper, what the hell, it's possible to unglue them, just watch out for the cops. When you get back home, you hang your loot on the wall. A Lautrec or a Chéret at home, well, Christ, it brightens up the place! So you can cheaply get yourself some art that's classier than the prune juice slops that overjoys the assholes of the upper crust). Fénéon, "Chez Les Barbouilleurs," 6–7.

12 Fournel, *Ce Qu' On Voit,* 294.

13 See Cates, *The French Poster,* 57; Iskin, *The Poster,* 5, 41, and throughout; Hahn, *Scenes,* 201; "L'Art de Jules Chéret," in Le Men and Bargiel, *La Belle Époque,* 19–20, for a summary of reactions to the impermanence of posters.

14 Timothée Trimm, "Les Condamnés de Saint-Lazare," *Le Petit Journal,* December 10, 1868, 1. Trimm, as was his wont, writes satirically here but is not clearly for or against the medium. Like his newspaper, he was known for keeping his cards close to his chest, and for playing safe.

15 Nonetheless, the metaphor remains the same; on both sides one must read in a larger context and sometimes between the lines to understand the stance of the writer.

16 Maurice Talmeyr's vitriolic attack on the genre can be found in "L'Age de l'affiche" (216; 213, Talmeyr's emphasis).

17 Claretie, "Quelques Opinions," 495.

18 Jullien, "Quelques Opinions," 496–97; Lemonnier, "Quelques Opinions," 497.

19 Champsaur, *L'Événement,* March 1892, quoted by Le Men in "L'Oeuvre," 67.

20 Grand-Carteret in the chronicle, "Les Curiosités," cited by Le Men in "L'Oeuvre," 56.

21 Bois, "Le Salon du pauvre," 2. While the presentation of urban poster displays as street Salons and museums for the poor may be a myth, as Iskin maintains—a cover for commercial culture and crass merchandizing—it is also true, in Roland Barthes's classic sense of myth; that is, any social discourse has both ideological and evidentiary components. See Iskin, *The Poster,* 175–78, and Barthes, *Mythologies,* especially the closing essay, "Le Mythe, aujourd'hui," in Barthes, *Mythologies,* 191–247.

22 Zola, "Le Camp des bourgeois," in Zola, *Écrits sur l'art,* 233; see "The Railroad Station and the Marketplace" in chapter 4 for the extended citations and translations from Zola. On Marx and Kahn, see Yoshida, "Jules Chéret."

23 Talmeyr, "L'Age de l'affiche," 203. Champsaur, writing of Chéret, observes that "il semble . . . piller . . . les ailes éclatantes de féeriques papillons" (he seems to take on the dazzling wings of enchanted butterflies). Champsaur, "Chronique," in *L'Événement,* March 1892, cited by Le Men, "L'Oeuvre," 68.

24 Huysmans, "Le Salon de 1879," 10.

25 Talmeyr, "L'Age de l'affiche," 208. The metaphor of the *affiche* as a mirror for modern life was frequently deployed by critics on both sides of the debate.

26 Boyer d'Agen's reference to Harlequin is typical, although his specific comment on the "brightly colored" mask of the character is odd, given that the mask is characteristically black, the only part of the costume *not* brilliantly hued. See Boyer d'Agen, "L'Art dans la rue," 621.

27 Lemonnier, "Quelques Opinions," 497; my emphasis. I am grateful to Karen Carter for her conversation and help with references.

28 Boyer d'Agen, "L'Art dans la rue," 624–25.

29 Grand-Carteret, "Les Curiosités de la rue," cited in Le Men, "L'Oeuvre," 54–56.

30 Talmeyr, "L'Age de l'affiche," 205; my emphasis.

31 Le Men and Bargiel speak of the poster collector Topino from Champfleury's novel, *La Mascarade de la vie parisienne,* who offers the children of his *quartier* space to dream through his collection of posters and popular fiction; they further suggest that this consolatory function of Champfleury's fictional posters is generalizable to the culture of posters in popular life: "Cette fonction compensatoire reste valable pour analyser les ressorts de l'affiche fin de siècle, et notamment ceux de l'affiche de Chéret, pourvoyeur continuel de rêves et de féeries pour les passants des rues parisiennes" (This compensatory function remains valid for an analysis of the allure of fin de siècle poster art, especially that of Chéret, unceasing purveyor of dreams and enchantments for pedestrians in Paris streets). Le Men and Bargiel, "L'Art de Jules Chéret," 24.

32 In Le Men and Bargiel's words: "Après avoir constitué le décor de la rue, à ciel ouvert, sous toutes les lumières, l'affiche entre d'abord dans le cabinet de l'amateur puis s'introduit dans le salon et dans la salle à manger" (After having served as street decor, in the open, beneath the streetlights, the poster next enters the collector's study and then living rooms and dining rooms). In "L'Art de Jules Chéret," 24.

33 For this rapid speculatory overview, I am indebted to the catalogue for the 2021–22 exhibition *Picasso l'étranger,* under the auspices of the Musée national de l'histoire de l'immigration and the Musée national Picasso-Paris. See the essays in the catalogue, Cohen-Solal, *Picasso l'étranger,* especially Emily Braun's "Arlequin l'étranger." See, too, Cohen-Solal, *Un Étranger nommé Picasso.* For the earlier nineteenth-century history of state crackdowns on itinerant artists in France, see Clark, *The Absolute*

Bourgeois. A 2014 conversation with Gijs van Hensbergen was extremely helpful to my thinking about Picasso's first years in Paris.

34 Veit, "An Economic History," See, too, Veit, "History of Our Love–Hate–Love Relationship."

35 See Boursin and Challamel, *Dictionnaire,* and the website of La Soupe Saint-Eustache, https://soupesainteustache.fr/.

36 Similarly, Saint-Eustache is a co-player, almost a character alongside les Halles, in Zola's *Ventre de Paris.*

37 For more on Mason's *Le Départ,* see https://www.tate.org.uk/art/artworks/mason -the-departure-of-fruit-and-vegetables-from-the-heart-of-paris-28-february-1969 -t11924; see also https://soupesainteustache.fr/.

38 The cooking and serving sites at Saint-Eustache change with the location of ongoing renovations at the church.

39 Gérard Seibel, "Le Mot du Président," https://soupesainteustache.fr/. Seibel has since retired from this office. The "word" of his successor, Jean Claude Scoupe, addresses the need for special protective measures and planning in order to continue to address food insecurity during the Covid-19 pandemic.

40 Catherine Girard, email message to author, January 16, 2017.

41 As explained by Girard, a very small number of the Saint-Eustache guests, usually not French, come with their own "Tupperware" and ask if they can take food home with them; this is permitted only at the end, once everyone has been served. Girard, email message to author, January 31, 2017.

42 Baguettes and pastries are donated by neighborhood bakeries from their remaining stock at the end of the previous day; other provisions are donated by markets and greengrocers, through the *Banque alimentaire,* all collected by volunteers from La Soupe Saint-Eustache.

43 Of course, nonperishables such as pasta and oil are stocked, and good use is made of refrigerators.

44 Girard, email message to author, January 28, 2017.

APPENDIX

1 The term, however, would only come into usage at Carlo Goldoni's pen two centuries later. These notes on the Commedia Harlequin and his successors are not intended to provide an exhaustive historical account, but to give voice to the elements that can enlighten our understanding of the harlequin way of eating. For a more complete picture of the Commedia, see my principal sources (which will be referenced in my text): Attinger, *L'Esprit*; "L'Évolution"; Baridon and Jonard, *Arlequin et ses masques*; Bourqui, *La Commedia*; Chaffee and Crick, *The Routledge Companion*; Chilton, *Harlequin Unmasked*; Gambelli, *Arlecchino a Parigi*; Lesage, Fuzelier, and D'Orneval, *Le Théâtre*; Ravel, "Trois Images"; Richards and Richards, *The Commedia*; Rubellin, "Un Rôle fondamental"; Sand, *Masques*. Some scholars claim a prehistory going back as far as Greek and Roman antiquity, but such narratives get speculative and fuzzy. See, for example, Monaghan, "Aristocratic Archeology."

2 Gambelli, *Arlecchino a Parigi,* 1:119; the actor was Tristano Martinelli, and Gambelli
 dates the emergence of the Arlequin character in the identity that crystallized to the
 one we still know to the mid-1580s.

3 See Bourqui, *La Commedia,* 15–25.

4 Bourqui elaborates on the amount of memorization involved for each player, com-
 parable in volume to ten traditional roles (17). He also explains the crucial sense of
 what is translated from the Italian as "improvisation" in French and English, but
 which would be better translated in French as "imprévu" or "non prévu," that is,
 unforeseen or unpredicted, referring rather simply to the absence of an author's
 text prior to the show. The gist of the theater this term refers to is immediacy: the
 fact that the theater of the Commedia is not completely premeditated and comes to
 fruition at the moment of the performance, on stage (51–52). The actors' individual
 words and routines are thought out in advance, but their combined performances
 are spontaneous. Bourqui, *La Commedia,* 53–57.

5 Ibid., 32–33.

6 Chilton, *Harlequin Unmasked.*

7 As Kenneth Richards and Laura Richards point out, the children of the Italian play-
 ers established in France who continued the family trade were not purely formed in
 the Italian theater; raised in France, they were Franco-Italian in their education and
 their training and brought this mixed influence to their craft. Richards and Richards,
 The Commedia, 260.

8 The title of queen could not be accorded, nor could the marriage be officially
 recognized due to the disparate social status of Louis XIV and Mme de Maintenon.
 The Italian troupe was rehearsing a play called *La Fausse Prude,* whose title Mme de
 Maintenon assumed was an allusion to her. Whether or not this was the case, the
 Théâtre Italien was generally judged to be too risqué, and the incident provided the
 right provocation to get rid of it. See Ravel, "Trois Images," 51.

9 The Foire Saint-Germain, whose earliest print traces go back to 1176, was situated
 at the site of the Saint-Germain-des-Près abbey, and ran, in the eighteenth century,
 from February 3 to Palm Sunday; it specialized in luxury items such as porcelain and
 silk. The Foire Saint-Laurent can be traced back to 1344 and took place at the site of
 the current Gare de l'Est; it ran from mid-July to mid-September, and traded in more
 everyday items such as tableware and sewing goods. See Lurcel, "Préface."

10 Ibid., 9.

11 Ibid., 12.

12 Ravel, "Trois Images," 51.

13 See Lurcel, "Préface," 15.

14 Ibid., 21.

15 See, for example, Lesage and d'Orneval's observation that "le seul titre de *Théâtre
 de la Foire* emporte une idée de bas et de grossier" (the mere title, *Fairgrounds
 Theater,* bears the sense of lowly and coarse) in their preface in *Le Théâtre,* 1:3.
 Cited by Lurcel, "Préface," 24. Lurcel notes that the authors dropped from their
 edition all the plays they judged to be too bawdy or obscene, thereby omitting more

than three-fourths of the plays produced at the Théâtre de la Foire between 1700 and 1740.

16 For example, the Foire players were, in 1743, the beneficiaries of a sumptuous new theater, l'Opéra Comique, constructed on the fairgrounds.

17 Bourqui, *La Commedia,* 163.

18 See Attinger, *L'Esprit,* 436–40; Tillier, *Maurice Sand.*

19 Attinger, *L'Esprit,* 432–49. Commedia revivals and derivatives continue to flourish today; a good introductory source is available in Chaffee and Crick, *The Routledge Companion,* Part III, 399–496.

BIBLIOGRAPHY

Alhadeff, Albert. *The Raft of the Medusa: Géricault, Art, and Race.* Munich: Prestel, 2002.

———. *Théodore Géricault, Painting Black Bodies.* Routledge: New York and London, 2020.

Allan, Keith, and Kate Burridge. *Forbidden Words: Taboo and the Censoring of Language.* Cambridge: Cambridge University Press, 2006.

Alloula, Malek. *The Colonial Harem.* Translated by Myrna Godzich and Wlad Godzich. Minneapolis: University of Minnesota Press, 1986 (1981).

Ames, Eric. "From the Exotic to the Everyday: The Ethnographic Exhibition in Germany." In Schwartz and Przyblyski, *The Nineteenth-Century Visual Culture Reader,* 313–27.

"Annatto (*Bixa Orellana, L.*)." *Kew Bulletin of Miscellaneous Information, Royal Gardens* 7. London: Eyre and Spottiswode, 1887.

Antle, Martine. "Introduction." *South Central Review* 32, no. 1, special issue, *Dada, Surrealism, and Colonialism* (Spring 2015): 1–7.

Arène, Paul. "Les Cuisines exotiques." In vol. 1 of *Revue de l'Exposition Universelle de 1889.* Paris: Motteroz, Le Dovic Baschet, 1889.

Armstrong, Marie-Sophie. "Vers Les Fondements psychiques de l'appropriation littéraire chez Zola." *Excavatio* 27 (2016). aizen.zolanaturalismassoc.org/excavatio/articles/v27/MarieSophieArmstrong.pdf.

Aron, Jean-Paul. *Le Mangeur du XIXe siècle.* Paris: Les Belles Lettres, 2013.

———. "Sur Les Consommations avariées à Paris dans la deuxième moitié du XIXe siècle." In *Annales: Économies, Sociétés, Civilisations* 30, nos. 2–3 (1975): 553–62.

Attinger, Gustave. *L'Esprit de la Commedia dell'Arte dans le théâtre français.* Geneva: Slatkine Reprints, 1981.

———. "L'Évolution d'un type en France: 'Arlequin.'" *Rivista di studi teatrali,* no. 3 (1954): 78–96.

Austin, J. L. *How to Do Things with Words.* Cambridge, Mass.: Harvard University Press, 1962.

Baguley, David. "Le Supplice de Florent: A Propos du *Ventre de Paris.*" *Europe* 46, nos. 468–69 (April–May 1968): 91–96.

Bakhtin, Mikhail. *Rabelais and His World.* Translated by Helene Iswolsky. Bloomington: Indiana University Press, 1984.

Balzac, Honoré. "Falthurne." In vol. 1 of *Oeuvres diverses,* edited by Pierre-Georges Castex. Paris: Gallimard (Pléiade), 1990 (1820).

———. *Gambara.* In vol. 10 of *La Comédie humaine,* edited by Pierre-Georges Castex. Paris: Gallimard (Pléiade), 1976–81.

Barbaret, Jean. *La Bohème du travail.* Paris: Hetzel, 1889.

Bargiel, Réjane, and Ségolène Le Men, eds. *La Belle Époque de Jules Chéret: De L'Affiche au décor.* Exposition catalogue. Paris: Les Arts Décoratifs, Bibliothèque nationale de France, 2010.

Baridon, Michel, and Norbert Jonard, eds. *Arlequin et ses masques: Actes du colloque franco-italien de Dijon 5–7 septembre 1991.* Dijon: Éditions universitaires de Dijon, 1992.

Barkan, Leonard. *The Hungry Eye: Eating, Drinking, and European Culture from Rome to the Renaissance.* Princeton, N.J.: Princeton University Press, 2021.

Barles, Sabine. "Experts contre experts: Les Champs d'épandage de la ville de Paris dans les années 1870." *Histoire urbaine* 14, no. 3 (2005): 65–80.

Barrett, Marie-Thérèse. "*Le Ventre de Paris*: Claude Lantier and Realist Themes of Food and Markets in Seventeenth and Nineteenth Century Paintings." In *Emile Zola and the Arts,* edited by Jean-Max Guieu and Alison Hilton, 47–53. Washington, D.C.: Georgetown University Press, 1988.

Barth, Volker. "Des Hommes exotiques dans les expositions universelles et internationales (1851–1937)." In Blanchard, Boëtsch, and Snoep, *Exhibitions,* 180–205.

Barthes, Roland. *La Chambre claire.* Paris: Seuil, 1980.

———. *Mythologies.* Paris: Seuil (Points), 1957.

———. *Sade, Fourier, Loyola.* Paris: Seuil, 1971.

———. *S/Z.* Paris: Seuil (Points), 1970.

Batchelor, David. *Chromophobia.* London: Reaktion Books, 2000.

Baudelaire, Charles. *Le Peintre de la vie moderne.* Edited by Jérôme Solal. Paris: Mille et une nuits (Fayard), 2010 (1863).

Baudry, Étienne. *Le Camp des bourgeois.* Illustrations de G. Courbet. Paris: Dentu, 1868.

Beck, Robert. "Esprit et genèse de la loi du 13 juillet 1906 sur le repos hebdomadaire." *Histoire, économie et société* 28, no. 3 (2009): 5–15. Accessed November 18, 2021. https://www.cairn.info/.

Becker, Colette. *La Fabrique des Rougon-Macquart: Édition des dossiers préparatoires.* Paris: Honoré Champion, 2003–17.

———. "Zola, un critique gourmet." In Reverzy and Marquer, *La Cuisine de l'œuvre au XIXe siècle,* 171–84.

Beizer, Janet. "Colette's *Côtelettes,* or the Word Made Flesh." In *Being Contemporary: French Literature, Culture, and Politics Today,* edited by Lia Brozgal and Sara Kippur, 305–18. Liverpool: Liverpool University Press, 2016.

———. *Family Plots: Balzac's Narrative Generations.* New Haven, Conn.: Yale University Press, 1986.

———. "The Textual Woman and the Hysterical Novel." In *Ventriloquized Bodies: Narratives of Hysteria in Nineteenth-Century France,* 15–29. Ithaca, N.Y.: Cornell University Press, 1994.

———. "Textual Women: Twenty-First-Century Reinscriptions." In *Parole #2: Phonetic Skin/ Phonetische Haut,* edited by Annette Stahmer, 64–74. Cologne: Salon-Verlag, 2012.

———. "Traveling with a Hairy Heart, or Where Cooking with Annatto Can Take You." In *Herbs & Spices: Proceedings of the Oxford Symposium in Food and Cookery 2020,* edited by Mark McWilliams, 99–107. London: Prospect Books, 2021.

———. "Why the French Hate Doggie Bags." *Contemporary French Civilization* 42, nos. 3–4 (2018): 373–89.

Belenky, Masha. *Engines of Modernity: The Omnibus and Urban Culture in Nineteenth-Century Paris.* Manchester: Manchester University Press, 2019.

———. "From Transit to *Transitoire*: The Omnibus and Modernity." *Nineteenth-Century French Studies* 36, no. 2 (Winter 2007): 408–21.

Belot, Adolphe, and Ernest Daudet. *La Vénus de Gordes.* Paris: E. Dentu, 1875 (1867).

Bénard, Daniel, and Bruno Guignard. *La Carte postale des origines aux années 1920.* Saint-Cyr-sur-Loire: Alan Sutton, 2010.

Benedict, Burton. "Rituals of Representation: Ethnic Stereotypes and Colonized Peoples at World's Fairs." In *Fair Representations: World's Fairs and the Modern World,* edited by Robert W. Rydell and Nancy E. Gwinn, 28–61. Amsterdam: VU University Press, 1994.

Benjamin, Walter. "Little History of Photography." In *The Work of Art in the Age of Its Technological Reproducibility, and Other Writings on Media,* edited by Michael W. Jennings, Brigid Doherty, and Thomas Y. Levin, translated by Edmund Jephcott, Rodney Livingstone, Howard Eiland, and others, 274–98. Cambridge, Mass.: Harvard University Press, 2008.

———. "Paris, Capital of the Nineteenth Century." In *Reflections: Essays, Aphorisms, Autobiographical Writings,* translated by Edmund Jephcott, 146–62. New York: Schocken, 1986.

Bennett, Tony. "The Exhibitionary Complex." In Schwartz and Przyblyski, *The Nineteenth-Century Visual Culture Reader,* 117–30.

Berenstein, Isidoro. " 'A Child Is Being Beaten' and the Battered Child." In Person, *On Freud's "A Child is Being Beaten,"* 133–56.

Betensky, Carolyn. "Reading Fantasies in Eugène Sue's *The Mysteries of Paris,*" In *M19: American Mysterymania,* edited by Catherine Nesci and Devin Fromm, 68–96. Accessed October 3, 2020. http://www.medias19.org/index.php?id=23815#tocfrom2n4.

Binet, Laurent. "Marianne est une métaphore." *L'Obs.* Accessed May 26, 2019. https://www.nouvelobs.com/politique/20151223.OBS1879/marianne-est-une-metaphore.html.

Bizet, Yves. *Chiens au travail dans la carte postale ancienne.* Paris: Gerfaut, 2002.

Blanc, Charles. *Grammaire des arts du dessin.* Translated by K. Newell Doggett as *The Grammar of Painting and Engraving.* New York: Hurd and Houghton, 1874 (1867).

Blanchard, Pascal, et al. *Human Zoos: Science and Spectacle in the Age of Colonial Empires.* Translated by Teresa Bridgeman. Liverpool: Liverpool University Press, 2008.

Blanchard, Pascal, Gilles Boëtsch, and Nanette Jacomijn Snoep, eds. *Exhibitions: L'Invention du sauvage.* Paris: Actes Sud/Musée du Quai Branly, 2011.

Blanquet, Rosalie. *La Cuisinière des ménages, ou manuel pratique de cuisine et d'économie domestique por la ville et la campagne.* Paris: Théodore Lefèvre, 1881.

Blérald-Ndagano, Monique. *Musiques et danses créoles au tambour de la Guyane française.* Cayenne: Ibis Rouge, 1996.

Blix, Göran. "The Storming of the Academy." Conference paper. Société des Dix-Neuvièmistes, Colloquium. 2007.

Bois, Jules. "Le Salon du pauvre" ("A Jules Chéret"). *Le Courrier français* 46 (November 16, 1890): 2–4.

Bonniot, Roger. *Gustave Courbet en Saintonge, 1862–63.* Paris: Klincksieck, 1973.

Bory, Jean-Louis. *Dandy mais socialiste.* Paris: Hachette, 1973.

———. *Eugène Sue: Le Roi du roman populaire.* Paris: Hachette, 1962.

Bottini, Michele. "You Must Have Heard of Harlequin . . ." In Chaffee and Crick, *The Routledge Companion to Commedia dell'Arte,* 55–61.

Bourdieu, Pierre. *Distinction: A Social Critique of the Judgement of Taste.* Translated by Richard Nice. Cambridge, Mass.: Harvard University Press, 1984.

Bourgeois, Claude, and Michel Melot. *Les Cartes postales: Nouveau Guide du collectionneur.* Paris: Atlas, 1983.

Bourqui, Claude. *La Commedia dell'arte.* Paris: Armand Colin, 2011.

Boursin, E., and Augustin Challamel. *Dictionnaire de la révolution française.* Paris: Furne, 1893.

Boutin, Aimée. *City of Noise: Sound and Nineteenth-Century Paris.* Urbana: University of Illinois Press, 2015.

Bouttoud, Gérard. "Prix et marché du bois à la fin du dix-neuvième siècle." *Revue forestière française* 29, AgroParisTech (1977): 129–38.

Boyer d'Agen, Augustin. "L'Art dans la rue: M. Jules Chéret." *Revue bleue, revue politique et littéraire* 20 (May 19, 1888): 621–28.

Braun, Emily. "Arlequin l'étranger." In Cohen-Solal, *Picasso l'étranger,* 74–83.

Briffault, Eugène. "Des Gens qui ne dînent pas." In *Paris à table,* 50–58. Paris: Mercure de France, 2003 (1846).

Brillat-Savarin, Jean-Anthelme. *La Physiologie du goût.* Paris: Flammarion (Champs Classiques), 1982 (1825).

Brontë, Charlotte. *Jane Eyre.* New York: Penguin, 2006.

Brooks, Peter. *The Melodramatic Imagination: Balzac, Henry James, Melodrama, and the Mode of Excess.* New Haven, Conn.: Yale University Press, 1976.

Bruce, Clint. "Looking at the Colonial Atlantic, Ironically: Slavery and the Idea of Africa in Eugène Sue's *Atar-Gull.*" *Nineteenth-Century French Studies* 48, nos. 3–4 (Spring–Summer 2020): 240–57.

Buck-Morss, Susan. "Hegel and Haiti." *Critical Inquiry* 26, no. 4 (Summer 2000): 821–65.

Buford, Bill. *Dirt: Adventures in Lyon as a Chef in Training, Father, and Sleuth Looking for the Secret of French Cooking.* New York: Knopf, 2020.

Carter, Karen L. "L'Age de l'affiche: Critics, Collectors and Urban Contexts." In *Toulouse Lautrec and the French Imprint: Sources and Legacies of Fin-de-Siècle Posters, Paris—Brussels—Barcelona,* edited by Phillip Dennis Cates, 8–27. New Brunswick, N.J.: Jane Voorhees Zimmerli Museum of Art, 2005.

——. "Joris-Karl Huysmans, a *Dénicheur* of Jules Chéret's Posters." *Nineteenth-Century French Studies* 41, nos. 1–2 (Fall–Winter 2012–13): 122–41.

——. " 'Masterpieces for Ragpickers': Working-Class Crowds, Collective Spectatorship, and the Censorship of Posters in Late 19th-Century Paris." *Space and Culture* 18, no. 4 (November 2015): 358–71.

——. "The Spectatorship of the *Affiche Illustrée* and the Modern City of Paris, 1880–1900." *Journal of Design History* 25, no. 1 (March 2012): 11–31.

——. "The Specter of Working-Class Crowds: The Political Censorship of Posters in Nineteenth-Century Paris." *Yale French Studies* 122 (December 2012): 130–59.

——. "Unfit for Public Display: Female Sexuality and the Censorship of Fin-de-siècle Publicity Posters." *Early Popular Visual Culture* 8, no. 2 (May 2010): 107–24.

Castelnau, Jacques. *Les Petits Métiers de Paris.* Paris: Astéria, 1952.

Cates, Phillip Dennis. "The French Poster 1868–1900." In *American Art Posters of the 1890s,* edited by David W. Kiehl, 57–72. New York: Metropolitan Museum of Art and Harry N. Abrams, 1987.

Chaffee, Judith, and Olly Crick, eds. *The Routledge Companion to Commedia dell'Arte.* London: Routledge, 2015.

Chambers, Ross. "Gossip and the Novel: Knowing Narrative and Narrative Knowing in Balzac, Mme de Lafayette and Proust." *Australian Journal of French Studies* 23, no. 2 (1986): 212–33.

——. "Irony and Misogyny in Balzac and Baudelaire." Plenary Address at the Nineteenth-Century French Studies Colloquium, Durham, N.H., October 26, 1989.

Chamoiseau, Patrick, with photographs by Rodolphe Hammadi. *Guyane, Traces-Mémoires du bagne.* Paris: Caisse Nationale des Monuments Historiques et des Sites, 1994.

Chang, David, and Peter Meehan, directors. *Ugly Delicious.* Tremolo Productions, 2018. Season 1, episodes 1–8, 2018. Netflix.

Charentenay, Alice, and Anaïs Goudmand. "Fiction et idéologie: Marx lecteur des *Mystères de Paris.*" *Contextes: Revue de sociologie de la littérature.* Varia, uploaded November 30, 2014; consulted May 17, 2017. http://contextes.revues.org/5991.

Chavette, Eugène. *Restaurateurs et restaurés.* Paris: A. Le Chevalier, 1867.

Chesnais, Jacques. *Histoire générale des marionettes.* Paris: Bordas, 1947.

Chilton, Meredith. *Harlequin Unmasked: The Commedia dell'Arte and Porcelain Sculpture.* Toronto and New Haven, Conn.: George Gardiner Museum and Yale University Press, 2001.

Claretie, Jules. "Quelques Opinions sur les affiches illustrées." *La Plume,* November 15, 1893.

Clark, T. J. *The Absolute Bourgeois: Artists and Politics in France, 1848–1851.* Berkeley: University of California Press, 1999 (1973).

Clayson, Hollis. *Paris in Despair: Art and Everyday Life Under the Siege (1870–71).* Chicago: University of Chicago Press, 2002.

Coffignon, Ali. *L'Estomac de Paris.* Paris: A La Librairie illustrée, ca. 1887.

Cohen, Margaret. *The Novel and the Sea.* Princeton, N.J.: Princeton University Press, 2010.

Cohen-Solal, Annie. *Un Étranger nommé Picasso: Dossier de police no. 74.664.* Paris: Arthème Fayard, 2021.

———. ed. *Picasso l'étranger.* Paris: Librairie Arthème Fayard, 2021.

Colette. *Les Vrilles de la vigne.* In vol. 1 of *Oeuvres,* edited by Claude Pichois. Paris: Gallimard (Pléiade), 1984 (1908).

Compagnon, Antoine. *Les Chiffonniers de Paris.* Paris: Gallimard, 2017.

Conklin, Alice L. *In the Museum of Man: Race, Anthropology, and Empire in France, 1850–1950.* Ithaca, N.Y.: Cornell University Press, 2013.

Cooke, Roderick. "Theorizing the Scapegoat in Maupassant and Zola." *French Forum* 41, no. 3 (Winter 2016): 177–91.

Corbin, Alain. *Le Miasme et la jonquille: L'Odorat et l'imaginaire social XVIII–XIXe siècles.* Paris: Flammarion, 1986 (1982).

Corbusier. *Journey to the East.* Translated by Ivan Zaknic. Cambridge, Mass.: MIT Press, 1987.

Courbet, Gustave. *Le Parc du Rochement.* Live Auction listing. Christie's. Accessed June 23, 2021. https://www.christies.com/en/lot/lot-6011712.

Cure, Monica. *Picturing the Postcard: A New Media Crisis at the Turn of the Century.* Minneapolis: University of Minnesota Press, 2018.

Daeninckx, Didier. *Cannibale.* Paris: Gallimard, 2009.

Damas, Léon-Gontran. *Retour de Guyane.* Paris: Jean-Michel Place, 2003 (1939).

Darbon, Nicolas. *Musique et littérature en Guyane: Explorer la transdiction.* Paris: Classiques Garnier, 2018.

Delescluze, Charles. *De Paris à Cayenne: Journal d'un transporté.* Paris: A. Le Chevalier, 1869.

Derrida, Jacques. *La Carte postale de Socrate à Freud et au-delà.* Paris: Flammarion, 1980.

———. Ms. Séminaire, *Manger l'autre* 5 (December 13, 1989). Archives de l'IMEC, Caen.

———. Ms. Séminaire, *Manger l'autre* 11 (March 21, 1990). Archives de l'IMEC, Caen.

———. Ms. Séminaire, *Rhétorique du cannibalisme* 7 (January 30, 1991). Archives de l'IMEC, Caen.

Desbuissons, Frédérique. "The Studio and the Kitchen: Culinary Ugliness as Pictorial Stigmatisation in Nineteenth-Century France." In *Ugliness: The Non-Beautiful in Art and Theory,* edited by Andreï Pop and Mechtild Widrich, 104–21. London: I. B. Tauris, 2014.

———. "Yeux ouverts et bouche affamée: Le Paradigme culinaire de l'art moderne (1850–1880)." *Sociétés et représentations* 2, no. 34 (Autumn 2012): 49–70.

Desvignes, Lucette. "Prénom Arlequin, nom de famille, peuple." In Baridon and Jonard, *Arlequin et ses masques,* 17–27.

Detienne, Marcel, and Jean-Pierre Vernant. *Les Ruses de l'intelligence: La Mètis des Grecs.* Paris: Champs (Flammarion), 1974.

Deutsch, Allison. *Consuming Painting: Food and the Feminine in Impressionist Paris.* University Park: Pennsylvania State University Press, 2021.

Didi-Hubermann, Georges. *Invention de l'hystérie: Charcot et l'iconographie photographique de la Salpêtrière.* Paris: Macula, 1982.

Diekmann, Stefanie. "Scenes from the Dressing Room: Theatrical Interiors in Fiction Film." In *Interiors and Interiority,* edited by Ewa Lajer-Burcharth and Beate Söntgen, 87–100. Berlin/Boston: De Gruyter, 2016.

Doane, Mary Anne. *The Desire to Desire: The Woman's Film of the 1940s.* Bloomington: Indiana University Press, 1987.

Doane, Mary Anne, Patricia Mellencamp, and Linda Williams, eds. *Re-Vision: Essays in Feminist Film Criticism.* Frederick, Md.: University Publications of America, 1984.

Dorfman, Ariel. *Darwin's Ghosts.* New York: Seven Stories Press, 2018.

Douglas, Mary. *Purity and Danger: An Analysis of the Concepts of Pollution and Taboo.* Routledge: New York and London, 1966.

Du Camp, Maxime. *Paris, ses organes, ses fonctions, et sa vie jusqu'en 1870.* Monte Carlo, Monaco: G. Rondeau, 1993 (1870).

Eco, Umberto. "Rhetoric and Ideology in Sue's *Les Mystères de Paris.*" *International Social Science Journal* 19, no. 4 (1967): 551–69.

Edwards, Elizabeth. "Little Theatres of Self: Thinking about the Social." In Fenton et al., *We Are the People,* 26–37.

———, ed. *Anthropology and Photography, 1860–1920.* New Haven, Conn.: Yale University Press, 1992.

Edwards, Nina. *Offal: A Global History.* London: Reaktion Books, 2013.

Eleb-Vidal, Monique, and Anne Debarre-Blanchard. *Architectures de la vie privée: Maisons et mentalités XVIIe–XIXe siècles.* Brussels: Éditions des archives d'architecture moderne, 1989.

Escoffier, Auguste. Avant propos. *Le Livre des menus.* Paris: Flammarion, 1912.

Felski, Rita. *The Limits of Critique.* Chicago: University of Chicago Press, 2015.

———. "Suspicious Minds." *Poetics Today* 32, no. 2 (Summer 2011): 215–34.

Fénéon, Félix. "Chez Les Barbouilleurs: Les Affiches en couleur." *Le Père Peinard,* April 30–May 7, 1893.

Fenton, James, Elizabeth Edwards, and Tom Phillips, eds. *We Are the People: Postcards from the Collection of Tom Phillips.* London: National Portrait Gallery, 2004.

Ferguson, Priscilla Parkhurst. *Accounting for Taste: The Triumph of French Cuisine.* Chicago: University of Chicago Press, 2006.

———. "The Sensualization of Flânerie." *Dix-Neuf* 16, no. 2 (July 2012): 211–23.

Ferrières, Madeleine. *Nourritures canailles.* Paris: Seuil, 2007.

Fischler, Claude. *L'Homnivore: Le Goût, la cuisine, et le corps.* Paris: Odile Jacob, 1990.

Flandrin, Jean-Louis. *L'Ordre des mets.* Paris: Odile Jacob, 2002.

Forsdick, Charles. "Postcolonializing the *Bagne.*" *French Studies* 72, no. 2 (April 2018): 237–55.

Fournel, Victor. *Ce Qu'On Voit Dans Les Rues de Paris.* Paris: Adolphe Delahaye, 1858.

Fréjacque, Pierre-Guillaume. *Du Pica: Dissertation présentée et soutenue à l'école de médecine de Paris.* Paris: Pancoucke, 1803.

Gambelli, Delia. *Arlecchino a Parigi*. 3 vols. Rome: Bulzoni, 1993–97.

Garval, Michael D. "Visions of Pork Production, Past and Future, on French Belle Époque Pig Postcards." Accessed April 6, 2015. https://www.19thc-artworldwide.org/spring15 /garval-on-visions-of-pork-production-past-and-future-french-belle-epoque-postcards.

———. "Change of Hearth: Magic, Marketing, and Modernity in the Odelin Stove Le Rustique Postcard Series." *Dix-Neuf* 24 (2020): 284–320.

Gates, Henry Louis, Jr. *Figures in Black: Words, Signs, and the "Racial" Self.* Oxford: Oxford University Press, 1987.

Gaudry, François-Régis. *Mémoires du restaurant: Histoire illustrée d'une invention française.* Geneva: Minerve (Aubanel), 2006.

Gaultier, Jules de. *Le Bovarysme: Essai sur le pouvoir d'imaginer.* Paris: Presses Universitaires de France, 2006 (1902).

———. *Le Bovarysme: La Psychologie dans l'oeuvre de Flaubert.* Paris: Éditions du Sandre, 2007 (1892).

Gauthier, Nicolas. *Lire La Ville, dire le crime.* Limoges: Presses Universitaires de Limoges, 2017.

———. "Le Tapis-franc criminel et le salon respectable: Mise en regard chronotopique dans les *mystères urbains* (1842–59)." *Nineteenth-Century French Studies* 46, nos. 1–2 (Fall–Winter 2017–18): 42–57.

Geary, Christraud M., and Virginia-Lee Webb, eds. *Delivering Views: Distant Cultures in Early Postcards.* Washington, D.C.: Smithsonian Institution Press, 1998.

Geltner, Guy. *Flogging Others: Corporal Punishment and Cultural Identity from Antiquity to the Present.* Amsterdam: Amsterdam University Press, 2014.

Genette, Gérard. "Les Frontières du récit." In *Figures II,* 49–69. Paris: Seuil, 1969.

Gimlette, John. *Wild Coast: Travels on South America's Untamed Edge.* New York: Vintage, 2012.

Gissen, David. *Subnature: Architecture's Other Environments.* New York: Princeton Architectural Press, 2009.

Goethe, Johann Wolfgang. "Pathological Colours." In *Theory of Colours,* translated by Charles Lock Eastlake, 45–58. Cambridge, Mass.: MIT Press, 1970 (1810).

Goncourt, Edmond de. Préface. *Les Frères Zemganno.* In vol. 9 of *Oeuvres complètes des frères Goncourt, Les Frères Zemganno,* edited by Catherine Dousteyssier-Khoze. Paris: Champion, 2012 (1879).

Goulet, Andrea. "Apache Dancers and Savage Boxers: Criminal Choreographies from *Les Mystères de Paris* to *The Wire*." In *M19: Les Mystères Urbains au XIXe siècle: Circulations, transferts, appropriations,* edited by Dominique Kalifa and Marie-Ève Thérenty. Electronic publication (PDF). Accessed April 15, 2018. https://www.medias19.org/pub lications/les-mysteres-urbains-au-xixe-siecle-circulations-transferts-appropriations/ choregraphies-criminelles-combat-chahut-et-danse-apache-des-mysteres-de-paris -wire-egalement-disponible-en-anglais.

Goutaland, Carine. *De Régals en dégoûts: Le Naturalisme à table.* Paris: Garnier, 2017.

Grand-Carteret, John. "Les Curiosités de la rue." *Le Livre et l'image,* 1893.

Grigsby, Darcy Grimaldo. "Cannibalism, Senegal: Géricault's *Raft of the Medusa, 1819.*" In *Extremities: Painting Empire in Post-Revolutionary France,* 165–235. New Haven, Conn.: Yale University Press, 2000.

Grimod de La Reynière, Alexandre Balthasar Laurent. *L'Almanach des gourmands: Servant de guide dans les moyens de faire excellente chère.* Paris: Menu Fretin, 2012 (1803–12).

———. *Manuel des amphitryons; Contenant un traité de la dissection des viandes à table, la nomenclature des menus les plus nouveaux pour chaque saison, et des éléments de politesse gourmande.* Paris: Menu Fretin, 2014 (1808).

Guest, Kristen. "Are You Being Served? Cannibalism, Class, and Victorian Melodrama." In *Eating Their Words: Cannibalism and the Boundaries of Cultural Identity,* edited by Kristen Guest, 107–128. Albany: SUNY Press, 2001.

Hahn, H. Hazel. "Boulevard Culture and Advertising as Spectacle in Nineteenth-Century Paris." In *The City and the Senses: Urban Culture Since 1500,* edited by Alexander Cowan and Jill Steward, 156–75. Burlington, Vt. and Abingdon, U.K.: Ashgate, 2007.

———. *Scenes of Parisian Modernity: Culture and Consumption in the Nineteenth Century.* New York: Palgrave Macmillan, 2009.

Hale, Dana S. *Races on Display: French Representations of Colonized Peoples, 1886–1940.* Bloomington: Indiana University Press, 2008.

Hamp, Pierre. *Mes Métiers.* Paris: Gallimard, 1929.

Hodeir, Catherine. "Decentering the Gaze at French Colonial Exhibitions." In *Images and Empires: Visuality in Colonial and Postcolonial Africa,* edited by Paul S. Landau and Deborah D. Kaspin, 233–52. Berkeley: University of California Press, 2002.

Hoffman, Léon-François. *Le Nègre romantique.* Paris: Payot, 1973.

Hossard, Nicolas. *Recto-Verso: Les Faces cachées de la carte postale.* Paris: Arcadia Éditions, 2005.

Hurault, Jean-Marcel. *Français et Indiens en Guyane, 1604–1972.* Paris: 10/18 (Union Générale D'Éditions), 1972; reprinted, Cayenne: Guyane Presse Diffusion, 1989.

Huysmans, Joris-Karl. "Émile Zola et *L'Assommoir.*" In vol. 1 of *Oeuvres complètes,* edited by Pierre Glaudes and Jean-Marie Seillan, 510–29. Paris: Garnier, 2017–.

———. "Le Salon de 1879." In *L'Art Moderne.* Paris: Charpentier, 1883.

Imbert, Pierre-Léonce. *Les Trappeurs parisiens au XIXe siècle.* Paris: André Sagnier, 1878.

Isidore of Seville. *Etymologies.* 2 vols. Translated by Priscilla Throop. Charlotte, Vt: Medieval MS, 2005.

Iskin, Ruth E. *The Poster: Art, Advertising, Design, and Collecting, 1860s–1900s.* Hanover, N.H.: Dartmouth College Press, 2014.

Jacobs, Margaret. *A Generation Removed: The Fostering and Adoption of Indigenous Children in the Postwar World.* Lincoln: University of Nebraska Press, 2014.

———. *White Mother to a Dark Race: Settler Colonialism, Maternalism, and the Removal of Indigenous Children in the American West and Australia, 1880–1940.* Lincoln: University of Nebraska Press, 2009.

James, Henry. Preface to *The Portrait of a Lady* (New York edition, 1908). Edited by Robert D. Bamberg. New York: Norton, 1995 (1880).

Jarvis, Katie. *Politics in the Marketplace: Work, Gender, and Citizenship in Revolutionary France.* Oxford: Oxford University Press, 2019.

Jullien, Jean. "Quelques Opinions sur les affiches illustrées." *La Plume.* November 15, 1893.

Jusselain, Armand. *Un Déporté à Cayenne: Souvenirs de la Guyane.* Paris: Michel Lévy frères, 1865.

Kalba, Laura Anne. *Color in the Age of Impressionism: Commerce, Technology, and Art.* University Park: Pennsylvania State University Press, 2017.

Kalifa, Dominique. *Les Bas-fonds: Histoire d'un imaginaire.* Paris: Seuil, 2013.

Kaplan, Steven Laurence. *Provisioning Paris: Merchants and Millers in the Grain and Flour Trade During the Eighteenth Century.* Ithaca, N.Y.: Cornell University Press, 1984.

Kessler, Marni Reva. *Discomfort Food: The Culinary Imagination in Late Nineteenth-Century Art.* Minneapolis: University of Minnesota Press, 2021.

———. *Sheer Presence: The Veil in Manet's Paris.* Minneapolis: University of Minnesota Press, 2006.

Kilgour, Maggie. *From Cannibalism to Communion: An Anatomy of Metaphors of Incorporation.* Princeton, N.J.: Princeton University Press, 1990.

Klich, Lydia, and Benjamin Weiss. *The Postcard Age: Selections from the Leonard A. Lauder Collection.* Boston: MFA Publications, 2012.

Kolb, Jocelyne. *The Ambiguity of Taste: Freedom and Food in European Romanticism.* Ann Arbor: University of Michigan Press, 1995.

Krieger, Murray. *Ekphrasis: The Illusion of the Natural Sign.* Baltimore: The Johns Hopkins University Press, 1992.

Lacan, Jacques. "*On Bat Un Enfant* et la jeune homosexuelle." In *Le Séminaire IV, La Relation d'objet,* edited by Jacques-Alain Miller. Paris: Seuil, 1994.

Lajer-Burcharth, Ewa, and Beate Söntgen, eds. *Interiors and Interiority.* Berlin: De Gruyter, 2016.

Lamiot, Christophe. *Littérature et hôpital: Balzac, Sue, Hugo.* Paris: Sciences en Situation, 1999.

Le Bon, Gustave. *Psychologie des foules.* Paris: Presses Universitaires de France, 2013 (1895).

Le Men, Ségolène. "L'Oeuvre de Chéret en résonance." In Bargiel and Le Men, *La Belle Époque de Jules Chéret,* 50–75.

Le Men, Ségolène, and Réjane Bargiel. "L'Art de Jules Chéret: Côté rue et côté salon." In Bargiel and Le Men, *La Belle Époque de Jules Chéret,* 10–33.

Leduc-Adine, Jean-Pierre. "Le Vocabulaire de la critique d'art en 1866 ou 'les cuisines des beaux-arts.'" *Les Cahiers Naturalistes* 54 (1980): 138–54.

Lemonnier, Camille. "Quelques Opinions sur les affiches illustrées." *La Plume,* November 15, 1893.

Leoni, Silvia. "'L'Autre Scène' ou Arlequin et son public." In Baridon and Jonard, *Arlequin et ses masques,* 185–96.

Leprun, Sylviane. *Le Théâtre des colonies.* Paris: L'Harmattan, 1986.

Lesage, Alain René, Louis Fuzelier, and Jacques-Philippe D'Orneval. *Le Théâtre de la foire, ou l'Opéra Comique.* Edited by Dominique Lurcel. Paris: Gallimard, 2014.

Lestringant, Frank. *Cannibals: The Discovery and Representation of the Cannibal from Columbus to Jules Verne.* Translated by Rosemary Morris. Berkeley: University of California Press, 1997.

Lévi-Strauss, Claude. *Le Cru et le cuit.* Paris: Plon, 1964.

——. *L'Origine des manières de table.* Paris: Plon, 1968.

Lindqvest, Sven. *"Exterminate All the Brutes": One Man's Odyssey into the Heart of Darkness and the Origins of European Genocide.* Translated by Joan Tate. New York: New Press, 1997 (1992).

Loichot, Valérie. *The Tropics Bite Back: Culinary Coups in Caribbean Literature.* Minneapolis: University of Minnesota Press, 2013.

Lott, Eric. *Love and Theft: Blackface Minstrelsy and the American Working Class.* New York: Oxford University Press, 1993.

Lurcel, Dominique. Préface. *Le Théâtre de la foire, ou l'Opéra Comique,* by Alain René Lesage, Louis Fuzelier, Jacques-Philippe D'Orneval, 7–33.

Lutz, Catherine A., and Jane L. Collins. *Reading National Geographic.* Chicago: University of Chicago Press, 1993.

Lyon-Caen, Judith. *La Lecture et la vie: Les Usages du roman au temps de Balzac.* Paris: Tallandier, 2006.

Lyu, Claire Chi-ah. "Blank Space and Affect: Reading Mallarmé through Balzac and Blanchot." *Nineteenth-Century French Studies* 47, nos. 1–2 (Fall–Winter 2018–19): 132–49.

MacClancy, Jeremy, and Helen Macbeth. "Introduction: How to Do Anthropologies of Food." In *Researching Food Habits: Methods and Problems,* edited by H. Macbeth and J. MacClancy, 1–14. Oxford: Berghahn Books, 2004.

MacClancy, Jeremy, Jeya Henry, and Helen Macbeth, eds. *Consuming the Inedible: Neglected Dimensions of Food Choice.* Oxford: Berghahn Books, 2007.

Mainardi, Patricia. *The End of the Salon: Art and the State in the Early Third Republic.* Cambridge: Cambridge University Press, 1991.

Malaurie, Christian. *La Carte postale, une oeuvre: Ethnographie d'une collection.* Paris: L'Harmattan, 2003.

Mam Lam Fouck, Serge. *La Guyane française au temps de l'esclavage, de l'or et de la francisation (1820–1946).* Petit Bourg, Guadeloupe: Ibis Rouge, 1999.

Marcus, Sharon. "The Portière and the Personification of Urban Observation." In Schwartz and Przyblyski, *The Nineteenth-Century Visual Culture Reader,* 348–58.

Marin, Mihaela. *Le Livre enterré: Zola et la hantise de l'archaïque.* Grenoble: ELLUG, Université Stendhal, 2007.

Marx, Karl, and Friedrich Engels. *The Holy Family, or Critique of Critical Criticism.* In vol. 4 of *Karl Marx, Frederick Engels: Collected Works.* Translated by Jack Cohen et al. New York: International Publishers, 1975.

Massé, Michelle A. *In the Name of Love: Women, Masochism, and the Gothic.* Ithaca, N.Y.: Cornell University Press, 1992.

Maupassant, Guy de. *Célébrités contemporaines: Émile Zola.* Paris: A. Quantin, 1883.

Maxwell, Anne. *Colonial Photography and Exhibitions: Representations of the "Native" and the Making of European Identities.* London: Leicester University Press, 1999.

Mazo, Adam, and Ben Pender-Cudlip, directors. *First Light.* Upstander Project, 2015. 14 min.

Mazouer, Charles. *Le Personnage du naïf dans le théâtre comique du moyen âge à Marivaux* Paris: Klincksieck, 1979.

McCauley, Elizabeth Anne. *A. A. E. Disdéri and the Carte de Visite Portrait Photograph.* New Haven, Conn.: Yale University Press, 1985.

Medina, Xavier. "Eating Cat in the North of Spain in the Early Twentieth Century." In MacClancy, Henry, and Macbeth, *Consuming the Inedible,* 151–62.

Melia-Sevrain, Yvonne. *Étienne Baudry: Une Vie charentaise . . . châtelain, dandy et écrivain militant.* Saintes: Le Croît Vif, 2010.

Mellot, Philippe. *La Vie secrète des Halles de Paris.* Paris: Omnibus (Place des Editeurs), 2010.

Mélonio, Françoise. "1815–1880: Vers Une Culture démocratique." In vol. 3 of *Histoire Culturelle de la France. Lumières et liberté: Les dix-huitième et dix-neuvième siècles,* edited by Jean-Pierre Roux and Jean-François Sirinelli, 189–350. Paris: Seuil, 1998.

Mercier, Louis Sébastien. "Mets hideux." In vol. 1 of *Tableau de Paris,* edited by Jean-Claude Bonnet. Paris: Mercure de France, 1994 (1789).

Mernissi, Fatima. *Women and Islam: An Historical and Theological Enquiry.* Translated by Mary Jo Lakeland. Oxford: Basil Blackwell, 1991 (1987).

Merriman, John. *Ballad of the Anarchist Bandits: The Crime Spree That Gripped Belle Epoque Paris.* New York: Nation Books, 2017.

Milani, Farzaneh. *Veils and Words: The Emerging Voices of Iranian Women Writers.* Syracuse, N.Y.: Syracuse University Press, 1992.

———. *Words, Not Swords: Iranian Women Writers and the Freedom of Movement.* Syracuse, N.Y.: Syracuse University Press, 2011.

Miller, Christopher L. *The French Atlantic Triangle: Literature and Culture of the Slave Trade.* Durham, N.C.: Duke University Press, 2008.

Miller, Nancy K. "Arachnologies." In *The Poetics of Gender,* edited by Nancy K. Miller, 270–95. New York: Columbia University Press, 1986.

Miller, William Ian. *The Anatomy of Disgust.* Cambridge, Mass.: Harvard University Press, 1997.

Mitchell, W. J. T. *Picture Theory: Essays on Verbal and Visual Representation.* Chicago: University of Chicago Press, 1994.

Mitterand, Henri. "L'Esclave et le paralytique: *Atar-Gull* d'Eugène Sue." *Littérature* 117, no. 1 (March 2000): 96–104.

———. *Zola.* 3 vols. Paris: Fayard, 1999–2002.

Monaghan, Paul. "Aristocratic Archeology." In Chaffee and Crick, *The Routledge Companion to Commedia dell'Arte,* 195–206.

Montaigne, Michel. "Des Cannibales." In *Essais, Livre premier,* edited by Pierre Michel, 300–14. Paris: Gallimard, 1962 (1580).

"Le Mot du Président." Accessed March 7, 2022. https://soupesainteustache.fr/le-mot-du -president/.

Musset, Danielle. "Charbonniers, le métier du diable?" *Le Monde alpin et rhodanien. Revue régionale d'ethnologie* 28, nos. 1–3 (2000): 133–50.

Nabokov, Vladimir. *Look at the Harlequins!* New York: Vintage/Random House, 1990 (1974).

Nadar. *Quand J'Étais Photographe.* Paris: Seuil, 1994 (1900).

Ndiaye, Marie. *La Cheffe, roman d'une cuisinière.* Paris: Gallimard (Folio), 2016.

Nesci, Catherine. "De la littérature comme industrie: *Les Mystères de Paris* et le roman-feuilleton à l'époque romantique." *L'Homme et la société* 200, no. 2 (April–June 2016): 99–120.

———. *Le Flâneur et les flâneuses: Les Femmes et la ville à l'époque romantique.* Grenoble: ELLUG, 2007.

Nochlin, Linda. *Misère: The Visual Representation of Misery in the 19th Century.* London: Thames & Hudson, 2018.

Norindr, Panivong. *Phantasmatic Indochina: French Colonial Ideology in Architecture, Film, and Literature.* Durham, N.C.: Duke University Press, 1996.

Nye, Robert A. *Crime, Madness, and Politics in Modern France.* Princeton, N.J.: Princeton University Press, 1984.

O'Neil-Henry, Anne. *Mastering the Marketplace: Popular Literature in Nineteenth-Century France.* Lincoln: University of Nebraska Press, 2017.

Paillet, Jean. "Ramasseur des bouts de cigares." In *Paris qui crie: Petits Métiers,* edited by Henri Beraldi, illustrations by Pierre Vidal, 111–12. Paris: Les Amis des livres, 1890.

Palermo, Lynn E. "Identity under Construction: Representing the Colonies at the Paris *Exposition Universelle* of 1889." In *The Color of Liberty: Histories of Race in France,* edited by Sue Peabody and Tyler Stovall. Durham, N.C.: Duke University Press, 2003.

Pastoureau, Michel. *Le Cochon: Histoire d'un cousin mal aimé.* Paris: Gallimard, 2009.

———. *L'Etoffe du diable: Une Histoire des rayures et des tissus rayés.* Paris: Seuil, 1991.

Peccatte, Patrick. "La Noirceur du petit ramoneur." *Déjà Vu, Carnet de Recherche de Patrick Peccatte,* December 9, 2013. https://dejavu.hypotheses.org/1538.

Peck, Raoul, director. *Exterminate All the Brutes.* HBO Documentary Films; Velvet Film, 2021. Four-part miniseries.

Person, Ethel Spector, ed. *On Freud's "A Child is Being Beaten."* New Haven, Conn.: Yale University Press, 1997.

Phillips, Tom. *The Postcard Century: 2000 Cards and Their Messages.* London: Thames & Hudson, 2000.

Pike, David L. *Metropolis on the Styx: The Underworlds of Modern Urban Culture, 1800–2001.* Ithaca, N.Y.: Cornell University Press, 2007.

———. *Subterranean Cities: The World Beneath Paris and London, 1800–1945.* Ithaca, N.Y.: Cornell University Press, 2005.

Pindard, Marie-Françoise. *Musique traditionnelle créole: Le* Grajé *de Guyane.* Matoury, Guyane: Ibis Rouge, 2006.

Piton-Foucault, Émilie. " 'L'Original introuvable' du *Ventre de Paris.*" *Les Cahiers Naturalistes* 92 (2018): 124–42.

Poe, Edgar Allan. *Marginalia* 176. Vol. 2 of *The Complete Works of Edgar Allan Poe,* edited by Burton R. Pollin. New York: Gordian Press, 1985 (1846).

Poulain, Jean-Pierre. "La Nourriture de l'autre entre délices et dégoût: Réflexions sur le relativisme de la sensibilité alimentaire." *Revue Internationale de l'imaginaire* 7, *Cultures, nourriture* (1997): 115–39.

Prendergast, Christopher. *Balzac: Fiction and Melodrama.* London: Edward Arnold, 1978.

———. *For the People by the People? Eugène Sue's "Les Mystères de Paris."* Oxford: Legenda: 2003.

———. "Le Panorama, la peinture et la faim: le début du *Ventre de Paris.*" *Les Cahiers Naturalistes* 67 (1993): 65–71.

———. *Paris and the Nineteenth Century.* Oxford: Blackwell, 1992.

Privat D'Anglemont, Alexandre. *Paris Anecdote.* Paris: Les Éditions de Paris, 1984 (1854).

Prochaska, David, and Jordana Mendelson, eds. *Postcards: Ephemeral Histories of Modernity.* University Park: Pennsylvania State University Press, 2010.

Przyblyski, Jeannene M. "The Makings of Modern Still Life in the 1860s." In Rathbone and Shackelford, *Impressionist Still Life,* 28–33.

Rancière, Jacques. *Le Fil perdu: Essais sur la fiction modern.* Paris: La Fabrique, 2014.

Rathbone, Eliza E., and George T. M. Shackelford, eds. *Impressionist Still Life.* Washington, D.C.: Phillips Collection in association with Harry N. Abrams, 2001.

Ravel, Jeffrey S. "Trois Images de l'expulsion des comédien italiens en 1697." *Littératures classiques* 82 (2013): 51–60.

Revel, Jean-François. *Un Festin en paroles.* Paris: Plon, 1995 (1978).

Reverzy, Éléonore. *La Chair de l'idée: Poétique de l'allégorie dans* Les Rougon-Macquart. Geneva: Droz, 2007.

Reverzy, Éléonore, and Bertrand Marquer, eds. *La Cuisine de l'œuvre au XIXe siècle: Regards d'artistes et d'écrivains.* Strasbourg: Presses Universitaires de Strasbourg, 2013.

Riccoboni, Luigi. *Histoire du théâtre italien depuis la décadence de la comédie latine: Avec Un Catalogue des tragédies et comédies italiennes imprimées depuis l'an 1500, jusqu'à l'an 1660, et une dissertation sur la tragédie moderne.* Paris: Imprimerie de Pierre Delormel, 1728.

Richard, Jean-Pierre. "Le Texte et sa cuisine." In *Microlectures,* 135–48. Paris: Seuil, 1979.

Richards, Kenneth, and Laura Richards. *The Commedia dell'Arte: A Documentary History.* Oxford: Basil Blackwell, 1990.

Richman, Kathy A. "Good Works: Altruism, Authorship, and the Desire for Mastery in the Nineteenth-Century French Novel." Ph.D. diss., Harvard University, 2002.

Ricoeur, Paul. *Freud and Philosophy: An Essay on Interpretation.* Translated by Denis Savage. New Haven, Conn.: Yale University Press, 1970.

Ripert, Aline, and Claude Frère. *La Carte Postale: Son Histoire, sa function sociale.* Lyon: CNRS/Presses Universitaires de Lyon, 1983.

Rivers, Christopher. *Face Value: Physiognomical Thought and the Legible Body.* Madison: University of Wisconsin Press, 1995.

Rodowick, D. N. *The Difficulty of Difference: Psychoanalysis, Sexual Difference, and Film Theory.* New York: Routledge, 1991.

Rogin, Michael. *Blackface, White Noise: Jewish Immigrants in the Hollywood Melting Pot.* Berkeley: University of California Press, 1996.

Rosler, Martha. *Decoys and Disruptions: Selected Writings, 1975–2001.* Cambridge, Mass.: MIT Press, 2004.

Rouff, Marcel. *La Vie et la passion de Dodin-Bouffant, gourmet.* Paris: Sillage, 2010 (1924).

Rubellin, Françoise. "Un Rôle fondamental: Arlequin." In *Marivaux dramaturge,* 40–60. Paris: Champion, 1996.

Ruffel, Lionel. *Brouhaha: Les Mondes du contemporain.* Paris: Verdier, 2016.

Sago, Kylie. "The Colonial Marketplace at the Exposition Universelle of 1889." In *Food and Markets: Proceedings of the Oxford Symposium on Food and Cookery 2014,* edited by Mark McWilliams, 362–71. London: Prospect Books, 2015.

Saillard, Denis. "L'Artification du culinaire par les expositions (1851–1939)." *Sociétés et Représentations* 34, no. 2 (2012): 71–84.

———. "Bijoutiers et Arlequins: Métamorphoses Alimentaires à Paris au XIXe siècle." *Le Magasin du XIX Siècle: L'Art de la Récup* 11 (2021): 33–44.

Sand, Maurice. *Masques et bouffons.* Paris: A. Lévy Fils, 1860.

Sante, Luc. *The Other Paris.* New York: Farrar, Straus and Giroux, 2015.

Sartre, Jean-Paul. *L'Être et le néant.* Paris: Gallimard, 1943.

Scarpa, Marie. *Le Carnaval des Halles: Une Ethnocritique du* Ventre de Paris *de Zola.* Paris: CNRS, 2000.

———. "Retour ethnocritique sur les modalités du ventre dans *Le Ventre de Paris.*" In Reverzy and Marquer, *La Cuisine de l'œuvre au XIXe siècle,* 203–15.

Schehr, Lawrence R. *Subversions of Verisimilitude: Reading Narrative from Balzac to Sartre.* New York: Fordham University Press, 2009.

Schor, Naomi. "*Cartes postales*: Representing Paris 1900." *Critical Inquiry* 18 (Winter 1992): 188–241.

———. *Zola's Crowds.* Baltimore: The Johns Hopkins University Press, 1978.

Schwartz, Vanessa R., and Jeannene M Przyblyski, eds. *The Nineteenth-Century Visual Culture Reader.* New York: Routledge, 2004.

Sciolino, Elaine. *The Seine: The River That Made Paris.* New York: Norton, 2020.

Sclaresky, Monique. *Paris si étrange.* Rennes: Éditions Ouest-France, 2005.

Sealy, Peter. "Dreams in Iron: The Wish Image in Émile Zola's Novels." In *Function and Fantasy: Iron Architecture in the Long Nineteenth Century,* edited by Paul Dobraszczyk and Peter Sealy, 221–45. New York: Routledge, 2016.

Serres, Michel. *Le Mal propre: Polluer pour s'approprier?* Paris: Le Pommier, 2012.

Shackelford, George T. M. "Impressionism and the Still-Life Tradition." In Rathbone and Shackelford, *Impressionist Still Life,* 20–27.

Shaw, Tony. "Étienne Baudry, Rochemont (Saintes) and Royan, Charente-Maritime (17), France." Accessed June 23, 2021. http://tonyshaw3.blogspot.com/2010/06/etienne -baudry-rochemont-saintes-and.html.

Shelley, Mary Wollstonecraft. *Frankenstein; or The Modern Prometheus.* In *The Annotated Frankenstein,* edited by Susan J. Wolfson and Ronald L. Levao. Cambridge, Mass.: Harvard University Press 2012 (1818).

Sherman, Daniel J. *Worthy Monuments: Art Museums and the Politics of Culture in Nineteenth-Century France.* Cambridge, Mass.: Harvard University Press, 1989.

Shryock, Richard. "Zola's Use of Embedded Narrative in *Le Ventre de Paris*: Florent's Tale." *Journal of Narrative Technique* 22, no. 1 (Winter 1992): 48–56.

Sicotte, Geneviève. *Le Festin lu: Le Repas chez Flaubert, Zola et Huysmans.* Paris: Liber, 1999.

Silverman, Kaja. *The Threshold of the Visible World.* New York: Routledge, 1996.

Solomon-Godeau, Abigail. *Photography at the Dock: Essays on Photographic History, Institutions, and Practices.* Minneapolis: University of Minnesota Press, 1991.

Sontag, Susan. *On Photography.* New York: Anchor Books, 1973.

"La Soupe Saint-Eustache." Accessed January 23, 2017. www.soupesainteustache.fr.

Spang, Rebecca. " 'And They Ate the Zoo': Relating Gastronomic Exoticism in the Siege of Paris." *MLN* 107 (1992): 752–73.

———. *The Invention of the Restaurant: Paris and Modern Gastronomic Culture.* Cambridge, Mass.: Harvard University Press, 2000.

Spieler, Amanda Frances. *Empire and Underworld: Captivity in French Guiana.* Cambridge, Mass.: Harvard University Press, 2012.

Spitzer, Leo. "The 'Ode on a Grecian Urn' or Content vs. Metagrammar." *Contemporary Literature* 7, no. 3 (Summer 1955): 203–25.

Staff, Frank. *The Picture Postcard & Its Origins.* New York: Frederick A. Praeger, 1966.

Stallybrass, Peter, and Allon Whyte. *The Politics and Poetics of Transgression.* Ithaca, N.Y.: Cornell University Press, 1986.

Steel, Carolyn. "A Tale of Two Cities: Paris, London, and the Political Power of Food." In *Proceedings of the Oxford Symposium on Food and Cookery 2019,* edited by Mark McWilliams, 37–50. London: Prospect Books, 2020.

Stephens, Sonya. "Framing the Eiffel Tower: From Postcards to Postmodernism." In *Framing French Culture,* edited by Natalie Edwards, Ben McCann, and Peter Poiana, 129–55. Adelaide: University of Adelaide Press, 2015.

Stoler, Ann Laura. *Duress: Imperial Durabilities in Our Times.* Durham, N.C.: Duke University Press, 2016.

Sue, Eugène. *Atar-Gull.* In *Romans de mort et d'aventures.* Paris: Laffont, 1993 (1831).

———. *Les Aventures d'Hercule Hardi ou la Guyane en 1772.* In *Deux Histoires.* Paris: Librairie Internationale, 1869 (1840).

———. *Les Mystères de Paris.* Edited by Judith Lyon-Caen. Paris: Gallimard (Quarto), 2009 (1842–43).

———. *The Mysteries of Paris.* Translated with an introduction and notes by Carolyn Betensky and Jonathan Loesberg. Foreword by Peter Brooks. New York: Penguin Books, 2015.

———. "Le Parisien en mer." Médiathèque André Malraux, Lisieux. Accessed February 2, 2017 [1832]. www.bmlisieux.com/archives/eugsue01.htm.

Suzanne, Alfred. "Les Coulisses de la Cuisine: Les Arlequins." *L'Art culinaire: Revue universelle de la cuisine,* dixième année (1892): 47.

Tagg, John. *The Burden of Representation: Essays on Photographies and Histories.* London: Macmillan, 1988.

Talmeyr, Maurice. "L'Age de l'affiche." *Revue des Deux Mondes* 137, no. 9 (September 1, 1896): 201–16.

Taussig, Michael. *What Color Is the Sacred?* Chicago: University of Chicago Press, 2009.

Thérenty, Marie-Ève. *La Littérature au quotidien: Poétiques journalistiques au XIXe siècle.* Paris: Seuil, 2007.

———. "Mysterymania: Essor et limites de la globalisation culturelle au XIXe siècle." *Romantisme* 160, no. 2 (2013): 53–64.

Thévenin. *Promenade gastronomique dans Paris.* Paris: Librairie orientale de Dondé-Dupré, 1833.

Thouvenot, Claude. "La Soupe dans l'histoire." *Cultures, Nourriture,* edited by Jean Duvignaud and Chérif Khaznadar. *Internationale de l'imaginaire,* Nouvelle Série—No. 7, 153–61. Paris: Babel/Maison des Cultures du Monde, 1997.

Tillier, Bertrand. *Maurice Sand marionnettiste.* Tusson, Charente: Éditions du Lérot, 1992.

Tompkins, Kyla Wazana. *Racial Indigestion: Eating Bodies in the 19th Century.* New York: New York University Press, 2012.

Tortonese, Paolo. "*The Mysteries of Paris* (Eugène Sue, 1842–1843)." Translated by Michael F. Moore. In vol. 2 of *The Novel,* edited by Franco Moretti, 181–88. Princeton, N.J.: Princeton University Press, 2006.

Tran, Van Troi. *Manger et boire aux Expositions Universelles.* Rennes: Presses Universitaires de Rennes, 2012.

Trimm, Timothée [Leo Lespès]. "Les Condamnés de Saint-Lazare." *Le Petit Journal,* December 10, 1868, 1.

Trott, David. "Du Jeu masqué au *Jeux de l'amour et du hasard*: L'Évolution du spectacle à l'italienne en France au 18e siècle." In vol. 5 of *Man and Nature: Proceedings of the Canadian Society for Eighteenth-Century Studies,* edited by E. T. Annandale and Richard A. Lebrun, 177–88. Edmonton, Alberta: Academic Printing and Publishing, 1986.

Trouillot, Michel-Rolph. *Global Transformations: Anthropology and the Modern World.* London: Palgrave, 2003.

Trubek, Amy. "Culinary Expositions in Britain and France," Chap. 7 in *Haute Cuisine: How the French Invented the Culinary Profession.* Philadelphia: University of Pennsylvania Press, 2000.

Ulbricht, Catherine, et al. "An Evidence-Based Systematic Review of Annatto *(Bixa Orellana L.)* by the Natural Standard Research Collaboration." *Journal of Dietary Supplements* 9, no. 1 (2012): 57–77.

Vachon, Marius. *Les Arts et les industries du papier en France, 1871–1894.* Paris: Librairies-Imprimeries Réunies, 1895.

Veit, Helen. "An Economic History of Leftovers." *The Atlantic,* October 7, 2015. https://www.theatlantic.com/business/archive/2015/10/an-economic-history-of-leftovers/409255.

———. "The History of Our Love-Hate-Love Relationship with Leftovers." NPR, *All Things Considered,* October 14, 2014. https://www.npr.org/sections/thesalt/2015/10/14/448427811/how-americas-leftovers-went-from-culinary-art-to-joke-to-renaissance.

Verret, Arnaud. "Un Roman de l'enfermement: Géographie, ethnologie et narration des Halles dans *Le Ventre de Paris.*" *Les Cahiers du Ceracc: Études sur les formes narratives des années cinquante à aujourd'hui* 8 (2015). https://hal.archives-ouvertes.fr/hal-01478124.

Vidocq, Eugène-François. *Mémoires.* Paris: Laffont, 1998 (1829).

Villiers de Isle-Adam, Philippe de. *Axël.* Paris: Éditions du Vieux Colombier, 1960.

Viñar, Marcelo. "Construction of a Fantasy: Reading 'A Child Is Being Beaten.'" In Person, *On Freud's "A Child is Being Beaten,"* 179–88.

Visser, Margaret. *The Rituals of Dinner: The Origins, Evolution, Eccentricities, and Meaning of Table Manners.* New York: Grove Weidenfeld, 1991.

Vitoux, Frédéric. *Cartes postales.* Paris: Gallimard, 1973.

Walkowitz, Judith. "Urban Spectatorship." In Schwartz and Przyblyski, *The Nineteenth-Century Visual Culture Reader,* 205–10.

Weil, Kari. "Let Them Eat Horse." Chap. 4 in *Precarious Partners: Horses and Their Humans in Nineteenth-Century France.* Chicago: University of Chicago Press, 2020.

Williams, Linda, ed. *Viewing Positions: Ways of Seeing Film.* New Brunswick, N.J.: Rutgers University Press, 1994.

Wilson-Bareau, Juliet, and David Degener. "Manet and the Sea." In *Manet and the Sea,* edited by Juliet Wilson-Bareau and David Degener, 55–90. Philadelphia: Philadelphia Museum of Art, 2003.

Wolf, Madeleine. "The Noise of the Text: Writing Dissonance and Disruption in Nineteenth-Century French Literature." Ph.D. diss., Harvard University, 2021.

Wood, John. "Situation des *Mystères de Paris.*" *Europe* 60, nos. 643–44 (November–December 1982): 31–36.

Woollen, Geoff. "Les 'Transportés' dans l'oeuvre de Zola." *Les Cahiers naturalistes* 72 (1998): 317–33.

Yeats, William Butler. "Among School Children." https://www.poetryfoundation.org/poems/43293/among-school-children.

Yee, Jennifer. *The Colonial Comedy: Imperialism in the French Realist Novel.* Oxford: Oxford University Press, 2016.

Yoshida, Noriko. "Jules Chéret et la critique d'art de Roger Marx à Gustave Kahn." In Bargiel and Le Men, *La Belle Époque de Jules Chéret,* 109–19.

Young, Sera L. *Craving Earth: Understanding Pica.* New York: Columbia University Press, 2011.

Yriarte, Charles. *Paris Grotesque: Les Célébrités de la rue (1815 à 1863).* Paris: Librairie Parisienne, Dupray de la Mahérie, 1864.

Zarobell, John. "Marine Painting in Mid-Nineteenth-Century France." In Wilson-Bareau and Degener, *Manet and the Sea.*

Zeyons, Serge. *La Belle Époque: Les Années 1900 par la carte postale.* Paris: Larousse, 1991.

Zhang, Dora. *Strange Likeness: Description and the Modernist Novel.* Chicago: University of Chicago Press, 2020.

Zola, Émile. *Correspondance.* In *Oeuvres complètes.* 50 vols. Edited by Maurice Le Blond. Paris: François Bernouard, 1928.

———. *Écrits sur l'art,* edited by Jean-Pierre Leduc-Adine. Paris: Gallimard, 1991.

———. *Germinal.* In vol. 3 of *Les Rougon-Macquart: Histoire naturelle et sociale d'une famille sous le Second Empire,* edited by Armand Lanoux and Henri Mitterand. Paris: Gallimard (Pléiade), 1966.

——. *L'Oeuvre.* In vol. 4 of *Les Rougon-Macquart: Histoire naturelle et sociale d'une famille sous le Second Empire,* edited by Armand Lanoux and Henri Mitterand. Paris: Gallimard (Pléiade), 1964.

——. "Quelques Opinions sur les affiches illustrées." *La Plume,* November 15, 1893.

——. *Le Ventre de Paris.* In vol. 1 of *Les Rougon-Macquart: Histoire naturelle et sociale d'une famille sous le Second Empire,* edited by Armand Lanoux and Henri Mitterand. Paris: Gallimard (Pléiade), 1960 (1873).

——. "Une Victime de la réclame." In *Contes et nouvelles,* edited by Roger Ripoll and Sylvie Luneau. Paris: Gallimard (Pléiade), 1976.

INDEX

Note: Page numbers in italics refer to figures, captions, and plates; n and nn to endnote number and numbers.

JANET BEIZER is C. Douglas Dillon Professor of the Civilization of France at Harvard University. She is author of *Family Plots: Balzac's Narrative Generations*; *Ventriloquized Bodies: Narratives of Hysteria in Nineteenth-Century France*; and *Thinking through the Mothers: Reimagining Women's Biographies*.